Imagini
Exploring Art in
Religions of Late
Antiquity across
Eurasia

Edited by Jaś Elsner and Rachel Wood

The British
Museum

The Empires of Faith research project was generously funded by the Leverhulme Trust

LEVERHULME
TRUST _____

Publishers
The British Museum
Great Russell Street
London WC1B 3DG

Series editor
Sarah Faulks

Imagining the Divine:
Exploring Art in Religions of Late Antiquity across Eurasia

Edited by Jaś Elsner and Rachel Wood

ISBN 978 0861592340
ISSN 1747 3640

Front cover: Plaque featuring a *senmurw (simorgh)*, 7th or 8th
century CE, stucco, h. 16.9cm, w. 19.3cm. Chal Tarkhan,
Iran. British Museum, London, 1973,0725.1

Pg. iv: Funerary stele inscribed in Coptic for 'Little Mary',
8th century CE, limestone, h. 134cm, w. 48.8cm. Egypt.
British Museum, London, 1903,0615

Printed and bound in the UK by 4edge Ltd, Hockley

Papers used by the British Museum are recyclable products
made from wood grown in well-managed forests and other
controlled sources. The manufacturing processes conform to
the environmental regulations of the country of origin.

Further information about the Museum and its collection
can be found at britishmuseum.org

Contents

Introduction

Jaś Elsner and Rachel Wood

Imagining the Divine: Art and the Rise of World Religions was an exhibition at the Ashmolean Museum in Oxford that ran from October 2017 to February 2018. In one space, it confronted the ways in which religions of late antiquity across Eurasia – some very old (like pagan polytheism in the Mediterranean, Judaism or the sacred cults of India) and some relatively newer (like Buddhism, Christianity or Islam) – defined their religious identities through the creation of new kinds of imagery. The exhibition made a comparative investigation of the different ways in which these religions, with awareness of others in their vicinity, competed and contrasted with each other in using material culture to construct both their objects and their sacred spaces. Through aiming to break out of discrete nationally, racially or theologically bound approaches to the grouping of material culture, the attempt was made to innovate in both academic research on late antiquity and in museum practice and display. A large team of researchers, assembled at the British Museum in collaboration with Wolfson College, Oxford, within the *Empires of Faith* project through the generous sponsorship of the Leverhulme Trust, was responsible for organising the show as a collective enterprise, under the formidable leadership of the exhibition project curator, Stefanie Lenk. In celebration of the exhibition and also of the academic project within which it was an integral part, the University of Oxford and the British Museum invited a number of distinguished speakers from across the world to speak at a series of lectures and seminars in the course of 2017, and held a major conference in January 2018; the papers in this volume have been drawn from these sources.

The emphasis of the *Empires of Faith* project, the *Imagining the Divine* exhibition and the essays collected here is upon the materialisation of religion in manufactured forms. A significant driver of the approach is the perception that the history of these religions in this crucial formative period has previously been dominated by text-based theology, while archaeologists have often tended to adopt an excessively secular (economic, political or social) interpretation of excavated objects. Our declared purpose is therefore to give fresh attention to the role which material objects have played, not merely as illustrations of religious ideas, but in constituting religious experience, including contributing to the construction of spaces in which such experience is able to take place. Thus, the project and the papers here have focused on material culture in two particular respects: first, the terms in which objects, archaeology and visual culture may serve to provide historical evidence for religious activity and belief independently from but alongside more traditional textual evidence; and second, the ways in which objects and material forms themselves helped to construct religious experience and understanding, including theology and interpretative commentary on religious concepts from a visual perspective, in the past.

This volume represents a selection of key reactions to the exhibition as well as major up-to-date statements on a number of the important themes raised by both the research project as a whole and the *Imagining the Divine* show in particular. In honour of the collaborative – sometimes quite animated – and conversational quality that characterised *Empires of Faith* as a group enterprise, the volume includes a

series of responses to these major essays from experts, most of whom were members of the curatorial research team. Additionally, as part of the attempt to make the conference more dialogic, within the spirit of the project as a whole, a number of speakers were invited to collaborate in collective or antiphonal contributions. It is a great pleasure that two of these – by Umberto Bongianino and Benjamin Tilghman and by Ivan Foletti and Katharina Meinecke – have made their way into the book.

The papers intentionally span the geographic and temporal range of the project and the exhibition, as well as its varied disciplinary focuses from art history to archaeology to the history of religions. Within those disciplinary bases, there have been many approaches to the questions raised by visual and material culture in the context of religion. Notable contributions have been made in recent years both from archaeology and from religious studies. One of the problems has always been how to integrate the place of objects so that they offer full empirical and evidential data to help us understand the issues, rather than presenting objects as illustrations of a given series of assumptions made through theory or of positions and conclusions derived from textual accounts. By mainly focusing on art-historical approaches to religion in a wide but specific historical and geographic context (namely a long 'late antiquity', from about 100 to about 1000 CE, and Eurasia), this book attempts to restore the object as both 'work of art' and 'instance of material culture' to this discourse. The chronological horizons were chosen deliberately to blur the traditional parcelling of history into stages by moments of religious foundation, notably 0 CE (the conventional date for the birth of Christ) and 610 CE (the year that Gabriel appeared to Muḥammad with the revelation that became the Qurʾān). In doing so, this serves the larger aim, which is to consider the circumstances in which the religious traditions under examination co-existed with and contributed to one another. The methodology of this book is thus art historical, with the emphasis laid equally upon both elements of the term.

One factor in approaching the question of art and religion through stressing particular objects in their cultural specificity is a resistance to what has proved one of the most significant strands in the traditional study of the image in religion. Many of the most important discussions of this theme in the past half-century have focused on ideal-typical objects (that is, objects as defined or described through texts) and their relation to religious production or activity, without needing to stumble on the distinctive eccentricity of any one piece of material culture and its specific limitations and constraints. The accounts within this book do not resist generalisation, but insist on the need to build empirically from the messy diversity and infuriating particularity of the surviving archaeological artefacts in their full material histories and object-biographies. Some of the difficulties are well illustrated in Christoph Uehlinger's closing discussion of the values of material culture from a history of religions perspective.

The book opens with Salvatore Settis' landmark essay on the materiality of the divine in the context of the different pulls in different cultures both towards rich visualisation of deities and the denial of any material articulation of the divine. All religions co-exist with varying internal models of

this dialogue – a dialogue which has occasionally risen to full-blown iconoclasm, usually presenting itself as an act of piety. One of the exceptional aspects of Settis' account is his willingness to range across religious visual and material cultures in search of the overarching issues. At the same time, he is relentless in stressing the visual and contextual specificity of the individual materially attested examples from which he argues.

After the response to Settis by Maria Lidova, the book moves to Verity Platt's paper on framing the divine in Greco-Roman antiquity, with some comparative attention given to later Christian models, themselves derived from the visual practices of the Roman empire, and to Dominic Dalglish's response. Platt makes the important point, largely avoided by secularising archaeology devoted to the study of ancient religion, that art – specifically in the instance of the British Museum's Dionysus from Cyrene, a rare surviving example of what was almost certainly a cult statue in its temple of worship – was a theologically potent, but entirely material and visual, model for the cognitive construction of what constituted religion for its devotees.

The question of framing gives rise to the very specific issue of the ways in which texts frame images and vice versa, especially in the so-called 'world religions' of the first millennium (Judaism, Hinduism, Buddhism, Christianity and Islam) that are characterised by their use of scriptures as well as their continued survival from antiquity to the present day. In the joint contribution by Benjamin Tilghman and Umberto Bongianino, introduced by Katherine Cross, the book turns to the major and specific question of the comparative illumination of scripture and of the use of calligraphically distinguished forms of text as visual signs in both Islam and Christianity at broadly the same temporal moment from the 7th to the 9th centuries. By examining Muslim manuscripts from the disciplinary viewpoint of a scholar of medieval Christian art, and Latin Insular codices from that of an expert of early Islamic art (what they call 'switching viewpoints'), Tilghman and Bongianino offer a vibrant discussion of questions of the materiality of the book as a site of worship and liturgy and of the variety of doctrinal, symbolic and ritual functions that it performed. Remaining within the context of a religion defined by scripture, Judaism, which has far too often been characterised incorrectly as 'aniconic', Martin Goodman offers a revised version of his classic and controversial argument that the charioteer mosaics found on the floors of a number of synagogues in late Roman Palestine may have been seen by some of their viewers as images of God Himself. The response by Hindy Najman and Jaś Elsner attempts to extend his proposal to argue for the theological significance of the visual imagery on synagogue floors as statements or claims, alongside scripture and its commentaries, within a discursive construction of what Judaism was and should be in the era after the fall of the Temple, when the Jews were always the subjects of someone else's empire and cultural sway.

In her paper, Catherine Karkov takes one of the most famous and controversial masterpieces of Anglo-Saxon art: the Franks Casket in the British Museum, the electrotype of which was a major highlight of the *Imagining the Divine*

exhibition, a box made of whalebone bearing texts in Latin and Runic, and images that refer to Christian, Jewish, polytheistic Germanic and Roman traditions. In her response, Katherine Cross applauds Karkov's suggestion that the casket creates a heterotopic space, referring outside the lived experience of its makers and viewers, as a kind of multicultural counteraction to the world in which it was created, rooted in multiple models from the past.

One aspect of the manifold questions surrounding the development of iconographies in religions of late antiquity that the *Imagining the Divine* exhibition attempted to explore, within the limits of what is practicable in a show with fewer than 200 exhibits, was the imagery of the bodies of the founders or major deities of certain faiths (Christianity, Hinduism and Buddhism). Responding to the question of the body, in his chapter on the Buddhapada, the very particular iconography of the footprints of the Buddha widely found in early Buddhist art, Jaś Elsner focuses on one of the major pieces that featured in the exhibition. He argues, by comparison with the creation of icons in the Christian East and especially at Mount Sinai, that in the remarkable monastic context of Amarāvatī on the coast of south-east India this motif acquired the status and significance of an icon. This visual form was embedded in brilliantly thoughtful ways in allusions to a string of sacred texts about the Buddha's miraculous body, which made substantive theological claims about the transcendent nature of Buddhahood as different from all other types of beings, but one that functioned entirely visually. In her response, Alice Casalini shows that the Buddhapada's status at the nexus between body and space offers a series of further theological ramifications, potentially extending to the infinite multiverse evoked in some Buddhist sutras and in what would become the Mahāyāna tradition. Staying with the sacred body, but moving from feet to face, the dialogue that follows between Katharina Meinecke and Ivan Foletti, with a response by Nadia Ali, picks up on a key theme of the exhibition to address the ways in which what became the standard bearded image of Christ developed from that of the Egypto-Roman god Serapis and found itself in play in relation to the creation of the controversial iconography of the standing Caliph in early Islam. Focusing on head and body, Meinecke and Foletti show the extraordinary richness and multicultural range of sources – Egyptian, Greco-Roman , Palmyrene and Sasanian Persian – out of which late antique images of spiritual and royal authority (both Christian and Islamic) were constructed.

Confronting the profound question of cultural diffusion across Eurasia in late antiquity, and from a more archaeological perspective, Richard Hobbs compares expensive and decorated silver plate from the Sasanian world with the technically very similar production of such materials from the later Roman and early Byzantine empires. As Rachel Wood makes clear in her response, a series of issues from exchange and copying, via production and trade, to potential roles in religious or royal ritual are in significant play here in a high-end material whose products have been excavated across the entire span of Eurasia from China to Britain. It is the immensely rich resource of the movement of objects, image-types and religions across the

Silk Routes (overland and via the Indian Ocean), so exceptionally evidenced by the movement and making of silver plate, that enabled the construction of new iconographic forms and the repurposing of old ones in the material, political and religious cultures of late antiquity.

The final contribution is Christoph Uehlinger's comparative account of material religion from a religious studies perspective, alongside Stefanie Lenk's response. Uehlinger raises a series of key issues from the question of ancient versus post-ancient religions, via the historiographical problems of 'primary' and 'secondary' religions, to the scholarly proposal of 'locative' versus 'utopian' religions. In all these cases he is concerned with the material and visual mediations by which versions of these models have been instantiated in historical and cultural contexts. His study opens up a series of methodological and theoretical challenges to future research, which Lenk takes up by applying Uehlinger's insights to a case study in late antique North Africa.

This is only a small – if significant – segment of the relations of religion with visual and material culture, and it is worth mentioning some of what may inevitably be missed by an emphasis on material religion, issues that this volume touches upon only in passing. A focus on materiality is inclined to lose touch with those aspects of religion that are ultimately immaterial experiences, whether conceived as transcendent or immanent, although they may come to be embodied in material records or memories. Although both the exhibition and this book are called *Imagining the Divine*, the demand to focus on material culture rather than revelatory or visionary experiential accounts of visual culture means that most of the arguments or conclusions of the essays collected here tend away from imagination towards what can be determined through a rigorous analysis of things. Theology, including its visualisation in works of art and their function as commentary on philosophical positions developed by religions, plays relatively little part. Mysticism, also, is largely absent. These issues indicate the enormous range of a field that this volume only begins to touch on – and from only some of the many angles that are available.

While we must acknowledge our limitations – not least the predominantly European and American weight of our participants' voices and, despite some effort, the imbalance of space to Christian themes – the intention is to begin a conversation, and to spark a response in the reader's own area of expertise and interest. The editors are immensely grateful to the contributors here for their enthusiastic engagement with the project, and we hope that similar enthusiasm in the readers will prompt future, further conversations in which new voices can be heard. The constraints of space and time required for publication mean that, as well as all those who participated in the *Imagining the Divine* conference and *Empires of Faith* seminars, the editors wish to thank the speakers whose papers were not ultimately able to be included in this volume but who greatly enriched our discussions and expanded their scope: Alain George, Emilie Savage-Smith, Finbarr Barry Flood, Georgi Parpulov, Gergely Hidas, Ine Jacobs, Lars Fogelin, Maria Cristina Carile, Mattia Guidetti, Michele Minardi, Philip Booth, Philippa Adrych, Robert Bracey, Susan Walker and

Zsuzsanna Gulácsi. We also wish to thank all those who have been involved in the *Empires of Faith* project from the start. A two-day workshop held at Wolfson College with Averil Cameron, Bruce Lincoln, Joan-Pau Rubiés, Matthew Canepa and Simon Coleman at the beginning of our research was crucial in shaping the questions and methodologies of the following years, and conferences in Berlin and Chicago, for which we cannot name all the individuals involved but to whom we are grateful for their time, thoughtful feedback and enthusiasm, were also formative for the work of this project.

What the essays here stress is the importance of exploring process and multivalency over rigid cultural stereotypes, and a commitment to material as distinct from immaterial religious experience. They do this from many perspectives in relation not only to different religious contexts but also to the retention and transformation across changing religious landscapes of certain motifs (such as the imagery of a male deity with a flowing beard from antiquity to Christianity) or activities (such as the breaking as well as the making of images for reasons of piety). The emphasis in this volume on these issues, on objects as such and on their agency within religious practice, should not put at risk a rounded understanding of the bigger central theme, which is that – despite the extraordinary and almost single-minded focus on texts in the study of religion for many centuries – there are an enormous number of ways in which images and objects were equally as important for the construction and experience of religion as was writing, and in many cases even more so. At the same time, one must emphasise that an openness to the rich issues of cultural appropriation, acculturation and pluralism in religious contexts needs to be balanced by sensitivity to the distinctiveness, and sometimes the incompatibility, of diverse religious positions.

Acknowledgements

We are indebted to our many generous sponsors, especially the Leverhulme Trust, without whose financial support the *Empires of Faith* project could not have happened. The *Imagining the Divine* conference was supported by the John Fell Fund; the British Museum; Corpus Christi College, Oxford; the Oxford Centre for Byzantine Research; and the Institute for Classical Studies. Further thanks in this endeavour, and throughout the project, are due to our colleagues across the departments at the British Museum and in Oxford, especially at Wolfson College, for their support, encouragement and expertise. The volume has been much improved by the comments and critiques of our two anonymous readers, to whom we also extend our gratitude. Finally, to our editor, Sarah Faulks, who has been supportive, patient and dedicated to the task, all the more remarkable and sincerely appreciated in the turbulent working environment brought by the COVID-19 pandemic.

Notes

1 See Elsner and Lenk 2017.

2 For archaeology, see for instance, in the last decade, Droogan 2013; Raja and Rüpke 2015; Adrych and Dalglish 2020. In religious studies, see for instance, the journal *Material Religion* (published from 2005); Promey 2004; Morgan 2005 and 2010.

3 On this issue see, for example, Fowden 2014.

4 Distinguished examples include Kitzinger 1954; Vernant 1965 (= Vernant 1983), 1979 and 1990; Gordon 1979; Barasch 1992; Rüpke 2010; Ando 2010, 2011 and 2015. It is telling that none of these discussions have felt the need for illustrations, since their focus is on the textual object as a model representation: but no actual objects have ever behaved in context precisely as textual prescriptions may imply. See Adrych and Dalglish 2020: 66–8 and esp. n. 41. For material culture and the need to make the easy flow of history stumble, see Elsner 2015: 67–9.

5 For an excellent introduction to and bibliography of the many issues at stake in art historical framing see Platt and Squire 2017.

6 On agency in relation to art, the classic account is Gell 1998, with discussion in Osborne and Tanner 2007.

Bibliography

Ando, C. 2010. '*Presentia numinis*. Part 1: the visibility of the Roman gods', *Asdiwal* 5, 45–73.

— 2011. '*Presentia numinis*. Part 2: objects in Roman cult', *Asdiwal* 6, 57–69.

— 2015. '*Presentia numinis*. Part 3: idols in context (of use)', *Asdiwal* 10, 61–76.

Adrych, P. and Dalglish, D. 2020. 'Writing the art, archaeology and religion of the Roman Mediterranean', in J. Elsner (ed.), *Empires of Faith in Late Antiquity: Histories of Art and Religion from India to Ireland*, Cambridge, 51–80.

Barasch, M. 1992. *Icon: Studies in the History of an Idea*, New York.

Droogan, J. 2013. *Religion, Material Culture and Archaeology*, London.

Elsner, J. 2015. 'Visual culture and ancient history: issues of empiricism and ideology in the Samos Stele at Athens', *Classical Antiquity* 34, 33–73.

Elsner, J., Lenk, S. *et al.* 2017. *Imagining the Divine: Art and the Rise of World Religions*, Oxford.

Fowden, G. 2014. *Before and After Muhammad: The First Millennium Refocused*. Princeton.

Gell, A. 1998. *Art and Agency: An Anthropological Theory*, Oxford.

Gordon, R.L. 1979. 'The real and the imaginary: production and religion in the Graeco-Roman world', *Art History* 2, 5–34.

Kitzinger, E. 1954. 'The cult of images in the age before iconoclasm', *Dumbarton Oaks Papers* 8, 84–150.

Morgan, D. 2005. *The Sacred Gaze: Religious Visual Culture in Theory and Practice*, Berkeley.

— (ed.) 2010. *Religion and Material Culture: The Matter of Belief*, London.

Osborne, R. and Tanner, J. (eds) 2007. *Art's Agency and Art History*, Oxford.

Platt, V.J. and Squire, M. (eds) 2017. *The Frame in Classical Art: A Cultural History*, Cambridge.

Promey, S. (ed.) 2004. *Sensational Religion: Sensory Cultures in Material Practice*, New Haven.

Raja, R. and Rüpke, J. (eds) 2015. *A Companion to the Archaeology of Religion in the Ancient World*, Chichester.

Rüpke, J. 2010. 'Representation or presence? Picturing the divine in ancient Rome', *Archiv für Religionsgeschichte* 12, 181–96.

Vernant, J.-P. 1965. 'Figuration de l'invisible et catégorie psychologique du double: le colossos', in J.-P. Vernant, *Mythe et pensée chez les Grecs. Études de psychologie historique*, Paris, 251–64.

— 1979. 'Naissance d'images', in J.-P. Vernant, *Religions, histoires, raisons*, Paris, 105–37.

— 1983. 'The figuration of the invisible and the psychological category of the double: the kolossos', in J.-P. Vernant, *Myth and Thought Among the Greeks*, trans. by J. Fort and J. Lloyd, London, 306–20.

— 1990. *Figures, idoles, masques*, Paris.

Chapter 1
The Materiality of the Divine: Aniconism, Iconoclasm and Iconography[1]

Salvatore Settis

Ut pictura poesis: only a very few sentences can claim to have been quoted or commented upon in European culture as often as Horace's famous words in his *Ars poetica* (line 361), 'as is painting so is poetry'. Yet, while such a principle, with all its implications and ambiguities, has travelled across the centuries through Lessing's *Laokoon* (1766) and up to the scholarship of our time, its most radical critique was artfully articulated by a 'man without letters', Leonardo da Vinci. In his unfinished notes *On Painting*, while comparing poetry and painting, he first suggests that we can comparatively weigh their merits by displaying side by side 'a furious battle painted by a good painter' and 'the same as written by a poet'.[2] Then, he directly states: 'Put somewhere the Name of God in writing, and across from it His painted image, and you will see which one will command more reverence.' According to Leonardo, then, images always beat words, even when it comes to representing the divine, because, through their immediate emotional effect, they can better induce in the beholder an inner submission that translates into visible acts of devotion (*acta religionis*).

Words versus images: this contrast has taken on various forms, culturally determined by varying circumstances of time and place. The best known of all, and relevant to our time, is the vivid contrast between the frequent representation of God in Latin Christianity (recently explored by François Boespflug) and the Islamic tradition of inscribing the name of Allah and his praise on sacred and profane buildings.[3] However, the word/image antithesis lends itself to being described not only in terms of conflict, but also as a perpetual, though difficult, dialogue. As Stefanie Lenk and Jaś Elsner have written, 'the encounter between religions and their visual cultures has been one of the foremost creative forces in human history', and therefore 'the borderlands situated between empires are of particular interest'.[4] Such an encounter can be described as a tension between word and image: a tension that is incessantly reformulated according to times, places and circumstances. At the opposite poles we can find Christian vs Islamic art, but also Indian vs Islamic, or even Latin vs Greek Christianity; or, within Eastern Christianity, images produced before, during and after the storms of iconoclasm. **Plates 1.1–1.2** show the *mise en abîme* of two icons: in the Chludov Psalter, the icon of Christ is wiped away with a sponge by the iconoclastic patriarch John the Grammarian, in parallel with a soldier offering to Jesus a vinegar-soaked sponge; in a panel at the British Museum, the icon of the Hodegetria (the Virgin holding the Child Jesus) is exalted on the altar to signal the triumph of iconodulism (veneration of images), still celebrated every year by Orthodox churches.

This paper does not aim to explore the boundaries between cultures or religions, but rather to examine, through a limited number of samples, the fluid boundaries between the matter of images and words on the one hand, and ideas about the divine on the other. Before offering some specific examples, three key points need to be outlined: the word/image opposition; the relationship between word, image and literacy levels of a given community; and finally the necessary reference of any tangible expression of the divine (words or images) to an intangible divine essence, which in the Christian writings on the controversy about

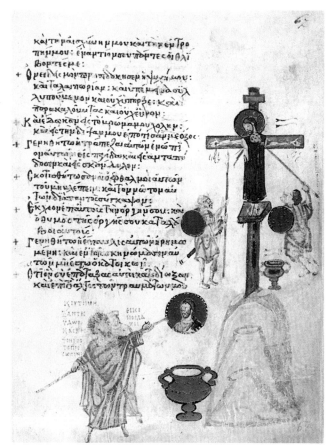

Plate 1.1 Illumination from the Chludov Psalter, 9th century, h. 19.5cm, w. 15cm. State Historical Museum, Moscow, MS. D.129

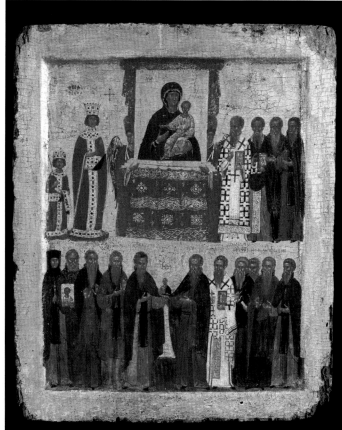

Plate 1.2 Icon of the Hodegetria, c. 1400, tempera on wood, h. 39cm. British Museum, London, 1988,0411.1

icons is called the 'prototype'. The halo around Christ or Buddhist figures does not necessarily bring their images closer to their prototype, but it certainly cuts them off from all that surrounds them.

We can now briefly address the first point: the clear antinomy between word and image in the representation of the divine. This is based on the assumption that the image is 'material', while the word is not; but this assumption is itself a cultural formation that needs to be analysed as such. On the one hand, one can argue that word and image are utterly different in that the pictorial is synchronic and caught potentially in a single glance, while both the written and the spoken word can only be grasped through diachronic temporality. On the other hand, the written word has its own materiality, whose elements are the writing support, the tools and aids of writing, the language and its conventions, and the very gesture of writing. Even in an oral tradition, the material dimension can never be absent: real people and their voices are necessary in order to impart information, values or practices from one generation to another. While it is true that word and image are radically different modes of quoting, representing or conjuring the divine, their diversity cannot be a matter of the full presence nor of the total absence of a material component; rather, this points to a distinction between different levels of materiality. We may assume that these levels are culturally determined and that consequently the word/image opposition is differently structured within historically differentiated interpretive communities.[5]

Regarding the second point, if we consider the choice between word and image in relation to the divine as mutually exclusive, this entails some important implications. If one recommends that only written texts be used and never images, implicitly one presupposes a generalised level of literacy. Yet the enormous intricacy of calligraphic writing, which requires highly trained eyes, makes the relevant texts only really readable to limited segments of society. One may even argue that the basically aniconic nature of writing is contradicted by calligraphic practices, which almost transform words into images, 'capable of veneration in their own right'.[6] Symmetrically, several Christian writers argued that, in Gregory the Great's words, 'painting is used in churches for those who are unable to read, in order to help them to learn from images what they cannot read in books'.[7] Such a principle implies a low level of literacy that requires very articulate images so that these can really serve as *litterae laicorum* (letters for the laity). In fact, however, in Christian art images are quite often paired with texts that are essential in order to make them intelligible, as is the case of the *Biblia pauperum* (**Pl. 1.3**). Therefore, the two opposite alternatives, word and image, have something in common: both require some mediation mechanism between the community at large and a smaller and more educated segment of it, which can often be identified with the clergy – people who are able to fully understand and explain inscriptions of great intricacy or complex iconographies, whether these are accompanied by didactic inscriptions or not.

The iconic potential of writing can briefly be shown by two opposite yet strangely consistent developments via the modification and arrangement of script. On the one hand, Islamic culture created an enormous amount of enjoyable,

Plate 1.3 *Biblia pauperum* with typologies, detail of the Resurrection page, 1465, woodcut, h. 30cm. Esztergom Cathedral, Hungary. Image: Wikimedia Commons

Plate 1.4 Chinese translation of the *Prajāpāramitāhrdaya* (the Heart Sutra), c. 9th century, ink on paper, h. 47cm, Dunhuang, China. British Library, London, Or.8210/S.4289 recto. By permission of the British Library

beautiful, increasingly decorative (and therefore less readable) inscriptions, occasionally even 'animated' by diminutive human figures, which were often copied by Christian artists for their decorative value and therefore almost 'anticipating' the abstract pseudo-writing of contemporary artists such as Cy Twombly. On the other hand, writing can be arranged, even forced, into images, such as a Chinese translation of a Buddhist *sutra* artfully transformed into the shape of a stupa (**Pl. 1.4**).

As far as my third preliminary point is concerned, the level of materiality of words or images articulated around the divine can be measured with respect to the 'divine prototype'. Of course, whenever we adopt the word 'prototype' in this sense, we are borrowing it from the Christian iconoclastic controversy, and by implication we are taking it for granted that the unusually deep and long-lasting discussion about images in the Eastern Church reached in this field a particularly elaborate awareness that can hardly be paralleled elsewhere: 'Both iconoclasm and the iconophile response to it enabled a long tradition of thinking about what an image was.'[8] A given interpretive community can therefore assume that a crucifix, including its inscription, once 'activated' on a magical gem is particularly effective; in a different historical context, a cross without the body of Christ (as in the apse of Hagia Irene in Istanbul) can be conceived as more effective precisely because it has been somewhat dematerialised.

Up to now I have been adopting the model proposed by Jaś Elsner in his seminal article 'Iconoclasm as discourse:

from antiquity to Byzantium' (2012), namely a model based on the discursive nature of practices and doctrines about the divine. He writes that 'the advantage of the model of discourse is that it includes, without prejudicing one before the other, both theory and practice'. By discourse, he means 'the visual and literary production of a society's self-reflections about how it related to itself and its God', continuing, 'the use of images as "discourse" could therefore be employed 'to make statements that were heavily loaded, either politically or theologically'.[9]

Nothing can be more heavily loaded theologically than the relationship between the material markers of the divine and their prototype. In the Byzantine horizon, this relationship runs between two extremes: from St Basil's iconophile statement, quoted by the Second Council of Nicaea, that every honour lent to the icons moves to the prototype, to the verdict by the Council of Constantinople (815), according to which only God is entitled to adoration, while the inanimate matter of the icons is not. The iconoclast council of Hiería in 754 gathered 300 bishops, and almost 400 were present at the iconophile council of Nicaea in 787: rarely, if ever, has discourse on the function of images played such an explicitly theological and political role. Even more rarely, at least before the institutionalisation of art history as a discipline, were so many high-ranking people convened in order to discuss the role, content and meaning of images. Yet similarly vibrant disputes, though not mediated by an institution such as a Church council summoned by the emperor, also took place in other cultures.

For instance, the scholarly discussions of our time about the origins of figurative representation of the Buddha actually mirror a much older contrast. As eloquently shown by recent scholarship (especially by Robert DeCaroli), early Buddhist doctrine includes both texts that encourage the representation of Buddha's bodily appearance and others that consider it a mere distraction or prohibit it expressly, while occasionally recommending indirect representations, such as footprints (see Elsner, this volume).[10]

The gap between the divine and its perceptible markers defines the space of a cognitive experience centred not only on the 'purpose or function of the image, i.e., to help know the divine', but also on the ability 'to direct the worshipper towards the divine'.[11] In this process, the descriptive category of discourse can arguably also be employed to capture the interaction of beholders or devotees with inanimate objects construed around the divine. Such a discourse comes into effect every time the gaze of the beholders or devotees activates an inanimate object, be it an inscription, coarse stone or sculptural masterpiece, which in exchange 'looks back', providing the beholders or devotees with a panoply of emotions from awe to hope. Even an immaterial conception of the divine, in fact, needs some corporeal dimension in order to allow for such a discourse to occur: the infinitely Other (i.e., the divine) needs something familiar, something tangible in order to be talked about. We must, in short, necessarily *faire de l'Autre avec du même*.[12]

Without necessarily embracing every aspect of Alfred Gell's theories about art and agency, we can describe the effect of the material markers of the divine on the viewer through the relational category of agency, namely the inherently fluid ability of perceptible objects to trigger an emotional response.[13] Gell's agency, in the sense in which I intend to use the concept here – without considering intentionality as a property of inanimate objects – more or less agrees with Thomas Aquinas' 13th-century notion of *virtus operativa* (operative power).[14] Items equipped with *virtus operativa* are, for instance, pictures on magical gems, which are often accompanied by more or less intelligible texts. Text and image act emotionally on those in possession of one of these objects, and therefore generate the belief that the owner can influence reality through magical practices.

Properly speaking, *imagines agentes* are images that, according to the practices of classical and medieval art of memory, have the power to arouse strong emotions and therefore settle in our mind and trigger a chain of associations capable of making us remember a story, a doctrine, a court case. Let me briefly mention two examples separated by many centuries: a 1st century CE stele from Alashehir, where the mnemonic device is organised around a 'Pythagorean' Y (i.e. the alternative between two opposite ethical choices);[15] and the 18th century's *Hieroglyphic Bibles*, meant to help children remember the Holy Scripture.

For evocations of the divine to act, they need some level of materiality. This is what Beate Pongratz-Leisten and Karen Sonik recently called 'the materiality of divine agency'.[16] In our context, it can tentatively be described according to an increasing gradation:
- the 'zero degree', ideally entailing a perfect immateriality, would be absolutely ineffable, and if anything tacitly internalised by the faithful in a sort of Augustinian *Deus melius scitur nesciendo* ('God is better known in not knowing him');[17]
- at the 'first degree', the divine would take on a textual and/or epigraphic form, such as the Name of Allah in the Dome of the Rock, Jerusalem;
- the 'second degree' would be an aniconic appearance of the divine, such as the Black Stone in Paphos, purportedly coming from the sanctuary of Aphrodite, which does not represent the goddess but could have been a marker of her presence;[18]
- the 'third degree' would include iconic depictions of the divine. The more they exhibit an inherent potential for animation, the closer to the prototype they might look. They might even display what Gell calls the 'technology of enchantment',[19] which perhaps points to the category of the 'sublime' as analysed by Caroline van Eck.[20] Therefore, they may elicit forms of worship that expose them to the belief that they actually attain:
- a supreme 'fourth degree', that of the divine presence within the image itself.

Such a process can be described in terms of the 'production of presence' explored by Hans Ulrich Gumbrecht.[21] The theories and practices of iconoclasm arise from the suspicion or worry that such beliefs can take hold.

We are dealing here with a paradox of representation: on the one hand, the divine as such, as inherently immaterial, is essentially an *absence*, although it must be able to act upon the material world; on the other, a more attractive or 'enchanting' materiality may trigger a stronger emotional response, and therefore increase the agency of the divine and its immaterial potency. Moving between the opposite extremes of total absence from the sensory sphere and of a full, visible and tangible presence, epiphanies of the divine offer many opportunities to explore a wide range of possibilities, to be understood both in terms of operational effectiveness, or agency, and within artistic tradition (i.e. workshop practice and iconographic conventions).

This discourse about the divine can also be understood as a mediation between presence and absence of materiality, entailing both substitutions and subtractions of its elements. Jaś Elsner has offered an eloquent example, namely the 'numismatic dialogue' between Justinian II and the Caliph 'Abd al-Malik (see Foletti and Meinecke, **Pls 7.6–7.8**, this volume).[22] 'Abd al-Malik adopted as a model for his own currency a *solidus* of Heraclius showing on the obverse the Byzantine emperor and his two sons (all crowned and holding a globe surmounted by the Cross), and on the reverse the Cross on steps. 'Abd al-Malik's coins show on the obverse three figures (without crowns or crosses on the globe), while on the reverse the Prophet's sceptre replaces the Cross atop the steps. Justinian II 'replied' by placing on the obverse Christ's image with the words *Rex Regnantium*, and himself on the reverse with the words *Servus Christi*, perhaps meant as 'possibly an appropriation of the Arabic formulation, since 'Abd is Arabic for slave'.[23] 'Abd al-Malik's 'response' was a gold *dinar* with the Prophet's sceptre on steps on the reverse, and on the obverse a figure with a sword, either the Caliph himself or the Prophet. Immediately afterwards, 'Abd al-Malik moved to an entirely non-

figurative coinage, replacing images with Quranic texts. With his final move, he therefore eventually reached safe ground far from the dangers of idolatry, 'moving away from the figurative toward the decorative', though in the tiny space of a coin the materiality of writing is not substantially different from that of images.[24]

In this exemplary case we can emphasise two points. First, this 'iconic cleansing' takes place by degrees and through a process of gradual subtraction of iconographic elements. Secondly, the merely textual presence of the divine necessarily presupposes the absent, perhaps banned, image and therefore implicitly refers to rival cultures that admit, indeed even exalt, it. Inscriptions are usually considered aniconic, although sophisticated calligraphic intricacies end up taking on a status very close to that of images. But what does 'aniconic' actually mean? This paradoxical term does not define, as it should, the total absence of images but the presence of images that are non-iconic in the etymological sense, that is, not similar to the anthropomorphic or zoomorphic aspect of divinities. Even a coarse rock like the alleged image of Aphrodite in Paphos is aniconic only in the second sense, but not in the first. Being always in balance between presence and absence, the divine has often been represented by subtraction of iconic elements.

Exemplifying the subtraction are the *aprosopoi* or faceless goddesses of Cyrene's necropolis, a very special class of monuments of about 30 mostly life-size busts created from the 5th century BCE through to the Roman period (**Pl. 1.5**). Their hair is set on a more or less elongated cylinder, without distinction between head and neck. These images, so visually arresting, never had a face either in painting or otherwise. According to Luigi Beschi, this is an 'original, intentional, conscious' anicionism that purposefully avoids the natural forms of head and neck in favour of the 'aniconic and geometric cylinder'.[25] Originally placed on the facade of rocky tombs, these busts were sometimes associated with inscriptions bearing the name of the deceased; but, although the names are often masculine, all the busts are feminine, perhaps representing Persephone or an unnamed goddess. The latter is Silvio Ferri's proposal, recently confirmed by the inscription *theà* found on one of these busts.[26] Such an avoidance of a personal name appropriately matches the absence of the face: 'Indeed, the visual effect is eerie. The semi-figural Cyrenean protomes alter the relationship between the figural and the non-figural.'[27] No text mentions these faceless images; they are a partial de-iconisation of pre-existent typologies, made clear by their alternation on Cyrenean tombs with others where the face is represented. We can assume that such a subtraction of iconic elements is oriented by the wish to push this manifestation of the divine into a dark, anonymous dimension, while increasing its effectiveness in funerary cults. By accepting the gaze and worship of her devotees even without eye contact, the anonymous *theà* might have been thought to be able to act precisely because her image is faceless. Her identity is hidden and yet she welcomes ceaseless *acta religionis*, very much like the 'unknown god' whose altar St Paul encountered in Athens' Areopagus (Acts 17:22–3).

The partial de-iconisation of the goddesses from Cyrene is achieved by subtracting an essential iconic element, the

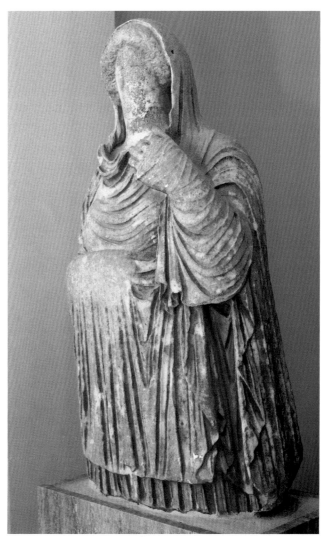

Plate 1.5 Faceless female figure, early 2nd century BCE, marble, h. 116cm, w. 61cm. Cyrene, Cyrene Museum, Libya. Image: Ross Burns/Manar al-Athar

face and the gaze. Likewise, other de-iconisation processes erase from the images of the divine, or of personalities close to it, their anthropomorphic features, yet retain their material trace. Frequent in many cultures, such a development takes on a special character when it applies to a person who actually lived, such as the Buddha, Muḥammad or divinised rulers. Even more peculiar is the case of Christ, who is considered to be man and God at the same time. Without dwelling on this point, let me briefly mention two examples, namely the empty throne and footprints.

Indirect representations of a divine presence through the empty throne on which a god or a person partaking in the divine could momentarily sit used to be widespread in time and space. In the Christian tradition, these representations are called *hetoimasia*, that is, 'preparation' or 'waiting condition'. The fact that the throne is ready, but only for the descent of Christ, sometimes referred to as his Second Advent, is made evident by the presence of his insignia: usually a cushion, a mantle, a closed book and sometimes the Cross and the instruments of the Passion of Christ (**Pl. 1.6a**). The veneration of the empty throne therefore implies the absence of the divine figure, but also the imminence of an epiphany presented as being always possible. The materiality of the throne and of its attributes

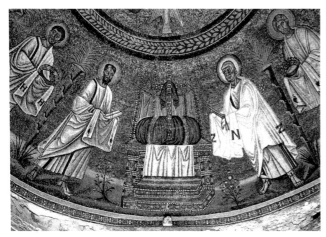

Plate 1.6a (left) The *hetoimasia* (prepared throne) mosaic, 6th century. Arian baptistery, Ravenna. Image: G. Jansoone, public domain

Plate 1.6b (below left) Cult pedestal of the fire god Nuska showing the king kneeling before the empty pedestal, from the reign of Tukulti-Ninurta I, *c.* 1243–1207 BCE, alabaster, h. 60cm, w. 57cm, Temple of Ištar, Aššur. Vorderasiatisches Museum, Berlin, VA 08146. Image © Staatliche Museen zu Berlin-Vorderasiatisches Museum, Olaf M. Teßmer

Plate 1.6c (below right) Buddha's empty throne, 2nd century CE, limestone, d. 65.15cm, Amarāvatī. British Museum, London, 1880,0709.2

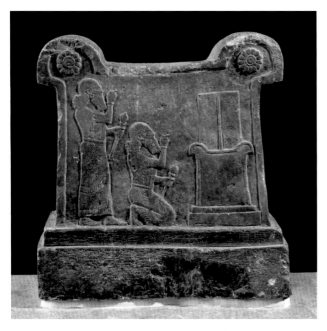

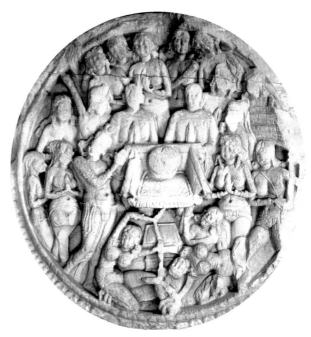

stands for the perceptible manifestation of the divine. The Assyrian king kneeling in front of the god's empty pedestal (**Pl. 1.6b**) is a very ancient example of a widespread cultural practice: even the *vacua sedes* that Pompey found as he entered the Temple in Jerusalem in 63 BCE, according to Tacitus, might have been an empty throne, as has recently been suggested by Cornelius Vollmer.[28] The throne of Allah, mentioned 22 times in the Qurʾān as well in some *ḥadīth*,

Plate 1.7 Empty throne of Neptune, 2nd century CE, marble. San Vitale, Ravenna. Image: P. Angiolini Martinelli, *The Basilica of San Vitale, Ravenna*, Modena, 1997, fig. 360, with permission

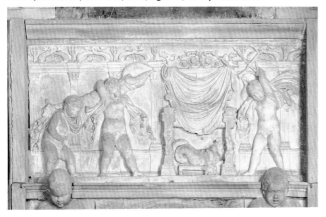

conventionally signals the omnipresence of God.[29] The empty throne as an indication of the presence of the Buddha is extremely frequent (**Pl. 1.6c**). Depending on the various interpretations, it can be considered either as the memory of a (past) moment, when the historical Buddha sat there, or as the projection of a (future) possibility that the Buddha might come back and sit there again, or else as a substitute for Buddha himself, meant to circumvent the ban against directly representing his figure.

Empty thrones are frequently found in the Greco-Roman world. The Ravenna slabs, for example, originally numbered 24 and show as many empty, richly decorated thrones, all ornamented with a large cloth, possibly the mantle of the god or goddess; his or her attributes are scattered around, while a number of *putti* playfully handle them (**Pl. 1.7**). In other words, while the gods are absent, their little attendants duly arrange for their imminent epiphany.[30] The Olympian gods were endowed with a rich iconography reflecting their corporeal appearance: therefore, their empty thrones are surely not meant to bypass any prohibition against anthropomorphic representation. The empty thrones should be understood, rather, as depictions of the divine *in absentia* that hint at the gods' ever-imminent epiphany precisely because they avoid the standard, bodily representation. Far from being a reaction

to a ban on bodily images of the divine, the Greco-Roman empty thrones actually imply a widely practised ritual banquet (*theoxenia* in Greek; *sellisternium* or *lectisternium* in Latin), rarely if ever represented in classical art, to which the gods were invited and their images, placed on thrones or couches, mingled with mortals.[31] Against this background, the Greco-Roman empty throne, far from denying the presence or corporeality of the divine, actually enhances and strengthens it.

The fleeting presence of a god, a great wise man or a prophet can also be signalled by the footprints he supposedly left on earth. Frequent in Buddhist iconography, sometimes in association with the empty throne and other marks of the Buddha, footprints are widespread in numerous cultural and religious traditions (see Elsner, this volume). Sometimes, as is the case of the Buddha, only the footprints are represented and may, depending on the context, be much smaller or much larger than life-size. The footprints of Jesus, instead, must be taken more literally, as truly material traces He left on earth, for instance in the Chapel of the Ascension in Jerusalem. Very much like a relic, Jesus' footprints, Abraham's at Mecca or Vishnu's in the aptly named Temple of Vishnupada (Vishnu's Foot) at Gaya, India, are meant as supernatural marks, not just of a transient presence, but also of a precise moment: Vishnu quashing the demon Gayasura, Abraham placing the Black Stone on the Kaaba, or the moment of Jesus' ascension. Jesus' footprints, though, resurface elsewhere, namely in Rome, in association with His alleged appearance to St Peter, for which no less than two sets of footprints are preserved, in San Sebastiano and in the Chapel of Domine Quo Vadis. If Roman popes took ownership of Jesus' footprints by encouraging the legend of his appearance in Rome, something similar was done by Ottoman caliphs, who moved Muḥammad's relics, including his footprint, to Istanbul (**Pl. 1.8**). By recording the presence on earth of divine or inspired characters, footprints embody documentary, metaphorical and symbolic values, based on the rhetorical figure of synecdoche: the present footprints refer not only to the no longer present feet, but to the entire bodily appearance of the person to whom those feet belonged. Footprints therefore act as the seal of a presence of the divine certified through its absence, combined with a trace of its appearance.

Holy footprints are to be seen against the contextual background of a much larger number of footprints: those of the faithful or pilgrims who left some trace of their passage in temples and shrines in order to record their fleeting presence and make it endure.[32] Often accompanied by inscriptions giving the name of their creators, the footprints keep alive the memory of those who left them behind. As Sassi remarks, footprints can trigger complex cognitive operations, such as in Electra's encounter with her brother in Aeschylus' *Choephori*, where the *anagnorisis* or recognition is based in part on the similarity of their footprints.[33] Footprints may therefore act as what Charles Sanders Peirce calls an index, where a sign has a natural link with the objects to which it relates, since it is directly caused by the latter.[34]

Nothing is in itself more ephemeral and irrelevant than a short visit paid to a sanctuary by an unimportant

Plate 1.8 The Prophet Muḥammad's footprint, brass. Topkapı Sarayı, Istanbul, inv. no. 21/195

commoner; yet, whoever left their footprints behind, occasionally adding their names, clearly intended to perpetuate their physical presence in that place well beyond their visit, but also beyond their lifetime. We can share similar feelings, if we only think how widely relevant some quite recent footprints are, such as those left on the moon by an astronaut or those still accumulating on the Hollywood Hall of Fame. Footprints act as snapshots that ensure the transmission of a given person through time, because they apparently preserve their presence and action at a distance. The holy footprints, while denying materiality by subtracting most bodily elements, in fact commemorate, certify and perpetuate the material presence of the god or person involved, enhancing its effectiveness and agency.

These and other iconographic practices based on the subtraction of bodily elements actually enhance the immateriality of the divine by manipulating its material data. Dematerialising the perceptible markers of the divine engenders a sort of magnetic vortex that attracts to the empty space a powerful mental image endowed with potency and agency.

No practice concerning images is so pervasively shared by various cultures as the most radical of them all: the destruction of sacred images, or iconoclasm.[35] We can hardly address this subject today without considering its present actuality in a sort of new wave of iconoclasm. Its birthdate could perhaps be set in 2001, when the two giant Buddhas of Bāmiyān, Afghanistan, were theatrically destroyed, and their demolition was staged as responding to the most rigorous Islamic orthodoxy, legitimising it with a historical precedent, namely Mahāmūd of Ghazna, a 10th- to 11th-century ruler still considered as an archetypal enemy of idolatry.[36] While analysing the destruction of the Bāmiyān Buddhas, Barry Flood proposed a new approach to Islamic iconoclasm. He distinguishes between instrumental iconoclasm, in which a particular action is executed in order to achieve a greater goal, and expressive iconoclasm, in

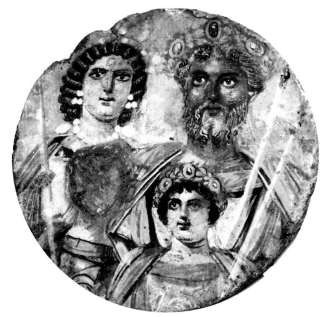

Plate 1.9 Septimius Severus and his family, *c.* 200 CE, tempera on wood, d. 30.5cm. Altes Museum, Berlin, acc. no. 31329.
Image © José Luiz Bernardes Ribeiro

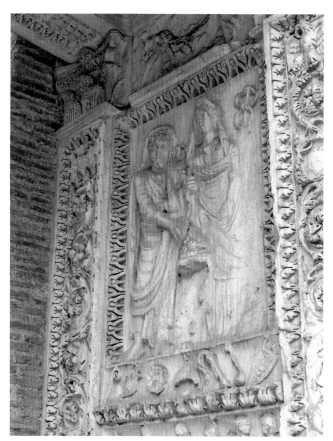

Plate 1.10 Relief on the inner face of the eastern pier of the Arch of the Argentarii, 204 CE, marble. Forum Boarium, Rome.
Image: Panairjdde (CC BY-SA 2.0)

which the desire to express one's belief or give vent to one's feelings is achieved by the act itself.[37] We may argue that the political, and therefore instrumental, relevance of the demolition of the Bāmiyān Buddhas is evidenced by the frequent parallel between this episode and the destruction of the Twin Towers exactly six months later: an eloquent drawing in the *New Yorker* even suggested that full-size replicas of the Buddhas could have been placed on Ground Zero, while the empty niches in Bāmiyān could have been filled with reduced size copies of the Towers and used to accommodate refugees.[38] According to a current prejudice based on episodes such as that of Bāmiyān, iconoclasm would be exclusive to Islam, or perhaps also a transient moment in Byzantine religious history. But things are far more complex. As a brief illustration, we can see Claudius, an adviser to the Carolingian emperor Louis the Pious in the 9th century and Bishop of Turin from 817 to 827, who in his writings boasts of having destroyed all the crosses and sacred images in his diocese.[39] At least equally active was the Protestant iconoclasm launched in Zurich in 1523, which then spread north of the Alps.[40] To mention only one episode of British iconoclasm, we can note William Dowsing, a Puritan soldier from Suffolk who in his diary exactly records the devastations he carried out in 1643–4 in 245 English parish churches.[41]

As far as the Bāmiyān Buddhas are concerned, we know that at some point before 1800 their faces were cut off, as were their hands. Strange as it may seem, these destructions met with Goethe's enthusiastic approval. In his *West-Eastern Diwan* (1819), he is particularly angry at the Bāmiyān Buddhas, which he describes as 'insane idols erected and worshipped on a giant scale', and praises Mahāmūd of Ghazna, to whom their mutilation was attributed: 'We must endorse the zeal of this destroyer of idols, and in him we must deeply admire the founder of Persian poetry and of the highest culture.'[42] We must therefore correct the sharp opposition between 'us', allegedly guardians of historical memory, and 'them', sometimes seen as the intolerant and

destructive Muslims. Iconoclastic thoughts, theories or practices can explode everywhere for multiple causes, and are not native to a single culture. Between the 9th and the 19th century, Claudius in Turin and Goethe in Weimar show that inclinations to religious iconoclasm can be present within the highest European culture.

As mentioned, iconoclasm can be either expressive or instrumental. In both cases, it takes on its full meaning only when it is argued, staged or recorded: the argument for the immateriality of the divine must necessarily be conveyed through something material. Even recent destructions, for example in Palmyra, Syria, are made in the name of a total war against images, but those who make them immediately record the images of destruction and spread them by any means. The deprecated idolatry of ancient cultures is actually replaced by a self-iconisation that among other things requires careful recording of the images of destruction, as well as intensely using mass media: 45,000 Twitter accounts spread images of destructions in Palmyra.[43] To be effective, iconoclasm must be highly visible.

Let me elaborate on this point by taking a case of *damnatio memoriae*, a conventional label for the effacement of Roman imperial images. This was both the same and the opposite of the apotheosis that took place after the emperor's death: while the mortal body of the ruler was burnt, his 'divine body' reached the consortium of the gods. A painted family group now in Berlin (**Pl. 1.9**) was probably exhibited in a public building, perhaps between candelabra, as seen in the *Notitia Dignitatum*.[44] The reigning emperor, Septimius Severus, and his wife, Julia Domna, are accompanied by

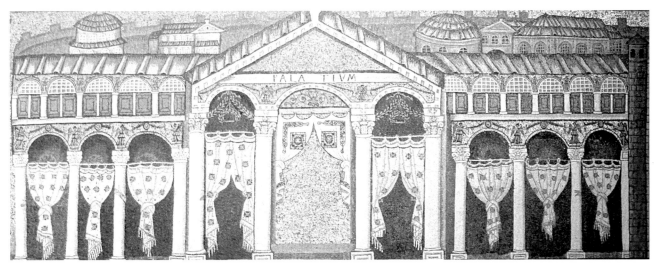

Plate 1.11 Mosaic from the Palace of Theodoric, *c.* 500–25. Basilica of Sant'Apollinare Nuovo, Ravenna. Image © José Luiz Bernardes Ribeiro

two smaller figures: two boys equipped with crown and sceptre, as is their father. These are the young Caracalla, later emperor, and his brother Geta, whose face has been intentionally deleted while the contours, attributes (crown and sceptre) and the rest of his body were left on view. This panel was probably painted when the imperial family visited Egypt in 200. After the death of Septimius Severus in York in 211, his two sons reigned together, but a few months later Caracalla ordered the killing of his brother and his *damnatio memoriae*. The image we are looking at therefore has a double chronology: 200 when it was painted, and 212 when it was 'censored'. But if Geta's memory had to be deleted, how can it be that it is so easy for us, and even more so for contemporary observers, to understand that he was originally painted with the very same dignity and attributes as his brother? The *damnatio memoriae* involves the defacement of Geta but not his effacement.[45] It demands that such erasure remains visible, and in the monstrously acephalous character it represents the defeat of the young prince who lost the struggle with his brother. The residual features of Geta's image are essential to the process of destroying it.

Something similar happened on the Arch of the Argentarii in Rome, where, next to Septimus Severus and his wife, Geta was originally shown making a sacrifice, as can be seen from the left arm of Julia Domna hanging along her side and from the caduceus left in the void (**Pl. 1.10**). While these two examples bear residual elements retaining the memory of the deleted image, Geta's image remained fully visible on his coins, which were still in use. The *damnatio memoriae*, therefore, rather than as a total erasure of every trace of the fallen prince, must be understood as the exhibition, staging and highlighting of the act of cancellation itself. The showy remnants of the erased figures are a performative trace of the cancellation gesture, with its heavy political implications: 'a marked erasure makes it quite clear that the condemned should be noted and remembered as condemned'.[46]

What is left of a destroyed image is meant to convey information and values at least as much as do the unharmed portions that surround it. This is also the case in the 6th-century mosaic of Sant'Apollinare Nuovo in Ravenna

showing the Palace of Theodoric, where around 560 the figures under the arches were replaced by just as many curtains; yet, some details of the 'censored' figures (such as hands on columns and heads half-seen behind the curtains) were left visible (**Pl. 1.11**). The performative process of erasure, still legible for us, must have been even more evident to contemporary observers. We may therefore say that iconoclasm truly has at its very centre a discursive aspect that actually overturns the potency of a given image through a process of transformation. While the image's *virtus operativa* is repudiated, it is actually absorbed and appropriated by the iconoclasts, who take ownership of the agency they are denying and employ it for their own purpose. Such a process can only take place within a context crammed with residues: in 212, what is left of Geta's painted or sculpted portraits and his coins; and in our own era, the dramatically empty niches at Bāmiyān must be seen within a context that includes the enormous number of Buddha images worshipped elsewhere.

The novelty of the neo-iconoclasm practised against the Bāmiyān Buddhas is that their residual memory is no longer something that only belongs to worshippers, but also involves an aesthetic aura created by theories and practices of cultural heritage, as Barry Flood has persuasively argued;[47] and this is why acts of iconoclasm such as those perpetrated at Bāmiyān or at Palmyra would be unthinkable without a careful recording and mass communication of the destruction itself. The destruction of 'idols', allegedly an act of worship to the true God in the name of His immateriality, capitalises on the materiality of the divine, aiming at absorbing its communicative power and making it its own.

Apparently, some form of materialisation of the divine becomes even more necessary when it is supposed to be radically denied. The tough repression of Christianity in Japan under the Tokugawa Shogunate in the 17th century, for example, led to the destruction of all images of Christian worship, although clandestine communities of Christians had survived up to this date and they were able to hide some cult images. This story is now well known thanks to Martin Scorsese's 2016 movie *Silence*, and is currently the subject of research by Yoshie Kojima at Waseda University in Tokyo. Among the images of worship of *Kirishitan*, or Japanese Christians, were bronze plaques of European origin.[48] These

were systematically destroyed, but sometimes they were copied for the sole purpose of forcing those suspected of being Christians to trample on them. The materiality of the divine could hardly be expressed more eloquently than by such a process whereby holy images were copied only in order to ensure their desecration, while keeping the copies in court files (where they were eventually found).

This quick overview of a few cases of iconography, aniconism and iconoclasm is of course quite incomplete, but raises many questions. Let me conclude by putting on the table just one among the many: should we, in our own time, suppose that the ineffable *quid* we may call 'divine' is perhaps more present, or acts more deeply, the more its materiality undergoes a process of subtraction? Some trends of contemporary art apparently point in that direction. For instance, Urs Fischer's *The Invisible Mother* (2015) reduces to bones Michelangelo's *Pietà* (1498–9) by abolishing the Virgin and transforming Jesus' body into a skeleton. Similarly, Giuseppe Modica's *Crucifixion of Light* (2016), created for the small Sicilian city of Gibellina after its destruction by an earthquake, is reduced to the shadow of the crosses, something Byzantine iconoclasts might have liked. In the same vein, Spanish photographer Josè Manuel Ballester reworked a crucifix by van Dyck (1627) by ripping Christ's body from the Cross (2017). Subtraction of the body of Christ from the Cross and its reduction to purely geometrical form also affects church architecture, as in the Church of Light in Ibaraki near Osaka, built in 1989 by Tadao Ando for the United Church of Christ in Japan, or in the dramatic east window of St Martin-in-the-Fields, London, by Shirazeh Houshiary and Pip Horne (2013). To what extent might these trends be influenced by the intercultural relationships of our time and the iconographies they generate? This is what *The Burning Bush* by the Indian artist Paul Koli, where footprints and other markers point to Buddhist iconography, apparently suggests. Whether the current developments will result in triggering a greater presence of a more spiritualised divine, or rather in encouraging the need for a somewhat renewed materiality of the divine, is not for me to tell.

Notes

1 I am indebted to Jaś Elsner, Amos Bertolacci, Pia Brancaccio, Lucia Franchi, Yoshie Kojima and Rachel Wood for sharing thoughts and information on the topics addressed in this chapter.

2 'Ma io non voglio … altro che uno bono pittore, che figuri 'l furore d'una battaglia, et ch'el poeta ne scrivi un'altra, e che sieno messi in pubblico de compagnia. Vedrai dove più si fermeranno li veditori, dove più considereranno, dove si darà più laude, et quale sattisfarà meglio. Certo la pittura, di gran longa più uttile et bella, più piacerà. Poni in scritto il nome d'Iddio in un locho, et ponvi la sua figura a riscontro, vedrai quale fia più reverita.' Leonardo da Vinci 1492, translated in Farago 1992: 210–11 (Italian text and English translation).

3 Boespflug 2008.

4 Elsner and Lenk 2017: 18.

5 On 'interpretive communities', see Fish 1980.

6 Elsner 2017: 80.

7 Gregory the Great 11.13.

8 Elsner 2012: 368.

9 Elsner 2012: 368, 386, 373.

10 Huntington 1992; Rhi 1994: 220–1; DeCaroli 2015.

11 Elsner 2012: 380, 382, 385–6.

12 Vernant 1986.

13 Gell 1998: especially 66–8.

14 Aquinas, *Summa theologica* 1, q.1, a.10, ad.3.

15 Carlini 1964.

16 Pongratz-Leisten and Sonik 2015.

17 Augustine, *De ordine*, 2.16.44.

18 Gaifman 2012.

19 Gell 1992.

20 Eck 2015.

21 Gumbrecht 2004.

22 Elsner 2012: 374–6, drawing on a rich literature including Grabar 1957: 67–74; Breckenridge 1959: 66–77; Cormack 1985: 96–106; Jamil 1999: 45–55; Raby 1999: 119–24, 147–8, 182; Elsner 2003; Treadwell 2005: 17, 19–21; Hoyland 2007: 593–6; and see Foletti and Meinecke, this volume.

23 Elsner 2012: 374.

24 Elsner 2012: 376.

25 Beschi 1972: 326–33.

26 Gaifman 2012: 240. See also Ferri 1929.

27 Gaifman 2012, 241.

28 Tacitus, *Hist.* 5.9. Vollmer 2014: 27.

29 Also Sahih al Bukhari, *ḥadīth* 93:514: 'There was Allah and nothing else before Him, and His Throne was upon the water, and He then created the Heavens and the Earth.' See also O'Shaughnessy 1973; Ess 2019: 455–9.

30 Vollmer 2014; 241–8, 466–87

31 Vollmer 2014: 225.

32 Castiglione 1970; Chiarini 2018.

33 Aeschylus, *Choephori*, 205–9; Sassi 2001: 64–6.

34 Peirce, as quoted by Sassi 2001: 64–6.

35 Latour-Weibel 2002.

36 Bosworth 2012; Morgan 2012.

37 Flood 2002: 646.

38 Drawing by Otto J. Seibold, *New Yorker*, 15 July 2002, 59 (accompanied by text by Calvin Tomkins, 'After the Towers. Nine artists imagine a memorial').

39 Boulhol 2000; Brunet 2011: 126–40; Noble 2012: 287–364; Fricke 2015: 11–12.

40 Freedberg 1977: 165–77; Freedberg 1989: 378–428; Dupeux, Jezler and Wirth 2000; Boldrick and Barber 2013.

41 Dowsing 1885; Cooper 2001; Simpson 2010.

42 Goethe 1819: 178, 189–90; Tafazoli 2012: 40–3.

43 Stern and Berger 2015; Harmanşah 2015; Flood 2016: 117.

44 Faleiro 2005; see also Clemente 1968; Di Dario 2006.

45 Most 2017.

46 Elsner 2012: 370.

47 Flood 2002.

48 Kaufmann 2010; Kojima forthcoming.

Bibliography

Beschi, L. 1972. 'Divinità funerarie Cirenaiche', *Annuario della Scuola Italiana di Atene e delle Missioni Italiane in Oriente* 47–8, 133–341.

Boespflug, F. 2008. *Dieu et ses images. Une histoire de l'éternel dans l'art*, Montrouge.

Boldrick, S. and Barber, T. (eds) 2013. *Art under Attack: Histories of British Iconoclasm*, London.

Bosworth, C.E. 2012. 'Maḥmud b. Sebüktegin', *Encyclopaedia Iranica*, http://www.iranicaonline.org/articles/mahmud-b-sebuktegin (accessed 24 April 2020).

Boulhol, P. 2000. *Claude de Turin. Un évêque iconoclaste dans l'occident medieval*, Paris.

Breckenridge, J. 1959. *The Numismatic Iconography of Justinian II*, New York.

Brunet, E. 2011. 'Inimicus et persecutor Crucis Christi: Claudio vescovo di Torino', *Teologia Politica* 4, 126–40.

Carlini, A. 1964. 'Sulla composizione della Tabula di Cebete', *Studi Classici e Orientali* XII, 164–82.

Castiglione, L. 1970. 'Vestigia', *Acta Antiquitatum Academiae Scientiarum Hungaricae* 22, 95–132.

Chiarini, S. 2018. 'The foot as gnórisma', in J. Draycott and E.-J. Graham (eds), *Bodies of Evidence: Ancient Anatomical Votives Past, Present, and Future*, London, 146–64.

Clemente, G. 1968. *La Notitia dignitatum*, Cagliari.

Cooper, T. (ed.) 2001. *The Journal of William Dowsing: Iconoclasm in East Anglia During the English Civil War*, Woodbridge.

Cormack, R. 1985. *Writing in Gold: Byzantine Society and Its Icons*, London.

DeCaroli, R. 2015. *Image Problems: The Origin and Development of the Buddha's Image in Early South Asia*, Seattle.

Di Dario, B.-M. 2006. *La 'Notitia dignitatum'. Immagini e simboli del tardo impero romano*, Padua.

Dowsing, W. 1885. *The Journal of William Dowsing of Stratford, Parliamentary Visitor, Appointed under a Warrant from the Earl of Manchester, for Demolishing the Superstitious Pictures and Ornaments of Churches*, Ipswich.

Dupeux, C., Jezler, P. and Wirth, J. (eds) 2000. *Bildersturm. Wahnsinn oder Gottes Wille?*, Munich.

Eck, C. van 2015. *Art, Agency and Living Presence: From the Animated Image to the Excessive Object*, Boston.

Elsner, J. 2003. 'Iconoclasm and the preservation of memory', in R. Nelson and M. Olin (eds), *Monument and Memory, Made and Unmade*, Chicago, 209–31.

— 2012. 'Iconoclasm as discourse: from antiquity to Byzantium', *Art Bulletin* 94, 368–94.

— 2017. 'Word as image', in J. Elsner, S. Lenk *et al.* 2017: 80–3.

Elsner, J. and Lenk, S. 'Introduction', in Elsner, Lenk *et al.* 2017: 13–29.

Elsner, J., Lenk, S. *et al.* 2017. *Imagining the Divine: Art and the Rise of World Religions*, Oxford.

Ess, J. van 2019. 'The image of God', in J. van Ess (ed.), *Theology and Society in the Second and Third Centuries of the Hijra: A History of Religious Thought in Early Islam*, Leiden, 403–534.

Faleiro, N. 2005. *La Notitia dignitatum. Nueva edición crítica y comentario histórico.* Madrid.

Farago, C.J. 1992. *Leonardo da Vinci's 'Paragone': A Critical Interpretation with a New Edition of the Text in the Codex urbinas*, Leiden.

Ferri, S. 1929. *Divinità ignote. Nuovi documenti di arte e di culto funerario nelle colonie greche*, Florence.

Fish, S. 1980. *Is There a Text in This Class? The Authority of Interpretive Communities*, Cambridge, MA.

Flood, F.B. 2002. 'Between cult and culture: Bamiyan, Islamic iconoclasm, and the museum', *Art Bulletin* 84, 641–59.

— 2016. 'Idol-breaking as image-making in the "Islamic State"', *Religion and Society: Advances in Research* 7, 116–38.

Freedberg, D. 1977. 'The structure of Byzantine and European iconoclasm', in A. Bryer and J. Herrin (eds), *Iconoclasm*, Birmingham, 165–77.

— 1989. *The Power of Images: Studies in the History and Theory of Response*, Chicago.

Fricke, B. 2015. *Fallen Idols, Risen Saints: Sainte Foi of Conques and the Revival of Monumental Sculpture in Medieval Art*, Turnhout.

Gaifman, M. 2012. *Aniconism in Greek Antiquity*, Oxford.

Gell, A. 1992. 'The technology of enchantment and the enchantment of technology', in J. Coote and A. Shelton (eds), *Anthropology, Art and Aesthetics*, Oxford, 40–67.

— 1998. *Art and Agency: An Anthropological Theory*, Oxford.

Goethe, J.W. 1819. *Poetische Werke*, Berlin.

Grabar, A. 1957. *L'Iconoclasme byzantin. Dossier archéologique*, Paris.

Gumbrecht, H.U. 2004. *The Production of Presence: What Meaning Cannot Convey*, Stanford.

Harmanşah, Ö. 2015. 'ISIS, heritage, and the spectacles of destruction in the global media', *Near Eastern Archaeology* 78, 170–7.

Hoyland, R. 2007. 'Writing the biography of the Prophet Muhammad', *History Compass* 5, 581–607.

Huntington, S.L. 1992. 'Aniconism and the multivalence of emblems: another look', *Ars Orientalis* 22, 111–56.

Jamil, N. 1999. 'Caliph and Qutb: poetry as a source for interpreting the transformation of the Byzantine Cross on steps on Umayyad coinage', in Johns 1999: 11–58.

Johns, J. (ed.) 1999. *Bayt al-Maqdis: Jerusalem and Early Islam*, Oxford Studies in Islamic Art 9.2, Oxford.

Kaufmann, T.D.C. 2010. 'Interpreting cultural transfer and the consequences of markets and exchange: reconsidering Fumi-e', in M. North (ed.), *Artistic and Cultural Exchanges Between Europe and Asia*, Farnham, 135–62.

Kojima, Y. forthcoming (2020). 'Fumi-e: trampled sacred images in Japan', in C. Franceschini (ed.), *Sacred Images and Normativity: Contested Forms in Early Modern Art*, Turnhout, 30–45.

Latour, B. and Weibel, P. 2002. *Iconoclash: Beyond the Image Wars in Science, Religion, and Art*, Karlsruhe.

Lessing, G.E. 1766. *Laokoon; oder, Über die Grenzen der Mahlerey und Poesie. Mit beyläufigen Erläuterungen verschiedener Punkte der alten Kunstgeschichte*, Berlin.

Morgan, L. 2012. *The Buddhas of Bamiyan*, Cambridge, MA.

Most, G.W. 2017. 'Effacement', in B. Holmes and K. Marta (eds), *Liquid Antiquity*, Geneva, 242-5.

Noble, T. 2012. *Images, Iconoclasm, and the Carolingians*, Philadelphia.

O'Shaughnessy, T.J. 1973. 'God's throne and the biblical symbolism of the Qur'ān', *Numen* 20, 202–21.

Pongratz-Leisten, B. and Sonik, K. (eds) 2015. *The Materiality of Divine Agency*, Berlin.

Raby, J. 1999. '*In vitro veritas*: glass pilgrim vessels from seventh-century Jerusalem', in Johns 1999: 111–90.

Rhi, J-H. 1994. 'From Bodhisattva to Buddha: the beginning of iconic representation in Buddhist art', *Artibus Asiae* 54.

Sassi, M.M. 2001. *The Science of Man in Ancient Greece*, Chicago.

Simpson, J. 2010. *Under the Hammer: Iconoclasm in the Anglo-American Tradition*, Oxford.

Stern, J., and Berger, J.M. 2015. *ISIS: The State of Terror*, New York.

Tafazoli, H. 2012. 'Goethe', *Encyclopaedia Iranica*, http://www.iranicaonline.org/articles/goethe (accessed 24 April 2020).

Treadwell, L. 2005. '"Mihrab and 'anaza" or "sacrum and spear"? A reconsideration of an early Marwanid silver drachm', *Muqarnas* 22, 1–28.

Vernant, J.P. 1986. 'Corps obscur, corps éclatant', in C. Malamoud and J.P. Vernant (eds), *Corps des dieux*, Paris, 19–45.

Vollmer, C. 2014. *Im Anfang war der Thron. Studien zum leeren Thron in der griechischen, römischen und frühchristlichen Ikonographie*, Rahden.

Response to S. Settis, 'The Materiality of the Divine: Aniconism, Iconoclasm, Iconography'

Maria Lidova

Salvatore Settis' contribution dwells upon a very wide and topical group of problems connected to the making of religious images and the significance of divine representation. At the core of the discussion lies analysis of the seeming dichotomy between representation of the sacred through the visualisation of the divine word or through images that adhere to the human form and embody the figure of a divinity. This set of questions is closely connected to the phenomena of aniconism and iconoclasm, as well as to the theme that was central at the initiation of the *Empires of Faith* project: how struggles for religious supremacy were realised with the help of art and material culture in late antiquity.[1]

The 'tension between word and image' raised in Settis' paper can be interpreted in different ways. It refers to conflict between sacred scriptures transmitting religious tradition and the rendering of the divine in material form, two aspects of religious experience that are constantly brought into relation to each other. At the same time, it pertains to the image of God that can either be represented in figurative form and given a recognisable likeness, or be perceived through letter signs and visualisation of text as the only or most authoritative form of divine revelation.[2] Debates surrounding 'words versus images' and the intellectual framework related to them have resulted in a number of conflicts throughout history and were in many ways responsible for shaping religious figurative language.

Leonardo da Vinci's writings on the supremacy of the image of God in relation to His written name, which open Settis' discussion, can find a counterpart in the sermon of the Byzantine Patriarch Photios (858–67/877–86) delivered on 29 March 867. Celebrating the end of the 150-year-long period of iconoclasm, when icons could not be made and many old ones were destroyed, and the creation of a new monumental image of the Mother of God in the apse of Hagia Sophia, Photios notes: 'The stories of martyrs are contained in books, but paintings offer a much more vivid record. … those who see the pictures are more likely to imitate the martyrs than those to whom the stories are simply read.'[3] The shared view of the great High Renaissance painter and intellectual and the 9th-century hierarch of the Byzantine Church underlines the importance that art has played in shaping perceptions of the sacred over the centuries. Furthermore, it once again confirms that the role of art was never restricted to mere illustrative function of an existing text. The image often went beyond the text, and certain representations had the potential to shape the ideas and *modus vivendi* of worshippers.

Byzantine iconoclasm provides an example of one of the most influential models of art censuring because it ignited an immense theological reaction sustaining two opposing viewpoints that, in a way, resulted in a complex theory of image.[4] The theoretical dimension is an important aspect since iconoclasm can be intellectual and actual in nature, becoming a phenomenon of religious ideology and substantiation and resulting in the physical destruction or modification of art. The two aspects can be connected or they can exist independently: the first as an example of a rational framework for the 'appropriate' forms of divine representation, the second as an act of vandalism or performed, almost sacralised, ritual of destruction.

Settis enriches the discussion of iconoclasm by dwelling upon the idea of emphasised absence, used as an artistic approach to enable visualisation of the divine while keeping gods invisible and thus respecting existing prohibitions or ideas surrounding the non-representability of the divine. Indeed, across different religious traditions the motif of an empty throne or footprints became a convincing rendering of perpetual or imminent sacred presence, triggering the viewer's emotional response and longing for divine revelation. The permeability of these visual patterns and similar approaches applied to comparable tasks demonstrate the profound links between cultures that tend to be studied separately and continue to be viewed as completely distinct from, and even in opposition to, each other. Another guiding thread in Settis' paper is a reflection on the importance of face and defacement in certain instances. The faceless heads of the Cyrene goddesses are brought into a relationship with the *damnatio memoriae* and the destruction of facial features in order to deprive the represented figure of his or her identity. This approach is somewhat similar to the phenomenon of visually highlighted absence: the object or a material image is present, while the divine likeness is missing. Indeed, the problem of divine representation goes beyond anthropomorphism, engaging in a more concrete problem of the face.

The face-to-face meeting designates the nature of the encounter between beholder and superior being in many religious traditions. The crucial significance of meeting a gaze in icons contributes to the experience of mystic dialogue and prayer. Besides the mirroring effect of this interaction, human likeness is given a greater significance because it grants hope of the potential transformation of the earthly and physical into the immaterial and supernatural. Therefore, it can be argued that anthropomorphism and the recognisable semblance of a face were directly linked to the idea of divinisation, which was another important aspect of material perception and image formation. Angels started to be represented in Byzantine art very early on, a practice heavily criticised by some early theologians and later on by iconoclasts.[5] By being represented, angels, who are spiritual beings, become material. In reverse logic, this could mean that images can be transformed and become something more than their material form and essence presuppose. Similarly, and even consequently, humans can aspire to become divine or semi-divine, a phenomenon which in Christian culture received the definition of *theosis*, and in Buddhism, the state of enlightenment.

However, art was never expected to accomplish the mystery of transformation on its own. Ritual and various forms of religious performance were also essential elements.[6] The majority of religions are built around the idea of a sacrifice as the most important and effective mode of interaction with the divine world. In late Vedic times, when the contemporary religions of India were assuming their recognised shape, the sacred reality formed around the idea of 'divine absence' and the irrepresentability of gods. Slowly this situation changed to give space to statues and numerous representations of divine beings defining the interiors of Hindu, Jain and Buddhist temples. This process went hand in hand with a change in ritual and, most of all, in the nature of sacrifice.[7] Invisible gods whose materiality could not be

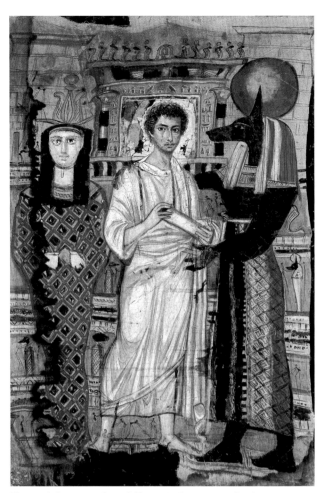

Plate 1.12 Funerary shroud, Egypt, 2nd century CE, h. 185cm, w. 125cm. The Pushkin State Museum of Fine Arts, Moscow, inv. 5749. Image © Pushkin State Museum

attested through physical manifestations were worshipped with burning sacrifices. Liquids and various substances were burned to produce foams ascending to gods. The materiality of the offering was destroyed in order to 'feed' the spiritual beings. Once images of gods started to appear in temples, the ritual of *pūjā* determined the use of fruits, garlands and material offerings placed in front of and physically present before the divine representation. The range of senses engaged in the process of apprehension of the divine changed as well, making vision and touch the vehicles of communication and therefore defining the new forms of worship.

While textual traditions have often been carefully edited over the centuries, contemporary objects reveal numerous examples of cross-religious contacts and visual interactions in antiquity. Just as a semblance of an Olympian god could be adopted for different purposes, a gem with an Islamic inscription could be used as the centre of an early medieval cross.[8] The features of Hercules can be used for Vajrapani standing beside the Buddha, while imitations of Christian icons may be produced in Japan with a mere scope of being refuted and destroyed, as highlighted by Settis. A series of fascinating examples of these phenomena from Egypt are indicative of the density of political and historical shifts experienced by the lands along the Nile from antiquity to the early Islamic period.[9] A 2nd-century CE Egyptian shroud once wrapped around the mummy of a man combines elements from three distinct visual traditions (**Pl. 1.12**). The

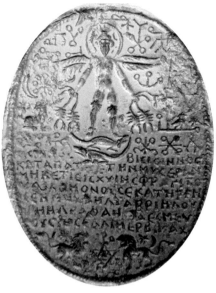

Plate 1.13 Amulet with (a) Christological cycle and (b) Horus, early 20th-century electrotype of a 6th-century original, bronze, h. 10cm. British Museum, London, 1938,1010.1

images of Osiris and Anubis clearly derive from the pantheon of ancient Egyptian gods; the rendering of the central figure is in line with Hellenistic ideals; while the portrait, made on a separate piece of textile and inserted in the pre-made composition, was inspired by Roman tastes for portraiture and the cult of ancestors. This combination of motifs and imagery demonstrates the polyvalency of the visual traditions and cultural richness surrounding inhabitants of Egyptian towns at the time, and is highly suggestive for our interpretations of many other urban centres.

Certain religious artefacts also demonstrate how beliefs could be combined and coexist creatively within one setting. A late antique amulet from Egypt brings together the Christological cycle and an image of the ancient Egyptian deity Horus standing on two crocodiles and holding snakes in his hands (**Pl. 1.13**).[10] Not fitting standard conventions, such objects are defined as gnostic or syncretic and seen as marginal to the main and dominant tradition. It can be argued, however, that they better indicate the complex contexts in which multiple religions coexisted and different forms of worship were performed in proximity to each other. They also help to explain the waves of political persecutions, and various takes on iconoclasm. Most importantly, attentive analysis of the visual tradition clearly demonstrates that all religions at different stages experienced aniconism and iconoclasm, as well as 'playing' with iconography, before elaborating the visual language that today is perceived as canonical for each faith. To study this moment of experimentation and elaboration taking place in the 1st millennium CE was the goal of the *Empires of Faith* project. The extant material has a lot to offer for future investigations to help us understand the paths of image-making and religious messages conveyed through art.

Notes

1 Elsner, Lenk *et al.* 2017: 128–33, 162–5.
2 Elsner, Lenk *et al.* 2017: 76–83.
3 Cormack 1985: 143–60, esp. 150.
4 Bryer and Herrin 1977; Cormack 1985: 95–140; Elsner 2012.
5 Peers 2001; Proverbio 2007.
6 Elsner 1998: 203–5.
7 Lidova 2010.
8 Elsner, Lenk *et al.* 2017: 31–3, 180, British Museum, 1075,1211.1.
9 Török 2005: 58–111.
10 Elsner and Lenk 2017: 46–9.

Bibliography

Bryer, A. and Herrin, J. (eds) 1977. *Iconoclasm*, Birmingham.
Cormack, R. 1985. *Writing in Gold: Byzantine Society and Its Icons*, London.
Elsner, J. 1998. *Imperial Rome and Christian Triumph: The Art of the Roman Empire AD 100–450*, Oxford.
— 2012. 'Iconoclasm as discourse: from antiquity to Byzantium', *Art Bulletin* 94, 368–94.
Elsner, J., Lenk, S. *et al.* 2017. *Imagining the Divine: Art and the Rise of World Religions*, Oxford.
Lidova, N. 2010. 'The changes in Indian ritualism: yajña versus pūjā', in H. Prabha Ray (ed.), *The Temple in South Asia*, New Delhi, 205–31.
Peers, G. 2001. *Subtle Bodies: Representing Angels in Byzantium*, Los Angeles.
Proverbio, C. 2007. *La figura dell'angelo nella civiltà paleocristiana*, Todi.
Török, L. 2005. *Transfigurations of Hellenism: Aspects of Late Antique Art in Egypt*, Leiden.

Chapter 2
Bodies, Bases and Borders: Framing the Divine in Greco-Roman Antiquity

Verity Platt

The brilliance of *Imagining the Divine*, the Ashmolean exhibition curated by the British Museum's *Empires of Faith* team, was that it juxtaposed artefacts related to the major world religions in ways that explored shared practices and concepts while simultaneously drawing attention to their distinctive theological, ritual and iconographic traditions.[1] In many cases, these cultural parallels can be traced to shared origins, including the religious and material cultures of classical antiquity. The religions of ancient Greece and Rome bear a complex relationship to those that superseded them. Patterns of influence are interlaced with those of counteraction and resistance; at the same time, antiquity itself can only be accessed through the scrim of its subsequent cultural and historiographical receptions, themselves laden with particular aesthetic and ideological investments. As a result, it is especially difficult to access 'emic' attitudes to Greco-Roman formulations of the divine.[2] In what follows, I open an avenue of interpretation that takes a rather oblique approach. Instead of focusing on the formal and iconographic means by which the 'pagan' gods were embodied for their viewer-worshippers, I examine some of the ways in which they were framed.[3] The relationship between instantiations of divine body and the elements that support, bound and adorn them (such as bases, borders and attributes) is difficult to unpack, especially when distorted by post-classical aesthetic hierarchies. Nevertheless, I shall argue that, by defamiliarising these phenomena and attempting to understand them on their own terms, we might shed valuable light on the theology of the sacred image in antiquity, while drawing attention to the visual operations of formal devices that are too easily dismissed as ancillary or supplemental.[4]

The striking opening to the *Imagining the Divine* exhibition presented visitors with five complex artefacts demonstrating the diverse visual strategies by which Judaism, Buddhism, Christianity, Islam and Hinduism shaped the religious experiences of their viewer-worshippers in the early modern period.[5] Together, the assemblage showed how phenomena deemed central to each faith – whether sacred texts, places or holy figures – are often framed by pictorial or textual elements which enhance, expand, explain, complicate, mediate or intercede.[6] To 'imagine the divine' in any of these traditions, these artefacts suggest, is to enter a system of multiple parts – a conversation between many voices, in which divinity might be accessed in multiple ways. It was thus quite remarkable to move from the formal, material and theological diversity of the exhibition's opening to its first main section, on the religions of ancient Rome.[7] Here was a dramatic shift from complex, polychrome, two-dimensional media to white marble sculpture in three dimensions or high relief and, more specifically, an encounter with divinity as naturalistically rendered, anthropomorphic body. Cast as avatars of the 'Dream Time of western civilization',[8] classical statues powerfully demonstrated how Greco-Roman tradition developed an elaborate system of iconographic differentiation by which deities might be defined, recognised and made present.[9] This system may have predated the ruptures of late antiquity, which were so critical to the development of the religious traditions explored in the *Empires of Faith* project, but it was

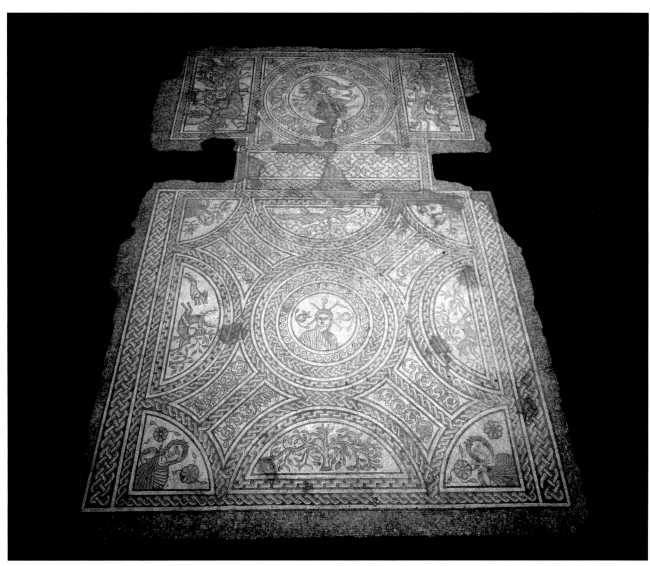

Plate 2.1 Floor mosaic, 4th century CE, Hinton St Mary, Dorset, l. 8.6m, w. 5.9m. British Museum, London, 1965,0409.1

nevertheless profoundly influential, for it both enabled a network of syncretistic parallels between deities associated with different cultures and provided a repertoire of iconographic building blocks for the religions that superseded it – most obviously, Christianity.[10]

The exhibition's emphasis in its 'Roman zone' on a metaphysics of presence aligned with the anthropomorphic body is not surprising. Within the western tradition, the naturalistic rendering of the human form is generally considered to be antiquity's greatest contribution to the visual arts: it has shaped both the discipline of art history and the museum collections on which such exhibitions draw.[11] It is also fundamental to any account of Greco-Roman religious art, which has traditionally placed great emphasis upon the roles played by anthropomorphic images of the gods as foci of cult practice.[12] In acting as epiphanic instantiations of divine presence, such objects were ascribed an agency that was fundamental both to the operations of ritual and to the Greco-Roman religious imagination more broadly.[13] They also offered a rich store of iconographic and symbolic motifs that circulated across media, contexts and periods. Indeed, as Jeremy Tanner has argued, the naturalistically rendered bodies of the Greek gods operated in both aesthetic and expressive terms, their subtle

evocations of age, gender and social role generating a strong sense of affective commitment and embodied identification in their mortal worshippers.[14]

Could it be, however, that our obsession with the classical body (provoked not least by the beguiling power of those marble bodies themselves) might sometimes obscure the panoply of other phenomena that shaped ancient imaginings of the divine? The aesthetic whitewashing of neoclassical statuary, for example, heads a long list of conceptual straitjackets that blind us to the complexities of ancient religious art.[15] Furthermore, how far is the emphasis of classical studies upon the cult statue as vehicle and focus of ancient religious experience actually the product of early Christian, and later Protestant, preoccupations with idolatry? That is, to what extent is our approach influenced by a scriptural and apologetic tradition rooted in a very different visual theology from that of Greco-Roman religion – one which actively sought to differentiate itself from antiquity?[16] How far is our focus on the bodies of the gods a product of the Christian incarnation, Renaissance naturalism or Enlightenment concerns with the priority of the 'work'? And how far do we import the aesthetic hierarchies we have inherited from this tradition into our classification of features such as divine 'attributes' – objects

which may symbolise or express divine power, but are deemed supplementary and ancillary to the corporeal forms that constitute the 'gods themselves'?[17]

Decentring the classical body

In recent years, classicists have greatly expanded our sense of the range of strategies by which divine presence could be instantiated in antiquity: from Milette Gaifman's work on Greek aniconism, to scholarship on hybrid or theriomorphic deities, we are well aware that the 'spectrum of iconicity' reached far beyond that of conventional anthropomorphism.[18] Yet we have been more reluctant, I would argue, to question the formal categories through which we parse the operations of the whole. In our efforts to ascribe agency to highly charged objects such as cult statues, we have tended to neglect the very real religious agency enacted by structural, decorative or symbolic elements – too quick, perhaps, to assign them to categories that are already loaded with aesthetic judgements we are slower to question. Those 'parergonal' features of ancient religious art – the 'frames', 'draperies' and 'colonnades' sidelined by Kantian tradition – are all too easily deemed supplementary or ornamental.[19] Despite their critical role within the material apparatus of Greco-Roman religion, their very ubiquity (and virtual invisibility) means that they are invested with limited sanctity or theological complexity.

Imagining the Divine showed how any notion of a specific deity is far less distinct than our focus on a standard anthropomorphic system might suggest – that the blurred edges between iconographic types and their associated traditions can be sites of the greatest innovation and richest cultural exchange. Yet what also came through very strongly was the vitality, longevity and transmediality of the more formal grammar that classical antiquity bequeathed to the great religions that superseded it – a grammar which, as Alois Riegl argued in the late 19th century, was itself developed out of prior Mediterranean and Near Eastern traditions.[20] Whether architectonic, compositional, ornamental or figural, that visual system may be considered subsidiary to cultic representations of divine body, but it was arguably just as influential (if not more so) on what followed.

To take just one example, ever since its discovery, the Hinton St Mary mosaic from late Roman Britain has been discussed primarily in terms of iconographic innovation: the possible representation of a young, beardless Christ within its central *emblema* and juxtaposition of an explicitly Christian image with 'pagan' myth, in the form of Bellerophon defeating the Chimaera (**Pl. 2.1**).[21] What is less often discussed (except in relation to local workshop styles) is the elaborate framework that makes the mosaic's iconographic juxtaposition possible.[22] The concentric system of geometric framing elements, dominated by an endlessly looping double and triple guilloche, draws on a formal vocabulary that is found across the Roman empire, one which is capable of infinite variation and elaboration (**Pl. 2.2**).[23] Its very familiarity makes the guilloche unworthy of comment, merely 'decorative'. And yet it is the isotropic nature of these geometric forms – their capacity to repeat indefinitely in any direction – that enables them to bring together figural 'content' from different religious and

Plate 2.2 Detail of Pl 2.1 showing double and triple guilloche borders

cultural traditions, ordering the viewer's experience of and behaviour within the room as a whole. This agency does not just rest in the open, semantically flexible nature of decorative motifs (capable of signifying diverse meanings for diverse audiences); crucially, it also resides in their formal operations.[24] Jonathan Hay observes that 'the non-rhetorical significance of ornament is that it always keeps open and available the movement of transfer and transit that leads designs to shed and acquire meaning, whether through formal mutation or through recontextualization': ornament, in this sense, embodies and enacts the idea of 'culture as flow, as movement, as exchange'.[25] The braided guilloche and encircling waves of the Hinton St Mary mosaic, by extension, bind together the whole while simultaneously indicating the possibility of its expansion in any direction: they enable, focus and reinforce its syncretistic message.

For scholars who work on Islamic or Celtic art (to take just two examples), such an observation must seem blindingly obvious. After all, the subtlety, complexity and agency of ornament is seldom in doubt for those traditions in which figural representation is absent, minimal or problematic, especially where this pertains to the divine. Indeed, one might argue that when the capacity of figural images to operate as a form of visual theology is rejected or constrained, the theological potential of ornament is correspondingly expanded – that it even becomes programmatic.[26] Recent attempts to open up the question of ornament in classical antiquity have radically reinterpreted the aesthetic range and value of the Greek *kosmos* or Latin *ornamentum* and have challenged traditional distinctions between 'ornament' and 'figure', with very exciting results.[27] Yet these discussions focus primarily upon style, aesthetics, social ideology and historiography; the realm of the sacred is conspicuously absent.[28] This is despite the fact that the 'minor' decorative friezes of Roman temples, altars and arches, for example, often display overtly sacred content in the form of religious personnel, ritual implements, sacrificial victims and the like (**Pl. 2.3**).[29] Far from being marginal,

Plate 2.3 Sacrificial frieze on the Ara Pacis Augustae, dedicated 9 BCE, marble, h. 1.57m. Museo dell'Ara Pacis, Rome. Image © HIP/Art Resource, New York

such elements worked hard to frame, guide and shape ritual performance, operating as a vital interface between architectural structure and viewing public, permanent edifice and cyclical event and, not least, human and divine.

In the study of Greco-Roman religious art more generally, the absence of scripture and the dominance of figural representation have arguably precluded the development of a more sophisticated discourse on 'parergonal' aspects of the visual, beyond attempts to decode the symbolic or allegorical significance of subsidiary iconography. There is no shortage of discussion of the identity and meaning of the four corner figures in the Hinton St Mary mosaic, for example – whether they are winds, seasons or Evangelists (**Pl. 2.1**).[30] In the *Imagining the Divine* exhibition, this dilemma was nicely demonstrated by the inclusion of a strigillated sarcophagus – a rare instance where scholars have worked harder than in other contexts to understand the range of visual strategies that might be attributed to abstract ornamental motifs that defy any straightforward form of allegorisation.[31] It is telling, however, that the example included was an overtly *Christian* sarcophagus, featuring Christ flanked by Peter and Paul (**Pl. 2.4**).[32] Whether strigillations are understood as pulsating divine energy, shimmering fabric or symbolic waves, a motif conventionally deemed 'ornamental' is far more readily assigned visual and theological complexity in a Christian context than a 'pagan' one. Indeed, in the case of non-Christian sarcophagi, scholars have even been reluctant to

ascribe any theological content to *figural* reliefs, never mind 'subordinate' decorative motifs such as strigillations.[33]

In the rest of this essay, I do not seek to suppress or elide the significance of the body for our understanding of Greco-Roman religious art. Rather, I explore what happens when we decentre the body (and, correspondingly, the anachronistic concept of the 'idol') when 'imagining the divine'. Not only do we find that 'parergonal' elements such as frames, ornament, drapery and attributes were fundamental to the presentification of divinity in antiquity, but also that bodies themselves were just one component of a modular system that was inherently multiple, flexible, improvisatory and infinitely expandable. In classical antiquity, representations of divine bodies did not operate as distinct focal entities, discrete from their environments (as their post-classical reception might imply): on the contrary, they were multifarious, often comprising multiple parts and playing diverse roles. Constructed by and in dialogue with a complex set of spatial, material, compositional and ritual frameworks, they took part in an active visual theology that may have lacked the doctrinal intricacies of scripture, but was no less sophisticated in its attempts to convey the nature of the ineffable.

Magnificentia in parvis: reframing the Athena Parthenos

Let us look more closely at a sacred image which, though lost to us since late antiquity, was the object of much aesthetic and theological reflection in antiquity itself: the chryselephantine statue of Athena Parthenos, designed by Pheidias and displayed in the Parthenon on the Athenian Acropolis from 438 BCE and known through various reproductions in other media (**Pls 2.5–2.6**).[34] In his discussion of marble sculpture in Book 36 of the *Natural History* (on stones), Pliny the Elder pays special attention to Pheidias as 'the most famous sculptor among all peoples who appreciate the fame of his Olympian Jupiter' (36.18). Yet in order to demonstrate Pheidias' brilliance, Pliny states that he 'shall not appeal to the beauty of his Olympian Jupiter or to the size of his Minerva at Athens'; instead, he shall proffer *argumenta parva et ingenii tantum* – 'small pieces of evidence, sufficient to demonstrate his talent'.[35] In a typical example of rhetorical *praeteritio*, Pliny passes over the beauty (*pulchritudo*) and size (*amplitudo*) of the Pheidian statues – that is, those elements of them that best embody the *kallos kai megethos*, the

Plate 2.4 Strigillated sarcophagus depicting Christ flanked by Peter and Paul, 4th century CE, marble, h. 55cm. Ashmolean Museum, Oxford, AN2007.47.a–b. Image ©Ashmolean Museum, University of Oxford

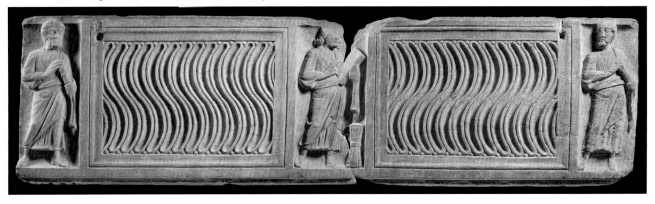

Plate 2.5 Lenormant Statuette, a Roman copy of Pheidias' Athena Parthenos, 1st century CE, marble, h. 42cm. National Archaeological Museum, Athens, 128. Image © Vanni Archive/Art Resource, New York

Plate 2.6 Varvakeion Athena, a Roman copy of Pheidias' Athena Parthenos, 2nd century CE, marble, h. 94cm. National Archaeological Museum, Athens, 129. Image © HIP/Art Resource, New York

'beauty and great stature' of the deities who appear to mortals in Homeric scenes of epiphany.[36] Instead, he states, he will focus on the Athena's attributes, clothing and statue base:

> Rather, I shall mention her shield, on the convex side of which he engraved a Battle of the Amazons, and on the hollow side Combats of Gods and Giants; and her sandals, on which he depicted Combats of Lapiths and Centaurs. So truly did every detail lend itself to his art. On the pedestal there is carved what is entitled in Greek the Birth of Pandora, with twenty gods assisting at the birth. Although the figure of Victory is especially remarkable, experts admire also the snake, as well as the bronze sphinx that crouches just beneath her spear. These are things which should be stated in passing with regard to an artist who has never been praised enough. At the same time, they make us realise that the grandeur of his notions was maintained even in small matters.[37]

The mythological scenes depicted across Athena's shield, the soles of her sandals and the pedestal beneath her feet; the winged Victory that rests on her right palm; the snake coiled between the shield and her left leg; and the sphinx beneath her spear (a detail so minor that no other source seems to mention it): *haec sint obiter dicta* ('these are things to be spoken

of in passing' or 'incidentally'). For Pliny, however, they demonstrate that there is a *magnificentia in parvis*, a 'magnificence in small things'. The awe-inspiring effect of Pheidias' statue – its power to make Athena 'present' for her viewers – did not just reside in its overall impact, but could operate metonymically through the concept of *pars pro toto*, whereby 'every part' (*momenta omnia*) was demonstrative of his skill (*capacia artis illi*).[38] The term Pliny uses here, *capax*, is difficult to translate effectively in the context, but conveys the idea of roominess, or containment: it suggests a sort of fractal logic, whereby each small component of the statue's assemblage has the 'capacity' to contain the whole.[39]

Pliny's observations here are generally read in relation to his narrative of artistic *inventio* – the sequence of 'first discoverers' who advanced the art of antiquity towards its naturalistic climax.[40] Yet the notion of *magnificentia in parvis*, or 'grandeur in small things', operates throughout the *Natural History*, as evidence of the supreme skill of Nature herself. We might read it as a commentary on the nature of *technê*: as the most talented *agalmatopoios* ('cult statue-maker') of classical antiquity, Pheidias' skill was made equally manifest in the smallest of details, just as, for Pliny, Nature's artistry can be experienced in the tiniest of her creations,

whether ugly insects or precious gems.[41] But beyond his own (largely Stoic) ideological investments, Pliny is also engaging with a broader discourse here about the nature of cult statues, and those of Pheidias in particular. The impossibility of apprehending the entire statue, save in the elucidation of its parts, is satirised as early as the 3rd century BCE. In Callimachus' iambic poem on Pheidias' Olympian statue of Zeus, the speaker resorts to listing the relative height of Zeus's throne and accompanying figures of Nike, the Seasons and Graces, rather than attempting to convey the epiphanic spectacle of the whole.[42]

Writing his *Description of Greece* some 100 years after Pliny, Pausanias attempts to describe the Athena Parthenos in his account of the Athenian Acropolis and likewise focuses on seemingly minor details – in his case, on Athena's helmet: 'The statue itself is made of ivory and gold. On the middle of her helmet is placed a likeness of the Sphinx – the tale of the Sphinx I will give when I come to my description of Boeotia – and on either side of the helmet are griffins in relief.'[43] After a detour into the mythical location of griffins, Pausanias gives us the briefest account of the statue: 'The statue of Athena is upright (*orthon*),' he claims, 'with a tunic reaching to the feet, and on her breast the head of Medusa is worked in ivory.'[44] He then zones in, like Pliny, on the Victory, shield, snake and base:

> She holds a statue of Victory about four cubits high, and in the other hand a spear; at her feet lies a shield and near the spear is a serpent. This serpent would be Erichthonius. On the pedestal is the birth of Pandora in relief. Hesiod and others have sung how this Pandora was the first woman; before Pandora was born there was as yet no womankind.[45]

In Pausanias' account, the statue is effectively conveyed to the viewer by means of its framing elements, 'parergonal' details that constitute the goddess's customary attributes. These include her set of armour, including the aegis on her chest, her Athenian progeny (in the theriomorphic form of the autochthonous snake, Erichthonius) and the myth on her pedestal – a narrative so complex and controversial that scholars are still wrestling to determine its relevance to the Parthenon.[46]

Our two most detailed *ekphraseis* of one of antiquity's most famous sacred images, then, provide minimal details about Athena herself, but instead focus on her attributes. Why should this be? First, we might observe that iconographic motifs translate most easily to verbal discourse, especially those that lend themselves to narrative. Amazonomachies, gigantomachies, centauromachies and tales of mythical births (such as those of Pandora and Erichthonius) invite allegorical and aetiological interpretation; hybrid, monstrous and apotropaic figures such as gorgons, sphinxes, griffins and giant snakes offer symbolic motifs that wrap the goddess about with power and meaning. As framing elements, they situate the Parthenos within the network of myth and ideology (usually understood in political terms) that plays out across the Parthenon, and the Acropolis, as a whole. This is a mode of interpretation that is all too familiar to us: it is discursive, exegetic, hermeneutic, didactic – hence the river of rationalising scholarship that has been poured over the iconographic 'programme' of the Periclean project.[47] Yet Pliny's pointed comment about *magnificentia in parvis* and Pausanias' seemingly wilful focus on helmet and base rather than body also alert us to an alternative descriptive strategy – one that leaves an overt absence right where the goddess herself should be.

What is going on here? One obvious notion we might look to (often associated with the works of Pheidias in particular) is that of the 'sublime', which for pseudo-Longinus is described by James Porter as 'in essence an aesthetic detail that has been lifted to the level of a high-order aesthetic experience'.[48] Such is the beauty and majesty, the epiphanic *thauma* (or 'wonder') generated by the colossal statue, that it is impossible to take in the Parthenos as a whole.[49] Instead, one can only apprehend her obliquely or in parts – notably, those most visible from the ground and thus accessible to the viewer, like her shield, sandals and base, or those that define her apex, like the figures on her helmet. We might note here alternative etymologies of the Latin *sublimis*, which suggests that which is apprehensible 'up to the threshold' (*sub-limen*) or 'up to the limit'/'very high' (*sub-limes*), just as its Greek equivalent, *hypsos*, suggests a 'height' or 'pinnacle'.[50]

It is possible to interpret Pliny's discussion of the Parthenos in terms of an *aesthetic* sublime that is (in Porter's phrase) 'intensely localized' in its appreciation of the artist's extraordinary genius.[51] Yet this would risk limiting the broader discourse at work within the Pheidian tradition (and, presumably, Pliny's sources), as well as its reception in Greek literature of the Imperial period, which must also be understood as *theological*.[52] As Porter observes, the Greek gods lie at the origins of the ancient immaterial sublime, for 'the gods in Homer, like all subsequent representations of divinity, point to something greater than themselves, and they do so both in their incompleteness in the imagination and in the essential inconsistency of their representations'.[53] Pheidias' Athena Parthenos, by extension, conveys the immaterial sublimity of the goddess herself through an elaborate set of attributes and framing devices which, in their brilliant craftsmanship and engrossing detail, continually draw our attention away from Athena's figural form. They thereby generate a sense that Athena *qua* deity defies both conception and representation. The effect is equivalent, one might argue, to that observed by Strabo at Olympia, where Pheidias' statue of Zeus seemed so squeezed into the space of the cella that 'if he arose and stood erect he would unroof the temple'.[54] In both cases, we see games of scale: either the whole surpasses the boundaries of its frame or its finely crafted subsidiary components have the capacity to fill the viewer's vision, so producing the awe-inspiring effect of the whole *in parvis*.

To interpret Pliny's *argumenta parva* in this way, however, is to shift the debate's focus back to the phenomenon which both he and Pausanias strategically pass over: Athena's body. Ornament and attribute, according to this interpretation, partake in a theology of the sublime, but only by virtue of their very 'parergonal' nature. Yet what if we follow Pliny's lead and pay closer attention to the statue's *obiter dicta* in their own right – to those components usually 'mentioned in passing'? Turning to replications (and, inevitably, miniaturisations) of the Parthenos in other media, we might note the degree of attention that is repeatedly given to the statue's component parts. For the

Plate 2.7 The Strangford Shield, Roman marble copy of the shield of Pheidias' Athena Parthenos depicting an Amazonomachy, *c*. 3rd century CE. British Museum, London, 1864,0220.18

Victory figure on Athena's hand, the shield, helmet and spear, the snake and the statue's base (whether with or without its figural scene) are what in fact make it recognisable. This is true both of visual citations of the statue dated to the 5th and early 4th centuries BCE found on vases, document reliefs and clay tokens, and of three-dimensional replications dated to the 1st and 2nd century CE, such as the famous Varvakeion and Lenormant statuettes (**Pls 2.5–2.6**).[55] When examined in *visual* terms, these *obiter dicta* are, in fact, what construct the figure as 'Athena Parthenos'. Indeed, in the case of the early 3rd-century CE Strangford Shield (a key piece of evidence for the Pheidian shield's Amazonomachy), they even attain an independence and visual authority of their own (**Pl. 2.7**).[56]

Divine body, according to this interpretation, operates as an assemblage of diverse parts. As in the Homeric poems, the divinity of Pheidias' statues is not experienced in terms of an unmediated perception of an integral godhead, but in a sensory encounter with the qualities, effects and surfaces of objects which provide an interface between the material and the metaphysical. In many cases, these are associated with the radiance, beauty and artfully constructed nature of the divine *parure*, a term which conveys the idea of a set of jewellery, garments, weapons or other attributes constituting the extended authority or puissance of a particular divinity.[57] These wondrous objects are where Porter's 'immaterial sublime' meets the phenomenal realm of material substance and mortal skill: they make divinity conceivable and apprehensible to humankind. It is no accident, we might observe, that the ultimate mediatory object in the *Iliad* – between gods and mortals, text and object, poem and world – is the shield of Achilles, crafted by Hephaestus; moreover,

the medium he employs (the chasing of 'genre scenes' upon precious metals) is at once the most esteemed of all ancient *ornamenta* and a technique that modern art history has all too readily assigned to that of the 'minor' arts.[58] In the case of the Athena Parthenos, this focus on the goddess' *parure* is particularly appropriate, especially for those objects experienced in relief, such as her aegis, shield and base. As Nicole Loraux so compellingly demonstrated, Athena is a goddess whose body must never be accessible, either to gods or to mortals.[59] Rather, she is encountered and made present to her worshippers as a series of surfaces and accoutrements. Even the chthonic origin of the snakey Erichthonius is a sign of the goddess's virgin impenetrability, born of Hephaestus' failed rape of Athena, when she wiped his semen onto the ground (*chthôn*) with a piece of wool (*erion*).[60] Just as Athena's aegis, her most powerful attribute, turns any negative force back upon the viewer who confronts it, so the fabric that garbs her acts as protective surface – a form of shield, or carapace, which can resist the force of the god of the forge himself.[61]

Here we come to one of the most difficult aspects of Greek cult statues, or, at least, one that is most at odds with post-Enlightenment aesthetic categories: for the components that are most 'parergonal' to the 'goddess herself' – the *obiter dicta* of Kantian tradition – often turn out to be those in which the revelatory force of divinity most powerfully resides. We might note, for example, how the 'ornament' of another famous garment on the Acropolis (that of the so-called 'Peplos Kore') enabled its identity as a goddess when it was recovered through analysis of surviving pigments: rather than a generic 'maiden', the kore was revealed as Artemis in her capacity as 'Mistress of Animals' (**Pl. 2.8**).[62] In such

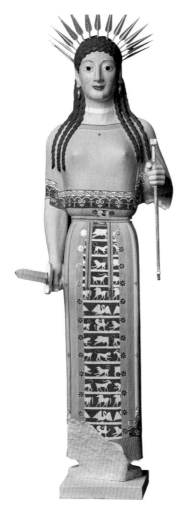

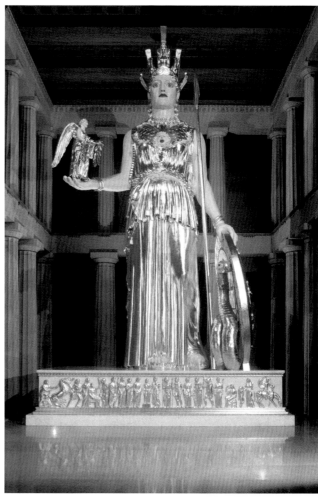

Plate 2.8 Experimental colour reconstruction of the so-called Peplos kore from the Athenian Acropolis as Artemis Tauropolos, Vinzenz Brinkmann and Ulrike Koch-Brinkmann 2019. Liebieghaus Skulpturensammlung, Frankfurt am Main, inv. St.P 687. Photo: Liebieghaus, Norbert Miguletz

Plate 2.9 Reconstruction of the Athena Parthenos with gilded drapery by Alan LeQuire, 2002. The Parthenon, Nashville, Tennessee. Image: Gary Layda

cases, colour, pattern and drapery – all those elements considered superfluous and supplemental to body and form – turn out to be the very phenomena that mark an image as divine. When it comes to the Athena Parthenos, scholars are perennially troubled by her gilded drapery (as emulated in the statue's reconstruction in Nashville, **Pl. 2.9**); her gold is repeatedly cast as mere *Schmuck* by religious historians reluctant to reconcile the value of her clothing with the idea that it was, quite literally, Athenian treasure, to be removed and melted down when the civic war chest required it.[63] The fungibility of Athena's gold is, in this sense, inseparable from its 'parergonality' – proof, even, of the fact that the Parthenos was not an official cult statue at all, the 'real' presence of the goddess residing in the olive-wood statue of Athena Polias, located in the Erechtheion.[64] In this reading, the Parthenos herself becomes 'parergonal', a merely decorative, glitzy addition to the authentically ancient cults of the Athenian Acropolis.

However, if we understand the Athena Parthenos as a sequence of frames and material surfaces that together create a visual encounter with divine body and construct the interiority of the statue as a locus of presence, we might venture the (rather heretical) claim that she is not, in fact, significantly different from the Athena Polias. For, despite

obvious contrasts in scale, both were effectively acrolithic statues made of multiple parts, constructed around a plain wooden core which supported (and was concealed by) additional attributes, or ornaments.[65] Indeed, Pausanias' comment that 'The statue of Athena is upright (*orthon*)' suggests the central, mast-like timber that structured the Parthenos' interior armature, the cutting for which can still be observed in the Parthenon's limestone foundations. Kenneth Lapatin draws our attention to an Athenian decree honouring the community of the Eteocarparthians for providing a temple of Athena with a massive cypress timber, cut from Apollo's sacred grove.[66] He goes so far as to suggest that this might refer not to the timber beams of the Parthenon's roof (as has been assumed) but to the internal armature of the Parthenos herself, which he compares to the keel or 'backbone' of a ship.[67] Both Polias and Parthenos, then, comprise a wooden core made of sacred wood – whether the olive of Athena (supposedly fallen from heaven) or the fragrant, durable cypress of Apollo (a gift, Lapatin suggests, 'from one Olympian to another').[68]

The olive-wood core of the Polias has traditionally been treated as the material instantiation of Athena herself, the aniconic or semi-iconic 'seat' of godhead, whereas the armature of the Parthenos has been cast as the statue's

grubby secret (inspired, in large part, by the much later comments of Lucian, who satirises the contrast between the magnificent exteriors of chryselephantine statues and their dusty, mice-ridden interiors).[69] Yet this contrast between inside and outside, or part and whole, is effectively true of all acrolithic cult statues – that is, all 'composite' forms, as well as hollow bronze figures, which were themselves often made of multiple, separately cast parts.[70] Rather than falling prey to simplistic hierarchies of sanctity, we might instead visualise both the Parthenos and the Polias in light of the Greek term *demas*, which means 'body' in its capacity as 'frame' – the muscular-skeletal 'framework' which supports the whole.[71] Understood as *demas*, the cult statue's wooden core does not act as a material presentification of 'divine body' itself, but rather constitutes the framework or armature that makes the entire project possible. Though structurally essential, it operates as one component in a complex system of parts, including those such as clothing which, though seemingly 'parergonal', construct an essential interface both between the inside and outside of the statue and between deity and worshipper.

In the case of the Athena Polias, these 'supplemental' features have generally escaped ornamental status because the statue itself (long since lost and rarely, it seems, reproduced in other media) is never analysed according to aesthetic categories.[72] Instead, the statue's *peplos*, woven by special cultic personnel and cyclically presented to the goddess at the Great Panathenaia, is treated as the Athenian ritual object *par excellence*, while its attributes and ornaments (its *parure*) are understood as a set of votive offerings, listed in the Acropolis inventories as the sacred property of Athena.[73] Yet dyed with saffron and rich purple, the *peplos* might also fall into Pliny's category of *obiter dicta*, for it was a supplemental object which depicted, like the interior of the Parthenos' shield, a scene of gigantomachy (in which Athena supposedly defeated the giant Enceladus).[74] Symbolic narratives like the gigantomachies might be understood as exegetic, there to explain and thereby enhance Athena's divine authority by casting it in terms of cosmic allegory. However, by means of their parergonal placing on drapery and armour, they also exert power and agency through their formal operations. Binding the surfaces of Athena's most holy images to the external facade of the Parthenon, itself adorned with a gigantomachy scene on the metopes at its east end, their repetitive, sequential motion across and around the divine 'content' that they frame is not unlike the guilloches of the Hinton St Mary mosaic. The flow of repeated forms across the media of fabric, gold, marble and paint weaves the entire complex together, while simultaneously indicating the possibility for its expansion: it enables, focuses and reinforces Athena's divine agency.

Weaving, of course, is the craft that Athena herself oversees as Athena *Erganê*, 'the worker'.[75] This emphasis on skill, or *technê*, is not only embodied in the sacred *peplos* presented to the Polias (woven by ritual *Ergastinai* and possibly depicted in the centre of the Parthenon's east frieze), but also the scene of Pandora upon the base of the Parthenos (another of Pliny's *obiter dicta*).[76] The action depicted here seems to have focused on the gods' *construction* of Pandora. If Pausanias was correct in identifying the influence of

Hesiod's version of the myth, we might note the latter's emphasis on the *daidala polla*, the 'many intricate works' that were crafted for Pandora, including a wonderful crown, wrought by Hephaestus with figures 'similar to living animals endowed with speech' (*zôoisin eoikota phônéessin*), as well as her finely worked garments and jewellery.[77] In Hesiod's narrative, it is Athena who both 'ornaments' Pandora (*kosmêse*), '[fitting] the whole ornamentation *(kosmon)* to her body', and teaches her *erga*, specifically 'intricate weaving' (*poludaidalon histon*).[78] As on the sacred *peplos* (which highlighted Athena's role in the gods' defeat of the giants), her prominence on the statue's base must have been crucial.

We have, then, a situation in which the *argumentum parvum* (to borrow Pliny's phrase) that frames and supports the Athena Parthenos depicts the very actions that inform its own construction – the facture of a divine *parure* which, in acting as an interface between body and viewer, embodies the puissance of the goddess herself. Whatever the more complex message of the Pandora myth (is her presence here a celebration or a warning?), it draws attention to the means by which divine craftsmanship can generate a series of external surfaces, devices and attributes that together construct the power and interiority of the figures they frame.[79] Understood according to the Greek language of *kosmos*, 'ornament' here is no mere supplement: rather, the skill and agency it embodies serves as a demonstration of the very divine forces it is summoned to adorn.[80] On the Athenian Acropolis, it is above all drapery (one of the most 'parergonal' of phenomena, according to Kant) which enacts and embodies the power of Athens' supreme deity: for textiles bind the goddess to the bodies of her worshippers and cultic personnel through the process of their facture and ritual presentation. Drapery does not just 'dress' the body of Athena, but literally constructs and makes her present. Athena's divine *parure*, in this sense, acts as a powerful encapsulation of ornament as *kosmos* – that which is both cosmic and cosmetic, a mode of beautiful adornment that is also constitutive of the deep structure of being, wrought with a supreme *technê* that aligns material phenomena with an abstract, even transcendent, logic.

Conclusion: disembodying Dionysus

One might argue that this essay has only managed to decentre and reframe the classical body through a crafty choice of case study, focusing on an assemblage that is acrolithic (rather than marble), a virgin goddess whose body is by definition inaccessible, and a statue that is conveniently lost to history. What happens, then, if we turn from the Athena Parthenos back to the white marble statuary so familiar to the classical tradition and, specifically, to its most compelling exemplar in the *Imagining the Divine* exhibition (**Pl. 2.10**)? Dated to the 2nd century CE (and based upon a 3rd-century BCE statuary type), the British Museum's Dionysus is a rare example of a surviving cult statue, discovered alongside a limestone panther in the Temple of Dionysus at Cyrene, where it was most likely displayed upon a two-foot-high pedestal situated at the western end of the cella.[81] As such, the statue should be understood in relation to the restoration of Cyrene's civic structures and temples under Hadrian following the Jewish Revolt of 115–16, a

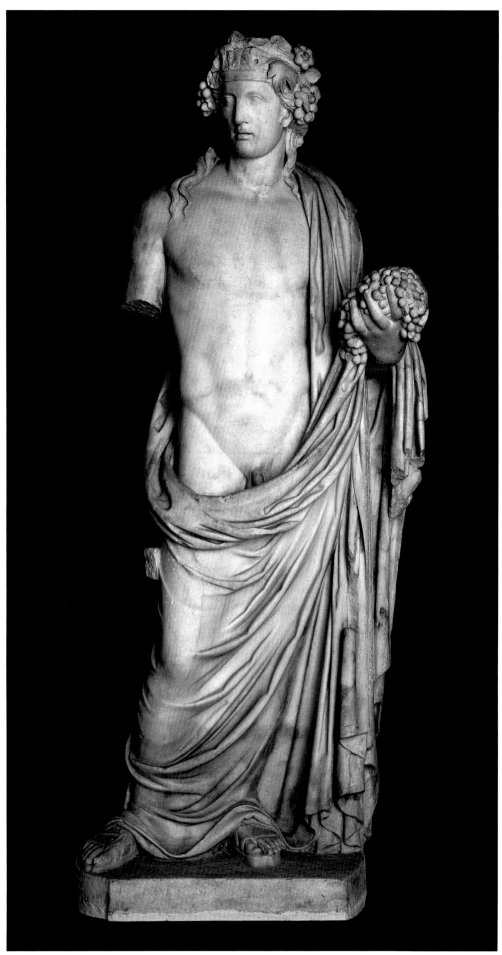

Plate 2.10 Statue of Dionysus, Cyrene, 2nd century CE. British Museum, London, 1861,0725.2

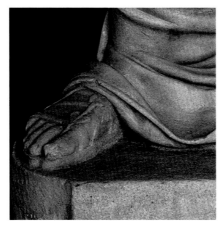

Plate 2.11a–c Details of Plate 2.10, showing Dionysus' hand grasping a bunch of grapes, his ivy-leaf sandals and headdress of vines

reassertion of Greco-Roman identity that was strikingly demonstrated by the city's inclusion in the Hadrianic Panhellenion.[82] It is fitting that, in capturing Dionysus' reputation as a deity of supreme sensuality, the statue's sinuous torso emulates all that is most delectable about the late classical Greek nude, the apogee of Winckelmann's 'beautiful' style.[83] Surely the notion of anthropomorphic body must be central to any reading of this smoothly sculpted form, its marble curves and sinews designed to seduce by means of every trick in the toolbox of classicism?

Yet, even here, seemingly 'parergonal' elements of the statue turn out to be fundamental to its operations – no mere supplements or even attributes, but constitutive elements of Dionysus' puissance. Consider the statue's draped cloak: spectacular in its sinuous gathering of fabric, the god's *himation* frames his body in such a way that its stacked, concentric folds draw attention (almost obscenely, for a modern viewer) to his phallus. Here is a supreme example of the anthropomorphic body as puissance, its sexual and reproductive power the focal point of the entire cultic composition. Yet, by directing the viewer's eye in this way, the statue's literal phallocentrism is almost overdetermined. Understood in *ritual* terms, the statue's composition is a reminder that this is a god whose epiphany in the Mysteries was primarily experienced in terms of symbolic parts – most notably, in the form of the sacred (probably phallic) object concealed within the Dionysiac *liknon* ('winnowing basket').[84] What appears to be an image of the body as whole, in other words, can also be viewed as an elaborate framing exercise which directs us elsewhere – to a *pars pro toto* encounter with godhead in which it is the deity's 'appendage' that most powerfully conveys his presence.

The statue's drapery, by extension, enacts a form of wrapping, containing and partial revelation that echoes the role played by the *liknon* itself. The flow of its folds carries the eye from Dionysus' phallus to the grapes that literally pour from his hand, the god's fingers pressing into their ripe globules so emphatically that one almost expects the juice to erupt between them (**Pl. 2.11a**). The sense of motion and flow thereby generated between grapes, garment and phallus enacts the production of wine itself (an effect that would have been magnified if the god's *himation* had been painted purple, as in the famous fresco in the Villa of the Mysteries at Pompeii).[85] This effect is reinforced at the god's apex and feet,

in both the vines of his headdress and the twisting ivy of his sandals, as these vegetal manifestations of his divinity shift between the categories of living plant and crafted ornament (**Pls 2.11b–2.11c**). The composition as a whole thus performs a kind of transubstantiation that directs us away from the god's body to the transformative power of the material substances in which his epiphany is arguably most directly experienced. In doing so, it brings to mind another image from Pompeii, of the Campanian Liber, in which the wine god's body is itself a bunch of grapes: a local manifestation, one might argue, of the 'True Vine' (**Pl. 2.12**).[86]

Plate 2.12 Fresco from the *lararium* in the House of the Centenary, Pompeii, depicting Dionysus Liber next to Mt Vesuvius, *c.* 62–79 CE. National Archaeological Museum, Naples, inv. 112286. Image © 2020, Photo Scala, Florence

Clothing and attributes, then, might fall neatly into modern parergonal categories, but they do not necessarily operate as such in Roman classicising statuary. Dionysus' folds do not conceal an essential body beneath – a fully anthropomorphic form that itself mediates transcendent godhead. Rather, they themselves support, create and enable a play of volume and surface which enacts divine puissance for Dionysus' viewer-worshippers. Within this play of parts, the god's visible body is itself a frame, or *demas*, for a divine *kosmêsis* – an 'adorning' or 'ornamenting' that is not supplementary to divine presence but rather embodies the very material conditions that make it possible. The Cyrene statue conducts this entire performance within the framework of a single object, yet, viewed in ritual and symbolic terms, it invites us to zone in more closely on its individual parts. The Dionysiac mysteries, we are reminded, unfold as a set of multiple components in which anthropomorphic divine body is itself but a frame, or access point, for sacred knowledge denied to the uninitiated beholder.

In his groundbreaking work on anthropological aesthetics, *Art and Agency*, Alfred Gell examined the use of serial or concentric framing devices in religious contexts, which he saw as central to the abduction of divine agency. Contemplating Egyptian temples, in which idols were secluded 'in a box or ark, which, in turn, was kept in the darkest and most central sanctuary of a vast temple complex, consisting of innumerable lesser sanctuaries', he suggested that such objects come to stand for an 'interiority' or 'animating mind': the sacred space that frames the idols is, in effect, what constructs them as gods, who in turn charge that space with sanctity.[87] One might argue that the divine *parure* of cult statues such as the Athena Parthenos and Cyrene Dionysus did something very similar: by circumscribing their rendition of divine *imminence* with multiple framing elements, the 'parergonal' components of such assemblages generated a sense of divine *immanence*, in all its excitement and anticipation.

Yet reading through Pliny and Pausanias, and taking into account Greek notions of *kosmos*, we might reach a slightly different conclusion – one that, in contrast to post-Reformation modernity (and the strictures of neoclassicism), is less in thrall to the idea of a coherent, transcendent signified within (and beyond) the image and its material vehicles; one that is less troubled by the concept of surface (though no less interested in notions of containment) and less affected by the idea that frames, ornaments and attributes are mere supplements. Understood as fractal components charged with the constant potential to expand or shift in significance, as synecdochic rather than ancillary, the *obiter dicta* of the classical gods powerfully demonstrate the enactive force of material religion. They also alert us to the theological vibrancy of Greco-Roman visual traditions in which divinity was continually being re-crafted, reframed and reimagined.

Notes

1 See Elsner and Lenk 2017.

2 On 'emic' concepts (i.e. those internal to a culture) versus the 'etic' interpretative approaches of external anthropologists or scientists, see M. Harris 1976.

3 In this sense, my paper continues the work of Platt and Squire

2017, especially my introduction to Part IV, 'Framing the Sacred' (Platt 2017b), and the essays by Elsner and Gaifman.

4 For a welcome re-examination of the category of 'ornament' in relation to classical art, see Dietrich and Squire 2018.

5 See Elsner and Lenk 2017: 12–17, figs 1–5 (a 1676 Jewish parochet; a 15th-century Tibetan painting of Sakyamuni; a 15th-century Byzantine icon of the Deesis; a 1432/3 Muslim pilgrimage certificate; and a 1771–9 scroll featuring the avatars of Vishnu).

6 On the *longue durée* of this phenomenon within the western tradition, see Elsner 2017.

7 See Adrych and Dalglish 2017.

8 Bowersock, Brown and Grabar 1999: x, claiming that the 'classical period of the ancient world has a surreal, almost weightless quality about it. It is the Dream Time of western civilization. It can act as a never-failing source of inspiration. But we cannot claim to come from that classical world alone, for whole segments of the modern world had no place in it.'

9 For helpful overviews of the study of iconography in Greek religion, see Scheer 2015; Osborne and Vout 2016; and Gaifman 2018, 9–11. Some key studies are Simon 1953; Straten 1982; B. Dietrich 1985; Bérard, Vernant *et al.* 1984/1989; Hägg 1992; Himmelmann 1998; and Mylonopoulos 2010. For a rich analysis of iconology, semiotics and the image in classical art history more broadly, see Lorenz 2016.

10 On the influence of classical iconography on early Christian art, Grabar 1968 is fundamental; see also Mathews 1993 (a controversial analysis, as reviewed by Brown 1995) and Finney 1994; for helpful overviews, see Elsner 1998 (esp. 199–236) and Jensen 2000: 8–63. For *Imagining the Divine*'s take on syncretism in classical antiquity, see Adrych and Dalglish 2017; on the relationship between pagan and Christian iconography, see Lidova 2017. For a sophisticated case study of religious influence and exchange, see Adrych *et al.* 2017, on images of Mithra.

11 See, for example, Osborne 2011 and Squire 2015.

12 From a vast bibliography, see in particular Gladigow 1985–6 and 1990; Donohue 1997; Scheer 2000; Bettinetti 2001; Gaifman 2006; Mylonopoulos 2010; Platt 2011; and F. Hölscher 2018. On the difficulties of determining the function, form and appearance of Greek sacred images, see Donohue 1988. On alternative modes of instantiating divine presence, such as aniconism, see Frontisi-Ducroux 1986 and Gaifman 2012.

13 On the agency of cult statues and sacred modes of viewing in antiquity, see esp. Gordon 1979; Elsner 1996 and 2000; Stewart 2007; Platt 2011 and 2016.

14 Tanner 2006: 31–96.

15 Recognition of the polychromy of ancient statuary (and of the gods in particular) is especially indebted to the *Bunte Götter* exhibitions spearheaded by Vinzenz Brinkmann (see e.g. Brinkmann and Wünsche 2007); see also Bradley 2009; Abbe 2015 (together with the resources listed at http://www.ancientpolychromynetwork.com (accessed 30 April 2020)); and Stager 2016. On the role of colour in Greco-Roman cult practice more broadly, see Grand-Clément 2010, 2011 and 2017; and Platt forthcoming. On the 'dread white army' of (neo)classical statuary that casts its shadow over the discipline, see Woods 2011.

16 For an interesting discussion of these methodological problems, see Donohue 1988, on the undue influence of early Christian sources over scholarly interpretations of the Greek term *xoanon*.

17 On the interpretative problems posed by the attribute, see Mylonopoulos 2010 and N. Dietrich 2018.

18 On aniconism, see Gaifman 2010 and 2012, together with the papers gathered in Aktor and Gaifman 2017. On hybrid and theriomorphic deities, see Gilhus 2006; Aston 2011; Stuckenbruck, Lewis and Newington 2019; and Kindt, forthcoming. On the 'spectrum of iconicity', see Gaifman 2012: 13, 44–5, with further discussion in Platt 2011: 77–123.

19 On Kant's critique of 'the frames of pictures or the draperies of statues or the colonnades around palaces' as mere *Zieraten* ('ornaments') in his 1790 edition of the *Critique of Judgement*, and subsequent identification of them as *parerga* in the 1793 edition, see Kant 1987: 72, with Kemal 1997. On the influence of this terminology on western aesthetics and the discipline of classical history in particular, see Platt and Squire 2017: 39–47.

20 Riegl 1992 [1893]. More recently, on the *longue durée* and cultural translatability of ornamental motifs, see Grabar 1992 (focusing on the Islamic tradition); Trilling 2001; Guest 2015 (on the Italian Renaissance); and the essays gathered in Necipoğlu and Payne 2016 (focusing on medieval and early modern contexts, as well as the complex historiography of ornament). For a recent study of 'transcultural' motifs in antiquity (focused on myth, and thus in keeping with classical archaeology's tendency towards iconocentrism), see Audley-Millar and Dignas 2018.

21 See Toynbee 1964; Henig 1995: 156 (suggesting that the central figure could be a Christianised Roman emperor such as Constantine); Dunbabin 1999: 95–6; Neal and Cosh 2005: 156–60, no. 172.1; Pearce 2008; and Adrych 2017.

22 On the so-called 'Durnovarian School', see e.g. Painter 1967: 23; Scott 2000: 53–4; and Neal and Cosh 2005: 157 (comparing inconsistencies in the mosaic's guilloche and Z patterns with a contemporary mosaic at Frampton).

23 On the question of whether Roman mosaics should be understood as 'ornamentalised figures or figuralised ornament', see Muth 2018, with further discussion of the spatial and interactive dynamics generated by mosaics in Muth 1998 and Molholt 2011.

24 Cf. a rare comment on the agency of ornament in Roman mosaics by Christine Kondoleon (2016: 1): 'The fact that almost all the extant Medusa mosaics – about one hundred – are set within a kaleidoscopic pattern that produces the impression of motion suggests that the ancients believed the kinesthetic effect of ornament could work in tandem with the mythic image of the Gorgon to ward off evil.' See also Platt and Squire 2017: 56–8, on Roman labyrinth mosaics.

25 Hay 2016, 69. Cf. Grabar 1992 (on ornament as mediation); Picon 2013: 16 (observing that ornament 'appears as a structure of exchange rather than static entity'); and Neer 2018 (on ornament as 'relational').

26 See, for example, Grabar 1992: 30–7 (comparing approaches to vegetal ornament on the Roman *Ara Pacis Augustae* and the Umayyad palace of Mshatta) and Necipoğlu 1995 (on geometry and ornament in Islamic architecture, although note Flood 2002, on the complex range of positions towards representation adopted across different social groups, regions and periods within the Islamic world). On the theological dimensions of Celtic ornament (especially in relation to early Christianity), see e.g. Kitzinger 1993; Redknap *et al.* 2002; Tilghman 2011, 2016 and 2017; and Ní Ghrádaigh 2012.

27 See T. Hölscher 2009; Barham 2015; and Dietrich and Squire 2018.

28 This includes my own contribution to Dietrich and Squire's volume (Platt 2018b)! For a welcome exception, see Marconi 2004.

29 See, for example, the small frieze on the altar of the *Ara Pacis Augustae* (discussed by Elsner 1991: 54–8) and the interior frieze of the Temple of Apollo Sosianus in Rome, both of which show ritual processions (of sacrifice and triumph, respectively).

30 See for example Dunbabin 1999: 95; Neal and Cosh 2005: 157; Henig 2006: 204, cat. 190; and Pearce 2008: 210.

31 See especially Huskinson 2012 and 2015; and Sidgwick 2014; with further comments in Platt 2017a: 365–6.

32 See Lidova 2017: 62–3.

33 See, for example, Nock 1946 (itself a secularising response to Cumont 2015 [1942]) and the ensuing privileging of 'classicism and culture' (Nock 1946: 166) over religious interpretation in sarcophagus studies, as discussed by Elsner 2011: 9–11 and 2016; and Platt 2011: 337–44.

34 The most thorough examination of evidence for the Athena Parthenos is Lapatin 2001: 61–95 (with further bibliography), as well as a helpful summary in Lapatin 2005; see also Leipen 1971; Prag 1972 and 1984; Ridgway 1989 and 2005; Nick 2002: 177–205; and Platt 2011: 86–91, 105–14. On discussions of the Parthenos in literary sources, see *DNO* s.v. Phidias no. 10, vol. 2, nos 889–935, 171–214; and Lapatin 1996 and 2001: 154–92. On Greco-Roman replications of the Parthenos (including the Lenormant and Varvakeion statuettes), see Gaifman 2006.

35 Pliny, *Natural History* 36.18: 'That Pheidias is the most famous sculptor among all peoples who appreciate the fame of his Olympian Jupiter is beyond doubt, but in order that even those who have not seen his works may be assured that his praises are well-earned I shall produce evidence that is insignificant in itself and sufficient only to prove his inventiveness' (*Phidian clarissimum esse per omnes gentes quae Iovis Olympii famam intellegunt nemo dubitat, sed ut laudari merito sciant etiam qui opera eius non videre, proferemus argumenta parva et ingenii tantum*); translations from Pliny 1962.

36 E.g. *Homeric Hymns* 2.275–9; 5.82, 171–5.

37 Pliny, *Natural History* 36.18–19 (*neque ad hoc Iovis Olympii pulchritudine utemur, non Minervae Athenis factae amplitudine, cum sit ea cubitorum xxvi – ebore haec et auro constat – sed in scuto eius Amazonum proelium caelavit intumescente ambitu, in parmae eiusdem concava parte deorum et Gigantum dimicationes, in soleis vero Lapitharum et Centaurorum. adeo momenta omnia capacia artis illi fuere. in basi autem quod caelatum est Πανδώρας γένεσιν appellant: dii adsunt nascenti xx numero. Victoria praecipue mirabili, periti mirantur et serpentem ac sub ipsa cuspide aeream sphingem. haec sint obiter dicta de artifice numquam satis laudato, simul ut noscatur illam magnificentiam aequalem fuisse et in parvis*).

38 On *pars pro toto* as a strategy for epiphanic presentification in ancient narrative and visual representation, see Platt 2015: 496 and 2018a: 241–2; and Petridou 2016: 72–86.

39 See e.g. *OLD* s.v. *capax* 1: 'Able to hold a lot, capacious, roomy'; 2: 'able to contain (immaterial or abstract things)'.

40 On the role of the *prôtos heurêtês* in Pliny's history of art, see e.g. Tanner 2006: 239–46.

41 See Pliny, *Natural History* 11.2–4 (on insects) and 37.1 (on precious stones), with discussion in Platt 2018b: 247–51. On Pliny's concept of *natura* more generally, see Beagon 1992 and 2011.

42 Callimachus, *Iambus* 6. For a range of interpretations (which include that of an ironic ekphrasis of the statue), see Kerkhecker 1999: 151–81; Acosta-Hughes 2002: 288–94; and Petrovic 2006: 30–6.

43 Pausanias, *Description of Greece* 1.24.5: αὐτὸ δὲ ἔκ τε ἐλέφαντος τὸ ἄγαλμα καὶ χρυσοῦ πεποίηται. μέσῳ μὲν οὖν ἐπίκειταί οἱ τῷ κράνει Σφιγγὸς εἰκών – ἃ δὲ ἐς τὴν Σφίγγα λέγεται, γράψω προελθόντος ἐς τὰ

Βοιωτιά μοι τοῦ λόγου – καθ᾽ ἑκάτερον δὲ τοῦ κράνους γρῦπές εἰσιν ἐπειργασμένοι. Translations from Pausanias 1918. On the origins, development and significance of Athena's helmet, see Ritter 1997.

44 Pausanias, *Description of Greece* 1.24.7: τὸ δὲ ἄγαλμα τῆς Ἀθηνᾶς ὀρθόν ἐστιν ἐν χιτῶνι ποδήρει καί οἱ κατὰ τὸ στέρνον ἡ κεφαλὴ Μεδούσης ἐλέφαντός ἐστιν ἐμπεποιημένη.

45 Pausanias, *Description of Greece* 1.24.7: καὶ Νίκην τε ὅσον τεσσάρων πηχῶν, ἐν δὲ τῇ ἑτέρᾳ χειρὶ δόρυ ἔχει, καί οἱ πρὸς τοῖς ποσὶν ἀσπίς τε κεῖται καὶ πλησίον τοῦ δόρατος δράκων ἐστίν· εἴη δ᾽ ἂν Ἐριχθόνιος οὗτος ὁ δράκων. ἔστι δὲ τῷ βάθρῳ τοῦ ἀγάλματος ἐπειργασμένη Πανδώρας γένεσις. πεποίηται δὲ Ἡσιόδῳ τε καὶ ἄλλοις ὡς ἡ Πανδώρα γένοιτο αὕτη γυνὴ πρώτη· πρὶν δὲ ἢ γενέσθαι Πανδώραν οὐκ ἦν πω γυναικῶν γένος.

46 On the significance of Pandora here, see Leipen 1971: 24–7 (with proposals for reconstructions); Schuhardt 1975; Lapatin 2001: 67 and 2005: 268–9; and Hurwit 2004: 151–3. On the question of why a myth with such negative connotations would be displayed on Athena's base, see Pollitt 1990; Steiner 2001: 104 (on Pandora as an allegory for the role of *technê* in Periclean Athens); Loraux 1993: 114–15; Hurwit 1995 (on Pandora as an 'anti-Athena' expressing Athenian notions of patriarchy); Connelly 1996: 72–6 (who argues for a beneficent 'gift-giving' Attic Pandora, rather than the Hesiodic version); and Platt 2011: 111–13 (on Pandora as a demonstration of superior divine *mimêsis*).

47 See, for example, Castriota 1992: 134–83; Neils 1992, 1996 and 2005; Tournikiotis 1994; Hurwit 1999 and 2004; Barringer 2008: 59–108; and (more controversially) Connelly 2014. On the iconography of Athena's shield, snake, and sandals and their relationship to the Parthenon's 'programme', see Lapatin 2001: 66–7 (with extensive bibliography).

48 Porter 2016: 145.

49 On *thauma* as an aesthetic desideratum in classical and archaic Greek art, see Neer 2010: 57–69, developing arguments made by Prier 1989. That experiencing the Pheidian statues by means of their parts was almost a cliché within antiquity is suggested by Lucian, who comments in his treatise on 'How to write history' that to 'leave out or skate over the important and interesting events' is 'like failing to observe and praise and describe for those who do not know it the entire grandeur and supreme quality of the Zeus at Olympia, and instead admiring the "good workmanship" and "good finish" of the footstool and the "good proportions" of the base, and developing all this with great concern' (27); translation from Lucian 1959.

50 See *OLD* s.v.v. *limen* 2a, 4; *sublimen*; and *OLD* s.v. *sublimis* I, with discussion by Porter 2016: 28, drawing on Meister 1925 and Haffter 1935.

51 Porter 2016: 143.

52 On the Pheidian cult statues as archetypal examples of a specifically theological sublime (particularly in Dio Chrysostom's *Olympian Oration* and Pausanias' *Description of Greece*), see Platt 2011: 224–35 (with further bibliography).

53 Porter 2016: 547.

54 Strabo 8.3.30 (ἐὰν ὀρθὸς γένηται διαναστάς, ἀποστεγάσειν τὸν νεών). For discussion, see Gordon 1979: 14 and Gaifman 2017: 392–401.

55 On replications of the Athena Parthenos, see Leipen 1971; Lapatin 2001: 66 n. 51 (with further bibliography); Nick 2002: 177–205; and Gaifman 2006.

56 Hurwit 1999, 187.

57 On the sensory aspects of divine *parures* in the Homeric poems, see Brouillet and Carastro 2018, together with Brouillet 2017 and forthcoming.

58 On the crafting and medium of the shield of Achilles (*Iliad* 18.478–608), see Becker 1990; Francis 2009; and Squire 2013 (with more extensive bibliography). On the technique of *toreutikê* or *caelatura* in antiquity, see Strong 1966 and Lapatin 2015: 19–44.

59 Loraux 1993; see also Blundell 1998. On the complexities of Athena's dress and her potential desirability, see Llewellyn-Jones 2001.

60 See Loraux 1993: 23–4, 37–71, esp. 47 n. 42, with Apollodorus 3.14.6 ('In disgust, she wiped off the seed with wool (ἐρίῳ) and threw it on the ground; and as she fled and the seed fell on the ground, Erichthonius was produced'); an alternative etymology juxtaposes 'ground' (*chthôn*) with 'strife' (*eris*).

61 On the apotropaic force of Athena's aegis (the *gorgoneion*), see Mack 2002.

62 See Brinkmann, 2007. On the painting of statues, see above, n. 16.

63 The primary source for this (contested) claim is Thucydides 2.13.5, echoed by several later authors including Pausanias (1.25.7) and Plutarch (*Pericles* 31.2–3). For discussion, see Donnay 1967; Eddy 1977; Lapatin 2001: 64–6; and Platt 2011: 109–11.

64 On evidence for the Athena Polias, see Kroll 1982 and Mansfield 1985: 135–88. On the Parthenos as a 'votive offering' rather than a 'cult statue', see Herington 1955: 37–8; Leipen 1971: 17; and Lapatin 2005: 282. For the argument that the Parthenos was, indeed, a *Kultbild*, see Nick 2002 (esp. 119–32). For an overview of the debate over the relative religiosity of the Parthenos and Polias, see Platt 2011: 83–114.

65 On the Athena Polias as a wooden core supporting figural additions, see Kroll 1982: 73–4, who argues that the Polias consisted of an aniconic 'nucleus' forming a standing image, which was anthropomorphised by 6th-century figural components attributed to the sculptor Endoios and supplemented with votive attributes such as a helmet, *gorgoneion* and jewellery.

66 *IG* I³, 1454, dated 445–30 BCE, discussed by Anderson and Dix 1997; Dix and Anderson 1997; and Lapatin 2001: 70.

67 Lapatin 2001: 70.

68 Lapatin 2001: 70.

69 Lucian, *Gallus* 24, *Jupiter Tragoedus* 8, both dated to the 2nd century CE. Lucian's conceit was later exploited in a critique of pagan idolatry by Arnobius (*Adversus Nationes* 6.16): 'O that you could enter the hollow interior (*medias introire pendigines*) of some statue!' (translation from Arnobius of Sicca 1959).

70 That the interior of a bronze figure might actually be understood as particularly sacred is suggested by the Piombino Apollo, dated 120–100 BCE and now in the Louvre, which concealed within it a lead tablet inscribed with the artists' signatures: see Daehner and Lapatin 2015: 288–91.

71 *LSJ* s.v. δέμας, A. 'bodily frame'. On the frame as armature, see Platt and Squire 2017: 8–9.

72 For Athenian coins that may depict the Athena Polias, see Kroll 1982.

73 On the *peplos* and its significance to the Great Panathenaia, see Mansfield 1985; Barber 1992; Neils 1992 and 1996; and Håland 2006. On evidence for the Polias' attributes in the Erechtheion inventory tablets, see *IG* 2², 1424, 11–16; 1425, 307–12; 1426, 4–8; 1428, 142–6; 1429, 42–7; 1424a 362–6, with D. Harris 1995.

74 Euripides (*Hecuba*, 468) describes Athena's *peplos* as 'saffron-coloured' (*krokeos*) and embroidered 'with threads of flowered hue' (*anthrokrokoisi pinais*), which Grand-Clément 2016 interprets as the best-quality dye, i.e. purple *murex*.

75 See Pausanias 1.24.3: 'I have already stated that the Athenians are

far more devoted to religion than other men. They were the first to surname Athena Erganê (*Worker*).' On Athena as goddess of weaving, see Detienne and Vernant 1978; Heintze 1993 and 1995; Håland 2006; Deacy 2008: 50–4.

76 On the complex evidence for the ritual role of women as *Ergastinai* and *Arrephoroi* in the cult of Athena at Athens, see Robertson 1983; Palagia 2008; and Sourvinou-Inwood 2011: 263–311.

77 See above, Pausanias 1.24.7, with Hesiod, *Works and Days* 59–82, and Hesiod, *Theogony* 570–93, esp. 581–4.

78 Hesiod, *Works and Days* 63–4, 72, 76: '[Zeus] told Athena to teach her crafts (ἔργα διδασκῆσαι), to weave richly worked cloth (πολυδαίδαλον ἱστὸν ὑφαίνειν). … The goddess, bright-eyed Athena, gave her a girdle and ornaments (κόσμησε); … and Pallas Athena fitted the whole ornamentation to her body (πάντα δέ οἱ χροΐ κόσμον ἐφήρμοσε).' Edition and translation in Hesiod 2018.

79 On the complexities of the Pandora myth here, see above, n. 46.

80 On the significance of *kosmos* as both 'cosmos' and 'ornament', see the extensive discussion in Barham 2015; together with Marconi 2004; T. Hölscher 2009; and Platt 2018b.

81 See Adrych and Dalglish 2017: 34–5, with Smith and Porcher 1864: 40, 91, 106, nos 118 and 119; Pryce and Smith 1900: 222, 254–5, both no. 1476; and Huskinson 1975: 17–19, nos 32 and 35 (noting that the panther may have been displayed separately from the god).

82 See Walker 2002. On another 2nd-century CE classicising depiction of Dionysus from Cyrene (discovered in the Temple of Apollo), see Adams 2001 (a statue now in the National Museum of Scotland, Edinburgh, 1886, 597).

83 Winckelmann 2006 [1764]: 233–8 dates 'the beautiful style' ('Der schöne Stil') to the period of Praxiteles and Lysippus, i.e. the 4th century BCE; for discussion, see Potts 1994: 67–81.

84 On the *liknon* (a form of winnowing basket in the shape of a cradle), which held sacred objects including a phallus and fruit, and its role in rituals of Dionysiac initiation, see Nilsson 1957: 38–45 and Seaford 1981.

85 That the statue was originally painted is demonstrated by traces of red pigment noted by the excavators upon the eyes and the grapes in the wreath: see Pryce and Smith 1900: 254, no. 1476.

86 On the art-historical and theological traditions of the 'True Vine', see Bann 1989.

87 Gell 1998: 133–43; see also Platt 2017b.

Abbreviations

DNO Kansteiner, S. *et al.* (eds) 2014. *Der neue Overbeck. Die antiker Schriftquellen zu den bildenden Künsten der Griechen*, Berlin.

IG I³ Lewis, D.M., Jeffery, L.H., Erxleben, E. and Hallof, K. (eds) 1981–8. *Inscriptiones Graecae, Vol. I: Inscriptiones Atticae Euclidis anno anteriores*, 3rd ed., Berlin.

IG II² Kirchner, J. (ed.) 1913. *Inscriptiones Graecae, Vol. II et III: Inscriptiones Atticae Euclidis anno posteriores*, 2nd ed., Berlin.

LSJ Liddell, H.G. and Scott, R. 1940. *A Greek-English Lexicon. Revised and augmented throughout by Sir Henry Stuart Jones*, with the assistance of Roderick McKenzie, Oxford.

OLD Glare, P.G.W. (ed.) 2012. *Oxford Latin Dictionary*, 2nd ed., 2 vols, Oxford.

Bibliography

Abbe, M. 2015. 'The polychromy of Roman sculpture', in E. Friedland, M.G. Sobocinksi and E.K. Gazda (eds), *The Oxford Handbook to Roman Sculpture*, Oxford, 173–88.

Acosta-Hughes, B. 2002. *Polyeideia: The Iambi of Callimachus and the Archaic Iambic Tradition*, Hellenistic Culture and Society 35, Berkeley, Los Angeles and London.

Adams, N. 2001. 'A statue of Dionysos from the sanctuary of Apollo at Cyrene: a recent join', *Libyan Studies* 32, 87–91.

Adrych, P. 2017. 'The Hinton St Mary Floor Mosaic', in J. Elsner, S. Lenk *et al.* 2017: 42–5.

Adrych, P. and Dalglish, D. 2017. 'Religions in the Roman world', in Elsner, Lenk *et al.* 2017: 30–41.

Adrych, P., Bracey, R., Dalgish, D., Lenk, S. and Wood, R. 2017. *Images of Mithra: Visual Conversations in Art and Archaeology*, Oxford.

Aktor, M. and Gaifman, M. (eds) 2017. *Exploring Aniconism*, special issue of *Religion*, 47.

Anderson, C.A. and Dix, T.K. 1997. 'Politics and state religion in the Delian League: Athena and Apollo in the Eteocarpathian Decree', *Zeitschrift für Papyrologie und Epigraphik* 117, 129–32.

Arnobius of Sicca 1949. *Arnobius of Sicca: The Case Against the Pagans*, ed. and trans. G.E. McCracken, London.

Aston, E. 2011. *Mixanthropoi: Animal–Human Hybrid Deities in Greek Eeligion, Kernos* supplement 25, Liège.

Audley-Millar, L. and Dignas, B. (eds) 2018. *Wandering Myths: Transcultural Uses of Myth in the Ancient World*, Berlin.

Bann, S. 1989. *The True Vine: On Visual Representation and the Western Tradition*, Cambridge.

Barber, E.J.W. 1992. 'The *peplos* of Athena', in Neils 1992: 103–17.

Barham, N. 2015. 'Ornament and art theory in ancient Rome: an alternative classical paradigm for the visual arts', PhD dissertation, University of Chicago.

Barringer, J.M. 2008. *Art, Myth, and Ritual in Classical Greece*, Cambridge.

Beagon, M. 1992. *Roman Nature: The Thought of Pliny the Elder*, Oxford.

— 2011. 'The curious eye of the Elder Pliny', in R.K. Gibson and R. Morello (eds), *Pliny the Elder: Themes and Contexts*, Leiden, 71–88.

Becker, A. S. 1990. 'The shield of Achilles and the poetics of Homeric description', *American Journal of Philology* 111, 139–53.

Bérard, C. Vernant, J.-P. *et al.* 1984. *La cité des images. Religion et société en Grèce antique*, Paris (= *A City of Images: Iconography and Society in Ancient Greece*, trans. by D. Lyons, Princeton, 1989).

Bettinetti, S. 2001. *La statua di culto nella pratica rituale greca*, Bari.

Blundell, S. 1998. 'Marriage and the maiden: narratives on the Parthenon', in S. Blundell and M. Williamson (eds), *The Sacred and the Feminine in Ancient Greece*, London and New York, 47–70.

Bowersock, B., Brown, P. and Grabar, A. 1999. *Late Antiquity: A Guide to the Postclassical World*, Cambridge, MA and London.

Bradley, M. 2009. 'The importance of colour on ancient marble sculpture', *Art History* 32, 427–57.

Brinkmann, V. 2007. 'Girl or goddess? The riddle of the "Peplos Kore" from the Athenian Acropolis', in Brinkmann and Wünsche 2007: 44–53.

Brinkmann, V. and Wünsche, R. (eds). 2007. *Gods in Color: Painted Sculpture of Classical Antiquity*, Munich.

Brouillet, M. 2017. '*Thambos* et *kharis*: constructions sensorielles et expériences du divin dans les épopées homériques', *Mythos* n.s. 11, 83–93.

— forthcoming. *Des chants en partage. L'épopée homérique comme expérience religieuse*, Paris.

Brouillet, M. and Carastro, C. 2018. 'Parures divines: puissances et constructions homériques de l'objet', *Mètis* n.s. 16, 85–106.

Brown, P. 1995. Review of Mathews 1993, *Art Bulletin* 77(3), 499–502.

Castriota, D. 1992. *Myth, Ethos, and Actuality: Official Art in Fifth-Century B.C. Athens*, Madison.

Connelly, J.B. 1996. 'Parthenon and *Parthenoi*: a mythological interpretation of the Parthenon frieze', *American Journal of Archaeology* 100(1), 53–80.

— 2014. *The Parthenon Enigma*, New York.

Cumont, F. 2015 [1942]. *Recherches sur le symbolisme funéraire des Romains*, ed. by J. Balty and J.C. Balty, Turnhout.

Daehner, J. and Lapatin, K.S. 2015. *Power and Pathos: Bronze Sculpture of the Hellenistic World*, Los Angeles.

Deacy, S. 2008. *Athena*, London and New York.

Detienne, M. and Vernant, J.-P. 1978. *Cunning Intelligence in Greek Culture and Society*, trans. by J. Lloyd, Hassocks.

Dietrich, B.C. 1985. 'Divine concept and iconography in Greek religion', *Grazer Beiträge* 12, 171–92.

Dietrich, N. 2018. *Das Attribut als Problem. Eine bildwissenschaftliche Untersuchung zur griechischen Kunst*, Image & Context 17, Berlin.

Dietrich, N. and Squire, M. (eds) 2018. *Ornament and Figure in Graeco-Roman Art: Rethinking Visual Ontologies in Classical Antiquity*, Berlin.

Dix, T.K. and Anderson, C.A. 1997. 'The Eteocarpathian Decree (*IG* I³, 1454) and the construction date of the Erechthion (abstract)', *American Journal of Archaeology* 101, 373.

Donnay, G. 1967. 'Comptes de l'Athéna chryselephantine du Parthénon', *Bulletin de Correspondance Héllenique* 91, 50–86.

Donohue, A.A. 1988, *Xoana and the Origins of Greek Sculpture*, Atlanta.

— 1997. 'The Greek images of the gods: considerations on terminology and methodology', *Hephaistos* 14, 31–45.

Dunbabin, K. 1999. *Mosaics of the Greek and Roman World*, Cambridge.

Eddy, S. 1977. 'The gold in the Athena Parthenos', *American Journal of Archaeology* 81, 107–11.

Elsner, J. 1991. 'Cult and sculpture: sacrifice in the *Ara Pacis Augustae*', *Journal of Roman Studies* 81, 50–61.

— 1996. 'Image and ritual: reflections on the religious appreciation of classical art', *Classical Quarterly* 46, 515–31.

— 1998. *Imperial Rome and Christian Triumph: The Art of the Roman Empire A.D. 100–450*, Oxford.

— 2000. 'Between mimesis and divine power: visuality in the Graeco-Roman world', in R.S. Nelson (ed.), *Visuality Before and Beyond the Renaissance*, Cambridge, 45–69.

— 2011. 'Introduction', in J. Elsner and J. Huskinson (eds), *Life, Death and Representation: Some New Work on Roman Sarcophagi*, Berlin, 1–20.

— 2016. 'Review of Cumont 2015, *Bryn Mawr Classical Review* 2016.06.38.

— 2017. 'Visual ontologies: style, archaism and framing in the construction of the sacred in the western tradition', in Platt and Squire 2017: 457–500.

Elsner, J. and Lenk, S. 2017. 'Introduction', in Elsner, Lenk *et al.* 2017: 12–30.

Elsner, J., Lenk, S. *et al.* 2017. *Imagining the Divine: Art and the Rise of World Religions*, Oxford.

Finney, P.C. 1994. *The Invisible God: The Earliest Christians on Art*, Oxford.

Flood, F.B. 2002. 'Between cult and culture: Bamiyan, Islamic iconoclasm, and the museum', *Art Bulletin* 84, 641–59.

Francis, J.A. 2009. 'Metal maidens, Achilles' shield and Pandora: the beginnings of "ekphrasis"', *American Journal of Philology* 130, 1–23.

Frontisi-Ducroux, F. 1986. 'Les limites de l'anthropomorphisme: Hermès et Dionysos', in C. Malamoud and J.-P. Vernant (eds), *Corps des dieux. Le temps de la réflexion* 7, Paris, 193–211.

Gaifman, M. 2006. 'Statue, cult and reproduction', *Art History* 29, 258–79.

— 2010. 'Aniconism and the idea of the primitive in Greek antiquity',

in J. Mylonopoulos (ed.), *Divine Images and Human Imaginations in Ancient Greece and Rome*, Leiden, 63–86.

— 2012. *Aniconism in Greek Antiquity*, Oxford.

— 2017. 'Framing divine bodies in Greek art', in Platt and Squire 2017: 392–424.

— 2018. *The Art of Libation in Classical Greek Art*, New Haven.

Gell, A. 1998. *Art and Agency: An Anthropological Theory*. Oxford.

Gilhus, I.S. 2006. *Animals, Gods and Humans: Changing Attitudes to Animals in Greek, Roman and Early Christian Ideas*, London.

Gladigow, B. 1985-6, 'Präsenz der Bilder, Präsenz der Götter: Kultbilder und Bilder der Götter in der griechischen Religion', *Visible Religion* 4–5, 114–33.

— 1990. 'Epiphanie, Statuette, Kultbild: Griechische Gottesvorstellungen im Wechsel von Kontext und Medium', *Visible Religion* 7, 98–121.

Gordon, R. 1979. 'The real and the imaginary: production and religion in the Greco-Roman world', *Art History* 2, 5–34.

Grabar, A. 1968. *Christian Iconography: A Study of Its Origins*, Princeton.

— 1992. *The Mediation of Ornament*, Princeton NJ.

Grand-Clément, A. 2010. 'Les yeux d'Athéna: le rôle des couleurs dans la construction de l'identité divine', *Archiv für Religionsgeschichte* 12: 7–22.

— 2011. *La Fabrique des couleurs. Histoire du paysage sensible des Grecs anciens (VIIIᵉ–début du Vᵉ s. av. n. è)*, Paris.

— 2016. 'Gold and purple: brilliance, materiality and agency of color in ancient Greece', in R.B. Goldman (ed.), *Essays in Global Color History: Interpreting the Ancient Spectrum*, Piscataway, NJ, 121–38.

— 2017. 'Des couleurs et des sens. percevoir la présence divine', in C. Pironti and C. Bonnet (eds), *Les Dieux d'Homère. Polythéisme et poésie en Grèce ancienne*, Kernos supplement 31, Liège, 43–62.

Guest, C.L. 2015. *The Understanding of Ornament in the Italian Renaissance*, Leiden.

Haffter, H. 1935. 'Sublimis', *Glotta* 23(3/4), 251–61.

Hägg, R. (ed.) 1992. *The Iconography of Greek Cult in the Archaic and Classical Periods*, Liège.

Håland, E.J. 2006. 'Athena's *peplos*: weaving as a core female activity in ancient and modern Greece', *Cosmos* 20, 155–82.

Harris, D. 1995. *The Treasures of the Parthenon and Erechtheion*, Oxford.

Harris, M. 1976. 'History and significance of the emic/etic distinction', *Annual Review of Anthropology* 5, 329–350.

Hay, J. 2016. 'The passage of the other: elements for a redefinition of ornament', in Necipoğlu and Payne 2016: 62–9.

Heintze, H. von 1993. 'Athena Polias am Parthenon als Ergane, Hippia, Parthenos', *Gymnasium* 100, 385–418.

— 1995. 'Athena Polias am Parthenon als Ergane, Hippia, Parthenos III: die Nord- und die Südseite: Athena Polias und Athena Parthenos', *Gymnasium* 102, 193–222.

Henig, M. 1995. *The Art of Roman Britain*, London.

— 2006. '190. Central roundel of floor mosaic', in E. Hartley, J. Hawkes, M. Henig, and F. Mee, *Constantine the Great: York's Roman Emperor*, York, 204–6.

Herington, C.J. 1955. *Athena Parthenos and Athena Polias*, Manchester.

Hesiod 2018. *Hesiod: Theogony, Works and Days, Testimonia*, ed. and trans. G.W. Most, Loeb Classical Library 57, Cambridge, MA.

Himmelmann, N. 1998. 'Some characteristics of the representation of gods in classical art,' in N. Himmelmann, *Reading Greek Art*, selected by H. Meyer and ed. by W. Childs, Princeton, 108–38.

Hölscher, F. 2018. *Die Macht der Gottheit im Bild. Archäologische Studien zur griechischen Götterstatue*, Göttingen.

Hölscher, T. 2009. 'Architectural sculpture: messages? Programs?

Towards rehabilitating the notion of "decoration"', in P. Schultz and R. von den Hoff (eds), *Structure, Image, Ornament: Architectural Sculpture in the Greek World*, Oxford, 54–67.

Hurwit, J.M. 1995. 'Beautiful evil: Pandora and the Athena Parthenos', *American Journal of Archaeology* 99, 171–86.

— 1999. *The Athenian Acropolis: History, Mythology, and Archaeology from the Neolithic Era to the Present*, Cambridge.

— 2004. *The Acropolis in the Age of Perikles*, Cambridge.

Huskinson, J. 1975. *Roman Sculpture from Cyrenaica in the British Museum*, Corpus signorum imperii Romani: Great Britain 2.1, London.

— 2012. 'Reading identity on Roman strigillated sarcophagi', *RES: Anthropology and Aesthetics* 61–2, 80–96.

— 2015. *Roman Strigillated Sarcophagi: Art and Social History*, Oxford.

Jensen, R.M. 2000. *Understanding Early Christian Art*, London.

Kant, I. 1987. *Critique of Judgment*, trans. by W.S. Pluhar [based on Kant's 1793 edition], Indianapolis.

Kemal, S. 1997. *Kant's Aesthetic Theory: An Introduction*, 2nd ed., London.

Kerkhecker, A. 1999. *Callimachus' Book of Iambi*, Oxford.

Kindt, J. forthcoming. *Animals in Ancient Greek Religion*, London.

Kitzinger, E. 1993. 'Interlace and icons: form and function in early insular art', in R.M. Spearman and J. Higgitt (eds), *The Age of Migrating Ideas: Early Medieval Art in Northern Britain and Ireland*, 3–15.

Kondoleon, C. 2016. 'Introduction', in A. Belis, *Roman Mosaics in the J. Paul Getty Museum*, Los Angeles.

Kroll, J. 1982. 'The ancient image of Athena Polias', in *Studies in Athenian Architecture, Sculpture and Topography Presented to Homer A. Thompson*, Hesperia supplement 20, Princeton, 65–76.

Lapatin, K.D.S. 1996. 'The ancient reception of Pheidias' *Athena Parthenos*: the physical evidence in context', in L. Hardwick and S. Ireland (eds), *The January Conference 1996: The Reception of Classical Texts and Images*, Milton Keynes, 1–20.

— 2001. *Chryselephantine Statuary in the Ancient Mediterranean World*, Oxford.

— 2005. 'The statue of Athena and other treasures in the Parthenon', in Neils 2005: 260–91.

— (ed.) 2015. *Luxus: The Sumptuous Arts of Greece and Rome*, Los Angeles.

Leipen, N. 1971. *Athena Parthenos: A Reconstruction*, Toronto.

Lidova, M. 2017. 'Gods in combination' and 'The rise of the image of Christ', in Elsner, Lenk *et al.* 2017: 46–63.

Llewellyn-Jones, L. 2001. 'Sexy Athena: the dress and erotic representation of a virgin war-goddess', in S. Deacy and A. Villing (eds), *Athena in the Classical World*, Leiden, 233–57.

Loraux, N. 1993. *The Children of Athena: Athenian Ideas about Citizenship and the Division between the Sexes*, trans. by Caroline Levine, Princeton.

Lorenz, K. 2016. *Ancient Mythological Images and Their Interpretation: An Introduction to Iconology, Semiotics and Image Studies in Classical Art History*, Cambridge.

Lucian 1959. *Lucian, Vol. 6*, ed. and trans. K. Kilburn, Loeb Classical Library 430, Cambridge, MA.

Mack, R. 2002. 'Facing down Medusa (an aetiology of the gaze)', *Art History* 25, 571–604.

Mansfield, J.M. 1985. 'The robe of Athena and the Panathenaic *peplos*', PhD dissertation, University of California Berkeley.

Marconi, C. 2004. '*Kosmos*: the imagery of the Greek temple', *RES: Anthropology and Aesthetics* 45, 211–24.

Mathews, T.F. 1993. *The Clash of the Gods: A Reinterpretation of Early Christian Art*, Princeton.

Meister, K. 1925. *Die Hausschwelle in Sprache und Religion der Römer*, Heidelberg.

Metzger, M. 1965. *Recherches sur l'imagerie athénienne*, Paris.

Molholt, R. 2011. 'Roman labyrinth mosaics and the experience of motion', *Art Bulletin* 93, 287–303.

Muth, S. 1998. *Erleben von Raum – Leben im Raum. Zur Funktion mythologischer Mosaikbilder in der römisch-kaiserzeitlichen Wohnarchitektur*, Archäologie und Geschichte 10, Heidelberg.

— 2018. 'Aus der Perspektive der römischen Bodenmosaiken: ornamentalisierte Figuren oder figuralisierte Ornamente?' in Dietrich and Squire 2018: 393–422.

Mylonopoulos, J. 2010. 'Odysseus with a trident? The use of attributes in ancient Greek imagery', in J. Mylonopoulos (ed.), *Divine Images and Human Imaginations in Ancient Greece and Rome*, Leiden, 171–204.

Neal, D.S. and Cosh, S.R. 2005, *Roman Mosaics of Britain*, vol. 2, London.

Necipoğlu, G. 1995. *The Topkapı Scroll: Geometry and Ornament in Islamic Architecture*, Oxford.

Necipoğlu, G. and Payne, A. (eds) 2016. *Histories of Ornament: From Global to Local*, Princeton.

Neer, R.T. 2010. *The Emergence of the Classical Style in Greek Sculpture*, Chicago.

— 2018. 'Ornament, incipience and narrative: geometric to classical', in Dietrich and Squire 2018: 203–40.

Neils, J. (ed.) 1992. *Goddess and Polis: The Panathenaic Festival in Ancient Athens*, Princeton.

— (ed.) 1996. *Worshipping Athena: Panathenaia and Parthenon*, Madison.

— (ed.) 2005. *The Parthenon: From Antiquity to the Present*, Cambridge.

Nick, G. 2002. *Die Athena Parthenos. Studien zum griechischen Kultbild und seiner Rezeption*, Mainz.

Ní Ghrádaigh, J. 2012. 'Otherworldly gesturing? Understanding linear complexity in medieval insular art', in M. Faietti and G. Wolf, *Linea II. Giochi, metamorfosi, seduzioni della linea*, Milan, 76–97.

Nilsson, M.P. 1957. *The Dionysiac Mysteries of the Hellenistic and Roman Age*, Lund.

Nock, A.D. 1946. 'Sarcophagi and symbolism', *American Journal of Archaeology* 50, 140–70.

Osborne, R. 2011. *The History Written on the Classical Greek Body*, Cambridge.

Osborne, R. and Vout, C. 2016. 'Art and religion in ancient Greece and Rome', *Oxford Research Encyclopedias*, doi: 10.1093/acrefore/9780199340378.013.81.

Painter, K.S. 1967. 'The Roman site at Hinton St Mary, Dorset', *British Museum Quarterly* 32, 1–2, 15–31.

Palagia, O. 2008. 'Women in the cult of Athena', in N.E. Kaltsás and H.A. Shapiro (eds), *Worshiping Women: Ritual and Reality in Classical Athens*, New York, 30–7.

Pausanias 1918. *Pausanias: Description of Greece*, ed. and trans. W.H.S. Jones, Loeb Classical Library 93, London.

Pearce, S. 2008. 'The Hinton St Mary mosaic: Christ or emperor?' *Britannia* 39, 193–218.

Petridou, G. 2016. *Divine Epiphany in Greek Literature and Culture*, Oxford.

Petrovic, I. 2006. 'Delusions of grandeur: Homer, Zeus and the Telchines in Callimachus' reply *(Aitia* Fr. 1) and *Iambus* 6', *Antike und Abendland* 52, 16–41.

Picon, A. 2013. *Ornament: The Politics of Architecture and Subjectivity*, Chichester.

Platt, V.J. 2011. *Facing the Gods: Epiphany and Representation in Graeco-Roman Art, Literature and Religion*, Cambridge.

— 2015. 'Epiphanies', in E. Eidinow and J. Kindt (eds), *The Oxford Handbook of Greek Religion*, Oxford, 491–504.

— 2016. 'Sight and the gods: on the desire to see naked nymphs', in M.

Squire (ed.), *Sight and the Ancient Senses, The Senses in Antiquity* 4, London, 169–87.

— 2017a. 'Framing the dead on Roman sarcophagi', in Platt and Squire 2017: 353–82.

— 2017b. 'Framing the sacred', in Platt and Squire 2017: 384–91.

— 2018a. 'Double vision: epiphanies of the Dioscuri in Greece and Rome', *Archiv für Religionsgeschichte* 20, 229–56.

— 2018b. 'Of sponges and stones: matter and ornament in Roman painting', in Dietrich and Squire 2018: 241–78.

— forthcoming. 'Religion and ritual', in D. Wharton (ed.), *A Cultural History of Color in Antiquity*, London.

Platt, V.J. and Squire, M. (eds) 2017. *The Frame in Classical Art: A Cultural History*, Cambridge.

Pliny 1962. *Pliny: Natural History, Books 36–37*, ed. and trans. D.E. Eichholz, Loeb Classical Library 419, Cambridge, MA.

Pollitt, J.J. 1990. 'The meaning of Pheidias' Athena Parthenos', in B. Tsakirgis and S.F. Wiltshire (eds), *The Nashville Athena: A Symposium. The Parthenon, Nashville, Tennessee May 21 1990*, Nashville, 21–3.

Porter, J.I. 2016. *The Sublime in Antiquity*, Cambridge.

Potts, A. 1994. *Flesh and the Ideal: Winckelmann and the Origins of Art History*, New Haven and London.

Prag, A.J.N.W. 1972. 'Athena Mancuniensis: another copy of the Athena Parthenos', *Journal of Hellenic Studies* 92, 96–114.

— 1984. 'New copies of the Athena Parthenos from the East', in E. Berger (ed.), *Parthenon-Kongress Basel. Referate un Berichte. 4. bis 8. April 1982*, Mainz, 182–7.

Prier, R.A. 1989. *Thauma Idesthai: The Phenomenology of Sight and Appearance in Archaic Greek*, Tallahassee.

Pryce, F.N. and Smith, A.H. 1900. *Catalogue of Greek Sculpture in the British Museum*, vol. 2, London.

Redknap, M., Edwards, N., Lane, A. and Young, S. 2002. *Pattern and Purpose in Insular Art: Proceedings of the Fourth International Conference on Insular Art Held at the National Museum and Gallery, Cardiff 3–6 September 1998*, Oxford.

Ridgway, B.S. 1989. 'Parthenon and Parthenos', in N. Basgelen and M. Lugal (eds), *Festschrift für Jale Inan*, Istanbul, 295–305.

— 2005. '"Periklean" cult images and their media', in J.M. Barringer and J.M. Hurwit (eds), *Periklean Athens and Its Legacy: Problems and Perspectives*, Austin, 111–18.

Riegl, A. 1992 [1893]. *Problems of Style: Foundations for a History of Ornament*, trans. by Evelyn Kain, Princeton.

Ritter, S. 1997. 'Athenas Helme: zur Ikonographie der Athena in der klassischen Bildkunst Athens', *Jahrbuch des Deutschen Archäologischen Instituts* 112, 21–58.

Robertson, N. 1983. 'The riddle of the Arrhephoria at Athens', *Harvard Studies in Classical Philology* 87, 241–88.

Scheer, T.S. 2000. *Die Gottheit und ihr Bild. Untersuchungen zur Funktion griechischer Kultbilder in Religion und Politik, Zetemata* 105, Munich.

— 2015. 'Art and imagery', in E. Eidinow and J. Kindt (eds), *The Oxford Handbook of Ancient Greek Religion*, Oxford, 168–9.

Schuhardt, W.-H. 1975. 'Zur Basis der Athena Parthenos', *Wandlungen.*

Studien zur antiken und neueren Kunst. Ernst Homann-Wedeking gewidmet, Waldsassen, 120–30.

Scott, S. 2000. *Art and Society in Fourth-Century Britain: Villa Mosaics in Context*, Oxford.

Seaford, R.A.S. 1981. 'The mysteries of Dionysos at Pompeii', in H.W. Stubbs (ed.), *Pegasus: Classical Essays from the University of Exeter*, Exeter, 52–67.

Sidgwick, E. 2014. 'Radiant remnants: late antique strigillation and productive *dunamis/energeia*', *IKON* 7, 109–30.

Simon, E. 1953. *Opfernde Götter*, Berlin.

Smith, R.M. and Porcher, E.A. 1864. *History of the Recent Discoveries at Cyrene, Made During an Expedition to the Cyrenaica in 1860*, London.

Sourvinou-Inwood, C. 2011. *Athenian Myths and Festivals: Aglauros, Erechtheus, Plynteria, Panathenaia, Dionysia*, Oxford.

Squire, M. 2013. 'Ekphrasis at the forge and the forging of ekphrasis: the "shield of Achilles" in Greco-Roman word and image', *Word and Image* 29(2), 157–91.

— 2015. *The Art of the Body: Antiquity and Its Legacy*, London.

Stager, J. 2016. 'The materiality of color in ancient Mediterranean art', in R.B. Goldman (ed.), *Essays in Global Color History: Interpreting the Ancient Spectrum*, Piscataway, NJ, 97–120.

Steiner, D. T. 2001. *Images in Mind: Statues in Archaic and Classical Literature and Thought*, Princeton.

Stewart, P. 2007. 'Gell's idols and Roman cult', in R. Osborne and J. Tanner (eds), *Art's Agency and Art History*, Oxford, 158–78.

Straten, F. van 1981. 'Gifts for the gods', in H.S. Versnel (ed.), *Faith, Hope and Worship: Aspects of Religious Mentality in the Ancient World*, Leiden, 65–151.

Strong, D.E. 1966. *Greek and Roman Gold and Silver Plate*, Ithaca.

Stuckenbruck, L.T., Lewis, S. and Newington, S. (eds) 2019. *Animals and Monsters in Ancient Religion and Culture*, Oxford.

Tanner, J. 2006. *The Invention of Art History in Ancient Greece*, Cambridge.

Tilghman, B.C. 2011. 'The shape of the word: extra-linguistic meaning in insular display lettering', *Word and Image* 27(3), special issue on *The Iconicity of Script* (ed. J. Hamburger), 292–30.

— 2016. 'Ornament and incarnation in insular art', *Gesta* 55(2), 157–77.

— 2017. 'Pattern, process, and the creation of meaning in the Lindisfarne Gospels', *West 86th* 24(1), 3–28.

Tournikiotis, P. (ed.) 1994. *The Parthenon and Its Impact in Modern Times*, Athens.

Toynbee, J.M.C. 1964. 'The Christian Roman mosaic, Hinton St. Mary, Dorset', *Proc. Dorset Nat. Hist. And Arch. Soc.* 85, 116–21.

Trilling, J. 2001. *Ornament: A Modern Perspective*, Seattle.

Walker, S. 2002. 'Hadrian and the renewal of Cyrene', *Libyan Studies* 33, 45–56.

Winckelmann, J.J. 2006 [1764]. *History of the Art of Antiquity*, trans. by H.F. Malgrave, Los Angeles.

Woods, C. 2011. 'Envoi: reception and the classics', in W. Brockliss, P. Chaudhuri, A.H. Lushkov and K. Wasdin (eds), *Reception and the Classics: An Interdisciplinary Approach to the Classical Tradition*, Yale Classical Studies 36, Cambridge, 163–73.

Response to V. Platt, 'Bodies, Bases and Borders': Framing the Divine in Greco-Roman Antiquity

Dominic Dalglish

In her contribution, which gracefully positions the images and objects presented in the *Imagining the Divine* exhibition in relation to her own extensive work on ancient material culture, Verity Platt challenges assumptions past and present concerning the centrality of the human form in the conception and perception of images. What this provides is, of course, essential context for these objects that are abstracted from their environments and presented in the modern museum exhibit. More than that, however, this type of critical approach is essential for contemplating the place of material culture in ancient religious life. Discussion of the frame or 'parergonal' elements of images, as Jacques Derrida used the term, thus relates to several issues that have been important for the members of the *Empires of Faith* project.[1]

In some ways, material culture has itself acted as a frame to an understanding of religion derived largely from texts. Buildings or their ruins, representations of gods, altars, processional routes and so on, all provide a structure on which 'religion' can be built. To reassess the relationship between parts of our evidence is inherently to question our understanding of what religion is and was. In much the same way, Platt's piece demands that we reconsider the status of subjects, images and objects that we customarily privilege above others. Thinking about how we use material culture to study religion was in essence the purpose of *Empires of Faith*, and our interest in Platt's work should therefore come as no surprise. In responding to her contribution, I will focus on issues of experience and consider further how we approach material constructions of the divine between intention and perception.

Imagining the divine

The 'frame' relates to whatever was being 'imagined' and how it was rendered. So what was being framed? In respect of divine representations, the frame – 'the elements that support, bound and adorn' – was framing, 'instantiations of [a] divine body' (p. 19). Platt duly takes the emphasis of the *Imagining the Divine* exhibition – especially in its 'Roman zone' – to have been 'the anthropomorphic body' or the representation of gods in human form. This is a broad category and in fact Platt has more specific concerns. Two questions posed at the start of her piece suggest an answer: 'Could it be … that our obsession with the classical body … might sometimes obscure the panoply of other phenomena that shaped ancient imaginings of the divine?' and 'how far is the emphasis of classical studies upon the cult statue as vehicle and focus of ancient religious experience actually the product of early Christian, and later Protestant, preoccupations with idolatry?' (p. 20).

Platt's focus thereafter is the representation of gods – and attention paid to them – as cult statues, but the discussion affords us an opportunity to briefly consider ancient anthropomorphism more generally. This phenomenon – not universal in the cultures of the ancient Mediterranean, but certainly common – is generally considered to be a characteristic feature of ancient religious life. Despite being well known, however, it is worth clarifying what 'imagining' the divine in human form could entail and what part was played by material, visual representations in this process.

This is, I hope, to clarify and extend Platt's discussion of the relationship between the bodies of gods and the place and status of 'idols' for the existence of the divine.

What was it to 'imagine the divine' in the ancient Mediterranean? Did people conceive of a kind of versatile 'action figure' in the mind that could be manipulated into any number of positions and be part of a host of situations? This was certainly possible, as is abundantly clear from ancient literature. From the first to the last book of *The Iliad*, we are told of gods feeling emotions, engaging in actions and occupying specific places (i.e. being 'here' or 'there'). We are also given the means of picturing them through descriptions of their appearance, some of which are almost inseparable from the gods themselves: 'aegis-bearing Zeus', 'white-armed Hera', 'bright-eyed Athena'. As Platt notes, these descriptions are never particularly detailed; they are specific references to particular features of the gods rather than the whole; the audience is left to fill the gaps. At other times, we are asked to imagine the gods in totally different forms: as birds or animals, or in the guise of specific humans (not the divine). Imagining gods also involved the conception of them in all manner of scenarios: another feature of ancient Mediterranean culture was the sheer number of types of situation in which people envisaged the gods partaking, from what might be thought of as the erotic or scandalous through to reverential or solemn occasions.[2]

It was not only in oral and written media that gods took shape. Dramatic performances brought the gods to life through actors taking on an appearance and manner intelligible to audiences as 'divine'. By the 5th century BCE, Greek gods appeared in wall and panel paintings, as sculpture and on pots that depicted scenes from written and orally transmitted myths. In these renderings, the gods were positioned – often with tell-tale iconographic indications of their identity, for example a caduceus for Hermes – in different postures and poses. The bodies of gods in these visual representations were as malleable as the narrative scenes in which they featured. This made for a fluid existence between evocations of them in poetry, dramatic performance, written description and their visual representation across a broad span of material culture.

Body, form and object

All of these conceptions were forms of anthropomorphic renderings of gods, and yet none of them were really the focus of *Imagining the Divine*. Although the exhibition did incorporate representations of gods in narratives, we were more concerned with what we might call their *iconic* appearance. In other words, although these were representations of gods, our interest lay less with the body of the deity than with the form of images and objects through which they were represented. This includes their iconographic features, the choices of media and formal aspects of the compositions. A bust of Zeus, a statue of Dionysus, a 'good shepherd' or a robed Christ are not quite the same as the divine imaginings previously discussed. For one thing, aspects of them were resolutely inflexible. As in those literary depictions, iconographic attributes are often prominent, but here their form is far more fixed. Experience of the gods through these images and objects might therefore

be considered different from other media, in part because of precisely the framing methods that Platt has highlighted. One was not necessarily more 'religious' than another, but, as strategies for contemplation of the divine and the presentation of ideas about them, they nevertheless differed.

Platt's piece explores 'what happens when we decentre the body (and, correspondingly, the anachronistic concept of the "idol") when "imagining the divine"' (p. 22). By doing so, she comes to argue that the body was itself a frame (p. 30) onto which parergonal iconographic and decorative features were placed that in turn served to raise the status of the object. The *Imagining the Divine* exhibition was, of course, concerned with embodiment – through visual and material culture – of the divine. It might then seem that Platt's approach is inconsistent with our own. In fact, the decentring objective of her contribution is well attuned to the deconstructive approach of *Empires of Faith*. Rather than approach gods as whole entities, we have sought to understand how they existed through a great variety of means, which were duly experienced differently by those who encountered them. Our concern in the exhibition was then less with the *bodies* of gods, than with the way that they were made to exist through iconic forms of representation, in the formal composition of the body in space, and through iconographic features of the objects.

Platt's use of the 'frame' to mean something that can both support and contain also allows us to understand how divine bodies could frame experiences of other objects.[3] Contrasts in representations of the divine – in media, formal composition and iconography – distinguished spaces and objects that occupied them. To demonstrate this, we can briefly return to the statue of Athena Parthenos. There are many features that frame it, particular those which organise space: the pathways through and views from across the city of Athens, the Athenian Acropolis and its buildings, and the Parthenon itself and its division of rooms. But another way that a viewer is introduced to this object is through other representations of the divine that not only surround it in a physical space, but serve to clarify the difference between the Parthenos statue as a way of experiencing the god and other means of imagining this deity. For brevity's sake, we shall take only other representations of Athena.

Someone coming to the Athenian Acropolis in the late 5th century BCE, whether familiar with the goddess Athena or not, was confronted by a number of representations of ostensibly the same goddess, albeit in different aspects. Here, the 2nd-century CE writer Pausanias provides us with details from which a selection will suffice. A 'portrait' of Athena Hygeia ('health') was in the vicinity of the entrance to the Acropolis.[4] Close by was a bronze group of Athena and the satyr Marsyas, known today from a copy in marble now in the Vatican.[5] Perhaps the most striking object – certainly by size – was the colossal bronze statue of Athena Promachos ('first in line') situated between the gate of the Acropolis and the Parthenon.[6] This statue showed the goddess wielding a spear above her head, striding forwards as if about to launch her weapon at an approaching foe. On the Parthenon itself, the two pediments of the building featured representations of Athena at their centre: on the east, her birth fully grown and armed from the head of Zeus; on the west, her conflict

with the god Poseidon for patronage of Athens.[7] On the frieze that runs atop the interior porch walls, Athena again appears on the central section of the east frieze, this time seated, framing the display of the *peplos* with her father, Zeus, mirroring her pose on the other side.[8] These 'active' or narratological representations of the goddess are in stark contrast to the image and object within, which is further emphasised by the likely appearance of Athena among the 20 gods assembled at the birth of Pandora on the Parthenos' base, and perhaps also among the gods fighting giants in the gigantomachy on the interior of her shield.[9] In any event, the activity of these scenes served to demonstrate how removed the Athena Parthenos representation of the god was from these others. The extraordinary size of the object, not to mention its composition from ivory and gold, also 'othered' it precisely through comparison with the numerous other Athenas on the Acropolis.

The viewer imagining the goddess – if not before walking up the Acropolis, then certainly as they approached the Parthenon – could have envisaged the deity in a malleable form. In fact, the images that frame the Athena Parthenos encourage one to do so. But the character of these representations in contrast to that of the statue – situated in and dominating a symmetrical space, distinguished by its material and size, not lifeless but static – would have heightened the experience of the goddess within this space. This experience was not discrete from other visual encounters with the goddess; in fact, it was in part produced through them, as they served to highlight the particularity of the Athena Parthenos. Rather than contrasting the presentation of the divine body – the same or similar in appearance and dress – the contrasts were a product both of framing and of aspects of the form and materiality of the object.

Intention and perception

Consideration of the parergonal – the marginal, periphery elements or the frame – puts us in a better position from which to question suppositions surrounding the status of divine images and/or 'cult statues' in ancient religious life. The study of particular subjects (e.g. a god) or forms of object (e.g. a cult statue) remains an important approach to the broader study of material culture and religion. Platt's work points to an understanding of 'frames' and what is 'framed' in concert, best understood as attempts to shape *experience*. This reframing, if you will, allows us to understand the representation of divinities as part of strategies – not universally but commonly employed – to engender experiences of the divine. In doing so, we do not deny the significance of material renderings of gods, but rather question our preoccupations with aspects of the material and our proclivities in selecting what we consider to be of import.

To discuss experience and strategies aimed at producing particular effects is to consider power. A 'frame' implies intention: the deliberate organisation of media to communicate information and/or shape experience. At the same time, to challenge our understanding of what constitutes marginal elements of images and object assemblages is to recognise that frames are in part constructs of the viewer. All of the members of *Empires of Faith* have grappled with the nexus that material culture presents – and where so much of the intrigue that surrounds it lies – between a producer's intention and a viewer's perception.[10] The issue is of critical importance in determining what type of religious histories we wish to write and what it is that we want to communicate about the ancient world. The great variety of presentations of gods in the ancient Mediterranean – in all manner of media – suggests that there is more to be gained, perhaps, from an assessment not of what was communicated, but how communication was achieved. This allows for a flexible assessment of the various possible perceptions of media, even if we acknowledge or are able to ascertain intention. It is particularly important for assessing cultures of accumulation; rarely in the ancient world was one ever working with a blank canvas – constant revision, adaptation and reinterpretation were not peculiar but the norm.

Notes

1 'Parergon' is the first part of Derrida 1978 (translated as Derrida 1987). The second section of this part, 'Le parergon', is the most important here (also available in English as Derrida and Owens 1979).

2 On 'godsbodies' more generally, see the important discussion in Osborne 2011: 185–215.

3 See in particular on this Platt 2011: ch. 2.

4 A statue by Pyrrhos: Pausanius 1.23.4, also mentioned in Plutarch, *Pericles* 13.8.

5 Pausanius 1.24.1. The Marsyas and Athena group is generally thought to be the work of Myron, thanks to a reference in Pliny *Historia Naturalis* 34.57. Vatican group: inv. nos 9974, 37022, 9975, 9970.

6 Pausanius 1.28.2, made by Pheidias *c.* 456 BCE supposedly from the spoils from the victory against the Persians at Marathon in 490 BCE.

7 Pausanius 1.24.5. Though large parts of the pediments survive, the central parts depicting Athena are both either missing or fragmentary.

8 This section of the frieze survives: British Museum, 1816,0610.19.

9 Pliny *Historia Naturalis* 36.18–19; Platt, this volume, p. 23.

10 None more so than Jaś Elsner and his work on the Roman viewer (Elsner 2007).

Bibliography

Derrida, J. 1978. *La Vérité en peinture*, Paris.

— 1987. *The Truth in Painting*, trans. by G. Bennington and I. Mcleod, Chicago.

Derrida, J. and Owens, C. 1979. 'The parergon', *October* 9, 3–41.

Elsner, J. 2007. *Roman Eyes: Visuality and Subjectivity in Art and Text*, Princeton.

Osborne, R. 2011. *The History Written on the Classical Greek Body*, Cambridge.

Platt, V.J. 2011. *Facing the Gods: Epiphany and Representation in Graeco-Roman Art, Literature and Religion*, Cambridge.

Chapter 3
Comparing Material Texts: Introduction to U. Bongianino and B.C. Tilghman, 'Kufa and Kells: The Illuminated Word as Sign and Presence in the Seventh–Ninth Centuries'

Katherine Cross

The visitor walking through the *Imagining the Divine* exhibition began by facing large-scale, anthropomorphic stone sculptures – Roman gods, seated statues of the Buddha – and ended, in the final room, contemplating illuminated parchment. The organisation of the exhibition by religious tradition and by chronology placed early Islamic codices next to Christian art from the Insular world. There was stone here, too, but sophistication, creativity and investment in religious visual production had found a new outlet over the course of the 1st millennium, and the last word for exhibition visitors certainly lay with just that – the written word.

This series of juxtapositions gave rise to Umberto Bongianino and Benjamin Tilghman's comparison. In the final gallery of the exhibition, in the display of Islamic and Christian holy books from the 6th to 11th centuries, we saw visual echoes between these distinct traditions. Parchment glittered with gold; entire pages were filled with densely worked designs. In our curatorial meetings, the *Empires of Faith* team discussed placing the Rawlinson Gospels next to a leaf from the Gold Qurʾān in a single case, to highlight those parallel elements. Yet, somehow, viewed side by side, the similarity seemed less convincing. Suddenly the basic differences stood out: the horizontal and vertical formats, the highlighted letters in the Insular Gospel book compared to the even use of colouring on the Quranic script, and even the differing states of conservation testifying to divergent histories of collecting and display.

We were not the first to suggest similarity. As Bongianino and Tilghman indicate, the unique Blue Qurʾān and the purple pages of deluxe Christian codices like the Royal Bible or the Stockholm Codex Aureus may perhaps have had common ancestors in Roman and Byzantine imperial productions.[1] Common ancestors have also acted as explanation for the prominence of decorative designs in Insular Gospels and Kufic Qurʾāns. Scholars have searched for the origins of 'carpet pages' found in Insular Gospel books, from the repeating patterns of the Book of Durrow to the designs developed around a central cross motif in the St Chad Gospels. Some have suggested that Roman mosaic pavements provided the inspiration for such pages; the same kind of source may have contributed to the full-page geometric decoration in Islamic manuscripts.[2] While the term 'carpet pages' may have been intended to refer to such pavements, the dominant allusion rapidly became the 'Oriental' rug, segueing into a perception of similarity or connection. Intimations of 'Eastern' influence on Insular manuscript art frequently refer to apparent Coptic models, identified by comparative method and through possible connections with Eastern Christian communities as the means of transmission.[3]

Bongianino and Tilghman's rigorous form of comparison holds a different kind of explanatory power. Theirs is a rare case in that it privileges neither case study, but treats them on equal terms: they neither mine Islamic traditions for possible influences on western Europe, nor hold up the early medieval Christian tradition as a norm or benchmark. Such an equal comparison is (usually) only possible through collaboration between experts in different fields. They seek not to identify connections, but to pinpoint similarity and

difference with more precision, thus focusing our eyes on specificities. This process of 'estrangement', as they name it, can provide a means of removing assumptions and generalisations, while building up a more complex and densely layered picture of developments in the second half of the 1st millennium. We do indeed see a flowering of manuscript art and commitment to the written word across the wider Mediterranean world, but there are no simple explanations here. Moreover, the distinctions between Christian and Islamic doctrinal positions and material productions bring us back to the idea of connection with a fresh perspective: we can imagine dialogue, response and reaction, rather than disembodied transmission.

The comparison here views Islamic and Insular manuscript art as intimately bound up with religious doctrine and its interpretations. It all comes back to representation: how members of different religious communities attempted to represent the divine, and their anxieties in doing so. The written word was not subject to the same struggles as were images in the 1st millennium, but its aesthetic qualities did provoke overlapping concerns – issues of interpretation and mediation, of representation and revelation. Viewed from this perspective, Pope Gregory the Great's statements in letters of 599 and 600, that pictures are the books of the unlearned, do not render images quite so innocuous.[4]

This chapter, then, demonstrates the distinct contribution of art-historical comparison to our understanding of 1st-millennium religion. Yet it also gestures towards the possibilities of viewing the same comparative cases through a different disciplinary lens, and bringing in more strictly historical variables. As a historian reading their piece, I was prompted to think about the material and social contexts of the production of these manuscripts. An Insular Gospel book was the product of a monastic scriptorium, and it can reveal further networks of ecclesiastical contact: the painter of the St Chad Gospels (c. 725–50) seems to have known the Lindisfarne Gospels (c. 700), for instance, and an 8th-century stone fragment from Aberlady (East Lothian) repeats the same design of interlaced birds that appears on its cross-carpet page.[5] More than this, however, they are products of institutions, not individual scribes and artists. The names we know, such as that of Eadfrith, the scribe of the Lindisfarne Gospels, present themselves as points of connection and of historical reference, but we must not forget that these individuals acted within their communities. After all, we know to associate Eadfrith with the Lindisfarne Gospels from the colophon added by a 10th-century priest, Aldred. Aldred listed the names not merely of the scribe but also of the bookbinder and the jeweller who covered it (all members of the community), and stated that the book was written 'for God and for St Cuthbert and – jointly – for all the saints whose relics are in the island'.[6] Besides the colophon, Aldred's own addition to the Gospels was an interlinear English translation, some three centuries after the book was first produced.

When we have information about the production of Quranic manuscripts, or maṣāḥif (sing. muṣḥaf), it is generally in the formal, original inscription naming the calligrapher and/or the donor-patron, although these almost never

survive in pre-10th-century manuscripts. The 'Nurse's Qur'ān', a fragmentary manuscript of the 11th century, is particularly interesting in this respect, since it not only mentions the calligrapher, 'Ali b. 'Aḥmad, but also the female donor, Fatima, a nursemaid in the court of the governors of North Africa, and a woman named Durra, a court secretary who may have supervised the production of the codex.[7] Such references become more common from the 11th century, but the use of paid scribes, and of non-Muslim scribes in the early period, seems to have been controversial.[8] Bongianino suggests that, more usually, the production of Quranic manuscripts of the 8th and 9th centuries may have been centred on 'dedicated scriptoria' (p. 51) under rulers and governors. Where the money and materials for Insular Bibles came from is often unclear – sometimes from a wealthy commissioner, perhaps, but frequently from the communities themselves and their estates; on the other hand, it is the scribal contexts of Quranic production for which we have little to guide us. We are certainly dealing with broadly comparable investments of wealth, resources, time and skill, but further consideration of who made those investments would, no doubt, distinguish the nature of the value ascribed to these books in different societies.

Colophons are relatively unusual (although their appearance in Insular manuscripts suggests another possible Eastern Christian influence),[9] but inscriptions record more about the lives of these books than their creation. The St Chad Gospels and a mid-8th-century Canterbury Gospel book, now known as the Stockholm Codex Aureus, bear witness to their own plundering and later purchase or ransom. The purchaser of the St Chad Gospels exchanged them for 'his best horse',[10] while the ealdorman Ælfred and his wife, Werburg, redeemed the Codex Aureus from vikings with 'pure gold'. These exchanges indicate that Christians and pagan vikings alike recognised lavish holy books as economic assets, which could be bought and sold. In the Islamic world, the controversy over paid scribes is but one facet of the discomfort over treating maṣāḥif in such a mercenary fashion, with some scholars prohibiting the buying and selling of Quranic manuscripts, and others protesting the use of Quranic text on coinage – the greater issue being one of ritual purity.[11] Legal notices recording the endowment of Qur'āns to mosques reflect the accepted attitude.

This is not to say that the special status of Gospel books did not guide their fates. Ælfred and Werburg claimed to have redeemed and donated the Codex Aureus to Christ Church, Canterbury, 'because we did not wish these holy books to remain longer in heathen possession'.[12] More often, as also in the St Chad Gospels, marginal additions in luxury Bibles recorded land grants or manumissions – economic information seemingly unrelated to the holy text. Yet, even then, it must have been the status of the book as preserved and respected by the community and by God that attracted such records. Oaths, legal transactions and donations all gained a sense (and perhaps, a greater reality) of permanence by their proximity to holy scripture. It is my impression that such notes are much less frequent in early Quranic manuscripts. Occasionally, calligraphers added

marginal notes giving details of the book's endowment (see **Pl. 3.8**), and in a few instances readers have recorded births.[13] It would be worthwhile investigating the occurrence of marginalia and the different information recorded in the two traditions. The permanence of holy books might be envisaged as unchanging and eternal, apart from the material world; or it might be accumulative, gathering adherents and associations throughout the life of the manuscript.

Colophons and marginalia point also to the role of political patronage and investment in religious texts and books. The uniformity of Islamic holy books, Bongianino and Tilghman suggest, lies with imperial power and centralisation; Christian manuscripts, in contrast, were each time 'an opportunity to cast the Gospels in a new and different form' (p. 53). This is an important insight, but it is also worth pausing to recognise that Christian rulers did not have the administrative structure to enforce such uniformity even if they desired to. Charlemagne (r. 768–814) – or, rather, Alcuin, his leading scholar and later abbot of Tours – made some efforts in that direction: the single-volume Bibles created at Tours are perhaps the closest that early medieval western Europe had to imperially sponsored mass production of holy books. Several of the Tours Bibles were produced for export to other monasteries, cathedrals or lay owners, but there is no evidence for a programmatic dissemination equivalent to that of the Umayyad governor al-Ḥajjāj (694–714), or of the Abbasid caliph al-Mahdī (775–85), who sent Qur'āns to the empire's capital cities for public recital.[14] The Carolingians placed emphasis on legibility and a correctly emended biblical text, rather than on complete uniformity.[15] The Tours Bibles did not become a universally authoritative model, nor was their production matched by any stifling of diversity, in contrast to caliphal attempts at either destroying or canonising variant texts of the Qur'ān.[16] For producers of early medieval Bibles, imperial authority was more often something to be invoked than obeyed. The Codex Amiatinus, for instance, produced for the Pope before 716 and modelled, partly, on Italian exemplars, was intended to tie the remote monastic community of Wearmouth-Jarrow to Rome: Rome as the seat of St Peter, but also as the imperial centre.[17]

Finally, the comparison brings us to a deeper understanding of social developments and concepts, most notably in the relationship between the spoken and written word. Scholars of the 1st millennium are by now familiar with the idea that orality and literacy co-occurred and intersected – that these were not separate systems, nor should we imagine a progression from orality to literacy.[18] In considering side by side early Islamic and early medieval Western Christian relationships with the holy word, the importance of this understanding is reinforced. Here we have two separate examples of the interaction between oral and literate cultures demonstrating this principle in divergent ways. As Bongianino and Tilghman so elegantly put it: 'If the Qur'ān originated as an oral text that was written down at one point, the New Testament was a written text regularly performed orally' (p. 52). The functioning of the written word in society immediately alters culture, administration and memory, creating a semi-literate society,

however few can actually read it.[19] But how that written text was imagined in relation to the spoken word is also of immense significance. When layered with religious meaning, incorporating issues of divine inspiration or revelation, and the complexities of language or possibilities of translation, then questions of belief *about* words must be as central to our investigations as is their practical function.

This last area is where art historians and historians can most profitably combine their energies in further investigation. Beyond the bounds of the central scripture and the pages of holy books, how did the written word act in society – and what did people believe about it? These questions open up the possibilities of a much broader comparison that investigates the functioning of the religious word as an object of study equivalent to the image in terms of materialising the divine. Other religious traditions can illuminate our understanding: the Dunhuang manuscript of the Heart Sutra (see **Pl. 1.4**), also displayed in the *Imagining the Divine* exhibition, provides further grounds for interrogating beliefs about translation, reading, image and speech.[20] This is an image created from words, that can only be read by the initiated and that claims to be a translation even while only being possible in the script in which it is now written: the Chinese characters, which must be read beginning from the centre, form the shape of a stupa, each character taking up equal space. We must also consider our manuscripts alongside those objects that have long been the preserve of the epigraphist or archaeologist. These holy texts, even when written, have never been confined to the manuscript page. As one materialisation of scripture among many – monumental inscriptions, amuletic tags, legends on coins and reliquaries – how do books convey their special meanings and definitive status?

Notes

1 Brown 2011: 24; Netzer 2011: 239; Bloom 2015: 196–218. D'Ottone Rambach 2017 suggests a direct Christian precursor from 9th-century Spain.
2 Kendrick 1938: 98–9; Elsner, Lenk *et al.* 2017: 154.
3 Brown 2003: 312–21 (where she also suggests the use of prayer mats in Western Christian communities); Brown 2011: 34.
4 Chazelle 1990.
5 Brown 2003: 380–1, 400; Henderson 1987: 124.
6 Lindisfarne Gospels (London, British Library, Cotton MS Nero D.iv), f. 259r; Brown 2003: 102–4.
7 Déroche 2017; Elsner, Lenk *et al.* 2017: 105–6.
8 Blair 2008: 81; George 2017: 125.
9 Brown 2011: 29. On colophons, see Gameson 2001.
10 Henderson 1987: 126.
11 Zadeh 2009: 454–5.
12 Dodwell 1982: 9.
13 George 2017: 121.
14 George 2017: 118; and below, p. 51.
15 Ganz 1994; McKitterick 1994.
16 Flood 2012: 265.
17 Bray and Story 2018: 126–7.
18 Innes 1998: 3–5.
19 Goody 1977; Finnegan 1988; Thornton 1988.
20 Elsner, Lenk *et al.* 2017: 80–1.

Bibliography

Blair, S.S. 2008. 'Transcribing God's word: Qur'an codices in context', *Journal of Qur'anic Studies* 10, 71–97.

Bloom, J.M. 2015. 'The Blue Koran revisited', *Journal of Islamic Manuscripts* 6, 196–218.

Bray, C. and Story, J. 2018. *Anglo-Saxon Kingdoms: Art, Word, War*, London.

Brown, M. 2003. *The Lindisfarne Gospels: Society, Spirituality and the Scribe*, London.

— 2011. 'The eastwardness of things: relationships between the Christian cultures of the Middle East and the Insular world', in M.T. Hussey and J.D. Niles (eds), *The Genesis of Books: Studies in the Scribal Culture of Medieval England in Honour of A.N. Doane*, Turnhout, 17–49.

Chazelle, C. 1990. 'Pictures, books, and the illiterate: Pope Gregory I's letters to Serenus of Marseilles', *Word & Image* 6, 138–53.

Déroche, F. 2017. 'Le prince et la nourrice', *Journal of Qur'anic Studies* 19, 18–33.

Dodwell, C.R. 1982. *Anglo-Saxon Art: A New Perspective*, Manchester.

D'Ottone Rambach, A. 2017. 'The Blue Koran: a contribution to the debate on its possible origin and date', *Journal of Islamic Manuscripts* 8, 127–43.

Elsner, J., Lenk, S. *et al.* 2017. *Imagining the Divine: Art and the Rise of World Religions*, Oxford.

Finnegan, R. 1988. *Literacy and Orality: Studies in the Technology of Communication*, Oxford and New York.

Flood, F.B. 2012. 'The Qur'an', in H. Evans (ed.), *Byzantium and Islam: Age of Transition*, New York, 265–9.

Gameson, R. 2001. *The Scribe Speaks? Colophons in Early English Manuscripts*, H.M. Chadwick Memorial Lecture 12, Cambridge.

Ganz, D. 1994. 'Mass production of early medieval manuscripts: the Carolingian Bibles from Tours', in R. Gameson (ed.), *The Early Medieval Bible: Its Production, Decoration and Use*, Cambridge, 53–62.

George, A. 2017. 'The Qur'an, calligraphy, and the early civilization of Islam', in F.B. Flood and G. Necipoğlu (eds), *A Companion to Islamic Art and Architecture, Vol. I: From the Prophet to the Mongols*, Hoboken and Oxford, 109–29.

Goody, J. 1977. *The Domestication of the Savage Mind*, Cambridge.

Henderson, G. 1987. *From Durrow to Kells: The Insular Gospel-Books, 650–800*, London.

Innes, M. 1998. 'Memory, orality and literacy in an early medieval society', *Past & Present* 158, 3–36.

Kendrick, T. 1938. *Anglo-Saxon Art to AD 900*, London, 98–9.

McKitterick, R. 1994. 'Carolingian Bible production: the Tours anomaly', in R. Gameson (ed.), *The Early Medieval Bible: Its Production, Decoration and Use*, Cambridge, 63–77.

Netzer, N. 2011. 'The design and decoration of Insular Gospel-books and other liturgical manuscripts, c. 600–c. 900', in R. Gameson (ed.), *The Cambridge History of the Book in Britain, Vol. I: c.400–1100*, Cambridge, 225–43.

Thornton, D.E. 1988. 'Orality, literacy, and genealogy in early medieval Ireland and Wales', in H. Pryce (ed.), *Literacy in Medieval Celtic Societies*, Cambridge, 83–98.

Zadeh, T. 2009. 'Touching and ingesting: early debates over the material Qur'an', *Journal of the American Oriental Society* 129, 443–66.

Kufa and Kells: The Illuminated Word as Sign and Presence in the Seventh–Ninth Centuries

Umberto Bongianino and
Benjamin C. Tilghman

The notion of sacred word occupies a key place in both Christian and Muslim theologies, with the Bible – particularly the Gospels – and the Qur'ān acting as a fundamental link between the faithful and the divine. As suggested by literary and material evidence, and often asserted in modern discourses, the content of both scriptures could and did assume, in particular contexts, visual and iconic connotations that transcended its textual meaning through a process of aestheticisation: word eliding into image.[1] In this essay, however, we will attempt to sharpen our sense of the aesthetics of holy writ in early Islam and early medieval Christianity by challenging the very utility of denoting calligraphic forms as 'image', emphasising instead the importance of locating the meanings of calligraphy within specific codicological and doctrinal contexts.

Undeniably, the material and visual care shown to holy writ in both revealed religions reflects a shared emphasis on the theological importance and numinous qualities of their respective scriptures. It is therefore hardly surprising to see broad visual similarities between early Gospel books and manuscripts of the Qur'ān. The *Imagining the Divine* exhibition at the Ashmolean Museum featured, among many instances of sacred writing, two deluxe codices from the 9th century that share a number of common characteristics, despite their profound differences in content and creation: the Royal Bible of Canterbury (**Pl. 3.1**) and the Blue Qur'ān of Kairouan (**Pl. 3.2**).[2] Both manuscripts use precious metals and vibrant pigments on parchment folios coloured in rich, dark hues to create a striking visual effect: the beholder is immediately impressed with the understanding that the text here presented is of a supremely important sort.

These similarities can be extended to the way in which such opulent codices were used and consumed within their communities. For example, early medieval Gospel books, often covered in highly decorated bindings featuring precious metals and gemstones, were carried through churches and served as a point of visual focus during ritual.[3] Although Quranic manuscripts never played a prescribed liturgical role during canonical prayers, medieval Arabic sources abound with references to their relic-like nature and the symbolic importance of their position in ceremonial settings.[4]

Even today, both religions make use of lavishly decorated books in a way that goes far beyond the simple act of reading them, thus emphasising their numinous nature as receptacles of revelation and simulacra of the divine. This is especially evident in the case of manuscripts that are particularly old, large, precious or otherwise extravagantly made, the more so when associated with saintly figures. In Islam, a special veneration is accorded to those Qur'āns said to have belonged to the third caliph, 'Uthmān b. 'Affān (r. 644–56), or to those allegedly copied by the fourth caliph 'Alī b. Abī Ṭālib (r. 656–61), traditionally revered as the first master of calligraphy, especially in Iran.[5] Similarly, the St Augustine Gospels, traditionally understood to have been brought to England by its eponymous missionary and first Archbishop of Canterbury, are still used today in the ceremony of enthronement for a new primate of the Church of England.[6]

It is evident, then, that there are many lines along which a comparative approach can bring forth telling parallels between these two traditions, especially when considering the way in which sacred books were commissioned, produced and displayed.[7] One might even go so far as to argue that, despite superficial differences such as language, script and ornamental repertoire, Christianity and Islam are fundamentally united in their way of treating holy writ visually and materially. In this essay, however, we aim to investigate the historical and ideological differences that underlie these superficial similarities. We believe that a comparative approach to these two manuscript traditions is instructive, not so much for the commonalities it reveals, but for the distinctions that it throws into sharper relief.

In the following pages, we will explore two intertwined problems that epitomise the different conception of sacred books developed by Latin Christianity and Sunni Islam between the 7th and 9th centuries. The first problem relates to the materiality of the codex, and to the different doctrinal, ritual and symbolic functions it performed. The second problem concerns calligraphy and illumination, and the way in which these two media were semiotically charged (or discharged) so as to best express the nature of the revealed text they were chosen to adorn. In tackling these questions, we will exclusively focus on deluxe Gospel books, which commonly found use in liturgical settings, and on mosque codices, by which we mean Quranic manuscripts intended for public ritual use.

Switching viewpoints on Qur'āns and Gospel books

The discipline of comparative art history, as we see it, can bear fruit in two different ways: by revealing what is familiar in objects that are unfamiliar, and by renewing scholarly interest in artefacts that have become subject to habitual seeing. As an exercise in this latter process of estrangement, we have deemed it useful to imagine how a western medieval cleric would have reacted to the aesthetics and materiality of an early Quranic codex and, conversely, how a Muslim religious scholar would have perceived a Christian illuminated manuscript, setting aside their possible aversion to the books' doctrinal content. The resulting considerations

Plate 3.1 Royal Bible, early 9th century, f. 43r, gold, silver and pigment on dyed parchment, h. 47cm. British Library, London, Royal MS 1 E VI. Image © British Library Board

have helped us develop a sharper edge to the traditional treatment of the subject, allowing a fresh look at some well-known material.

If we take as an example a folio from the famous Gold Qur'ān (**Pl. 3.3**), several unfamiliar features would immediately attract the attention of a medieval Christian beholder.[8] There is, first and foremost, the format: wider than it is tall, the horizontal orientation of the page is a marked departure from the habitual shape of the Christian

Plate 3.2 Bifolio from the Blue Qur'ān, 9th century, gold and silver ink on dyed parchment, h. 28.9cm. The Sarikhani Collection, I.MS.1024. Image © The Sarikhani Collection

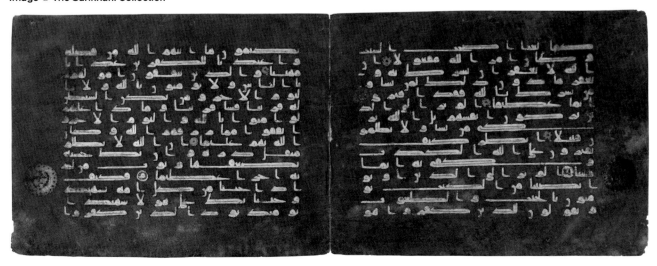

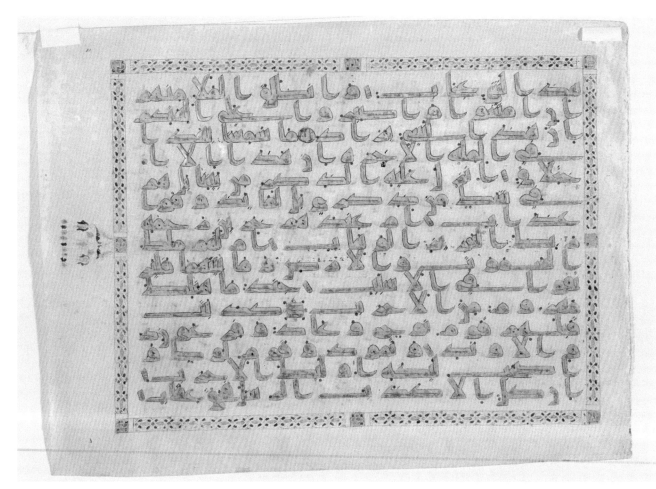

Plate 3.3 Folio from the Gold Qur'ān, 9th century, ink, gold and watercolour on parchment, h. 27.4cm. The Sarikhani Collection, I.MS.1020. Image © The Sarikhani Collection

Plate 3.4 St Chad (or Lichfield) Gospels, p. 16, h. 31.7cm. Lichfield Cathedral Library, MS 01. Image © Chapter of Lichfield Cathedral, CC BY-NC-SA 4.0

codex. In the Christian tradition, the upright rectangular format is not a simple accidental feature but had become, by the early Middle Ages, an iconographic motif that immediately conveyed the idea of 'bookness' in pictorial communication, as will be discussed later in this essay. The format is also important for reasons beyond the familiarity of shape, as it changes the way that the beholder relates to the codex phenomenologically. The horizontal parchment leaves are more flexible and unconstrained than upright folios stitched along the long side. As a result, the kinetic experience of turning the pages is amplified as they swing dramatically through the space of the reader. But perhaps the most striking aspect of the orientation is aesthetic. The elongated Kufic letters of the Arabic match the oblong format of the book, creating a pleasing resonance which even the non-Muslim viewer would be able to appreciate. The impression is that of an intentional congruence between script and format, in contrast with the calligraphy of early Gospel books, which often works dynamically against the upright format of the page. In fact, while Christian scribes frequently used vertical ascenders and descenders, they also employed dynamic diagonals and compressed letters along the horizontal axis, treating the frame as a kind of foil against which to play the forms of calligraphy.[9]

A prominent feature which would not escape our Christian cleric is the way in which the Gold Qur'ān is supremely concerned with creating a page that is pleasing as a unified whole. This concern is also apparent, to a certain extent, in deluxe Gospel books: consider, for instance, how

the scribe of the St Chad Gospels attempted to meet the ruling on both the left *and* the right sides of text pages, occasionally truncating words, breaking them across two lines or, on one occasion, decoratively elongating a letter M (**Pl. 3.4**).[10] The Gold Qur'ān, however, outstrips its Christian contemporary in consistency and harmony: the variegated nature of Christian writing and the particular forms that make up its alphabet(s) cannot match Arabic for producing a unified calligraphic composition. While geometric forms were a common feature of major decorative pages in Christian manuscripts, Quranic codices were suffused with a geometric sensibility on every folio – in ornament but also, and perhaps principally, in script. To a medieval scribe accustomed to the constant shape-shifting of letter forms in contemporary Christian manuscripts, this level of consistency and geometric rigour would indeed be astonishing.

Finally, something about the illumination of the Gold Qur'ān would arguably perplex the Christian beholder. The manuscript is, clearly, a deluxe codex, with its golden script recalling the most luxurious Gospel books of the time. However, the framing border on each page does not call attention to itself as the borders of luxurious Christian manuscripts do. It is scaled to less than the width of a line of text, and thus is rather unassuming within the page as a whole. Both the border and the foliated vignette in the left margin appear understated in their design, despite the use of gold and coloured pigments. The decoration thus falls somewhere between the relative simplicity of regular text

pages in Christian manuscripts – even the most opulent ones – and the complexity and invention of major initial pages.

The Gold Qur'ān and other Qur'āns from the same period opened with full-page illuminated frontispieces that would have most likely reminded our Christian viewer of the carpet pages of Insular Gospel books (**Pls 3.5, 3.7**). However, if the harmonious geometric design of these compositions would have felt familiar, the use of gold as the primary medium engenders a very different effect from the variegated pigments of Insular carpet pages, perhaps emphasising magnificence over complexity. Our Christian viewer would have looked in vain for any of the zoomorphic shapes that enliven most, if not all, of the Insular carpet pages, and would also have noted the lack of any other major decorative elements, save perhaps the finispiece at the end. Overall, the decorative programme of early Quranic manuscripts would likely have struck the eye of a medieval Christian as somewhat betwixt and between: too visually meagre for a deluxe codex, but much too lavish for a workaday book.

Now, in a similar way, let us imagine the possible reaction of a 9th-century Muslim scholar confronted with a manuscript such as the St Chad Gospels (**Pls 3.4, 3.6–7**). Contrary to his Christian counterpart, he would be acquainted with the book's format, since most Qur'āns of the first Islamic century shared the same vertical orientation (the transition to the horizontal format was only completed at the beginning of the 9th century). Polychrome

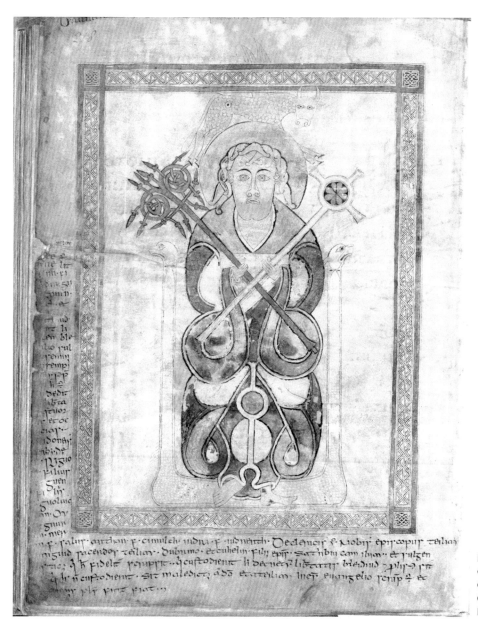

illumination would also be a familiar concept, in terms of both ornate calligraphy and full-page drawn decoration and frontispieces, which he would easily understand as a way of beautifying and enhancing the codex. However, other features of the St Chad Gospels would undoubtedly puzzle him, and perhaps disturb him.

First of all, our Muslim scholar would probably feel a sense of unease about the presence of figural representations in a religious manuscript (**Pls 3.6–3.7**): since the beginning of Islam, figural art has consistently been avoided in religious contexts, as is well known. He would be troubled, and perhaps even offended, by the more superficial iconographic messages of the illumination (such as the cross), while the complex symbolism of other motifs would simply fall beyond his comprehension (for example, the birds and quadrupeds, perhaps representing pelicans or peacocks and lions respectively, with their Christological connotations). He would doubtless marvel at the bewildering variations of calligraphic styles in a single codex, and at the malleability of the different scripts and letter shapes employed by the scribe. This feature would perhaps make him wonder whether the text was not written in a number of different languages, or

whether the manuscript did not include a series of disparate and unrelated texts, perhaps copied at different times. While the qualitative aspects of penmanship displayed in the St Chad Gospels would surely be acknowledged, the iconographic treatment and symbolic charge of different scripts and alphabets (Greek letters, runes, zoomorphic initials, etc.) would certainly be lost on him.

Also surprising to our Muslim scholar would be the scribe's attempts to highlight particular passages or sentences in the text (such as in **Pl. 3.4**, for the Beatitudes) at the expense of the visual balance and harmony of the written page. Whereas in the Islamic tradition every single letter of the Qurʾān is equally sacred and deserves the same calligraphic treatment, the way in which this and other Gospel books were copied eloquently conveys the structure of the text and often also the ways in which the text was read and interpreted. It would be hard for him to understand why the first letters of verses are calligraphically elaborated, or why certain verses are treated differently from the surrounding text. Moreover, in the full-text pages of the St Chad Gospels, the scribe seems to have accepted the visual noise of a jagged right margin caused by the desire to make

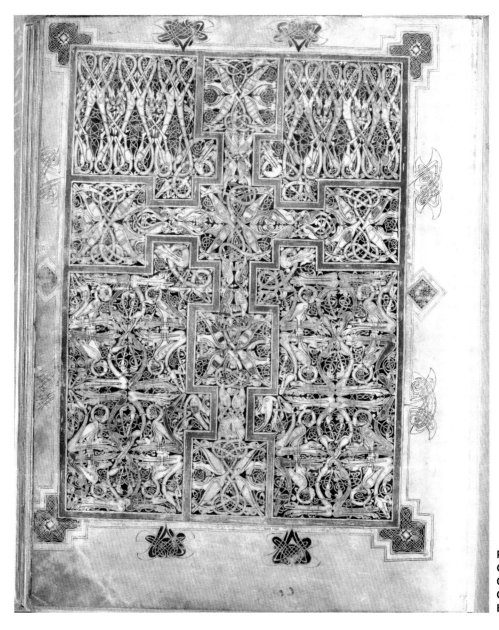

the end of each line coincide with the end of a word or, at least, with a syllable break. This results in written pages that, despite the aforementioned attempts to create visual unity, would still strike our Muslim beholder as untidy, asymmetric, perhaps even unsuited to represent the numinous nature of the Revelation.

If we were to draw an interim conclusion from these observations, we could certainly say that, despite the similar techniques and approaches to the illuminated Word adopted in these two traditions, scribal practice also diverged in important ways. In the case of Insular Gospel books, for instance, scripts and letter forms are constantly combined with iconographic motifs, shaped and reshaped by an extremely elaborate system of symbolic references acting on multiple interpretive levels. In the case of early Quranic codices, the text is treated in a much more sober way – certainly not in the choice of pigments and calligraphic forms, but in the geometric, uniform, almost hypnotic character of every single page, and in the rejection of textual hierarchies and symbolic references. While both scribes were thinking carefully about the text they copied and how it would be received by the beholder, we can provisionally

conclude that the amanuensis of the St Chad Gospels was primarily thinking textually, while the calligrapher of the Gold Qur'ān was mainly concerned with the visual qualities of his work. In the following discussion, we will explore how the divergent aesthetic features of Gospel books and Quranic codices reflected important doctrinal distinctions between the very nature of the two revealed texts.

Casting holy writ in script and codex

In order to better understand these doctrinal differences, we must broaden our perspective to consider some of the cultural forces at work in both the British Isles and the Arabian Peninsula during the 7th century.

Looking first at the British Isles, we find that many early Gospel books, such as the St Chad Gospels, are marked by strongly individualised styles that often reflect their local and regional artistic traditions. Such an insistence on regional identity accords with a European political and cultural geography that was marked by division and fluidity in the early medieval period.

It is important also to remember that the codex arrived in the early medieval British Isles as an iconic object. We know

that missionaries believed that the visual appeal of sacred books aided in their evangelisation of peoples who were largely illiterate.[11] And the iconic Gospels also just so happened to land in a region where text was commonly employed in ways that emphasised its sense of presence. The two primary non-Latin writing systems, runes and ogham, were rarely – if ever – used in literary contexts in the British Isles in the early Middle Ages. Rather, they served primarily as epigraphic scripts, serving often to invoke ancestors or absent patrons. Holy writ was therefore received into a culture that already understood writing as something to be seen and felt as much as read, and this provided fertile ground for the elaboration of new calligraphic forms.

The development of Insular Gospel books has often been cast as a process of assimilation whereby the 'foreign' forms of late antique Mediterranean Christianity were shaped to reflect regional traditions and tastes.[12] But we should be mindful to recognise how self-conscious these changes were. The Codex Amiatinus – which looks astonishingly like a late antique book – bears a dedicatory inscription emphasising that it was made at the edge of the world, and a distinct sense of the distance separating the British Isles from the rest of the known world was a common feature of early medieval discourses.[13]

Insular consciousness of being at the periphery is one of the driving forces shaping the scripts of this region. Insular Christian scribes were particularly aware of local paganism and of Roman authority, and they wanted to translate both into something that was distinctly of their place. Thus, the image of Matthew in the Lindisfarne Gospels famously derives from the same source as the image of the scribe Ezra in the Codex Amiatinus (see **Pl. 3.9**), and casts it in a markedly graphic style, with an inscription that transcribes the Greek word 'AGIOS' in Roman letters rendered in runic forms.[14] These differences are the products of two distinct sacred agendas: the Codex Amiatinus was designed as a gift to the Pope, while the Lindisfarne Gospels served the ecclesiological needs of its Northumbrian monastic community.[15] When we look at the decoration of an early medieval Gospel book, then, one of the first questions we must ask ourselves is how its decoration marks – or effaces – its particular geographic, temporal and cultural origins. Even though the Gospel text might have been seen as timeless and universal, the specific visual and material form of any given copy would have associated it with a particular place.

When considering the coeval Islamic world, scholars have often remarked on the diverse cultural history and scribal traditions of the regions conquered in just a few decades by the Umayyad armies, from the Iberian Peninsula in the west, to Transoxiana and the Indus Valley in the east. Despite this incredible geographic and cultural diversity, the codification of an 'official' (or perhaps 'orthodox') mode of treating holy writ seems to have taken place not only in a very short period of time – between the end of the 7th and the beginning of the 8th century – but also within a relatively limited geographic span – roughly between Arabia and Greater Syria, in the so-called central Islamic lands. This means that there is little need to bring into the discussion the peripheries of the caliphate (which were crucial in many other respects) if our aim is to investigate the aesthetics and

doctrinal framework of early Quranic manuscripts. In the Islamic calligraphic tradition of the first centuries, the 'centre' stretches out to reach the extreme peripheries, in an attempt to impose a single style and format for transcribing and disseminating the Qur'ān throughout the Islamic world. This successful quest for uniformity demonstrates the existence of a widespread and carefully devised doctrine that hinged upon the semiotic power of lavish Quranic codices. Incidentally, that uniformity also renders it virtually impossible to attribute such manuscripts to particular scriptoria, cities or even regions with absolute certainty.[16] This contrasts sharply with the Latin Christian world, where attempts to harmonise the styles of the periphery with those of the centre (usually Rome) can always be associated with distinct political and religious programmes on the part of makers and patrons.[17] Claims of universality, somewhat paradoxically, were very often locally motivated.

Interestingly, the rise of Islamic calligraphy shares some commonalities with the Insular Christian milieu. Based on archaeological and epigraphic evidence, Arabic writing in late antique Arabia and Syria mainly served commemorative purposes similar to those of ogham and runic inscriptions in the British Isles.[18] Just like those Insular alphabets, pre-Islamic Arabic scripts were only loosely codified, and were regionally varied, aesthetically modest and not ornamented in any way. However, while ogham and runes may have possessed magical connotations and a certain sacred quality, which would be occasionally transferred into Christian manuscripts and inscribed liturgical objects, pre-Islamic Arabic epigraphy was a purely utilitarian medium, the expression of 'a vernacular employed by non-literate peoples and by those who, for whatever reason, preferred to write in other languages',[19] especially Greek and Syriac.

It is essentially with the codification of the Qur'ān and the rise of Islam that inscribed tombstones, commemorative texts, milestones, coinage and so forth acquired a special geometric configuration, stylistic uniformity and iconic aura driven by the extensive inclusion of Quranic formulae and excerpts. In brief, it was to visually express the numinous character of the Revelation that Arabic acquired its first calligraphic and geometric codification, with the birth of Kufic script. This happened 'at the turn of the 8th century, in the context of the state-building programmes of the [Umayyad] caliphs 'Abd al-Malik and al-Walīd', when the new script 'spread to different media, and was consistently displayed as a vehicle of the public image of the new religion and state'.[20] However, while Alain George and other scholars have argued for the influence of state-sponsored epigraphy (such as the mosaic inscriptions of the Dome of the Rock) on the scripts developed by Quranic calligraphers, it seems more likely that this aesthetic revolution was primarily driven by the transformations that were occurring in the Quranic manuscripts of the period. In fact, if angular Kufic became the only accepted mode of conveying the Qur'ān in all media for the following three centuries, this norm was arguably first established in the codices, which were the Qur'ān's primary mode of transmission, and not in monumental epigraphy, which served other purposes, and ultimately depended on the preparatory drawings of Quranic calligraphers.

As opposed to the British Isles, where the arrival of Christian manuscripts completely revolutionised the local notion and perception of holy writ, the rich scribal traditions of late antique Arabia, Egypt, Syria and Iraq exerted a strong influence on the rise of Islam as a scriptural religion. Syriac, Greek, Aramaic and Coptic codices circulated among Christian communities of different denominations, and the early Muslims were perfectly aware of their material aspect and liturgical importance. Christian manuscripts in Middle Persian are also attested in north-west Arabia and Mesopotamia in the 7th century, as well as Hebrew scrolls from Egypt, Palestine and Babylonia, written on both papyrus and parchment. The model followed by the earliest Quranic copyists must have been that of Christian parchment codices, especially Greek and Syriac, and some Islamic sources mention Christian calligraphers hired by Muslims to transcribe the Qurʾān.[21]

The problems posed by the writing down of the Qurʾān, however, went far beyond the choice of scribal models. All Islamic traditions stress that the Qurʾān is an oral revelation: sacred utterances resulting from Muḥammad's mystical visions, etched on the hearts of his companions, who memorised them and handed them down through recitation. But oral transmission soon proved difficult within a rapidly expanding empire, and the first caliphs were faced with the problem of how to make sure that the Qurʾān was preserved and transmitted correctly. They could no longer rely on Muḥammad's companions, who were dying out, or their pupils, who had begun to break down into factions and come up with a number of textual variants. The Qurʾān had to be codified in written form as quickly as possible, a task that was undertaken by a group of scholars by order of the third caliph, ʿUthmān b. ʿAffān, at least according to later Muslim sources.

Up until the last quarter of the 7th century, what can be seen in the material features of Quranic manuscripts is the result of sensible, utilitarian choices. From this early period, all that survives are around 600 sparse folios and fragments written in the so-called 'Ḥijāzī style' (from Ḥijāz, the region of Arabia where Mecca and Medina are located), on parchment leaves of vertical format, with very rare use of margins, ruling or decoration. As observed by François Déroche, these scripts are unassuming and highly individual, and do not attempt to convey any visual message: in short, there seems to be very little visual ideology in these early fragments.[22] All this would change dramatically with the codification of Kufic scripts, and the introduction of geometric principles and extensive illumination in the imperial codices produced under ʿAbd al-Malik (r. 685–705) and al-Walīd (r. 705–15), some of which were sent to the mosques of the main cities of the caliphate – Damascus, Mecca, Medina, Kufa, Basra, Fustat and also possibly Sanaa and Kairouan – in the early 700s.[23] This process reached its peak under the Abbasid caliph al-Mahdī (r. 775–85), when a new series of monumental codices was again sent to the main mosques of the caliphate,[24] and continued in the 9th century, with the proliferation of multi-volume horizontal codices, some of which were entirely written in gold.

These manuscripts, arguably produced in dedicated scriptoria and commissioned by rulers and governors to be endowed to important congregational mosques, were lavish artefacts: unwieldy, extremely voluminous and created with the intention of boosting their materiality as sacred objects at the expense of their textuality as books. Furthermore, they were penned in highly stylised, uneconomic, barely legible scripts exempted from standard orthographic rules, which vigorously demand to be appreciated for their extralinguistic, pictorial features. A number of scholars have persuasively argued that these manuscripts were principally meant as a mnemonic aid for professional reciters who had already memorised the text of the Qurʾān.[25] However, the same scholars have rarely concerned themselves with the possible reasons why such recitational props had to be this large, lavish and elaborate. The economic implications of these aesthetic choices – the use of hundreds of parchment folios, gold, precious pigments and so forth – are especially worth considering: endowing such artefacts meant immobilising a considerable amount of capital into a fixed asset, for the exclusive benefit of a single mosque and its clerics (**Pl. 3.8**).[26] Because these assets had little practical use and were categorically inalienable (that is, they could not be sold for money, even in times of dire need), the symbolic and ideological motives behind these endowments – and behind the material features of the manuscripts themselves – must have been particularly compelling.

When considered alongside the sustained engagement with the transcendent oral nature of the Revelation in the history of the Qurʾān, the early history of the Christian Bible is marked by a high degree of textuality. Although the teachings of Christianity must have been largely transmitted orally as the religion spread, the core of the faith was clearly understood to lie in the written accounts that recounted the story of Jesus and his early disciples, and it is telling that the early Christian community, generally with few resources and occasionally under official persecution, made a concerted effort to publish and disseminate those written accounts.[27] Also telling is the clear preference in the New Testament for textual sources: epistles rather than sermons, histories rather than songs. Jerome's Vulgate translation constantly reaffirms this textuality, especially in the Gospels. Mark and Luke both include short prefaces which clearly designate the text as a written source, and it is certainly not a coincidence that the Gospels as a whole commence with the word 'book' (Mt 1:1: *Liber generationis Iesu Christi*; 'The book of the generations of Jesus Christ'), and conclude with a particular emphasis on the writing of books (Jn 21:25: *quae si scribantur per singula, nec ipsum arbitror mundum capere posse eos, qui scribendi sunt, libros*; 'which, if they were written every one, the world itself, I think, would not be able to contain the books that should be written').

Throughout the early Middle Ages, manuscript production similarly emphasised this textuality. A full account of that tradition is outside the scope of this essay, but two examples should suffice to illustrate this phenomenon.[28] In 331, the Roman emperor Constantine sent a letter to Eusebius, Bishop of Caesarea, in Palestine, directing him to 'order fifty volumes with ornamental leather bindings, easily legible and convenient for portable use, to be copied by skilled calligraphers well trained in the art, copies that is of Divine Scriptures, the provision and use of which you well know to be necessary for reading in

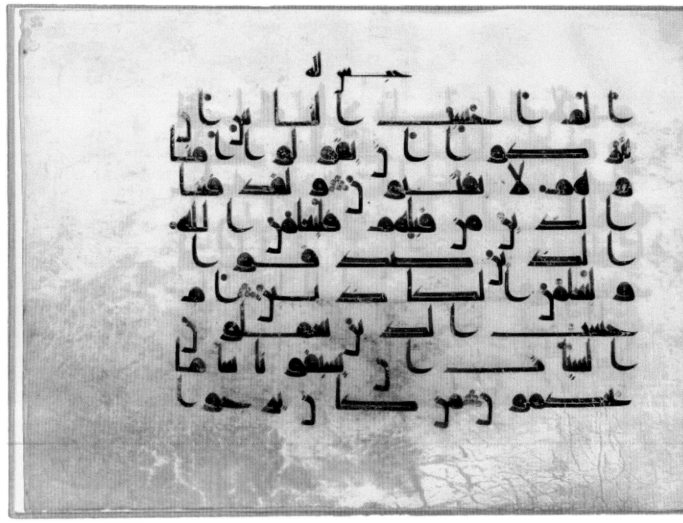

Plate 3.8 Bifolio from a Qur'ān endowed to the Great Mosque of Damascus in 911, ink, gold and watercolour on parchment, h. 23cm. The Morgan Library and Museum, MS M.712, ff. 19v–20r. Image © The Morgan Library & Museum

church'.[29] The term 'divine scriptures' might not refer specifically to full Bibles, since pandects were very rare at this time. It is possible that Constantine asked for Gospel books or lectionaries, which would be more appropriate 'for reading in church'.

The passage above clearly reveals Constantine's concerns with the books' material and visual form, concerns that were both practical (legibility and convenience) and aesthetic (the ornamented bindings). But the fact that he put this request to Eusebius of Caesarea, who at this time was in Palestine, or perhaps Antioch, and thus a less convenient source, is telling. Though Eusebius is now largely remembered as the first historian of the Church and Constantine's court biographer, at the time he was better known for his work as a textual critic, having produced editions of the Septuagint and the Gospels, which he divided into subsections that prefigured modern chapters and verses and would be used throughout the Middle Ages. These subsections were then listed as a series of concordances that became a fixture in the prefatory material for early medieval Gospel books. Such canon tables are an emphatically textual form designed to aid the kind of cross-referenced reading that is deeply embedded in the nature of written communication.[30] So, even as Constantine's request emphasises the oral performance of scripture, it still affirms its essential

textuality. If the Qur'ān originated as an oral text that was written down at one point, the New Testament was a written text regularly performed orally.

Many centuries after Constantine, we can observe the textuality of the Christian Bible emphasised in the Codex Amiatinus, especially in the miniature representing Ezra (**Pl. 3.9**). Though the emphatically Roman style of the painting has already been noted, it is the iconography and the accompanying *titulus* that is most illuminating in this context. Behind the man is a large bookcase brimming with volumes, and another book and writing utensils are scattered about the floor. An inscription at the top of the page identifies him:

> When the sacred codices were burned by the enemy horde,
> Ezra, glowing with God, repaired this work[31]

The text refers to the passage in IV Esdras, an extra-biblical text that circulated in early medieval Europe, where the Jewish scribe Ezra is commanded by God to gather around him a team of scribes to restore the scriptures that had been destroyed during the Babylonian captivity. Fittingly, the intricate headpiece and breastplate that he wears mark him as a Jewish high priest, at least according to contemporary iconography, but his garment is the habit of a Benedictine monk. Ezra, the ancient protector and restorer of scripture,

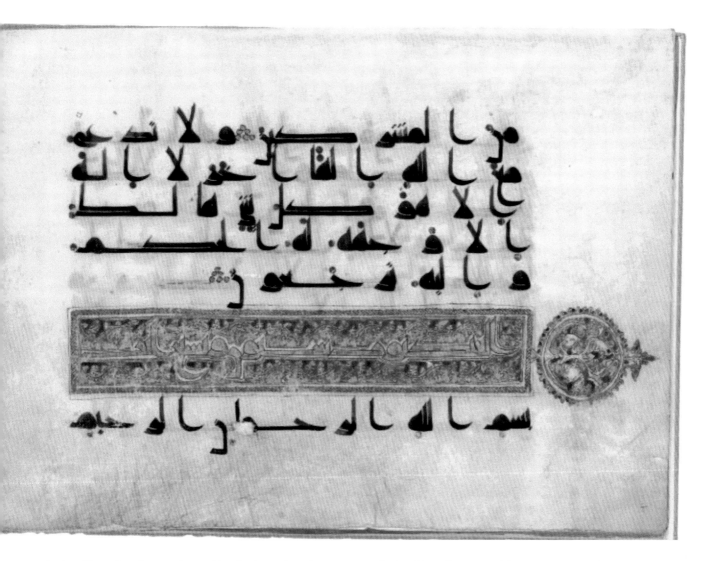

is thus likened to the monks working in the scriptorium at Wearmouth-Jarrow in England where the Codex Amiatinus was produced. Coming near the end of several centuries of tumult following the dissolution of the Roman empire, Abbot Ceolfrith and his monks seem to be setting themselves up as 'latter-day Ezras', sharing with Rome the scriptures that they have protected and restored. In fact, it has been proposed that the inscription and miniature so closely reflect the scholarship of Bede, then a resident of Wearmouth-Jarrow, that he may have been directly involved in their creation, perhaps even wielding the pen and brush.[32]

As a frontispiece to the volume, the portrait of Ezra the scribe surrounded by books marks the Codex Amiatinus as a work of bibliography: the text may be that of the Bible, but this particular edition of it is deeply concerned with bookmaking. Just a few pages after the portrait of Ezra is a succession of diagrams showing different ways of grouping the books of the Bible according to Saints Augustine, Jerome and Epiphanius, and then a further diagram showing the books of Pentateuch.[33] The Codex Amiatinus emphasises the bookly nature of Christianity in another way: it was apparently modelled in part on the now-lost Codex Grandior of the Roman scholar Cassiodorus (c. 485–c. 585), who commissioned the book as part of a larger Bible-production programme for the library of the Vivarium, his monastery in southern Italy.[34] The depiction of Ezra, in fact, seems likely to be based on one of Cassiodorus from the

Codex Grandior, a suspicion supported by faint impressions on the page that indicate it was traced from another source.[35]

The text of the Gospels, and of the Christian Bible more broadly, was thus conceived throughout the early Middle Ages as a resolutely bookish form. It is not for nothing that the Evangelists are often pictured as scribes writing in bound codices, even though medieval scribes much preferred to work on loose, unbound sheets. The format of the codex was intrinsic to the origin and meaning of the Gospels. At the same time, every new Gospel book afforded an opportunity to cast the Gospels in a new and different form. That early medieval Christians did so with great regularity – even enthusiasm – indicates that they were not just comfortable with visual difference, but might have seen it as appropriate, or even necessary. As in the Islamic tradition, deluxe Gospel books were often commissioned and gifted as impressive acts of piety and munificence, but the tradition of seeing the form of biblical codices as highly mutable favoured a greater stylistic diversity, allowing patrons and scribes to carefully tailor a manuscript to address the spiritual, political and ideological needs of a particular moment.

Sign and presence in the Bible and the Qur'ān

Christianity and Islam emphasised the experience of holy writ as an encounter with the divine on the one hand, and as a complex message to be contemplated and interpreted on

CODICIBVS SACRIS HOSTILI CLADE PERVSTIS
ESDRA DŌ FERVENS HOC REPARAVIT OPVS

Plate 3.9 Codex Amiatinus, early 8th century, fol. Vr, ink and pigment on parchment, h. 50cm. Florence, Biblioteca Medicea Laurenziana, Ms. Amiatino 1. Image: by permission of the Ministero per i Beni e le Attività Culturali

the other. But the relative balance between affective and intellectual responses to scripture within each religion was significantly different. Early Islam tended to privilege the transcendent experience of scripture, while Christian doctrine emphasised close readings and complex exegesis of the text. The Qur'ān was largely believed to be the uncreated manifestation of God and His Word (*kalām Allāh*), but the teachings of prophets and evangelists in the Bible were understood as mortal communications that led to salvation through their study.[36] Since the texts in the Bible needed to be decoded to be understood, early medieval Christianity was deeply invested in the concepts of 'sign' and 'symbol'.[37]

Conversely, it seems that early Islam was relatively less concerned with questions of signification in writing, and more tied to a notion of divine immanence. At the risk of oversimplifying the issue, it can be argued that the Qur'ān was not conceived of in hermeneutic terms by the majority of

its recipients, but rather as pure and clear Revelation, as implied in the verses 'And We have sent down on thee the Book that makes all clear' (16:89) and 'a book whose verses are explained in detail, a Qur'ān in Arabic for a people who know' (41:3). In the only Quranic passage acknowledging the existence of 'verses that are ambiguous', these are explicitly presented as lying beyond human comprehension – 'Nobody knows their true interpretation, save God' – and condemned are those who 'pursue what is ambiguous, seeking discord by pursuing its interpretation' (3:7). As opposed to early Christianity, in which exegesis became a core part of the religious discourse, the task of extrapolating the meaning of difficult narrative and normative passages in the Qur'ān (*tafsīr*) was undertaken by a relatively small cohort of professional exegetes, mostly concerned with the grammatical and semantic aspects of particular words or expressions.[38] As a result, it seems that the faithful's prevailing approach to the Quranic text, especially in the

first centuries of Islam, would have been based less on interpretation and more on surrender, in accordance with the original meaning of the word 'Islam'.

One can distinctly perceive a reflection of this doctrinal principle in the aesthetics of Kufic calligraphy. The solemn uniformity and strict geometric configuration of these scripts evoke an all-embracing feeling of numinousness which is deliberately disengaged from the meaning of the text. The purpose is never to give semiotic emphasis to particular letters, words or passages, but to present the Word of God as an indivisible and homogeneous continuum. It is indeed tempting to regard codices of the Qur'ān as being more about the experience of the revealed text than about its actual meaning. This may also explain why some iconographic experiments in Umayyad illumination, clearly derived from contemporary Christian practices, were soon abandoned by Quranic scribes: through their symbolism, they emphasised the sign over the presence. Although lacking representations of living beings, realistic depictions of mosques and paradisiac gardens such as those found in the Sanaa Umayyad codex may still have seemed incompatible with the doctrine of Quranic immanence, and were therefore replaced by entirely abstract geometric compositions and stylised vegetal motifs in later manuscripts.[39] The absence of iconographic symbolism from the work of the Quranic calligraphers and illuminators of the Umayyad and early Abbasid periods seems to support our antithetical characterisation of the Muslim and Christian scriptural traditions. These artists – who must also have been religious scholars – do not seem to have ever been interested in depicting, or even alluding to, some of the Qur'ān's most striking images, from the divine glass lamp blazing in the niche of the Verse of Light (24:35), to God's throne in the Throne Verse (2:255), to the many vivid descriptions of heaven and hell. Similarly, they never tried to give material form to the symbolic interpretation of the letters of the Arabic alphabet advanced by some contemporary authors, from the Sufi exegete al-Tustarī (d. 896) to the Shiite al-Qummī (d. 911), to the famous philosopher Avicenna (980–1037).[40]

Unlike the Christian Bible, the Islamic Revelation did not derive its sacredness from it being a kaleidoscope of allegories and symbols,[41] but rather from two other aspects that are absent from the Christian scriptural tradition and that epitomise the dual nature (oral and written) of the Qur'ān. The first aspect relates to the Qur'ān's linguistic perfection and miraculous literary qualities, according to the doctrine of i'jāz or 'inimitability' of the sacred book.[42] Experiencing the Qur'ān meant (and often still means) marvelling at its beautiful and poignant expressions, rhythm and sounds, especially when chanted by a professional reciter; such oral performances are traditionally believed to induce ecstasy, weeping, fainting and even the immediate conversion of the listeners.[43]

The second aspect, developed as a consequence of the Qur'ān's written codification, concerns the intrinsic sacredness of Quranic manuscripts as the physical manifestation of the divine, and as the materialisation of the Qur'ān's celestial matrix, referred to in the Qur'ān itself as umm al-Kitāb ('mother of the Book', in 13:39 and 43:4) and lawḥ maḥfūẓ ('guarded tablet', in 85:22). This theological concept naturally resulted in Quranic codices being treated and revered as sacred objects, endowed with charismatic and talismanic qualities. From very early on, they were touched only by people in a state of purity, reverentially stored and displayed, ritually kissed, employed for divinatory purposes, brought in procession, paraded on the battlefields and so forth.[44] It is therefore possible to interpret the rise of Quranic calligraphy and illumination as a means to express this second aspect, and to provide a suitable visual counterpart to the oral performance and acoustic experience of the Qur'ān.

In order to visually express the extraordinary nature of the Qur'ān, Umayyad and early Abbasid calligraphers made use of powerfully immediate and sensuous signifiers, whose rationale is not to be found in the erudite works of exegesis and philosophy of the period. This semiotic strategy did not just rely on the large size and solemnity of Kufic scripts; crucial elements were also the chromatic contrast between the parchment and ink, the frequent use of chrysography, the perfect proportions of the page layout based on the golden ratio, and the exceptional horizontal format that aimed to set the Qur'ān apart from all other Islamic and non-Islamic books (including those of the Christians and the Jews). Had these copyists continued to attach a specific symbolism to, say, letters of the Arabic alphabet, colour schemes, geometric shapes and the like, they would have irremediably fallen behind the other religions of late antiquity with their well-established iconographies and manuscript traditions. Instead, they understood the necessity to reject iconography as an interpretive method, changed the rules of the game and succeeded in creating a powerful and original paradigm for presenting the Qur'ān in its material form.

If the Quranic tradition is marked by an unease about iconography, in early medieval Gospel books we see an ecstatic embrace of it. Let us consider, for instance, the Gospels of Medard of Soissons, produced in the milieu of the court of Charlemagne around the year 800.[45] Each Gospel in the manuscript is prefaced by a full-page representation of its respective evangelist facing a calligraphic treatment of the Gospel's first words. At the beginning of Luke on ff. 123v–124r (**Pl. 3.10a–b**), we find the Evangelist busy at his writing desk, inspired by the Holy Spirit acting through his symbol, the Ox, above him, while across the gutter we see the beginning of Luke 1:1: *Quoniam quidem multi conati sunt in ordinare narrationem …* ('Forasmuch as many have taken in hand to set forth in order a narration …'). Viewed together, the adduced images present not a contrast between alphabetic sign and iconic image, but a clear understanding of the reciprocity and resonance between them. Notice that Luke and his symbol both hold books with writing in them: the Ox's codex repeats the verse on the opposite page, while Luke's features a verse (6:36) from later in his Gospel. The image of written words on the left-hand page is mirrored by the presentation of writing as an image itself on the right. Besides the striking visuality of the large golden initials, both the Q and the O act as frames for representational images. The enthroned Christ in the Q particularly serves to reinforce an identification of holy writ with the eternal Word

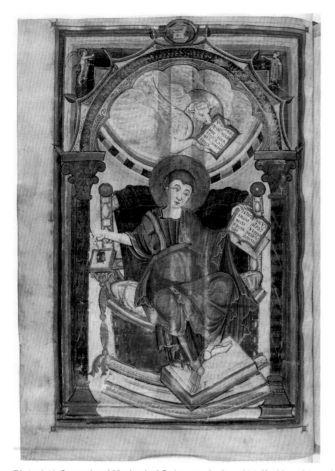
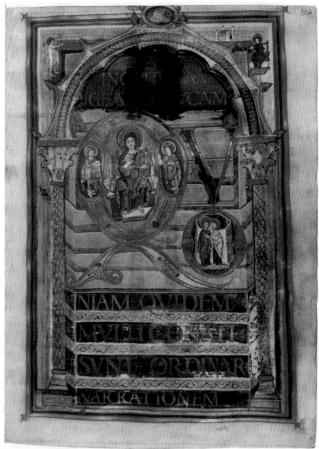

Plate 3.10 Gospels of Medard of Soissons, before 814, ff. 123v–124r, gold, pigment and ink on parchment, h. 36.5cm. Bibliothèque nationale de France, Département des Manuscrits, Latin 8850. Image © BnF, reprinted with permission of the Bibliothèque Nationale de France

itself. Formal devices further connect word and image in this opening: the framing of the pages is nearly identical, and the lines of text at the bottom on the right illusionistically advance into the beholder's space just as Luke's foot does on the left, implying a physical presence beyond the visual for both. Further underscoring the visual impact and material presence of writing in the book are the framing devices, often with illusionistic ornamental patterns, that surround the body text of the Gospels. Such semiotic fluidity, in which iconic signs evoke the verbal and words encompass images, can be found in many manuscripts of this time, both in the British Isles and on the Continent. That fluidity is only one of several in early medieval manuscript illumination, where centre and frame, figure and ground, abstract forms and representational images combine to create a complex and sometimes even unstable visual ecosystem.[46] In early medieval Gospel books, we often see artist-scribes exploring ways to stretch and mutate visual forms so that signs multiply across the page.

In fact, one of the dominant concerns of many Gospel books is their own nature as a book and as a bearer of signs. This is particularly true in the Book of Kells, which was made in either Scotland or Ireland in the early 9th century.[47] Books appear with unusual frequency throughout the Book of Kells, appearing in places where we might expect them, such as in the hands of the Evangelists and Christ, and in places unexpected but logical, as with the two figures – possibly deacons – holding books on the initial page to Matthew, thus calling attention to the word *Liber* which

begins the Gospels.[48] The *breves causae* for Matthew (f. 8r), a short summary of the events in the Gospel, features a figure sitting amid the words with a book on his knee and another beside him, seeming to illustrate the reading of the Gospel text that the beholder is about to undertake. While figures carrying books are a stock image in early medieval art, they are far more widespread in the Book of Kells than in any of its contemporaries. Particularly notable are the several images of angels carrying books. While angels are often depicted holding crosses, christograms (chi-rho symbols), cloths of honour and especially the edges of nimbuses, they are rarely shown in early medieval art carrying books.[49] As messengers, the most common means by which angels communicate is orally: they tell and show, but seldom deliver written missives in the form of books.

It is hard to say with certainty what underlies this unusual iconography. The primary association between angels and books at this time seems to be with the *liber vitae* that records a soul's virtues and sins.[50] This is unlikely the case in the Book of Kells, however, since judgement does not seem to be a major theme of the decoration as a whole.[51] Most likely, the book-bearing angels serve to emphasise the nature of the Gospels as a divinely given text. An emphasis on divine transmission would be consistent with the iconographic emphasis on the symbols of the Evangelists, particularly the winged man of Matthew, who appear carrying books throughout the manuscript.[52] In addition, the book-bearing angels in the Book of Kells might also serve as sacramental signs. Carol Farr notes that the three angels bearing *flabella*

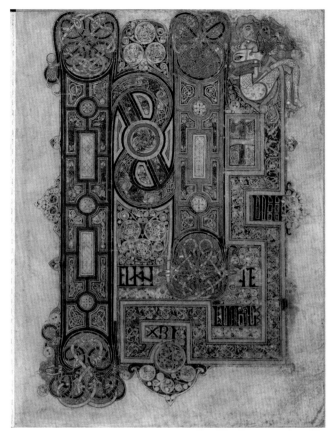

Plate 3.11 Book of Kells, *c.* 800, f. 130r, ink and pigment on parchment, h. 33cm. Dublin, Trinity College Library, MS 58. Image: courtesy of the Board of Trinity College, Dublin

Plate 3.12 Book of Kells, *c.* 800, f. 130r, detail, ink and pigment on parchment, h. 33cm. Dublin, Trinity College Library, MS 58. Image: courtesy of the Board of Trinity College, Dublin

(liturgical fans) and the fourth holding an *aspergillum* (a kind of liturgical sprinkler) mark off the Virgin and Child on folio 8r as occupying a ritual space, with the Virgin perhaps even representing a metaphorical altar for the body of Christ.[53] As a whole, there is a clear programme in the Book fostering resonances with the liturgical understanding of the Gospel text.[54] Images throughout the manuscript of angels carrying books, then, would serve to emphasise the sacramental nature of this particular manuscript, evoking at the same time the idea of the text as divinely given.

The more one notices the many codices in the Book of Kells, the more one observes oblong, upright rectangles as a general form appearing throughout the book. Consider the initial page for the Gospel of Luke (f. 188r), where the centre of the Q can also be read as a representation of a book. The diamond, or lozenge, at the centre of the Luke figure recalls a common motif found on the covers of books in the Book of Kells, as held by the Evangelist John – and this appears in other manuscripts, such as the earlier Codex Amiatinus. A book-shaped design also appears as a minor motif on the initial page for the Gospel of Mark (**Pl. 3.11**). The rectangular panel at the upper right, immediately below the man grappling with the beast, contains the T and I of the word *Initium* (**Pl. 3.12**), with the upright T in black with yellow interlace, and the yellow I crossing it horizontally. The cruciform structure of the composition, in conjunction with the adduced beasts on either side of the stem of the T, might serve to recall contemporary treasure bindings such as the lower cover of the Lindau Gospels, which was probably made in Austria in the late 8th century.[55]

Here we come to a point familiar to scholars of the Book of Kells: motifs, once noticed, seem to proliferate worrisomely. Suddenly, upright rectangles pop up in new places in the manuscript, such as on folio 183r, where we find them included in a passage of display lettering, and next to the seated figure on folio 8r. The motif also appears in the form of several letter Ds that appear throughout the manuscript (**Pl. 3.13**). These Ds depart from the more common form of the Insular half-uncial D with a rounded bowl and upright or fallen ascender. Interestingly, six of the eight times that the rectangular D is used as an initial occur in conjugations of the word *dico* – to say, talk or declare.[56] Heather Pulliam has demonstrated that the minor initials in the Book of Kells often hold broad affinities with certain themes: for example, many of the passages in which Christ confronts the Pharisees are marked off by letters formed by human figures whose legs and tongues are tangled together.[57] Perhaps these book-shaped Ds serve to remind the beholder of the lineage of the text, from the mouth of Jesus to the book before them, thus securing the chain of signs that connects them with the divine. Seen this way, the two exceptions are telling: one is on folio 8r, directly adjacent to the figure sitting with books that we just observed; the other, on folio 101v, occurs in the word *ideo* in a passage where Jesus promises to send people who will also speak the word of God: prophets, wise men and scribes (Mt 23:34).

The book-shaped T-I on the Mark page can be read as confirming the presence of programmatic concerns for the mediated and material nature of the holy text.[58] The puzzling, quasi-monogrammatic nature of the design itself – not to mention the page as a whole – served to call attention to the nature of the biblical text as a complex

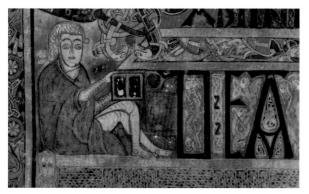

Plate 3.13 Book of Kells, *c.* 800, details of (l. to r.), ff. 8r, 50v and 114v, ink and pigment on parchment, h. 33cm. Dublin, Trinity College Library, MS 58. Image: courtesy of the Board of Trinity College, Dublin

system of signs.[59] But the T-I figure is particularly thick with significance, for it can be seen not only as a book but also as a cross, and within the divine semiotic of Christianity, the cross held a special place as a sign which was at once unique and paradigmatic.[60] In the most general sense, every cross stood as a representation – or at least an evocation – of the cross upon which Christ was crucified. But at very early stages in Christian visual culture, the cross also came to be used and understood as a linguistic sign. The staurogram (tau-rho symbol), for example, serves alongside the christogram as an aniconic representation of Christ in early and medieval Christian visual culture.[61]

The cross became a form where word and image swelled into each other as concomitant representations of the divine. But the cross is clearly also more than a sign for medieval Christians: it is sometimes described as the fundamental structure of the cosmos, and it is constantly used as a gesture of blessing and protection. That is to say that the cross – like the codex – was understood not solely as a sign that pointed in the direction of past people and events, but also as an immediately present form with agency and sacred power. The T-I figure on the Mark initial, in its form, makes particular reference to the cross as a specific material object. The crossing of the T, in forming a second, upper bar for the cross, evokes the True Cross, which had been excavated by the empress Helena, Constantine's mother, and was displayed with gold and jewelled revetments in Jerusalem.[62] The True Cross as a simplified form with a shorter bar added at the top was familiar in the early Middle Ages, especially on Byzantine coinage.

Thus, the T-I evokes immaterial sign and material object in many ways: it is letters, it is a jewelled book binding, it is a cross and it is the True Cross. Interestingly, the form of the True Cross is itself also concerned with the nature of the written sign. The shorter second bar specifically represents the *titulus crucis*, the wooden panel appended to the cross under Pilate's orders which identifies Christ as 'Jesus of Nazareth, King of the Jews' in Latin, Greek and Hebrew. Early medieval theologians such as Isidore of Seville saw in the *titulus crucis* a divine recognition of the translation of sacred truth across languages, which is to say that it highlights the arbitrary nature of the linguistic sign.[63] It is also an instance of the disjunction of literal meaning and contextual sense. To Pilate, the sign was a mocking declaration highlighting the crime of sedition for which Christ was punished, but medieval commentators read the

sign as ironically confirming and proclaiming the truth that Christ's persecutors failed to acknowledge.[64]

The simple combination of the T-I, then, can be read as a dense set of allusions not only to events described in the Gospels, but to the very existence of the Gospels themselves, both as a text and as a codex, and further as a reminder of the Christian practice of spiritual interpretation. Moreover, it appears within a textual passage that is itself self-referential through its proclamation of the beginning of the Gospel (*initium evangelii ihu xri*), with special attention drawn visually to Christ's identity with the Gospel through the framing of the XRI at the bottom. Writing, book, artefact and divine being are collapsed together, even as the difficulty of parsing them emphasises the impossible distance of God.

The origin and nature of the *muṣḥaf*: contemplating the writ in early Islam

The aniconic and anti-iconographic nature of Islamic calligraphy makes it impossible to approach early Quranic codices from the same perspective and through the same methodologies developed by specialists of medieval Christian manuscripts. This can create problems for modern scholars of Islamic art, a discipline that has largely developed along the same lines of enquiry as European art history. Bedrock art-historical concepts such as iconography, symbolism, artistic intent and the use of stylistic analysis for localisation are all nearly useless when considering early Qur'āns. However, this does not mean that art historians cannot contribute fruitfully to the debate surrounding the early history of the Qur'ān, or that the material evidence in our possession does not pose a number of important aesthetic questions. In fact, Islam managed to rapidly establish around the sacred book a complex doctrine that also involved the codification of its material and visual aspects, successfully propagated throughout the empire over the course of three generations, in contrast with the prolonged development and heterogeneity of the Christian scriptural tradition.

As we have seen, the pivotal moment for the canonisation of the Qur'ān in its written form was the second half of the 7th century, a period that stretched between the collation and recension ordered by the third caliph, 'Uthmān b. 'Affān, and the orthographic reform undertaken by the governor of Iraq al-Ḥajjāj (d. 714) in the years 703–5, under the aegis of the Umayyad caliph 'Abd al-Malik.[65] This

period witnessed the development of an entirely new concept that stood in contradistinction to the oral connotation of the word 'Qur'ān' (literally meaning 'recitation') and to the abstract notion of *kitāb* (a generic term meaning 'book' or 'scripture', which is how the Qur'ān mainly refers to itself). This concept was signified by an appositely coined Arabic word: *muṣḥaf* (plural: *maṣāḥif*), a neologism that is not found in the Qur'ān, literally meaning 'a collection of bound leaves/pages', which from its earliest appearance acquired the almost exclusive meaning of 'Quranic codex'.[66] What is particularly interesting for our argument, is that the *muṣḥaf* became – in the literature as well as in practice – almost like an 'alter ego' of the Qur'ān itself, to the point that both terms began to attract pious epithets in common usage, still very much alive today: *al-Qur'ān al-karīm* ('the noble Qur'ān'), and *al-muṣḥaf al-sharīf* ('the honoured *muṣḥaf*'). This phenomenon is indicative of the dualism intrinsic to the sacred book of Islam: while the term Qur'ān signifies the oral, intangible text uttered by Quranic reciters and the faithful during their prayer, the word *muṣḥaf* describes its physical manifestation, equally sacred, but for different doctrinal reasons.

The intrinsic contradiction between oral and written – and between textual and iconic – is palpable in the monumental Quranic manuscripts of the late Umayyad and early Abbasid period, which were penned by specialised calligraphers according to aesthetic canons that emphasised the abstract and pictorial qualities of the text. This aestheticisation came at the expense of its legibility, but the text in those manuscripts was, somewhat surprisingly, accurately vocalised using a complex system of polychrome dots (the so-called system of Abū al-Aswad al-Du'alī) aimed at facilitating the recitation, which often also contemplated alternative readings.[67] This clearly indicates that these codices functioned as much more than simple books: they were repositories of the Revelation, meant to be handled and used by a select few from among the religious authorities, namely those who could decipher this notation system. The act of deciphering the *muṣḥaf*, however, did not require the interpretation of signs and symbols as in the Christian manuscript tradition. Instead, the aim was to breathe life into the shell of the Qur'ān's written text, its hallowed consonantal skeleton (*rasm*), thus transforming it into sound, and bringing it back to its original oral state. According to the early jurist and traditionist Mālik b. Anas (711–94), the institution of this doctrinal principle and ritual practice dates from the years of al-Ḥajjāj: 'The recitation of the Qur'ān from the *muṣḥaf* in the mosque was not performed by the early Muslims. The first to introduce it was al-Ḥajjāj b. Yūsuf.'[68]

Without the performance of a Quranic reciter, the written text of these early Qur'āns would have remained dormant, frozen in its relic-like state, with the Kufic calligraphy conveying in the most eloquent way this sense of arcane fixity. It is indeed tempting to interpret the aesthetic qualities of Umayyad and ancient Abbasid scripts – in particular, their geometric and proportional principles, the *scriptio continua* (lack of separation between words) and the frequent breaking of words between lines – as a way to signify and enhance the non-verbal aspects of the Qur'ān,

and involve the beholder in an act of spiritual contemplation of the Revelation in its pictorial form. More than 40 years ago, Martin Lings wrote that:

> one of the great purposes of Qur'ān calligraphy is to provide a visual sacrament. It is a widespread practice in Islam to gaze intently at Quranic inscriptions so as to extract a blessing from them, or in other words so that through the windows of sight the soul may be penetrated by the Divine radiance of the 'signs of God', as the verses are called.[69]

Statements such as this have been generally criticised as reflecting later sensibilities, popular devotion and non-mainstream practices, especially those established in Sufi circles from the 12th century onwards.[70] According to the vast majority of scholars, it would be anachronistic to imagine that this contemplative approach already existed under the Umayyads and early Abbasids. The visual clues provided by the manuscripts themselves have been largely ignored, and the only accepted discourses around the history of the Qur'ān continue to be based exclusively on its textual nature, linguistic functions and oral performances.[71]

However, a small but extremely interesting body of prophetic traditions demonstrates that the notion of contemplating the Qur'ān can be traced back to the first centuries of Islam, that it was relatively widespread among the Muslim community and that it became directly associated with sayings of Muḥammad himself. For instance, the famous traditionist and historian Abū al-Shaykh al-Iṣbahānī (887–979) included in his *'Aẓama* the following *ḥadīth*:

> It has been related to us by Aḥmad b. 'Umar, on the authority of 'Abd Allāh b. Muḥammad b. 'Ubayd …, on the authority of Abū Sa'īd al-Khudrī – may God be pleased with him – that the Messenger of God – peace be upon Him – said: 'Give your eyes their share of worship.' They asked: 'O Messenger of God, what is their share of worship?' He replied: 'Looking in the *muṣḥaf*, contemplating it and recognising its marvellous nature.'[72]

The choice of verbal nouns (*al-naẓar*: 'gazing'; *al-tafakkur*: 'concentrating'; *al-i'tibār*: 'pondering') makes it extremely clear that, as far as this *ḥadīth* is concerned, the act of reading or reciting the Qur'ān is not under discussion. What the faithful are encouraged to do instead is to behold the *muṣḥaf* and reverentially meditate on its portentous nature, a task that was arguably facilitated by the mesmerising and awe-inspiring quality of Kufic calligraphy (**Pl. 3.14**).

In another *ḥadīth* attributed to Muḥammad, the act of gazing intently at a Quranic manuscript (*al-naẓar fī al-muṣḥaf*) is presented as an act of worship in itself, conceptually distinct from the practice of Quranic recitation (*tilāwa*, *qirā'a*):

> It has been related to us by al-Ḥarīrī, on the authority of al-'Usharī, on the authority of al-Dāraquṭnī …, on the authority of Abū Hurayra, that the Messenger of God – peace be upon Him – said: '[There are] five [forms] of worship: eating small quantities of food is [an act of] worship; sitting in the mosques is [an act of] worship; looking in the direction of the Ka'ba is [an act of] worship; looking in the *muṣḥaf* without reciting [the Qur'ān] is [an act of] worship; looking at the face of a learned man is [an act of] worship.'[73]

According to a long-established and widely accepted exegetic tradition, the visuality of the Qur'ān – that is, what

Plate 3.14 Folio from a Qur'ān, mid-9th century, ink, gold and watercolour on parchment, h. 21.5cm. The British Library, MS Or.1397, f. 17v. Image © The British Library

is perceived by the eyes – is as significant as its textuality, which the faithful experience through the ears. The *muṣḥaf* makes it possible for these two aspects to converge and manifest themselves at the same time, as explained by several medieval theologians, including al-Nawawī (1234–77), on the authority of earlier scholars and the consensus of the *salaf* (the companions of the Prophet and their immediate successors):

> Recitation from the *muṣḥaf* is better than recitation by heart, because looking in the *muṣḥaf* is a required [form of] worship: the act of reciting is thus combined with the act of gazing. Thus spoke Ḥusayn the judge from among our contemporaries, as well as Abū Ḥāmid al-Ghazālī and all of our forefathers.[74]

The spiritual merits that the *muṣḥaf* can earn the faithful through its material and visual qualities had already been remarked by early traditionists such as al-Ṭabaranī (873–971), in their commentary on the prophetic *ḥadīth*: 'Recitation without the *muṣḥaf* is worth a thousand, but recitation from the *muṣḥaf* is worth many times more.'[75] To make the sacredness and miraculous beauty of the Qur'ān manifest to the eye, the Islamic tradition seems to have encouraged the use of calligraphy from the very beginning, and a careful scrutiny of the *ḥadīth* literature could contribute considerably to our understanding of Umayyad and ancient Abbasid scripts and their aesthetics. For instance, the *Muṣannaf* of Ibn Abī Shayba (776–849) transmits the following saying attributed to ʿAlī b. Abī Ṭālib, the son-in-law of the Prophet and fourth caliph:

> It has been related to us by ʿAbd al-Malik b. Shaddād al-Azdī, on the authority of ʿUbayd Allāh b. Sulaymān al-ʿAbdī, that

Abū Ḥukayma al-ʿAbdī said: 'I was copying Quranic manuscripts in Kufa, and ʿAlī passed while I was at work, and he told me: "Make your reed pen splendid!" So I sharpened its nib, and then I wrote, and he said: "Just like that! Make luminous what God has made luminous!"'[76]

Other sayings and anecdotes included in Ibn Abī Shayba's *Muṣannaf* stipulate that the *muṣḥaf* should always be copied in a large format and majestic script, and that the word *muṣḥaf* itself should never be used in its diminutive form (*muṣayḥif*).[77] These passages seems to confirm the hypothesis formulated by François Déroche that the notion itself of 'Quranic calligraphy' may have originated as an ideological move: the production and diffusion of monumental codices penned according to precise aesthetic norms would have posed a direct visual challenge to the splendour of Christian and Jewish manuscripts.[78] Similarly, the treatise on the merits of the Qur'ān by Ibn Sallām (770–838) condemns the practice of 'transcribing the Qur'ān hastily (*mashqan*)',[79] and transmits the following *ḥadīth* associated with the second caliph ʿUmar b. al-Khaṭṭāb:

> It has been related to us by ʿAbd al-Ghafār b. Dāwūd al-Ḥarrānī, on the authority of Ibn Lahīʿa, on the authority of Abū al-Aswad, that ʿUmar b. al-Khaṭṭāb found a *muṣḥaf* that a man had written with a small reed pen, and asked him 'What is this?' The man replied: 'This is the whole of the Qur'ān.' ʿUmar disapproved of that and beat him. Then he said: 'Make the Book of God large!' [Abū al-Aswad] also reports that ʿUmar would rejoice when he saw a *muṣḥaf* of large format.[80]

Evident from these early sources is what Zadeh calls the 'emergent sanctification of the physical codex' of the

Qurʾān: the traditionists' insistence that the aspect of the *muṣḥaf*, its size and its script should be enhanced can indeed be interpreted as a strategy to engage the faithful in acts of contemplative worship.[81] It is therefore likely that other aesthetic choices condemned by the same sources as an intrusion of worldly luxury in the religious sphere – from the use of chrysography to polychrome illumination and decorated bindings – were also motivated by doctrinal discourses and concerns about the necessity to express in material form the exceptionality of the Qurʾān. A thorough investigation into these discourses and concerns would perhaps allow specialists in early Quranic manuscripts to better explain the palaeographic and codicological features of the material they study.

'Writing anxiety' in early Islam and Christianity: theory versus practice

The Muslim and Christian traditions undoubtedly share a rich history of thinking about the nature of holy texts as written forms but, as we have seen, the terms of this thinking were very different in their emphasis. Medieval Latin Christendom, while certainly eager to produce books that were materially and visually impressive, remained firmly anchored to a textual framework of scriptural interpretation, and invested considerable energy in thinking about the semiotic value of images, ornament and scripts. This was in marked contrast to the discourses around the visuality of the *muṣḥaf*, which developed independently from, and often in contrast with, the textuality of the Qurʾān. What the two vibrant calligraphic traditions share, however, is a central irony: they both flourished in spite of a widespread anxiety about the nature of the written sign, and about the potential risks inherent in its aestheticisation, particularly evident in the Latin and Arabic sources of the late antique and early medieval period. This anxiety over writing, we believe, constituted an important factor in the development of an 'iconology of the Word' in both traditions.

In Christendom, the brilliantly ornamented and calligraphed manuscripts of the early medieval period ran in direct contradiction to the pronouncements of theological authorities with respect to writing. Jerome disdained the use of luxury parchment and fancy ornamentation in Bibles; Gregory the Great declared it foolish to wonder at the hand of a scribe without attending to the meaning of the words he wrote; Augustine, Bede and many others similarly dismissed the visual nature of writing as inconsequential.[82] All that mattered to these theologians was the meaning to be found through the study of the holy text. Script reforms, such as the development of Caroline minuscule, along with the revival of square capitals among Carolingian scribes, seem to have been aimed, at least in part, at resolving this contradiction between theory and practice by reducing the visual distractions of script.[83] One could even argue that the entire history of Christian palaeography can be represented as a series of swings back and forth between scripts that are 'invisible' (or 'transparent') and scripts that approach illegibility. Meanwhile, some Church leaders attempted to rationalise the utility of ornate writing, as when Boniface, an Anglo-Saxon missionary active in Germany in the 8th century, requested books with gold lettering to appeal to the

'carnal tastes' of his recent converts, although he was careful to emphasise that it was the meaning of the words that was most important to him.[84]

In early Islam one finds a very similar situation, with countless religious scholars ranting against the use of gold, colours and calligraphic scripts for writing down the Revelation.[85] It seems that these features were frowned upon for three main reasons: they were perceived as impiously earthly and immorally ostentatious; they were dismissed as imitating the custom of the infidels; and they were considered a distraction to readers and thus a hindrance to prayer. Mālik b. Anas, for instance, disapproved of the practice of decorating the pages of the *muṣḥaf* with patterns (*khawātim*) or illumination in gold (*tadhhīb*) because that would disturb the reader's reflection (*tadabbur*).[86] Several traditions ascribed to the companions of the Prophet insist on the prohibition of writing the Qurʾān in gold, embellishing it or marking the beginning of suras with decorated headings.[87] Moreover, Muḥammad himself is reported to have said: 'If you decorate your mosques and embellish your Quranic manuscripts, ruin will be upon you.'[88] And yet, as we have seen, many early Quranic codices are extremely lavish, boastful and ideologically charged artefacts, almost defiant in their disobedience to the principles of austerity preached by the more conservative jurists and traditionists.

In the Muslim context, the anxiety about writing down the Word of God has an additional dimension, namely the preference expressed in doctrinal discourses for the experience of the oral revelation over its written form. Even today, reading from a copy of the Qurʾān is not normally permitted when performing the canonical prayer. Such discourses seem to have developed in direct contrast with those traditions praising the intrinsic merits of the *muṣḥaf* and, since they have become somewhat prevalent in the modern period, they are much more familiar to both practising Muslims and scholars of Islam.[89] Even so, unease about the theological status of the written Qurʾān can be traced back to the 8th century, which may partly explain why Umayyad and early Abbasid mosque codices were made as inaccessible as possible, both physically and symbolically: written in arcane scripts, closed up in cases and cabinets, stored away and exhibited only on special occasions as miraculous signifiers of God's presence among the faithful, as well as tokens of the piety and patronage of the ruling elites. Unlike the Latin script reforms in coeval Europe, the rise of Islamic calligraphy and the development of Kufic resulted in Quranic scripts becoming more and more removed from the utilitarian writing styles employed in other contexts. This anxiety seems to have been overcome only in the 11th century, with the appearance of Quranic codices written in cursive scripts derived from standard bookhands, and vocalised in the same way as all other 'normal' books, according to the system of al-Khalīl b. Aḥmad al-Farāhīdī.[90]

The deep investment in the early Christian idea of the 'sign' might have offered a way to reconcile the apparent anxiety about fancy writing and the obvious desire for it among medieval Christians. Signs were identified as a necessary impediment between the self and God that

mediated the capacity for mortals to glimpse the ineffable nature of the divine. The relative comfort that Christians had with translation – which is particularly striking when considered next to the rather strong aversion to it in Islam and Judaism – is rooted in a conception of language as a human construct. Even if both translation and writing were understood as introducing another layer of difficulty in parsing the meanings of signs, they were still acceptable because they served as effective, if ultimately flawed, means of approaching the divine. This is why we often see, as we did above in the Book of Kells, Christian scribes playing with semiosis as a phenomenon, stretching and twisting their letters into different shapes and representational forms. In the Christian tradition, early medieval calligraphy was complex precisely to make the point that scripture needed to be carefully read *and* interpreted as part of the same act, and that reading *meant* interpreting. It is even possible to speculate that, in some contexts, clarity in a script might have been seen as improperly implying that the text was equally easy to understand. Perhaps this would partly explain the habitual abandonment of the regular attempts at script reform throughout the Middle Ages.

In the Islamic tradition, it was the necessity to visually convey the notion of divine immanence that made the *muṣḥaf*, and all the other modes of displaying Quranic texts, a non-negotiable component of doctrine, culture and statecraft from the time of ʿAbd al-Malik onwards. The materiality of the *muṣḥaf* served symbolic purposes and induced affective reactions that were simply beyond the reach of oral recitation, for all its spiritual power and moving beauty. Compared to medieval Christianity, it is perhaps more difficult to see in classical Islam a reconciliation between theories of scriptural austerity and the practice of illuminating the sacred book, since the most intransigent religious scholars would not only oppose luxury and decoration in religious art but also question the very idea of giving the Qurʾān a material form. Nevertheless, with the exception of a very few episodes in Islamic history, the veneration for the *muṣḥaf* as the supreme signifier of God's presence has always prevailed.

Conclusion

If we had inherited no physical artefacts from the early Middle Ages and could work only with written sources divorced from their manuscript contexts, we would never guess that Christianity or Islam could give rise to artistic traditions as rich and complex as they are. This is particularly true of the two traditions of holy writ, in which the aestheticisation of scripture enriched the faithful's understanding of their own religious belief, albeit in completely different ways. It would be madness to try to make the available visual and material evidence fit the textual testimony, which generally understates the importance of religious material culture. The codicological evidence points to an appreciation for visual and material elaboration of the transcendent realities expressed in holy writ, and art historians are well equipped to articulate how that evidence helps to understand these religions more deeply.

Visual analyses of religious artefacts, however, are meaningless when they do not take into consideration the historical development of the doctrinal discourses that informed the aesthetics of such artefacts. In the course of the conversations that shaped this essay, we increasingly came to feel that, when submitted to close scrutiny, the many apparent parallels between deluxe Qurʾāns and Gospel books are somewhat illusory, especially when viewed in light of the discrepancies between Christian and Muslim belief and practices. What a *muṣḥaf* was to an early Muslim and what a Gospel book was to an early medieval Christian were markedly different things. Our original charge for the *Imagining the Divine* conference was to address the issue of 'word as image', and to explore the iconic nature of holy writ. However, while such terms – 'image', 'iconic' – are perfectly useful when thinking about Christian books, they introduce a paradigmatic bias to our appreciation of Islamic calligraphy, and of Islamic art in general. This problem will subsist for so long as the art-historical study of Quranic manuscripts continues to draw on categories and methodologies borrowed from Christian manuscript studies. While it is likely that a desire to distinguish Islam from other religions of late antiquity prompted a pointed rejection of iconography in religious art, we feel that it is far too limiting to think of Islamic calligraphy as the surrogate of, or even as an alternative to, Christian images. Rather, the arts of the *muṣḥaf* need to be understood in their own right as an attempt to convey the unique and even contradictory qualities of the Qurʾān, in much the same way that the decoration of Gospel books responded to the particular conceptions of the Bible developed in medieval Christendom. What these traditions ultimately share, then, is not so much a visual language as a common problem: the impossibility of condensing divine understanding in material form.

Notes

1 On the subject of 'word as image' in late antique and early medieval Christian art, see especially Nordenfalk 1970; Kendrick 1999; and Hamburger 2014. On the aesthetics and 'visuality' of early Quranic calligraphy and inscriptions, see especially Dodd 1969; Lings 1976; Dodd and Khairallah 1981: vol. 1, *passim*; Schick 2010; George 2010: 55–114; and Milwright 2016: 172–213.

2 Elsner, Lenk *et al.* 2017: 154–5, no. 139, and 175–8, no. 158.

3 Ó Carragáin 1994.

4 Bennison 2007; Blair 2008; George 2010: 86; Déroche 2014: 142.

5 Al-Munajjid 1972: 50–73; Déroche 2004: 33–4; Bennison 2007.

6 Cambridge, Corpus Christi College, Lib. MS. 286.

7 See the interesting parallels drawn between the Qurʾān of Amājūr and the Codex Amiatinus in Blair 2008: 76–7, and between the Blue Qurʾān and the Bible of Cava in D'Ottone 2017.

8 On the Gold Qurʾān, see Lings 1976: 18, pls 3–4; Déroche 1992: 90–1, no. 41; Elsner, Lenk *et al.* 2017: 79, no. 58. The manuscript, in two volumes, is kept in the Süleymaniye Library, Istanbul (mss. Nuruosmaniye 26-27), with the exception of a few folios in the Sarikhani Collection, the Khalili Collection and the Schøyen Collection.

9 Schapiro 2005.

10 For more on the St Chad Gospels, see Henderson 1987: 122–9 and Endres 2012; on the visual localisation of manuscripts, see M. Brown 2003: 227–30.

11 M. Brown 2012: 49.

12 M. Brown 2003.

13 Chazelle 2003; Tilghman 2011b.

14 For this and other examples, see M. Brown 2003; Tilghman 2011a.

15 Gameson 2013: 66–72.

16 Blair 2006: 101–40.

17 Neuman de Vegvar 2003; Hawkes 2007.

18 Hoyland 1997; George 2010: 21–31.

19 Hoyland 2007: 233–4.

20 George 2010: 92–3.

21 George 2010: 52–3.

22 Déroche 2004: 18–19.

23 Déroche 2014: 75–133.

24 Déroche 2018: 158–60.

25 See, for instance, Blair 2008: 72 and Flood 2012: 268.

26 Déroche 2007: 30–1.

27 Gamble 1995.

28 Irvine 1994 provides a rich discussion.

29 Eusebius 1999: 166.

30 Ong and Hartley 2013: 121–3.

31 Translated in Chazelle 2003: 149.

32 Meyvaert 2005.

33 Farr 1999; Kessler 2005.

34 Meyvaert 1996.

35 Meyvaert 2005: 1115.

36 The Islamic doctrine of the Qur'ān has also been defined as 'inlibration' by western scholars, because of its comparability with the Christian dogma of the incarnation: see Wolfson 1976: 244ff. For a history of the early Islamic debate on the createdness of the Qur'ān, see Martin 2001.

37 The authoritative text on the importance of signs to medieval Christians is Augustine's *De doctrina Christiana*: see Augustine 1958.

38 Gilliot 2002.

39 For the frontispieces of the Sana'a Umayyad Qur'ān, see Bothmer 1987; Grabar 1992: 155ff; George 2010: 79–86.

40 Welch 1979: 25–6; Schimmel 1984: 90–114.

41 Behrens-Abouseif 1999: 13–14: 'Because the orthodox interpretation of the Koran leaves little room for allegory, Sunni Muslim culture did not develop a symbolic repertoire, neither did it need a clergy to solve mysteries or interpret allegories.'

42 Martin 2002.

43 Kermani 2015, 14–24.

44 Zadeh 2008: 53, 63; Zadeh 2009. As remarked by Annemarie Schimmel, it is often possible to describe such practices as acts of bibliolatry: see Schimmel 1994: 159.

45 Bibliothèque nationale de France, Département des Manuscrits, Latin 8850, digital reproduction available at https://gallica.bnf.fr/ark:/12148/btv1b8452550p (accessed 8 May 2020).

46 Schapiro 2005.

47 Dublin, Trinity College Library, MS 58, digital reproduction available at: https://digitalcollections.tcd.ie/concern/works/hm50tr726?locale=en (accessed 2 July 2020).

48 Farr 1997: 155.

49 Werner 1994; Pulliam 2006: 105.

50 Sowerby 2016: 55, 130–1.

51 Dimock 1867: 124.

52 For the iconographic complexity of Matthew's symbol, see O'Reilly 1998.

53 Farr 2007: 121–2.

54 Lewis 1980; O'Reilly 1993; Farr 1997.

55 New York, Morgan Library & Museum, M.1.

56 See f. 8r, 'in bethlehem iu**D**eae magi' (*Breves causae*); f. 50v, '**D**ico autem vobis' (Mt 8:11); f. 101v, 'I**D**eo ecce ego mitto ad vos prophetas, et sapientes, et scribas' (Mt 23:34); f. 114v, '**D**icit illis Jesus' (Mt 26:31); f. 120v, '**D**icit illi Jesus: Tu dicis' (Mt 27:11); f. 227v, '**D**icebat autem ad omnes' (Lk 9:23); f. 251v, '**D**ixitque ei filius' (Lk 15:21).

57 Pulliam 2006: 151–3.

58 For an alternative but not necessarily contradictory interpretation of this figure, see O'Mahoney 2017, in which the beasts flanking the T-I cross are read specifically as eagles and thus as signs of the resurrection, through reference to the *Physiologus*.

59 Tilghman 2011a.

60 Kitzinger 2013.

61 Traube 1907; Hurtado 1998; Hurtado 2006.

62 On interest in the True Cross in medieval Ireland, see Warner 1990.

63 Isidore of Seville 1957/2006, 9.1.3.

64 Ferda 2014.

65 On the reform project of al-Ḥajjāj, see Hamdan 2010.

66 Burton 1993.

67 Dutton 1999, Dutton 2000.

68 Hamdan 2010: 825.

69 Lings 1976: 16.

70 See, for instance, Kermani 2015: 163–4, who dismisses all acts of veneration towards the *muṣḥaf* as expressions of popular 'fetishism' and 'reification'.

71 Wild 1996; McAuliffe 2006; Reynolds 2007; Neuwirth, Sinai and Marx 2010; Déroche, Robin and Zink 2015; Kermani 2015.

72 Al-Iṣbahanı 1998: vol. I, 225–6, no. 12-12 ('Al-naẓar fī al-muṣḥaf, al-tafakkur fī-hi, wa-l-i'tibār 'inda 'ajā'ibi-hi').

73 Ibn al-Jawzī 1983: vol. II, 828–9, no. 1386 ('Al-naẓar fī al-muṣḥaf min ghayr an yaqra'a').

74 Al-Nawawī 1996: 100.

75 Al-Suyūṭī 2008: 229.

76 Ibn Abī Shayba 2006: vol. v, 503, no. 8643.

77 Ibn Abī Shayba 2006: vol. v, 502–4.

78 Déroche 2007: 27.

79 Ibn Sallām 1995: vol. II, 237–8, no. 916.

80 Ibn Sallām 1995: vol. II, 236, no. 912.

81 Zadeh 2009: 466.

82 C. Brown 2011: 262–3; Tilghman 2011a: 294.

83 Ganz 1987: 31; Bischoff 1990: 112.

84 Boniface 1940.

85 For a recent discussion and reappraisal of these sources see Flood 2018.

86 Jahdani 2006: 275.

87 Asfaruddin 2002: 8–9; George 2010: 90–1.

88 Ibn Abī Shayba 2006: vol. III, 85, no. 3166.

89 Asfaruddin 2002: 18–20.

90 Blair 2006: 160–78; George 2010: 115–46.

Bibliography

Asfaruddin, A. 2002. 'The excellences of the Qur'ān: textual sacrality and the organization of early Islamic society', *Journal of the American Oriental Society* 122(1), 1–24.

Augustine 1958. *De doctrina Christiana*, ed. and trans. D. Robertson, New York.

Behrens-Abouseif, D. 1999. *Beauty in Arabic Culture*, Princeton.

Bennison, A.K. 2007. 'The Almohads and the Qur'ān of 'Uthmān: the legacy of the Umayyads of Cordoba in the twelfth century Maghrib', *Al-Masāq* 19(2), 131–54.

Bischoff, B. 1990. *Latin Palaeography: Antiquity and the Middle Ages*, trans D. Ganz and D. Ó Cróinín, Cambridge.

Blair, S. 2006. *Islamic Calligraphy*, Edinburgh.

— 2008. 'Transcribing God's word: Qur'an codices in context', *Journal of Qur'anic Studies* 10(1), 71–97.

Boniface 1940. 'Letter to Eadburga', trans. E. Emerton, in *The Letters of Saint Boniface*, New York, available at http://epistolae.ctl.columbia.edu/letter/355.html (accessed 2 July 2020).

Bothmer, H.-C. von 1987. 'Architekturbilder im Koran: eine Prachthandschrift den Umayyadenzeit aus dem Yemen', *Pantheon* 45, 4–20.

Brown, C. 2011. 'Remember the hand: bodies and bookmaking in early medieval Spain', *Word & Image* 27(3), 262–78.

Brown, M. 2003. *The Lindisfarne Gospels: Society, Spirituality, and the Scribe*, London.

— 2012. 'Images to be read and words to be seen: the iconic role of the early medieval book', *Postscripts* 6(1–3), 39–66.

Burton, J. 1993. 'Muṣḥaf', in P. Bearman *et al.* (eds), *Encyclopaedia of Islam vol. VII*, 2nd ed., Leiden, 668–70.

Chazelle, C. 2003. 'Ceolfrid's gift to St Peter: the first quire of the Codex Amiatinus and the evidence of its Roman destination', *Early Medieval Europe* 12 (2), 129–57.

Déroche, F. 1992. *The Abbasid Tradition: Qur'ans of the 8th to 10th Centuries*, London.

— 2004. *Le livre manuscrit arabe. Préludes à une histoire*, Paris.

— 2007. 'Beauté et efficacité: l'écriture arabe au service de la révélation', in M. Kropp (ed.), *Results of Contemporary Research on the Qur'an: The Question of a Historio-Critical Text of the Qur'an*, Beirut, 17–31.

— 2014. *Qur'ans of the Umayyads: A First Overview*, Leiden.

— 2018. 'Of volume and skins: the Qur'anic manuscripts of al-Mahdi', in I. Chabbouh and F. Déroche (eds), *Research Articles and Studies in Honour of Iraj Afshar*, London, 145–72.

Déroche, F., Robin, C. and Zink, M. (eds) 2015. *Les Origines du Coran, le Coran des origines*, Paris.

Dimock, J. 1867. *Giraldi Cambrensis Opera*, vol. v, London.

Dodd, E. 1969. 'The image of the Word: notes on the religious iconography of Islam', *Berytus* 18, 35–79.

Dodd, E. and Khairallah, S. 1981. *The Image of the Word: A Study of Quranic Verses in Islamic Architecture*, 2 vols, Beirut.

D'Ottone, A. 2017. 'The Blue Koran: a contribution to the debate on its possible origin and date', *Journal of Islamic Manuscripts* 8, 127–43.

Dutton, Y. 1999. 'Red dots, green dots, yellow dots and blue: some reflections on the vocalisation of early Qur'anic manuscripts – part I', *Journal of Qur'anic studies* 1(1), 115–40.

— 2000. 'Red dots, green dots, yellow dots and blue: some reflections on the vocalisation of early Qur'anic manuscripts – part II', *Journal of Qur'anic studies* 2(1), 1–24.

Elias, J. 2012. *Aisha's Cushion: Religious Art, Perception and Practice in Islam*, Cambridge, MA.

Elsner, J. Lenk, S. *et al.* 2017. *Imagining Divine: Art and the Rise of World Religions*, Oxford.

Endres, B. 2012. *Manuscripts of Lichfield Cathedral*, https://lichfield.ou.edu/ (accessed 16 July 2018).

Eusebius 1999. *Life of Constantine*, ed. and trans. A. Cameron and S. Hall, Oxford.

Farr, C. 1997. *The Book of Kells: Its Function and Audience*, Toronto.

— 1999. 'The shape of learning at Wearmouth-Jarrow: the diagram pages in the Codex Amiatinus', in J. Hawkes and S. Mills (eds), *Northumbria's Golden Age*. Stroud, 336–44.

— 2007. '*Bis per chorum hinc et inde*: the 'Virgin and Child with Angels' in the Book of Kells', in A. Minnis and J. Roberts (eds), *Text, Image, Interpretation: Studies in Anglo-Saxon Literature and Its Insular Context in Honour of Éamonn Ó Carragáin*, Turnhout, 117–34.

Ferda, T. 2014. 'Matthew's titulus and Psalm 2's King on Mount Zion', *Journal of Biblical Literature* 133(3), 561–81.

Flood, F.B. 2012. 'The Qur'an', in H.C. Evans and B. Ratliff (eds), *Byzantium and Islam: Age of Transition*, New Haven and London, 265–73.

— 2018. 'Bodies, books, and buildings economies of ornament in juridical Islam', in D. Ganz and B. Schellewald (eds), *Clothing Sacred Scriptures: Book Art and Book Religion in Christian, Islamic, and Jewish Cultures*, Berlin, 49–68.

Gamble, H. 1995. *Books and Readers in the Early Church: A History of Early Christian Texts*, New Haven.

Gameson, R. 2013. *From Holy Island to Durham: The Contexts and Meanings of the Lindisfarne Gospels*, London.

Ganz, D. 1987. 'The preconditions for Caroline Minuscule', *Viator* 18, 23–43.

George, A. 2010. *The Rise of Islamic Calligraphy*, London.

— 2017. 'The Qur'ān, calligraphy, and the early civilization of Islam', in F.B. Flood and G. Necipoğlu (eds), *A Companion to Islamic Art and Architecture vol. I*, Hoboken, 109–29.

Grabar, O. 1992. *The Mediation of Ornament*, Princeton.

Gilliot, C. 2002. 'Exegesis of the Qur'ān: classical and medieval', in J.D. McAuliffe (ed.), *Encyclopaedia of the Qur'ān*, Leiden, vol. II, 99–123.

Hamburger, J. 2014. *Script as Image*, Paris and Walpole, MA.

Hamdan, O. 2010. 'The second *maṣāḥif* project: a step towards the canonization of the Qur'anic text', in Neuwirth, Sinai and Marx 2010: 795–835.

Hawkes, J. 2007. 'Anglo-Saxon Romanitas: the transmission and use of early Christian art in Anglo-Saxon England', in P. Horden *et al.* (eds), *Freedom of Movement in the Middle Ages: Proceedings of the 2003 Harlaxton Symposium*, Donnington, 19–36.

Henderson, G. 1987. *From Durrow to Kells*, London.

Hoyland, R. 1997. 'The content and context of early Arabic inscriptions', *Jerusalem Studies in Arabic and Islam* 21, 77–102.

— 2007. 'Epigraphy and the emergence of Arab identity', in P. Sijpesteijn *et al.* (eds), *From al-Andalus to Khurasan: Documents from the Medieval Muslim World*, Leiden and Boston, 217–42.

Hurtado, L. 1998. 'The origin of the nomina sacra: a proposal', *Journal of Biblical Literature* 117, 655–73.

— 2006. 'The staurogram in early Christian manuscripts: the earliest visual reference to the crucified Jesus?', in T. Kraus and T. Nicklas (eds), *New Testament Manuscripts: Their Text and Their World*, Leiden, 207–26.

Ibn Abī Shayba 2006. *Al-Muṣannaf*, ed. M. 'Awwāma, Beirut.

Ibn al-Jawzī 1983. *Al-ʿilal al-mutanāhiya fī al-aḥādīth al-wāhiya*, ed. K. al-Mays, Beirut.

Ibn Sallām 1995. *Faḍāʾil al-Qurʾān wa-maʿālimu-hu wa-adābu-hu*, ed. A. al-Khayyāṭī, Mohammedia.

Al-Iṣbahānī 1998. *Kitāb al-ʿaẓama*, ed. R. al-Mubārakfūrī, Riyadh.

Irvine, M. 1994. *The Making of Textual Culture: 'Gramatica' and Literary Theory, 350–1100*, Cambridge.

Isidore of Seville 1957/2006. *Etymologiae*, ed. W. Lindsay, Oxford. Trans. S.A. Barney, W.J. Lewis, J.A. Beach and O. Berghof 2006, *The Etymologies of Isidore of Seville*, Cambridge.

Jahdani, A. 2006. 'Du *fiqh* à la codicologie: quelques opinions de Mālik (m. 179/796) sur le Coran-codex', *Mélanges de l'Université Saint-Joseph* 59, 269–79.

Kendrick, L. 1999. *Animating the Letter: The Figurative Embodiment of Writing from Late Antiquity to the Renaissance*, Columbus, OH.

Kermani, N. 2015. *God is Beautiful: The Aesthetic Experience of the Quran*, Cambridge.

Kessler, H. 2005. 'Images of Christ and communication with God', in *Comunicare e significare nell'alto medioevo. LII Settimana Internazionale di Studio della Fondazione Centro di Studi sull'Alto Medioevo*, Spoleto, 293–328.

Kitzinger, B. 2013. 'Cross and book: late-Carolingian Breton Gospel illumination and the instrumental cross', PhD dissertation, Harvard University.

Lewis, S. 1980. 'Sacred calligraphy: the chi rho page in the Book of Kells', *Traditio* 36, 139–59.

Lings, M. 1976. *The Quranic Art of Calligraphy and Illumination*, London.

Martin, R. C. 2001. 'Createdness of the Qur'ān', in J.D. McAuliffe (ed.), *Encyclopaedia of the Qur'ān*, Leiden, vol. I, 467–71.

— 2002. 'Inimitability', in J.D. McAuliffe (ed.), *Encyclopaedia of the Qur'ān*, Leiden, vol. II, 526–36.

McAuliffe, J.D. 2006. *The Cambridge Companion to the Qur'an*, Cambridge.

Meyvaert, P. 1996. 'Bede, Cassiodorus, and the Codex Amiatinus', *Speculum* 71, 827–83.

— 2005. 'The date of Bede's *In Ezram* and his image of Ezra in the Codex Amiatinus', *Speculum* 80, 1087–1133.

Milwright, M. 2016. *The Dome of the Rock and Its Umayyad Mosaic Inscriptions*, Edinburgh.

Al-Munajjid, S. 1972. *Dirāsāt fī tārīkh al-khaṭṭ al-'Arabī: Mundhu bidāyati-hi ila nihayat al- aṣr al-Umawi*, Beirut.

Al-Nawawī 1996. *Al-Tibyān fī ādāb ḥamalat al-Qur'ān*, ed. M. al-Ḥajjār, Beirut.

Nelson, R. 2000. 'To say and to see: ekphrasis and vision in Byzantium', in R. Nelson (ed.), *Visuality Before and Beyond the Renaissance*, Cambridge, 143–68.

Neuman de Vegvar, C. 2003. 'Romanitas and realpolitik in Cogitosus' description of the church of St Brigit, Kildare', in M. Carver (ed.), *The Cross Goes North: Processes of Conversion in Northern Europe, A.D. 300–1300*, York, 153–70.

Neuwirth, A., Sinai, N. and Marx, M. (eds) 2010. *The Qur'ān in Context*, Leiden and Boston.

Nordenfalk, C. 1970. *Die spätantiken Zierbuchstaben*, Stockholm.

Ó Carragáin, É. 1994. '"Traditio evangeliorum" and "sustentatio": the relevance of liturgical ceremonies to the Book of Kells', in F. O'Mahoney (ed.), *The Book of Kells: Proceedings of a Conference at Trinity College Dublin, 6–9 September 1992*, Brookfield, VT, 398–436.

O'Mahoney, F. 2017. 'God is in the detail: observations on the Book of Kells, folios 8r and 130r', in R. Moss, F. O'Mahoney and J. Maxwell (eds), *An Insular Odyssey: Manuscript Culture in Early Christian Ireland and Beyond*, Dublin, 231–48.

Ong, W. and Hartley, J. 2013. *Orality and Literacy: The Technologizing of the Word*, 3rd ed., London.

O'Reilly, J. 1993. 'The Book of Kells, folio 114r: a mystery revealed yet concealed', in R.M. Spearman and J. Higgit (eds), *The Age of Migrating Ideas: Early Medieval Art in Britain and Ireland*, Dover, NH, 106–14.

— 1998. 'Gospel harmony and the names of Christ', in J. Sharpe and K. van Kampen (eds), *The Bible as Book: The Manuscript Tradition*, New Castle, DE, 73–88.

Pulliam, H. 2006. *Word and Image in the Book of Kells*, Dublin.

Reynolds, G.S. 2007. *The Qur'an in Its Historical Context*, New York.

Saleh, W.A. 2010. 'Word', in J. Elias (ed.), *Key Themes for the Study of Islam*, Oxford, 356–76.

Schapiro, M. 2005. *The Language of Forms: Lectures on Insular Manuscript Art*, New York.

Schick, I.C. 2010. 'Text', in J. Elias (ed.), *Key Themes for the Study of Islam*, Oxford, 321–35.

Schimmel, A. 1984. *Calligraphy and Islamic Culture*, New York and London.

— 1994. *Deciphering the Signs of God*, Edinburgh.

Sowerby, R. 2016. *Angels in Early Medieval England*, Oxford.

Al-Suyūṭī 2008. *Al-Itqān fī 'ulūm al-Qur'ān*, ed. S. al-Arna'ūt, Beirut.

Tilghman, B. 2011a. 'The shape of the word: extra-linguistic meaning in Insular display lettering', *Word & Image* 27(3), 292–308.

— 2011b. 'Writing in tongues: mixed scripts and style in Insular art', in C. Hourihane (ed.), *Insular and Anglo-Saxon: Art and Thought in the Early Middle Ages*, University Park, PA, 92–108.

Traube, L. 1907. *Nomina Sacra. Versuch einer Geschichte der christlichen Kurzung*, Munich.

Warner, M. 1990. 'The cross-carpet page in the Book of Durrow: The cult of the true cross, Adomnán, and Iona', *Art Bulletin* 72, 174–223.

Welch, A. 1979. *Calligraphy in the Arts of the Muslim World*, Austin.

Werckmeister, O.-K. 1967. *Irisch-Northumbrische Buchmalerei des 8. Jahrhunderts und monastische Spiritualität*, Berlin.

Werner, M. 1994. 'Crucifixi, sepulti, suscitati: remarks on the decoration of the Book of Kells', in F. O'Mahoney (ed.), *The Book of Kells: Proceedings of a Conference at Trinity College Dublin, 6–9 September 1992*, Brookfield, VT, 450–88.

Wild, S. 1996. *The Qur'an as Text*, Leiden.

Wolfson, H.A. 1976. *The Philosophy of the Kalam*, Cambridge, MA.

Zadeh, T. 2008. '"Fire cannot harm it": mediation, temptation and the charismatic power of the Qur'an', *Journal of Qur'anic Studies* 10(2), 50–72.

— 2009. 'Touching and ingesting: early debates over the material Qur'an', *Journal of the American Oriental Society* 129(3), 443–66.

Chapter 4
The Jewish Image of God in Late Antiquity

Martin Goodman

The significance of the depiction of the sun god as the central figure of the zodiac mosaics found in many Palestinian synagogues of late antiquity has been long debated. The most artistically sophisticated of these depictions is that found in the Hammat Tiberias mosaic, variously dated between the beginning and the end of the 4th century CE (**Pl. 4.1**).[1] This is only one example of a common motif, however, which appears also in a less impressive form at Naaran and in near-caricature in the 6th-century synagogue at Beth Alpha (**Pl. 4.2**), while the synagogue mosaic at Sepphoris simply illustrated the shining sun (**Pl. 4.3**).[2] Both the inscriptions and the distinctively Jewish iconography of the other mosaic floors in the synagogues demonstrate that the buildings in question served a religious purpose for Jews.[3] So what, in the mind of the artist (Jew or gentile) or the commissioning patron(s) or community, was the function of the apparently pagan image situated so as to confront Jews at their feet as they worshipped?

Over the years, various suggestions have been made. An early hypothesis that the synagogue decoration reflected the taste of non-Jewish, perhaps imperial, patrons has come to seem less attractive as the wide extent of the phenomenon has been realised.[4] Nor does the ascription of such motifs to deviant, non-rabbinic Jews carry much weight since the discovery that the Hammat Tiberias mosaic was dedicated by, among others, a member of the household of the patriarch.[5] Claims that the zodiacs were primarily intended as calendrical reminders of the passing months are possible in the general sense that they may celebrate the order inherent in God's universe,[6] but as strict calendars their use is questionable in the light of the inaccuracies of the Beth Alpha mosaicist, who failed to correlate the signs correctly with the seasons.[7] In any case, the hypothesis fails to explain the depiction of the sun god in human form, presumably a deliberate choice at Hammat Tiberias, Naaran (**Pl. 4.4**) and Beth Alpha, since the Sepphoris mosaicist took a different path and showed the sun as a shining orb.[8] The assertion by Morton Smith that the sun god depicted 'a great angel, important for the liturgy', based on the image of Helios as a celestial figure in the mystical treatise *Sefer Harazim*, has the merit of connecting the visual to the literary remains from late antiquity but raises the difficult question, so far unanswered, of the reason why Jews might depict this angel as so central a figure in their iconography.[9]

My suggestion in this paper is that all previous discussions of these mosaics have shied away unnecessarily from the interpretation that the divine figure depicted in the centre of a Jewish place of worship may have been intended to represent the God of the Jews. In the context of any other religious cult place in the Roman world, archaeologists would have taken for granted that the god depicted in a shrine was likely to be the (or a) god worshipped in that shrine. My intention in this study is not to give a full interpretation of the images of the sun god in synagogues, which can be achieved only by analysing their role within the zodiacs and the role of the zodiacs themselves, but to elucidate one possible way that Jews in late antiquity might have understood them when confronted by them as they prayed.

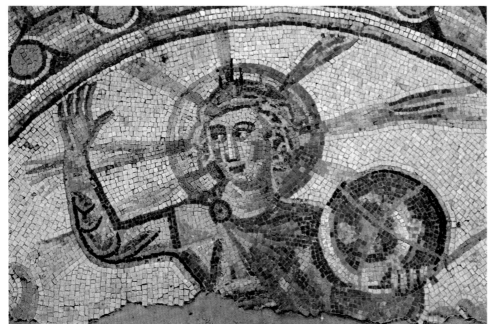

Plate 4.1 Detail of the central medallion within the zodiac of the mosaic floor, Hammat Tiberias, 4th century. Image: Alamy

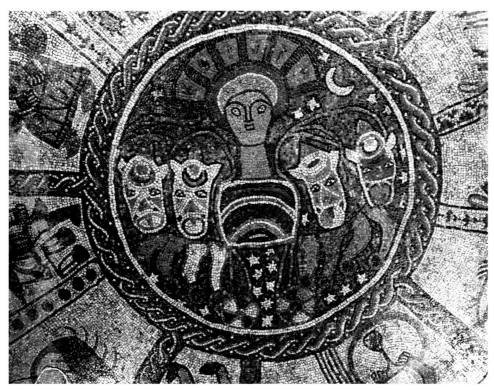

Plate 4.2 Detail of mosaic floor, nave of the Beth Alpha synagogue, 6th century. Image: Alamy

Standard interpretations of the sun god image in synagogues derive their timidity from the ambiguous and contradictory Jewish traditions as to whether God has any form and, if so, whether that form is anthropomorphic.[10] The contradictions go back to the Bible, where Pentateuchal passages which presumed that God can be seen by humans, including the Revelation on Mount Sinai (Exod. 24:9–10; see also 33:17–23), co-existed with assertions that 'God has no form that humans can see or imagine' (Deut. 4:12–24) without any attempt having been made in the biblical period to conflate or clarify these conflicting images.[11] Nonetheless, among those biblical passages which do presuppose a specific divine form, the predominant image is anthropomorphic on the basis of the statement in Genesis 1:26–8 that God made humankind in his likeness; most vivid

of these in the imagination of later interpreters of the biblical text was the human figure on a chariot which appeared to Ezekiel 'as the appearance of the semblance of the presence of the Lord' (Ezek. 1:26). On the other hand, a significant factor for the present discussion is the evidence that some Jews, with or without the approval of their brethren, thought of the divine form as being like the sun (see 2 Kings 23:11; Ezek. 8:16),[12] and of God as subsisting in fire (Exod. 3:2; Deut. 4:11–12, 14; Dan. 7:9).

If the biblical text permitted varied and contradictory views on this issue, there are good grounds to expect similar variety and contradiction in post-biblical Judaism, both because all later Judaism was based to a greater or lesser extent on biblical interpretation and this is particularly likely to be true of a theological issue such as the imagining of the divine

Plate 4.3 Detail of mosaic floor, Sepphoris, 5th century. Image: Alamy

Plate 4.4 Detail of the central medallion within the zodiac of the mosaic floor, Naaran, 6th century. Image courtesy of the Center for Jewish Art

form, and because post-biblical Judaism was particularly variegated at least up to the destruction of the Temple in 70 CE and probably far beyond.[13] In addition, extensive speculation, for which there is much evidence, about the surroundings of God in the heavenly realm, and especially about the roles and hierarchies of angels,[14] may have encouraged the speculation about the divine figure at its centre to be found eventually in the mystical *Shiur Komah* texts.

Some Jewish writers in late antiquity reasserted the notion that God has no image of any kind. In the 1st century CE Josephus claimed that 'it is impious to conjecture the form and magnitude of God, which cannot be described, depicted or imagined' (*Contra Apionem* 2.190–2), having stated (not wholly plausibly) in the passage immediately preceding that all Jews agree about the nature of God (2.181). This

extreme view was found also in the rather ham-fisted efforts of Aristobulus in the 2nd century BCE to use allegory to demonstrate that it is not necessary to take literally the biblical references to the hands, arms, face and feet of God (*ap.* Eusebius, *Praeparatio evangelica* 8.10) and in the arguments of Philo in the 1st century CE that because God is unlike anything else he must be without body or form (*De specialibus legibus* 2.176).[15] In later antiquity, rabbinic texts generally used periphrases such as 'divine presence' to refer to God and, in particular, the targumim (Aramaic paraphrases of the Bible) applied circumlocutions to avoid translating some of the blatant anthropomorphisms in the biblical texts from which they derived.[16]

On the other hand, the embarrassment about anthropomorphisms sometimes displayed by the targumists

was by no means consistent, and sometimes Jews talked freely about God as having a human form.[17] One of the accusations made by the 2nd-century Christian apologist Justin Martyr against the teachers of the Jew Trypho was, according to his *Dialogue with Trypho*, their penchant for taking the human image of God literally (*Dialogue* 114). Justin's claim was doubtless polemical, but there is also evidence in early rabbinic literature for such literalness.[18] Attempts have been made to distinguish anthropomorphic schools and their opponents within early rabbinic texts, but without clear results:[19] a great variety of human images of God were adopted in rabbinic literature of all kinds.[20] At some time in the Hellenistic period, Ezekiel the Tragedian had envisaged God as an impressive king seated on a throne (*Exagoge of Ezekiel*, lines 68–72),[21] a picture also reflected in 1 Enoch 14:18–22. According to *y. Yoma* 5:2, however, Rabbi Abbahu (*c.* 279–320) interpreted as God the old man dressed in white whom the High Priest Simon the Just (probably 4th–3rd century BCE) was said to have seen each Yom Kippur in the Holy of Holies (the inner sanctuary of the Temple in Jerusalem). Most references to the human form of God are vague about gender, but there is no doubt that he is generally envisaged as male,[22] and speculation on his physique reaches its peak in the images of a bearded youth of unimaginable proportions and strength on which the *Shiur Komah* texts dwell, from the Third Book of Enoch (48A), a mystical revelation in Hebrew probably composed in the late antique period, to the recensions of these texts preserved by the medieval mystics.[23]

At the same time, the biblical notion that the divine form subsists in fire flourished among Jews down into late antiquity. Thus 1 Enoch 14:18–22 described the surrounds of the divine throne as like the shining sun, with rivers of burning fire flowing from beneath it, and the raiment of God as brighter than the sun. According to the exegetical biblical commentary *Sifre to Deuteronomy* 49, compiled in the third century CE, 'because God is fire, it is impossible to go up to the heavens to join him'.[24] On the basis of such passages it seems hard to avoid concluding that the strange depiction by Josephus, writing in the 1st century CE, of the Essenes (a contemporary Jewish sect) as offering prayers to the sun was not as peculiar to ordinary Jews as is sometimes imagined. According to the *Bellum Judaicum* 2.128–9, 'before the sun is up, [the Essenes] offer to him certain prayers … as though entreating him to rise'. That they are meant to be treating the sun as divine seems reinforced by a slightly later passage (2.148–9), which describes how the Essenes 'cover their excrement to avoid offending the rays of the deity'. The claim that these Essenes were deviant Jews like those opposed in Deut. 4:15–24, 17:3; 1 Kings 21:3; Jeremiah 8:2, 19:13; and elsewhere founders on the strong approval of them as pious Jews voiced by Josephus.[25] Morton Smith's suggestion that they revered the sun 'like an angel, not God' encounters the simple objection that the sun is described by Josephus at *Bellum Judaicum* 2.148 not as an angel but as 'the god'. It is true that angels are sometimes called 'gods' in the Hebrew of the Dead Sea Scrolls, but such ambiguity is not likely in Josephus' Greek.

Enough has been said to show that Jews in late antiquity were quite capable of imagining God both in human form

and as the sun, but it is quite another step to demonstrate that any Jews might produce a physical object to illustrate such images. The prohibition on making images of God of any kind had a strong biblical base (see Exod. 20:23; Lev. 19:4; Deut. 27:15; etc.) and was evidently generally observed by Jews both in biblical times and down to the end of the Second Temple period, when Josephus asserted that 'all material is unworthy for an image of Him, however expensive, and all artistic skill is useless for thinking about his representation' (*Contra Apionem* 2.191).[26] In so far as any physical object could be said to embody the divinity, it was the scroll of the Torah, which was carried in Titus' triumph through the streets of Rome at the end of the procession of cult objects from the Temple as a symbol of the Jewish God (Josephus, *Bellum Judaicum* 7.150). That Jews had no physical image of their God was well known to pagans, who generally viewed it as a bizarre trait (Hecataeus, *ap.* Diodorus 40.3.4; Livy, *ap. Scholia in Lucanum* 2.593; Strabo, *Geographica* 16.2.35; Cassius Dio 37.17.2), but occasionally as admirable (Varro, *ap.* Augustine, *De civitate Dei* 4.31), and they interpreted Jewish reverence for Torah scrolls as equivalent to their own piety towards their own cult statues.[27]

Jewish reluctance to depict the divine in any physical medium, however, was in part a product of a general reluctance to use physical images of almost any kind: Josephus explained the uprising in Jerusalem in 4 BCE when Herod set up an eagle image above the entrance to the Temple by stating that it was 'contrary to ancestral laws, because it is unlawful to have in the sanctuary an image or bust of any living thing' (*Bellum Judaicum* 1.648–55), and he claims to have persuaded the people of Tiberias to destroy the palace of Herod Antipas on the grounds that it contained figures of living creatures (*Vita* 65). This attitude evidently changed during the following centuries, when two-dimensional representations of human and animal figures became common in Jewish buildings, both in mosaics like those under discussion here and in the rather earlier complex narrative pictures of Bible stories found in the Dura Europos synagogue of the mid 3rd century.[28] The simultaneous avoidance of three-dimensional art is almost certainly significant, demonstrating an ability among Jews as among Christians to distinguish between images made for worship and those made for decoration.[29]

Once Jews accepted in principle the notion that they could depict some images in two dimensions, could they envisage depicting God? The answer is equivocal. In a number of narrative pictures from Dura Europos and in some of the mosaic depictions of the binding of Isaac, the right hand of God can be clearly seen emerging from the sky (**Pl. 4.5**).[30] Here is a physical equivalent to the literary depictions of the divine as anthropomorphic, even if the size of the divine hands – much larger than those of humans – is (not surprisingly) not as gigantic as the dimensions of God's hands should have been according to the *Shiur Komah* texts. The restriction of the representation to the divine hand, however, may have been precisely intended to avoid depiction of the rest of the divine image.

So who was the sun god on the synagogue mosaics meant to represent? An image of God as a human figure and as a bright sun-like fire pervades Jewish literature both in the

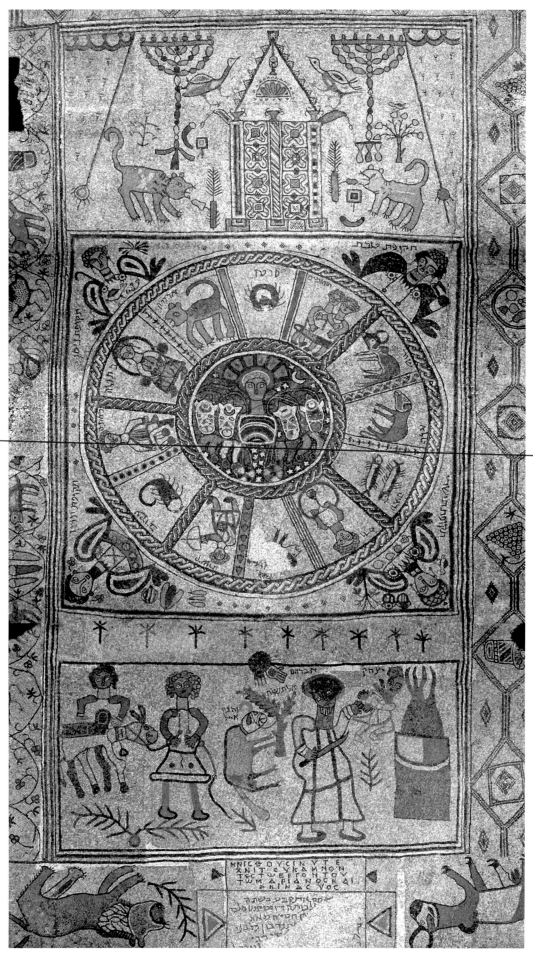

Plate 4.5 Mosaic floor, nave of the Beth Alpha synagogue, 6th century. Image: The Picture Art Collection / Alamy Stock Photo

period when the mosaics were commissioned and before. God on his chariot would bring to the mind of any late antique Jew the intensely mystical and powerful images in the first chapter of Ezekiel.[31] It was standard in rabbinic parlance to refer to God by his location in the heavens when making vows, offerings, prayers and oaths.[32] Pagans sometimes thought that the Jewish God was to be identified with the heavens (Hecataeus, *ap.* Diodorus 40.3.4; Strabo, *Geography* 16.2.35),[33] although at other times they might suggest that he was 'really' Jupiter (Varro, *ap.* Augustine, *De consensu evangelistarum* 1.22.30[34]) – a sky god, of course – or, as the 3rd-century antiquarian Cornelius Labeo asserted from the Clarian Oracle of Apollo (*ap.* Macrobius, *Saturnalia* 1.18.19–20), the name Iao (often ascribed to the Jewish God) is actually to be identified with Liber (i.e. Dionysus), Hades and Zeus, and all of them in turn are to be identified with the sun.

I do not for a moment wish to leave an impression that the problem is simply solved by all this. After all, other pagan texts in the 2nd and 3rd centuries reveal their awareness of the Jewish belief that their God has no image at all (Numenius of Apamaea, *ap.* Origen, *Contra Celsum* 1.15; Cassius Dio 37.17.2). There is good rabbinic evidence that too literal a worship of the sun as divine would incur the hostility of at least some fellow Jews: according to *t. Berachot* 6(7):6, 'if one says a blessing over the sun, this is heterodoxy' ('another way'). Much is to be said for the seeming paradox that Jews could indulge boldly in human and solar images of the divine precisely because they took it as axiomatic that God does not in fact possess a physical form of any kind.[35] If the images on the floor mosaics were reminders of the God worshipped in the synagogues, rather than cult objects for worship in themselves, it would be unsurprising if a Jew could walk over the mosaic without scruples. There is no evidence that any pagan polytheists who depicted Olympian or other gods on a mosaic floor, a common practice, ever felt concerned about sacrilege. It is also unlikely that these mosaics were ever the central focus in liturgy, since nothing suggests that worshippers looked down at their feet when praying. The depiction of the sun god as a much smaller figure in the synagogue mosaics than in contemporary pagan zodiacs is therefore irrelevant for determining the meaning of the figure depicted for either the artist or the commissioning patron.

Up to now I have tried to explain these images to be found in the late Roman synagogues in terms of internal developments within Judaism, but it would be quite wrong to ignore the impact of the wider religious changes in the contemporary world which encouraged the flowering of this specific iconography at this specific time. The image of the sun at Hammat Tiberias (**Pls 4.1, 4.6**) is quite clearly the image of Sol Invictus and Helios as found widespread in imperial religious propaganda in the 3rd and 4th centuries.[36] That the sun became the symbol of monotheism within late antique paganism of the 4th century is well attested, most coherently in the emperor Julian's *Hymn to King Helios*,[37] but what has been less often noted until recently is the way in which Christians certainly, and Jews probably, latched on to this identification to give legitimacy to their own forms of monotheism.

In a useful article on the cult of Theos Hypsistos ('the Most High God'), Stephen Mitchell has suggested how

pagan worshippers of this divinity identified him (or very occasionally her) with the God of the Jews, and later of the Christians.[38] Mitchell argues that this identification was accepted by many Jews: Philo used the term *Hypsistos* to denote the Jewish God (*Legatio ad Gaium* 278), as did Josephus when quoting a decree by Augustus in favour of the Jews (*Antiquitates Judaicae* 16.163). Closer to the time of the Hammat Tiberias mosaic, according to the 6th-century Byzantine writer John Lydus (*De mensibus* 4.53), the emperor Julian (331/2–63) described the Temple to be rebuilt in Jerusalem as the shrine of Theos Hypsistos. Any Jew who recognised pagan worshippers of the highest god as god-fearers could very easily adopt some of the religious mentality of these pagan monotheists.[39]

One characteristic of the cult of Theos Hypsistos was its lack of iconography: references to the god tend to abstractions, and anthropomorphic images are strikingly rare in the context of standard Greco-Roman customs (although see Settis, this volume).[40] Also highly unusual was the mode of worship by devotees, who used prayer rather than sacrifice and practised their cult in open sanctuaries facing the east, gazing up at heaven and the sun. The essence of the divinity was encapsulated in an oracle of Apollo of which a copy was engraved in a 3rd-century inscription at Oenoanda in south-western Asia Minor:

> Born of itself, untaught, without a mother, unshakeable, not contained in a name, known by many names, dwelling in fire, this is god. Aether is god who sees all, on whom you should gaze and pray at dawn, looking towards the sunrise.[41]

This, so Mitchell argues, is the cult adopted by the father whose decision to worship nothing but the clouds and the spirit of heaven would, according to Juvenal (*Satires* 14.96–106), in time lead to his son becoming Jewish.[42] What is crucial for present purposes is the extensive evidence both from literary descriptions and from inscriptions of prayers to the rising and setting sun, and the major role in worship of lamps and fire. The best source from the 4th century comes from the Church Father Gregory of Nazianzus, *Orations* 18.5, in the funeral oration for his father. Writing about his father's early errors, Gregory describes a group to which his father belonged in his youth:

> its followers reject the idols and sacrifices of the former [i.e. pagans] and worship fire and lamplight; they revere the Sabbath and are scrupulous not to touch certain foods, but have nothing to do with circumcision. To the humble they are called Hypsistarians, and the Pantokrator is the only god they worship.[43]

Here the connection between the Pantokrator and fire seems clear.

But in any case, the identification of solar worship with monotheistic belief was so widespread in the 4th century as to need little demonstration to anyone at the time. It can be plausibly argued that Constantine's notorious continued adherence to the sun god after his conversion to Christianity is best understood as his identification of the sun god with the Highest God worshipped by Christians.[44]

At the same time, the commonly expressed reluctance of Christians in the first three centuries of their religion to depict God – a reluctance which co-existed, as for Jews, with many visual metaphors of the divine in literary texts, with

some of these metaphors also apparently portrayed physically in images of the good shepherd and such like – gave way during the 4th century to a new iconography.[45] In this iconography, Christ was portrayed no longer only as a human figure within a depiction of a Gospel narrative,[46] but at times as a grand image of an enthroned monarch.[47] This occurred precisely during the period of affirmation, after the Council of Nicaea in 325, that the Christ portrayed was to be treated not as human but as an integral element in the threefold divinity worshipped by Christians.

Christians adopted much of their iconography from pagan types, to some of which they gave new meaning, while some seem to have been treated simply as decoration.[48] So, for instance, the mausoleum of Constantine's daughter Constantina built in the 320s combined originally Dionysiac imagery with sacred scenes from both Old and New Testaments.[49] Treating the image of the sun as purely decorative rather than significant, however, does not seem to have been an option.

At least by 427, some Christians seem to have come to state openly that some of their pictures were images of the divine, for a law of that year (*Codex Justinianus* 1.8) forbade the placing of Christ's image on the ground because it was seen as sacrilege. The issue of the same law reveals, of course, that floor mosaics depicting Christ must have existed. It seems likely that this is precisely what is to be found in the late 4th-century mosaic from Hinton St Mary in Dorset (see **Pl. 2.1**), in which a head, almost certainly of Christ, embellished with the chi-rho was depicted alongside some strikingly pagan scenes.[50] The emperors in 427 may not have approved of the practice, but other Christians must have found reasonable the notion of putting an image of the divine on the floor of a sacred building.

So too, I suggest, did the Jews of Tiberias. At a time when the identification of the highest god with the sun was made by both pagans and Christians, the notion that the Jews who chose to commission the same image for their synagogue at Hammat Tiberias can have done so without awareness of its iconographic import is deeply implausible. It seems to me much more likely that their choice demonstrated their confident conviction that the God to whom both pagans and Christians paid greatest observance was the God of Israel.

Afterword

This study, originally presented at a conference in the Jewish Theological Seminary in New York in March 2000, was first published in 2003.[51] Much work has been done on the mosaics of late Roman Palestine over the past 17 years.[52] These include both new attempts to achieve an overall understanding of synagogue iconography,[53] and the publication of newly excavated mosaic floors, most strikingly from the synagogue of Huqoq in Galilee, where a plethora of remarkable biblical scenes have been unearthed, including a new (but, as yet, unpublished) depiction of Helios.[54] In a detailed article published in 2004, Stuart Miller discussed the evidence in rabbinic texts for rabbinic accommodation to images of the sun through insistence on the subordination of the sun to the power of God, tracing this polemic back to biblical times and the composition of Psalm 19.[55] Jodi Magness proposed identification of Helios with the angelic

figure Metatron, and Lucy Wadeson argued that the figure riding a 'chariot of fire' should be recognised as Elijah.[56] In 2014, Steve Fine, focusing on the position of the sun image within the zodiac, concluded with a 'modest proposal' that the sun image should be taken simply to signify the sun as conventionally portrayed in late antique art. Fine noted correctly that all the mosaicists labelled the rest of the figures of the zodiac and the seasons but never the figure representing the sun, but it is not clear to me how or whether this fact, or the portrayal of the moon as a small crescent in the background in the depiction of Helios in the Beth Alpha mosaic (**Pls 4.2, 4.5**), supports his 'modest proposal'.[57]

There is something to be said for all these interpretations, and it is unreasonable to imagine that a motif that evidently became standard in synagogue decoration was not interpreted differently by different constituencies of Jews. As Stuart Miller stresses, it is possible to imagine rabbis successfully negotiating the image of the sun god at Hammat Tiberias by thinking of it as simply the sun, at the same time as other worshippers viewed it as a representation of the invincible ruler Sol Invictus, who governed the heavens.[58] Which view predominated among Jews in late Roman Palestine, it may now be impossible to tell.

Notes

1 Dothan 1983. On the date, see Goodman 1992: 130, n. 11; and Magness 2003.

2 Weiss and Netzer 1996.

3 For the inscriptions from Hammat Tiberias, see Dothan 1983: 52–62; on the common Jewish symbols, such as the *lulavim* (palm fronds), *shofar* (ram's horn trumpet) and others, found in the other mosaics, see Goodenough 1953–68.

4 See the discussion in Sukenik 1934: 62–3.

5 For this argument, see Goodenough 1953–68; on the inscription by Severus, see Dothan 1983: 57–60. The view that the mosaic is 'non-rabbinic' is also proposed by Levine 1989: 178–81.

6 Calendrical argument in Dothan 1983: 49; Fine 1997: 124, 200–1 (with extensive bibliography). For the more general interpretation and wide discussion, see Foerster 1985 and 1987.

7 Stemberger 1975.

8 Weiss and Netzer 1996: 35–6.

9 Smith 1982: esp. 210*.

10 For general bibliography on this topic, see Marmorstein 1927–37; Smith 1958 and 1968; Rowland 1979; Neusner 1988; Schäfer 1992; Eilberg-Schwartz 1992; D. Stern 1992; Goshen-Gottstein 1994; E. Wolfson 1994: ch. 1; Moore 1996; Aaron 1997.

11 Barr 1968–9.

12 Taylor 1993, with critique by Wiggins 1996.

13 On the extent of variety in late Second Temple Judaism, see Goodman 2000; on continued variety after 70 CE, see Goodman 1994.

14 1 Enoch 82:14–20; 3 Enoch 18; Newsom 1985; Davidson 1992.

15 H. Wolfson 1947: vol. II, 97.

16 Marmorstein 1927–37: vol. I, 54–107; McCarthy 1989; Lodahl 1992.

17 Klein 1982.

18 Marmorstein 1927–37: vol. II, 48–56.

19 Goshen-Gottstein 1994: 171–2.

20 See Marmorstein 1927–37: vol. II, 23–93 on anthropomorphism in the Aggadah.

21 Jacobson 1983.

22 On the texts as vague in this respect, see Eilberg-Schwartz 1994; on the male image, see *Abot de R. Nathan* A2, p. 12 (God as circumcised); Neusner 1987: 168.

23 For these texts, see Cohen 1985. Discussions of date and significance in Cohen 1983: 66–7; Halperin 1988: 362; Schäfer 1992: 7–8. In general, see Maier 1979.

24 E. Wolfson 1994: 43–4, on the Shekhina as light; Goshen-Gottstein 1994; Aaron 1997: 312–13 (despite numerous disagreements with Goshen-Gotsten, he acknowledges that there is 'no question that within the vast array of rabbinic materials one can find imagery that posits God's body as light').

25 Smith 1982: 204*.

26 Hendel 1988.

27 Goodman 1990.

28 For the Dura paintings, see Kraeling 1956.

29 S. Stern 1996 and 2000.

30 Goodenough 1957–68: vol. I, 246–8; vol. x, 107, 180–4; examples in vol. 3, figs 602, 638, 1039.

31 Halperin 1988.

32 Marmorstein 1927–37: vol. II, 105–7.

33 M. Stern 1974–86: *ad loc.*

34 Weihrich 1904.

35 D. Stern 1992: 152: all anthropomorphic statements are 'to be understood figuratively precisely because it is assumed as axiomatic that the Rabbis could never have believed that God actually possesses a human, let alone a corporeal, form'.

36 Dothan 1983: 42. These imperial images, found especially on coins, are much closer to the images found in the synagogues than the images of local solar deities in Syria for which, despite Tacitus, *Historiae* 3.24–5, there is much less evidence than is often supposed: see Seyrig 1971; Millar 1993: 522.

37 Athanassiadi and Frede 1999: 18–19.

38 Mitchell 1999.

39 Mitchell 1999: 110–15.

40 Mitchell 1999: 101.

41 Mitchell 1999: 86.

42 Mitchell 1999: 120.

43 Mitchell 1999: 95.

44 On Constantine and the sun god, see Wallraff 2001.

45 Rice 1957: 26; Finney 1994: 279.

46 Finney 1994: 221, on depictions of Jesus as a *magus*; but note that one of the most striking characteristics of early Christian art is the rarity of even such images of Jesus (293).

47 Milburn 1988: 217 (St Pudenziana), 224 (St George at Salonika). This view, once unquestioned, has been strongly contested by Mathews 1993, but still seems to me broadly correct; see the review of Mathews in Brown 1995.

48 Finney 1994: ch. 6.

49 H. Stern 1958.

50 Toynbee 1964.

51 Goodman 2003. I am grateful to Richard Kalmin and Seth Schwartz for permission to republish this article.

52 Talgam 2014.

53 Levine 2012; S. Stern 2013; Leibner and Hezser 2016.

54 Magness *et al.* 2018.

55 Miller 2004.

56 Magness 2005; Wadeson 2008.

57 Fine 2014: 165–6.

58 Miller 2004: 74–5.

Bibliography

Aaron, D.H. 1997. 'Shedding light on God's body in rabbinic midrashim', *Harvard Theological Review* 90, 299–314.

Athanassiadi, P. and Frede, M. 1999. 'Introduction', in P. Athanassiadi and M. Frede (eds), *Pagan Monotheism in Late Antiquity*, Oxford, 1–20.

Barr, J. 1968–9. 'The image of God', *Bulletin of the John Rylands Library* 51, 11–26.

Brown, P. 1995. Review of Mathews 1993, *Art Bulletin* 77, 499–502.

Cohen, M.S. 1983. *Shi'ur Qomah: Liturgy and Theurgy in Pre-Kabbalistic Jewish Mysticism*, London.

— 1985. *Shiur Qomah: Texts and Recensions*, Tübingen.

Davidson, M.J. 1992. *Angels at Qumran*, Sheffield.

Dothan, M. 1983. *Hammat Tiberias: Early Synagogues and the Hellenistic and Roman Remains*, Jerusalem.

Eilberg-Schwartz, H. (ed.) 1992. *People of the Body: Jews and Judaism from an Embodied Perspective*, Albany.

— 1994. *God's Phallus and Other Problems for Men and Monotheism*, Boston.

Fine, S. 1997. *This Holy Place: on the Sanctity of the Synagogue During the Graeco-Roman Period*, Notre Dame.

— 2014. *Art, History and the Historiography of Judaism in Roman Antiquity*, Leiden.

Finney, P.C. 1994. *The Invisible God: the Earliest Christians on Art*, Oxford.

Foerster, G. 1985. 'Representations of the zodiac in ancient synagogues', *Eretz-Israel* 18, 380–91 (in Hebrew).

— 1987. 'The zodiac in ancient synagogues and its place in Jewish thought and literature', *Eretz-Israel* 19, 225–34 (in Hebrew).

Goodenough, E. 1953-68. *Jewish Symbols in the Graeco-Roman Period*, 13 vols, New York.

Goodman, M. 1990. 'Sacred scripture and "defiling the hands"', *Journal of Theological Studies* 41, 99–107.

— 1992. 'The Roman state and the Jewish patriarchate in the third century', in L.I. Levine (ed.), *Galilee in Late Antiquity*, Jerusalem, 127–39.

— 1994. 'Sadducees and Essenes after 70 CE', in S.E. Porter, P. Joyce and D. Orton (eds), *Crossing the Boundaries: Essays in Biblical Interpretation in Honour of Michael D. Goulder*, Leiden, 347–56.

— 2000. 'Josephus and variety in late Second Temple Judaism', *The Israel Academy of Science and Humanities: Proceedings* 7(6), 201–13.

— 2003. 'The Jewish image of God in late antiquity', in R. Kalmin and S. Schwartz (eds), *Jewish Culture and Society under the Christian Roman Empire*, Leuven, 133–45.

Goshen-Gottstein, A. 1994. 'The body as image of God in rabbinic literature', *Harvard Theological Review* 87, 171–95.

Halperin, D.J. 1988. *The Face of the Chariot*, Tübingen.

Hendel, R.S. 1988. 'The social origins of the aniconic tradition in early Israel', *Catholic Biblical Quarterly* 50, 365–82.

Jacobson, H. (ed. and trans.) 1983. *The Exagoge of Ezekiel*, Cambridge.

Klein, M.L. 1982. *Anthropomorphisms and Anthropopathisms in the Targumim of the Pentateuch*, Jerusalem.

Kraeling, C.H. 1956. *The Excavations at Dura-Europos, Final Report VIII, Part I: The Synagogue*, New Haven.

Leibner, U. and Hezser, C. (eds) 2016. *Jewish Art in Its Late Antique Context*, Tübingen.

Levine, L.I. 1989. *The Rabbinic Class of Roman Palestine in Late Antiquity*, Jerusalem and New York.

— 2012. *Visual Judaism in Late Antiquity*, New Haven and London.

Lodahl, M.E. 1992. *Shekinah/Spirit: Divine Presence in Jewish and Christian Religion*, New York.

Magness, J. 2003. 'Archaeological testimonies: Helios and the zodiac cycle in ancient Palestinian synagogues', in W.G. Dever and

S. Gitin (eds), *Symbiosis, Symbolism and the Power of the Past*, Winona Lake, IN, 363–89.

— 2005. 'Heaven on earth: Helios and the zodiac cycle in ancient Palestinian synagogues', *Dumbarton Oaks Papers* 59, 1–52.

Magness, J. *et al.* 2018. *Huqoq Excavation Project*, http://huqoq.web.unc.edu (accessed 11 May 2020).

Maier, J. 1979. 'Die Sonne im religiösen Denken des antiken Judentums', in W. Haase (ed.), *Aufstieg und Niedergang der römischen Welt* 2.19(1), 346–412.

Marmorstein, A. 1927–37. *The Old Rabbinic Doctrine of God*, 2 vols, London.

Mathews, T. 1993. *The Clash of Gods*, Princeton.

McCarthy, C. 1989. 'The treatment of biblical anthropomorphisms in the Pentateuchal targums', in K.J. Cathcart and J.F. Healey (eds), *Back to the Sources*, Sandycove, 45–66.

Milburn, R. 1988. *Early Christian Art and Architecture*, Aldershot.

Millar, F. 1993. *The Roman Near East*, Cambridge, MA.

Miller, S. 2004. '"Epigraphical" rabbis, Helios and Psalm 19: were the synagogues of archaeology and the synagogues of the sages, one and the same?', *Jewish Quarterly Review* 94(1), 27–76.

Mitchell, S. 1999. 'The cult of Theos Hypsistos', in P. Athanassiadi and M. Frede (eds), *Pagan Monotheism in Late Antiquity*, Oxford, 81–148.

Moore, S.D. 1996. 'Gigantic god: Yahweh's body', *Journal for the Study of the Old Testament* 70, 87–115.

Neusner, J. 1988. *The Incarnation of God: the Character of Divinity in Formative Judaism*, Philadelphia.

Newsom, C.A. 1985. *Songs of the Sabbath Sacrifice*, Atlanta.

Rice, D.T. 1957. *The Beginnings of Christian Art*, London.

Rowland, C.C. 1979. 'The visions of God in apocalyptic literature', *Journal for the Study of Judaism* 10, 137–54.

Schäfer, P. 1992. *The Hidden and Manifest God*, Albany.

Seyrig, H. 1971. 'Antiquités syriennes', *Syria* 48, 85–120.

Smith, M. 1958. 'The image of God', *Bulletin of the John Rylands Library* 40, 473–512.

— 1968. 'On the shape of God', in J. Neusner (ed.), *Religions in Antiquity: Essays in memory of Erwin Ramsdell Goodenough*, 315–26.

— 1982. 'Helios in Palestine', *Eretz-Israel* 16, 199*–214*.

Stemberger, G. 1975. 'Die Bedeutung des Tierkreises auf Mosaikböden spätantiker Synagogen', *Kairos* 17, 23–56.

Stern, D. 1992. '"Imitatio hominis": anthropomorphism and the character(s) of God in rabbinic literature', *Prooftexts* 12, 151–74.

Stern, H. 1958. 'Les mosaïques de l'église de Sainte-Constance à Rome', *Dumbarton Oaks Papers* 12, 159–218.

Stern, M. 1974–84. *Greek and Latin Authors on Jews and Judaism*, 3 vols, Jerusalem.

Stern, S. 1996. 'Figurative art and halakha in the Mishnaic–Talmudic period', *Zion* 61, 397–419. (in Hebrew).

— 2000. 'Pagan images in late antique Palestinian synagogues', in S. Mitchell and G. Greatrex (eds), *Ethnicity and Culture in Late Antiquity*, London and Swansea, 241–52.

— 2013. 'Images in late antique Palestine: Jewish and Graeco-Roman views', in S. Pearce (ed.), *The Image and Its Prohibition in Jewish Antiquity*, Yarnton, 110–29.

Sukenik, E.L. 1934. *Ancient Synagogues in Palestine and Greece*, London.

Talgam, R. 2014. *Mosaics of Faith: Floors of Pagans, Jews, Samaritans, Christians, and Muslims in the Holy Land*, Jerusalem.

Taylor, J.G. 1993. *Yahweh and the Sun*, Sheffield.

Toynbee, J.M.C. 1964. 'A new Roman mosaic pavement found in Dorset', *Journal of Roman Studies* 54, 7–14.

Wadeson, L. 2008. 'Chariots of fire: Elijah and the zodiac in synagogue floor mosaics of late antique Palestine', *Aram Periodical* 20, 1–41.

Wallraff, M. 2001. *Christus Verus Sol. Sonnenverehrung und Christentum in der Spätantike*, Münster.

Weihrich, F. (ed.) 1904. *Sancti Aureli Augustini. De consensu evangelistarum*, Vienna.

Weiss, Z. and Netzer, E. 1996. *Promise and Redemption: A Synagogue Mosaic from Sepphoris*, Jerusalem.

Wiggins, S.A. 1996. 'Yahweh: the god of sun?', *Journal for the Study of the Old Testament* 21, 89–106.

Wolfson, E.R. 1994. *Through a Speculum that Shines*, Princeton.

Wolfson, H.A. 1947. *Philo: Foundations of Religious Philosophy in Judaism, Christianity, and Islam*, 2 vols, Cambridge, MA.

Response to M. Goodman, 'The Jewish Image of God in Late Antiquity'

Hindy Najman and Jaś Elsner

Martin Goodman's article suggests the possibility that the Helios figure within a zodiac at the central point of a series of synagogue floors in Palestine might have been intended to be, and might have been recognised as, God's self by both patrons and congregants. Goodman's essay steps outside what he calls the 'timidity' of scholarship on late ancient synagogue art.[1] The original publication of his paper encouraged a number of other ventures, notably those he describes in the afterword. He is undoubtedly correct; it is not for scholarship to legislate what ancient viewers did or did not think, any more than it is for museums to seek control over what their visitors think about the works therein. In a swift and surefooted move, well grounded in contextual scholarship of other religions within the pluralist environment of the later Roman world (at any rate before the hegemonic takeover by Christianity at the end of the 4th century), he shows that we are dealing with issues of likelihood and probability in interpretation, not old-fashioned positivist certainty.[2] Most attempts to legislate are about the legislators preserving their views of how ancestral religions ought to reflect what they believe is appropriate now. But the question remains whether Goodman is still thinking in monotheistic, or even Jewish legal, terms, when he takes 'out of the box' risks at the end of his essay. He writes: 'It seems to me much more likely that their choice demonstrated their confident conviction that the God to whom both pagans and Christians paid greatest observance was the God of Israel' (p. 72). What is not dramatic or risk-taking about this position is that Goodman still presupposes a normative rabbinic, monotheistic and Jewish legal context for an environment that may suggest otherwise.

In our comments we want to extend the conversation beyond Goodman's focus on the Helios motif to the larger environment of the imagery on the floors he discusses, and argue that the larger literary context goes well beyond the confines of so-called monotheistic rabbinism. The imagery in texts and material culture from earlier depictions of deity in biblical, Hellenistic and later examples suggest a far more radical integration of pagan, Jewish and Christian culture, incorporated into a whole array of cultural trends and religious traditions that are at times even syncretistic. Was this transgressive or was this integration a way of life in the face of multiple religious cultures, philosophical influences and competing, or even at times complementary, cultures?

In the larger context of the imagery, and in each case, Helios is situated within a circular zodiac within a large square panel with the four seasons in the corners, which is located in the central section of the floor.[3] In each case, at the upper section of the floor, furthest from where the congregants would enter and presumably closest to the most sacred part of the synagogue — assuming a longitudinal axis with the Torah shrine at the end (which interestingly is *not* how the building at Dura Europos was disposed)[4] – are depictions of Temple implements with a variety of features that may include menorahs, an aedicule with the Ark of the Covenant, lamps, *shofars* (rams' horns), incense shovels and lions.[5] These may belong to a single panel, as is the case in Hammat Tiberias (4th century, **Pls 4.1, 4.6**),[6] Naaran (6th century, **Pls 4.4, 4.7**)[7] – although this adds Daniel in the lion's den to the mix – and Beth Alpha (6th century, **Pls 4.2,**

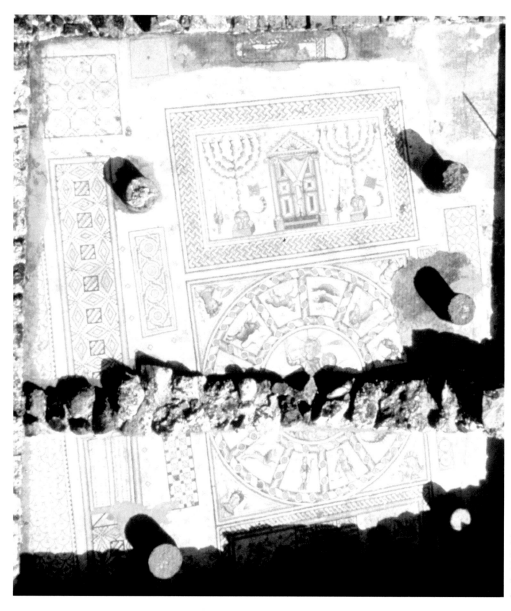

Plate 4.6 Mosaic floor, 4th century, synagogue at Hammat Tiberias. Image courtesy of the Center for Jewish Art

4.5, 4.8).[8] In Sepphoris (5th century), a range of Temple-related subjects are placed in four tiers of separate framed panels (including a scene of Aaron's consecration of the first Tabernacle) above the zodiac panel (**Pls 4.3, 4.9**).[9] Below the zodiac, closest to the entrance, are a range of different options including dedicatory inscriptions (at both Hammat Tiberias and Beth Alpha); biblical narrative scenes (the angels' visit to Abraham and Sarah at Mamre and the sacrifice of Isaac in the Sepphoris synagogue floor, the sacrifice of Isaac at Beth Alpha); and an intricate carpet scene with animals and birds in hexagons (at Naaran).

Many of these features also occurred in other synagogues whose mosaics survive in very poor condition – for example Hulda and Maon, and especially at Huseifa and Susiya, which likely had parallel schemes with at least a zodiac and Helios scene.[10] Like Naaran, Susiya was subject to later iconoclasm and refurbishment.[11] In the great new discovery at Huqoq, the zodiac with Helios in a chariot and the seasons at the corners appears in the middle of the main nave as usual but with a much richer array of scriptural narrative imagery than known from earlier mosaic finds.[12] In each case, this display of images was laid out longitudinally within an elegant overall mosaic frame, to be

seen from the position of the person entering and all in the same disposition – except for the zodiac, whose images circle. In the case of the Beth Alpha floor, the frame itself contained a range of images: animals, birds, fruit and abstract designs in lozenges along the right and the top; a vine scroll with animals and birds along the left; and on either side of the *tabula ansata*, with inscriptions in Aramaic and Greek that face the entrant, were a bull and a lion disposed upside down to the viewer so that they would be right side up from the point of view of someone leaving the synagogue, the feet of the beasts placed on the ground line that makes the frame of the lowest panel.

These are a range of complex cues, and all could be discussed in much greater detail. The initial point is that all are stock elements, mixable in different dispensations and orders, some quite specific to Judaism (such as the Temple implements and the biblical narratives) and some – like the zodiac and charioteer – borrowed from the larger Greco-Roman environment. But are they to be seen as alien to Judaism in antiquity?

The closest parallel for a Helios charioteer within a zodiac comes from a 3rd-century Roman mosaic found in a villa in Münster.[13] The willingness to mix and match

different elements appropriated from elsewhere into new wholes, where specific iconographies (like the charioteer) could acquire new meanings by virtue of their accoutrements and attributes, is a normal feature of the Roman artistic tradition.[14] This mixing is precisely what we want to suggest goes beyond the conclusion in Martin Goodman's essay. The integrated image and variegated appropriation – many cultures which came to be understood as incompatible in later religious tradition, albeit retrospectively – live side by side here. Does that really reflect the triumphalist narrative embedded in Goodman's tentative conclusion about Jewish confidence that it was their own God to whom they saw pagans and Christians giving worship?

The Roman tradition is adapted here to suit the subaltern needs of a religious group that had non-hegemonic status within the larger Roman state (whether pagan polytheist or later Christian).[15] We may legitimately ask – when speaking of subaltern Jews (as of pre-hegemonic Christians) – whether the concept of a defined group is in fact appropriate. Arguably in the synagogue floors of Palestine, we have evidence of multiple, differentiated and self-differentiating groups claiming to be Jews with slightly different beliefs, mixes of texts and commentaries, and mixes of image-types and iconographies. None of these floors are the same, but each works within a pattern with the Temple at the longitudinal end, the Helios with zodiac and seasons in the centre, and other imagery at the entry point. It may be fairly assumed that there was an overall but not rigid scheme.[16]

It is important here to note two issues. First, we are dealing with holy spaces – no one seriously doubts that these are the mosaic floors of synagogues. Second, a cluster of conundra: how do you reconstruct a space from a floor? How important is a floor to the rest of the space and its decoration? How does a floor relate to that decoration? If anyone is in doubt about the difficulties, just look at the flooring (carpet, tile, stone, wood) of any group of spaces, public and private, in our own experience and ask how one could extrapolate anything from the floor in its own right if this were all that survived. No walls survive from Palestinian synagogues, at any rate with their painted decoration, while at Dura Europos we have spectacular paintings and even ceiling tiles, but no floor.[17]

The floor question is more than just an archaeological problem. We have a very interesting text from the *Targum Pseudo-Jonathan*, a Palestinian translation of and commentary on the Torah into Aramaic, which seems to have been produced over a long period that includes the time when the model of the floors we are discussing was created and in the same cultural context.[18] Here, in its version of Leviticus (26:1), the *Targum* writes: 'and you shall not place a figured stone in your land, upon which to bow down; however you may place a mosaic pavement impressed with figures and images in the floors of your sanctuaries — but not for kneeling to it'.[19] This seems targeted precisely at the kinds of images being discussed here, and designed to rescue the tradition of making them from any imputation of idolatry by removing such imagery from the sphere of worship in the sense of being bowed down to or knelt before. What we cannot know is whether such regulations went side

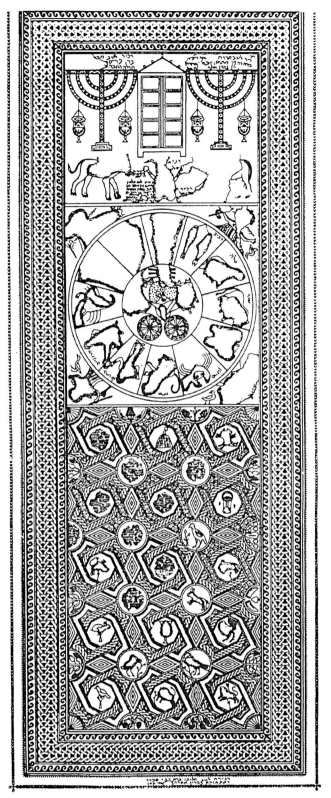

Plate 4.7 Line drawing of mosaic floor, 6th century, synagogue at Naaran. Image courtesy of the Center for Jewish Art

by side with the making of the floors under discussion (roughly 4th–6th century) or were a post hoc justification at a later period, or were used to justify the pattern once it had been established (say, after Hammat Tiberias) but before later floors (such as Beth Alpha or Naaran).

So how are we to read the synagogue mosaics? How does Goodman read them and what are the alternatives? We want to problematise Goodman's reading on two fronts. First, his reading presupposes normative Jewish and

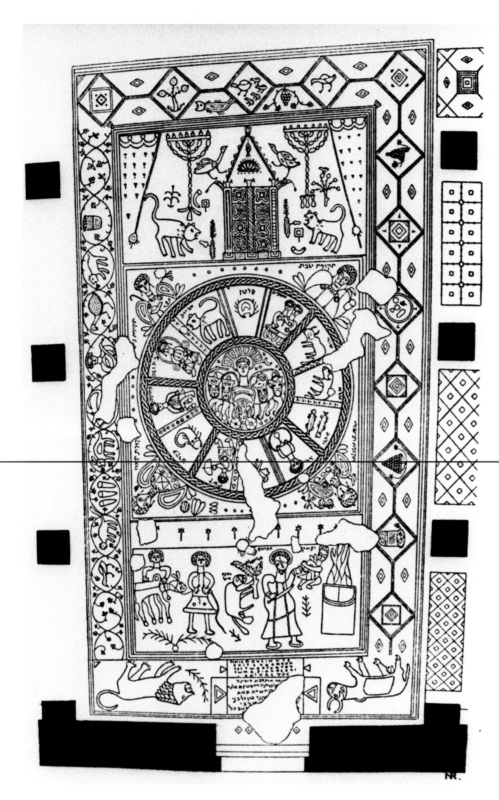

Plate 4.8 Line drawing of mosaic floor, 6th century, synagogue at Beth Alpha. Image courtesy of the Center for Jewish Art

monotheistic, or even halakhocentric assumptions (that is, centred on patterns of religious observance) about the singularity of the Jewish deity. But secondly, and perhaps more importantly, he isolates Helios from the overall mosaic context. Let us take Beth Alpha (**Pls 4.5, 4.8**), which is the best survival, even if its style has frequently been dismissed as 'provincial' (or, in Goodman's words, 'near-caricature').[20] The panel with the Temple utensils (a close parallel to Hammat Tiberias, Naaran and Susiya, if stylistically different) clearly evokes ritual activity, whether directed self-reflexively to the synagogue as a space of worship or to the memory of the destroyed Temple or to both.[21] The scene of

the binding or sacrifice of Isaac, known in Hebrew as the ʿAqedah, is presented in a number of commentarial exegeses as taking place on the same site where the Temple would ultimately be built – Mount Moriah.[22] So, in a not hugely difficult exegetic model, the Helios charioteer in a zodiac is sandwiched between a founding biblical-mythical evocation of the holiest site in Judaism where the Temple would be built and the biblical-historical visualisation of that site as the Temple, the focus of the religion before the Diaspora in the days of the kings. That site is not the synagogue of Beth Alpha or where the synagogue was built, but it is a sacred memory to which the process of synagogue worship relates,

which it re-enacts and represents. Between these scenes, an animate and frontal evocation of the sun as charioteer (true also of Sepphoris, where the chariot is represented, though there is no figure driving it) appears within a zodiac surrounded by the seasons – evoking the passage of cosmic and seasonal time.

The range of ramifications is extended or tweaked in the different mosaics. In Hammat Tiberias, any reference to scriptural narratives is missing, but the zodiac panel – whose charioteer holds the globe in his left hand – is sandwiched between the Temple implements and a Greek dedicatory inscription flanked by lions. These lions seem displaced from those above the Temple panel in Sepphoris and within the Temple panel at Beth Alpha, implying Temple evocation at both the entrance and the end of the room, with the cosmological charioteer between. At Sepphoris, the Temple evocations are considerably extended, with a founding image of Aaron consecrating the Tabernacle and panels with the showbread and the daily sacrifice at the Temple. Likewise, the scene of the 'Aqedah is extended with the visitation of the angels at Mamre – widening the scope of geographic as well as biblical reference but nonetheless casting both the theophanies from Genesis (of the angelic appearance and of God's appearance to Abraham to stop his sacrifice) within the cosmological frame of Helios and the imagery of the Temple. Here, as at Beth Alpha, the 'Aqedah is extended by Genesis 22:5: 'stay here with the donkey',[23] At Naaran, the Temple lions become those between whom Daniel stands in the orant pose, casting a potentially salvific dimension on the relation of charioteer and Temple themes.

None of this imagery is fixed in its meanings, but was open to liturgical framing and reframing. In addition, it inherited and generated exegetical inflection from the kinds of texts known to or recited by the congregations at these sites or commented upon by the rabbis who served these congregations. In every case, these floors open the space for a vision of divine grandeur evoking cosmology (through the zodiac and its celestial implications), the passage of cyclical time (through the seasons) and geography (through the evocation of sacred mountains). This set of intimations looks well beyond the relatively small architectural dispensation of the places of worship in which the mosaics were set. That opening to symbolic and sacred meanings is precisely not constrainable by the kinds of interpretative timidity that insist on keeping them respectable by modern standards of rational belief: it reveals an almost endless imaginative set of potentials and is itself set against the natural imagery of birds, animals and vines found beneath the zodiac at Naaran or in the framing border of Beth Alpha.

Goodman's argument – that this should include the possibility that the entire floor is a frame around a non-idolatrous visualisation of God himself – is entirely feasible, but it may go further than this. That it might imply reference to a vast literature centred on the divinisation of the human as celestial charioteer is also compelling and verifiable.[24] Yet, further to that, could the mosaic open intimations beyond the immediate, and contiguities of iconography that allow non-literal and imaginative connections? Such mosaics could frame the sanctity of the

Plate 4.9 Line drawing of mosaic floor, 5th century, Sepphoris. Image: after Weiss 2005: 57, fig. 2

space as one that looks beyond itself (whether to the past, in narratives of Jewish history and the lost Temple, to the future, in the promise of the Temple rebuilt, or to a mystical eternity).[25] Does this artwork construct a self that looks beyond its own internal parochial narrative? The images and the cultural context for those images are not distinctively Jewish, and neither are they in any clear manner monotheistic. Why should we 'monotheise' the mosaic? These spaces are holy but not in the sense of being separated off from otherness. Rather, the mosaic engages

otherness in a manner that opens up a new context for us to evaluate the textual evidence for imagining the divine.

The Jewish tradition from the Persian to the Hellenistic periods and beyond is deeply engaged with the pagan imagination. This has been noticed through the Hellenistic Jewish materials, from the *Exagoge of Ezekiel* and *Joseph and Aseneth*, to the Dead Sea Scrolls in the colourful and imaginative *Songs of the Sabbath Sacrifice*, and many more such examples. The cosmos and the shrine are filled with depictions of seraphs and divine beings that create a heaven on earth enlivened, not by indigenous verses from the Deuteronomic law code, but by the poetic spirit and artistry of the pagan world, which was remarkably shaping the very spaces for prayer and communion with the divine. Does this in fact suggest that notions of apotropaic prayer and amulets, or magical formulas – borrowed from contemporaneous cultures – shaped the rabbinic imagination in ways that we have overlooked, as scholarship was co-opted by religious right thinking, instead of by the very objects that are before us? Have we eclipsed the very things that demanded we rethink our constructed narratives? Perhaps we should return to the evidence before us and re-evaluate the messiness and the syncreticity of ancient Jewish creativity and imagination, as so spectacularly evidenced by late ancient Jewish art.

Notes

1 With thanks to Ishay Rosen-Zvi and Yael Fisch for their helpful comments, and especially to Rina Talgam for help with acquiring images.

2 One might here also applaud Seth Schwartz's attack on excessively programmatic interpretations of the floors in Schwartz 2000: 181: 'The art of the ancient synagogue is not a code to be broken.'

3 The literature on the zodiacs is now vast. One might start with Hachlili 2009: 35–56 and 2013: 339–88; Levine 2012: 317–36; Talgam 2014: 257–318; Denies 2016.

4 See e.g. Levine 2012: 97–11, especially the plans on 99.

5 On the Temple implements, see e.g. Hachlili 2009: 17–34 and 2013:285–338; Levine 2012: 337–62.

6 Dothan 1983: 27–88 for the fundamental publication, with Levine 2012: 243–59 and Talgam 2014: 265–81.

7 Vincent 1919, 1921 and 1961; Fine 2005: 82–97; and Talgam 2014: 304–8.

8 Sukenik 1932; Levine 2012: 280–3; and Talgam 2014: 296–303.

9 Weiss and Netzer 1996; Weiss 2005; Levine 2012: 260–77; and Talgam 2014: 281–95.

10 On Susiya, see Gutman *et al.* 1981 and Talgam 2014: 309–14; for Huseifa, see Avi-Yonah 1934; for Huseifa and Hulda, see Talgam 2014: 317–19; for Maon, see Talgam 2014: 327–8.

11 On iconoclasm see e.g. Fine 2000; Hachlili 2009: 209–17.

12 See Magness *et al.* 2018: 106–11. At n. 59 it is claimed that Huqoq proves that the fragmentary mosaic remains at Yaphi'a and Wadi Hamam also depicted Helios in a zodiac.

13 Now in the Rheinisches Landesmuseum in Bonn. See Wirth-Bernards 1939 and Şahín 2009: 98, no. 5.

14 The larger 'system' is brilliantly described by Hölscher 2004, although his account is limited by being focused on Greek models and does not include eclectic borrowings from elsewhere: see Elsner 2006 for critique. On figural borrowings and the replication of repeated motifs with different attributes to give different

identities, see Pearson 2015: 158–62; also Elsner and Squire 2016: 192–203 for issues about memory.

15 Neis 2013 describes the rabbis as a minority group within the empire who were being bombarded by images from pagan contexts, and then generating limitations on sight (working 'to legislate and rabbinize vision', 10). What the mosaics show is that this 'bombardment' does not simply come from the direction of the empire, but also from 'within' existing Jewish images. We would want to problematise this claim of bombardment. The evidence we are considering here requires an alternative model for describing the interaction between the rabbis and the Romans with respect to images and their power.

16 See Hachlili 2013: 473–515 for issues of workshop practice, including 511–13 on pattern books.

17 See Baird 2018: 138–41.

18 For the early date of much of the material collected in a document whose final form may have been reached in the Islamic period, see Mortensen 2006 and Hayward 2009: 126–54.

19 See Klein 2011: 57.

20 See Stewart 2016, with further condemnatory bibliography at n. 23. Other terminology used there includes 'disintegration' of classical artistic traditions (75, 77, 82, 84, 93), '"folk art"' (90–1, in scare quotes), '"provincialized" or "popular" or "*bad*" art' (91) and 'decline' (93).

21 For a comparative survey of these panels, see Hachlili 2013: 286–91, with the various implements discussed in detail at 292–338. The incense shovel refers specifically to an item only used by the High Priest in the Temple: 328–30.

22 See Kessler 2004: 82–3, 88, 127–8; Smith 1987: 47–95, esp. 83–6.

23 See e.g. Kessler 2003.

24 See Magness 2005, following a very rich Merkabah mystical tradition, on which, see Halperin 1980 and 1988. See also Schäfer 2009: 34–85 on Ezekiel and Enoch; and Rowland and Morray-Jones 2009: 219–64 on Merkava mysticism in Rabbinic and Hekhalot contexts (esp. 240–2 on hymns).

25 On the ancient synagogue and its different image elements as a system of symbols that refers beyond itself to the cosmic temple, see Talgam 2014: 264–81.

Bibliography

Avi-Yonah, M. 1934. 'A sixth-century synagogue at Isfiya', *Quarterly of the Department of Antiquities in Palestine* 3, 118–31.

Baird, J.A. 2018. *Dura-Europos*, London.

Denies, R. 2016. 'God's revelation through Torah, creation, and history: interpreting the zodiac mosaics in synagogues', in U. Leibner and C. Hezser (eds), *Jewish Art in Its Late Antique Context*, Tübingen, 155–86.

Dothan, M. 1983. *Hammath Tiberias*, vol. 1, Jerusalem.

Elsner, J. 2006. 'Classicism in Roman art', in J. Porter (ed.), *Classical Pasts: The Classical Traditions of Greece and Rome*, Princeton, 270–97.

Elsner, J. and Squire, M. 2016. 'Vision and memory', in M. Squire (ed.), *Sight and the Ancient Senses*, London, 188–212.

Fine, S. 2000. 'Iconoclasm and the art of late antique Palestinian synagogues', in Levine and Weiss 2000: 183–94.

— 2005. *Art and Judaism in the Greco-Roman World*, Cambridge.

Gutman, S. *et al.* 1981. 'Excavations in the synagogue at Horvat Susiya', in L. Levine (ed.), *Ancient Synagogues Revealed*, Jersualem, 123–8.

Hachlili, R. 2009. *Ancient Mosaic Pavements*, Leiden.

— 2013. *Ancient Synagogues: Archaeology and Art*, Leiden.

Halperin, D. 1980. *The Merkabah in Rabbinic Literature*, New Haven.

— 1988. *The Faces of the Chariot: Early Jewish Responses to Ezekiel's Vision*, Tübingen.

Hayward, C. 2009. *Targums and the Transmission of Scripture into Judaism and Christianity*, Leiden.

Hölscher, T. 2004. *The Language of Images in Roman Art*, Cambridge.

Kessler, E. 2003. 'A response to Marc Bregman', *Journal of Textual Reasoning* 2, http://jtr.shanti.virginia.edu/volume-2-number-1/response-to-marc-bregman/ (accessed 11 May 2020).

— 2004. *Bound by the Bible: Jews, Christians and the Sacrifice of Isaac*, Cambridge.

Klein, M.L. 2011. 'Palestinian targum and synagogue mosaics', in *Michael Klein on the Targums: Collected Essays 1972–2002*, Leiden, 49–57.

Levine, L. 2012. *Visual Judaism in Late Antiquity*, New Haven.

Levine, L. and Weiss, Z. (eds) 2000. *From Dura to Sepphoris*, Providence, RI.

Magness, J. 2005. 'Heaven on earth: Helios and the zodiac cycle in ancient Palestinian synagogues', *Dumbarton Oaks Papers* 59, 1–52.

Magness, J. *et al.* 2018. 'The Huqoq excavation project 2014–2017 interim report', *Bulletin of the American Schools of Oriental Research* 380, 61–131.

Mortensen, B. 2006. *The Priesthood in Targum Pseudo-Jonathan: Renewing the Profession*, Leiden.

Neis, R. 2013. *The Sense of Sight in Rabbinic Culture: Jewish Ways of Seeing in Late Antiquity*, Cambridge.

Pearson, S. 2015. 'Bodies of meaning: figural repetition in Pompeian painting', in S. Lepinski and S. McFadden (eds), *Beyond Iconography: Materials, Methods, and Meaning in Ancient Surface Decoration*, Boston, 149–66.

Rowland, C. and Moray-Jones, C.R.A. 2009. *The Mystery of God: Early Jewish Mysticism and the New Testament*, Leiden.

Şahín, D. 2009. 'The zodiac in ancient mosaics', *Journal of Mosaic Research* 3, 95–111, http://dergipark.gov.tr/download/article-file/294046 (accessed 11 May 2020).

Schäfer, P. 2009. *The Origins of Jewish Mysticism*, Tübingen.

Schwartz, S. 2000. 'On the programme and reception of the synagogue mosaics', in Levine and Weiss 2000: 165–81.

Smith, J.Z. 1987. *To Take Place: Toward Theory in Ritual*, Chicago.

Stewart, P. 2016. 'The Bet Alpha synagogue mosaic and late-antique provincialism' in U. Leibner and C. Hezser (eds), *Jewish Art in Its Late Antique Context*, Tübingen, 75–96.

Sukenik, E. 1932. *The Ancient Synagogue of Beth Alpha*, Jerusalem.

Talgam, R. 2014. *Mosaics of Faith: Floors of Pagans, Jews, Samaritans, Christians, and Muslims in the Holy Land*, University Park, PA.

Vincent, R. 1919. 'Le sanctuaire juif d'Ain-Douq', *Revue biblique* 16, 532–63.

— 1921. 'Le sanctuaire juif d'Ain-Douq' *Revue biblique* 30, 442–3.

— 1961. 'Une sanctuaire dans la region de Jericho, la synagogue de Na'aren', *Revue biblique* 68, 163–77.

Weiss, Z. 2005. *The Sepphoris Synagogue*, Jerusalem.

Weiss, Z. and Netzer, E. 1996. *Promise and Redemption: A Synagogue Mosaic from Sepphoris*, Jerusalem.

Wirth-Bernards, H. 1939. *Über das Heliosmosaik aus Münster bei Bingerbrück*, Bonn.

Chapter 5
Empire and Faith: The Heterotopian Space of the Franks Casket

Catherine E. Karkov

The Franks Casket, a small (29 × 19 × 13cm) whalebone box made in early 8th-century Northumbria, possibly near Whitby, remains something of a puzzle.[1] Its inscriptions are written in verse and prose, the Old English and Latin languages, and the runic and Roman alphabets. Two sections of the inscriptions are positioned upside down, one is written retrograde and one is encrypted using a vowel substitution code. Its panels are carved with scenes that have their sources in the Christian, Jewish and polytheistic Germanic and Roman traditions. There is no agreement as to why the Casket was made or for whom, what its original function was or what it means. Whether it had a religious function, or whether it was intended to be understood exclusively or even primarily for the religious content of its panels – only one of which carries an unarguably Christian scene – is questionable. It is clear, however, that the Casket refers to stories of both faith and empire, as each of its panels is carved with a scene or scenes that relates directly to the religious, ethnic and political origins that the Anglo-Saxons traced for themselves; origin stories that would also be incorporated – indeed would help to justify – the much later English empire.[2]

On the front panel (**Pl. 5.1**) a scene from the Germanic story of Weland the Smith is juxtaposed with a biblical one depicting the Adoration of the Magi (the three male figures are labelled 'magi' in runes). The surrounding Old English verse inscription reads:

fisc flodu ahof on fergenberig

warþ gasric grorn þær he ongreot giswam.

hronæs ban.

The fish beat up the seas [or rose by means of the sea] onto the mountainous cliff [or high hill, or burial place]; gasric [the 'king of terror' or 'one strong in life or power' or maybe just the name given to the whale] became sad when he swam aground onto the shingle. Whale's bone [or bones].

The words *warþ gasric grorn þær he angreot giswam* are carved retrograde across the bottom border panel. The inscription tells us about the material from which the Casket is made, and about how it came to be made from the bone, or bones, of a stranded whale, the jawbone(s) of a sperm whale judging from the size of the panels, but it has seemingly little to do with the two scenes it surrounds.

The fragmentary lid (**Pl. 5.2**) is carved with a scene of a battle and an archer, possibly Ægil, Weland's brother, defending a fortified building. The inscription *Ægili*, usually taken as the name Ægil, a simple identification of the figure of the archer, could however be the uncontracted Old English dative singular for the name, so 'to or for Ægil', or it could be the Latinised genitive singular, in which case 'belonging to Ægil'.[3] On the back (**Pl. 5.3**) is the sack of the Temple in Jerusalem by the emperor Titus and his troops, and the flight or capture of the Jews. The prose inscription, in a mixture of the Old English and Latin languages and the runic and Roman alphabets, reads: *her fegtaþ titus end giuþeasu hic fugiant Hierusalim afitatores* ('Here Titus and a Jew [or Jews] fight. Here the inhabitants flee Jerusalem'). On the left side (**Pl. 5.4**), Romulus and Remus are suckled by the she-wolf, and the inscription, again in prose, tells us *romwalus ond remwalus twoegen gibroþær afoedd˙ hiæ wylif in romcæstri oþlæ unneg*

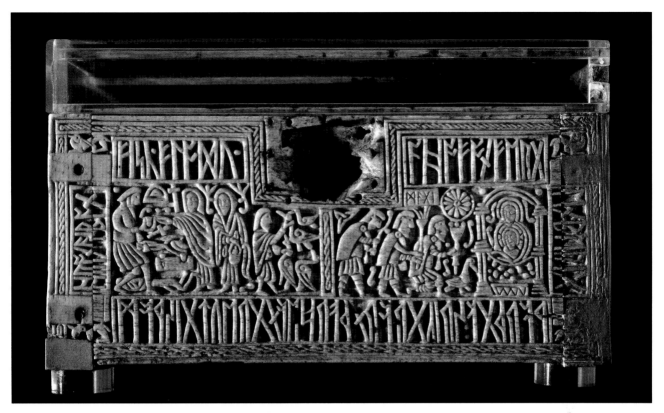

Plate 5.1 Franks Casket, front panel, early 8th century, whalebone, 22.9 × 10.9cm. British Museum, London, 1867,0120.1

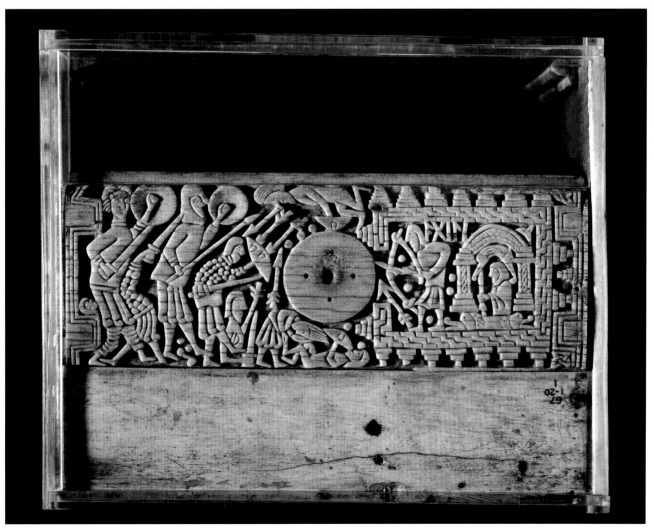

Plate 5.2 Franks Casket, lid, early 8th century, whalebone, originally 22.9 × 19cm. British Museum, London, 1867,0120.1

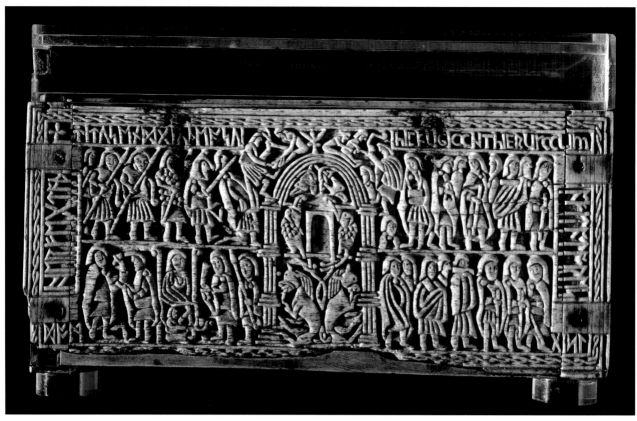

Plate 5.3 Franks Casket, back panel, early 8th century, whalebone, 22.9 × 10.9cm. British Museum, London, 1867,0120.1

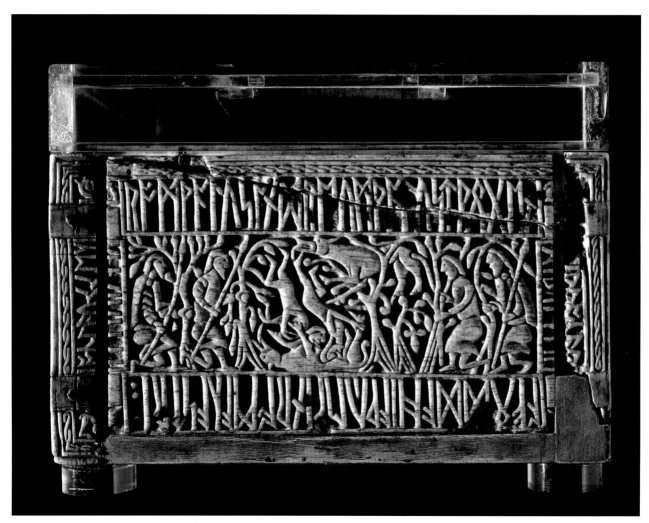

Plate 5.4 Franks Casket, left side panel, early 8th century, whalebone, 19 × 10.9cm. British Museum, London, 1867,0120.1

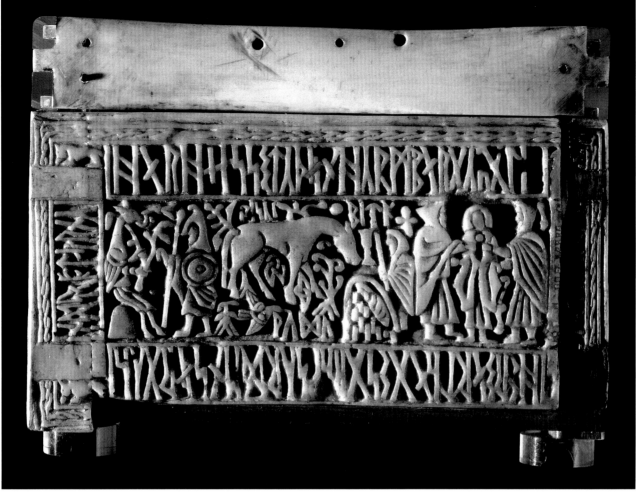

Plate 5.5 Franks Casket, replica of the right side panel, early 8th century, resin, 19 × 10.9cm. British Museum, London, 1867,0120.1

('Romulus and Remus, two brothers, a she-wolf nourished them in the city of Rome far from their native land'). The words 'a she-wolf nourished them in Rome' are carved upside down across the bottom border.

Finally, on the right side (**Pl. 5.5**), is a scene including humans, animals and hybrid creatures that has never been fully interpreted, although it is clearly one of sorrow and distress. There is some disagreement about how to read the surrounding inscription. Many follow Ray Page in reading:

Her Hos sitiþ on harmberga

agl['] drigiþ swa hiræ Ertae gisgraf

sarden sorga and sefa torna

Here Hos sits on the sorrow mound; she suffers distress as Ertae had imposed it upon her, a wretched den [or wood] of sorrows and torments of mind.[4]

Tom Bredehoft, however, has suggested that three of the runes should be read not as 'r'-runes but as cryptic runes signifying the letter 'u'. He reads *harmberga* as *hæumberga* (high hill), *Ertae* as *Eutae* (the Jute) and *sarden* as *sæuden*, which he leaves untranslated.[5] Transcribing the runes very differently, Gaby Waxenberger reads:

Her hos sittaþ on harmberg a

ægl[æcca] drigiþ swa (=swac) irri Ertae egi sgræf (=scræf)

sar den sorga ænd sefa torna

Here/listen, the company presides over the harmful burial place/mound (always). The awesome opponent/ferocious fighter always performs/acts/endures. Anger has left Ertae assigned/decreed by means of the horse distress, the grave of sorrows and the sad mood.[6]

The inscription is in verse and encrypted, and the words in the lower border are again arranged upside down in relation to the figures in the main panel. This panel was found in the same house in Auzon, France, as the other panels, but it had become separated from the rest of the panels and was not located until a later date. The Casket had been used by the family as a sewing box but its fittings were removed at some point by one of the family.[7] The right side panel is now in the Museo Nazionale del Bargello in Florence. The British Museum has replaced it with a replica.

It has most frequently been argued that the Casket's panels are syncretic, establishing a harmony between Christianity and the polytheistic religions of the northern Germanic world, even though the Adoration of the Magi is the only explicitly Christian scene on the Casket and none of its inscriptions has an obviously Christian content.[8] In addition, the three wise men are labelled 'magi' in runes on the front of the Casket, and this also raises the question of why the Magi, though not Weland, would need to be identified by inscription on a Christian object. On the other hand, the level of literacy and multilingualism required to read the inscriptions effectively precludes anything but a

Christian maker, owner or audience. Very few people outside the Church were able to read in any language, and Latin learning was very much the preserve of the Church until a much later date. Runes were an archaic and learned script, a display of learning rather than a means of day-to-day communication. The encrypted inscription of the Hos panel, moreover, relies on 'a systematic substitution of older runic forms for all the vowels … [that] are ingeniously derived from the runic forms of the consonants that end the Old English names of the normal runic symbols'.[9] The only other surviving early Anglo-Saxon artwork to include similarly lengthy and complex inscriptions is the 8th-century Ruthwell Cross (Dumfries), which was indisputably produced by and for a Northumbrian monastic community. At least some of that community's members could read both Latin and Old English in the Roman and runic alphabets, though it has to be admitted that, unlike the Franks Casket's iconography, all the carved panels and inscriptions on the Ruthwell Cross are of unquestionably Christian subjects. It is possible, however, that the Casket expresses a respect for, or tolerance of, multiple belief systems, much as roughly a century later the *Anglo-Saxon Chronicle* records that in 876 King Alfred respected, or at least tolerated, the swearing of viking oaths on a sacred pagan ring or arm-ring (*halgan beage*).[10]

Some have also interpreted the Casket more generally as establishing a harmony or, again at the very least, a relationship between the Germanic/Anglo-Saxon and Roman cultures.[11] Given the subject matter of the carved panels and the language of the inscriptions, it is undeniable that some sort of relationship between cultures is established, although whether it is harmonious or not is another question. There is an undeniably violent element in or behind each of the episodes depicted. Weland has just murdered the prince whose body lies beneath his feet and is about to rape the princess. The Adoration of the Magi will be followed by the Massacre of the Innocents, and Romulus will murder Remus. The lid and back are carved with scenes of war, and whatever is happening on the right side revolves around death and sorrow. There is also the violence done to a third culture that should perhaps be considered in this scenario: that of the Britons who feature significantly in the histories and politico-religious ideologies of both Rome and Northumbria. Gildas compared the sack of the Temple in Jerusalem to the ruin of Britain by the Anglo-Saxons,[12] so the Britons might be made present obliquely in, or perhaps as ghosts floating silently behind, this and possibly other of the Casket's scenes. The founding and destiny of Anglo-Saxon England can be seen narrated typologically through the founding of Rome (Romulus and Remus) and the fall of Troy (if *Ægili* on the lid is read as 'Achilles' and the scene interpreted as his slaying by Paris). In this scenario, the Trojan War is likened to the Anglo-Saxon wars against the Britons, and both become part of the larger triumphant narrative of progression from so-called paganism to Christianity.[13] This reading has the advantage of keeping the Britons present, if only through their death or exile, although it should be noted that a triumphant narrative of progression, indeed any sort of progression, is difficult to discern and suggests a linear reading that the form and

composition of the Casket argue against. There is no set order to these scenes. We may start with the front panel or the lid, but ultimately the scenes can be put together in any order one chooses.

In this paper I will argue that the Casket presents neither a harmony of religions nor a linear teleological narrative. Rather it presents us with the journeys and encounters of peoples, cultures and religions in a way that is open to multiple – even contradictory – readings, and that does not necessitate privileging any single belief system or culture over any other. It does tell us about faith, and it also tells us about empire, the two inextricably linked, as they were from the very foundation of Anglo-Saxon England.[14] For the 6th-century Welsh monk Gildas, who chronicled the departure of the Romans and the arrival of the Anglo-Saxons, the battle of Badon Hill was the final end of Roman Britain and was thus a defeat of both an empire and the Christian faith that it had brought to Britannia.[15] Similarly, the establishment of both Germanic polytheistic beliefs and the re-establishment of Roman Christianity on the island were part and parcel of, if not empire, Anglo-Saxon colonisation of and expansion over that part of the island that became known as England. The expansion of Northumbrian hegemony in the north was bound up with the expansion of the Roman Christianity with which it had come to identify and the defeat of both the old polytheistic religions and the British, or Irish, church. Integral to these processes was the rewriting of the island's famously marginal position, afloat in a sea at the edge of the known world, as central. The Anglo-Saxons were the chosen people, as Kathy Lavezzo puts it, the angels at the edge of the world and, ultimately,

> Built into the myth of a sublime English frontier was a related imperial dream. If their otherworldliness made the English exceptional, their exceptionalism might also suggest how the English should be the rightful masters of the earth itself. The exaltation of the English world margin, in other words, could authorize the expansion of England beyond its borders into the world.[16]

That myth and the special nature of the Anglo-Saxons begins in 7th- or 8th-century Northumbria, most notably, as many have observed, in the writings of Bede, especially the *Historia ecclesiastica*.[17] Gildas had described Britain as a fallen bride and a kind of paradise, but Bede expanded the idea, making the island into a promised land, a living paradise and a mirror of the earthly paradise. This is reflected in the description of the island with which his *Historia ecclesiastica* begins:

> *Opima frugibus atque arboribus insula, et alendis apta pecoribus ac iumentis, uineas etiam quibusdam in locis germinans, sed et auium ferax terra marique generis diuersi, fluuiis quoque multum piscosis ac fontibus praeclara copiosis; et quidem praecipue issicio abundat et Anguilla.*

> The island is rich in crops and trees, and has good pasturage for cattle and beasts of burden. It also produces vines in certain districts, and has plenty of both land- and waterfowl of various kinds. It is remarkable too for its rivers, which abound in fish, particularly salmon and eels, and for copious springs.[18]

Place, *topos*, mattered to the Anglo-Saxon people, and Bede and others constructed a picture of them as just as exceptional as their island. Both the *Historia ecclesiastica* and

the anonymous *Whitby Life of Gregory the Great* record the story of Pope Gregory the Great encountering a group of Deiran boys in the Roman market. Struck by their beauty Gregory asks the boys who they are; when they reply that they are *Angli*, he famously makes a play between Angli and the Latin *angeli*. They are angels; "'Good", he said, "they have the face of angels, and such men should be fellow-heirs of the angels in heaven".[19] Like their island, the Anglo-Saxon people are fallen, yet also worthy inhabitants of paradise. Nicholas Howe has noted that this view of the Anglo-Saxons made it impossible to condemn Germanic polytheism entirely as this would have been a betrayal of both the Anglo-Saxons' own past and the self-created Christian destiny that writers such as Bede embedded within it.[20]

In the topographical description of the island with which the *Historia ecclesiastica* opens, Bede was referring to a real place, but his text is a construct that combines passages from a selection of earlier texts, not all of them about England, with his own observations. His England was thus already a fictional place floating somewhere between past and present, precisely located, yet still imaginary. The dual nature of the island, both marginal and central, real and imagined, is articulated in the Franks Casket. I argue that, like England, the Casket is a strange and otherworldly floating space, a space of contestation, a place both real and imagined, a heterotopia in which faiths and empires jostle against each other in no single predetermined order.

Heterotopias, as defined not unproblematically by Foucault, are like mirrors in that they exist – they are real places or things – but they exist as 'a sort of counteraction'. From the 'virtual space that is the other side of the glass' one comes back towards oneself.[21] I do not have the space here to go into Foucault's full definition of heterotopia and the many and varied critiques of it, and the Anglo-Saxons would certainly not have been familiar with the term; however, just as utopias were written about long before the publication of More's *Utopia*, so heterotopias existed well before Foucault defined them for postmodernity. Indeed, in writing about the 'zooheterotopias' of contemporary cryptozoology, John Miller looked back to the poem *Beowulf*, identifying Grendel as 'a cryptid *avant la lettre*'.[22] In summary, heterotopias are a constant of every human group; they are manipulable (that is, they can be made to function in ways other than that or those originally intended); they juxtapose or tie together multiple and often incompatible spaces, places and/or times or peoples; they are both isolating and penetrable, closed and open; they are able to create a space of illusion expressive of a real space, or a space that is other and opposite to the real; they often contain the simultaneous possibilities of utopia and dystopia. They are uncanny spaces, and they are often associated with the formation of societies: times in which multiple peoples, traditions and beliefs coexist as concepts in a culture in the process of coming into being. I find heterotopia a useful way for thinking about the Franks Casket as it allows us to entertain its different times, narratives, peoples and places as things existing together on or in the Casket without necessarily privileging one over the other or imposing any one set order on them. The Casket does not do that; it does not privilege one over the other. Nor does it provide a linear narrative; it is

only in the minds of individual readers that any such subjective privileging or overarching narrative becomes possible – and this is a feature of much of Anglo-Saxon art that has been explored elsewhere by Laura Ashe and myself, among others.[23]

Examples of heterotopias identified across the ages include the cemetery, the museum, the library (one could also add here the typical Anglo-Saxon manuscript, a collection of texts set next to each other rather than a single narrative to be read from beginning to end), the colony, the mirror and the ship. Building on the idea of the cemetery and the museum as types of heterotopia, Eric Smith has fruitfully explored the Cubicula of the Sacraments in the Callistus Catacomb in Rome as a heterotopic space expressive of an early Christian community's idea of itself in relation to a Jewish past, the city of Rome and the larger Roman Empire.[24] It is possible to interpret the Franks Casket in the same manner as expressive of a people's idea of itself in relation to (among other things) the Jewish past, Rome and the Roman Empire. A depiction of the story of Jonah features prominently in the Cubicula of the Sacraments, though Smith considers it only in terms of the cemetery and not in terms of how the figure of the whale might connect it with other forms of heterotopia such as the ship. In the case of the Franks Casket, however, it is the ship and the mirror that perhaps provide the most useful models for analysis. The ship is a container that is both closed and open, floating, like England, in the vast expanse of the sea. The Franks Casket is something like a ship in that it carries its origin myths and stories of other times and places that mirror the evolving postcolonial nature of Anglo-Saxon England back to England, a space in which we can see the messy and disorganised beginnings of the country reflected as a united whole. As both ship and mirror, it picks up in a new and imaginative way on the Exodus motif that was told and retold over and over in different forms by the Anglo-Saxons from the age of Bede onwards.[25]

While the Franks Casket is not technically a ship, it is a vessel of another sort: a container for something – treasure, jewels, a relic, a book have all been suggested – as well as a vessel bearing its carved narratives telling stories of past times and other places into the here and now of 8th-century Northumbria. Moreover, the Casket is made, as the inscription on the front tells us, from the bones of a whale, a traveller on and across the sea run aground somewhere on the island. The positioning of this inscription on the front of the Casket indicates that its makers felt that this information was absolutely essential for us to know. That the Casket had once been a living whale and that its bone was the medium used to convey its narratives is a crucial part of its meaning, and whales had very specific meanings for the Anglo-Saxons. Above all, they were known for their double nature. They were especially dangerous and deadly creatures when hunted and, while there is no concrete physical evidence that they were hunted in Anglo-Saxon England, the opening description of the island in Bede's *Historia ecclesiastica* suggests that they may have been hunted along with dolphins and seals.[26]

Moreover, the fisherman in the *Colloquy* written *c.* 1000 by Ælfric, Abbot of Eynsham, states that he does not want to

hunt a whale because it could kill him and his companions with a single blow, attesting that the danger of the hunt was known.[27] Stranded whales were resources to be exploited, their bones providing the raw material to make combs, gaming pieces, fishing floats and other such mundane objects. Whalebone was much less frequently used for luxury objects like the Franks Casket; when it was, it is assumed that it was used as a substitute for elephant ivory when that material was scarce or unavailable, as it was in the 8th century.[28] That assumption, however, is problematic, since the symbolic meanings of the two materials were very different. Elephants were renowned for their memory as well as their size and strength. They were believed to be the enemies of serpents and to be chaste because it was thought that they rarely reproduced,[29] all of which led to their association with the Virgin Mary and her purity. As a pure material, elephant ivory was suited to reliquaries and other such luxury items. Whales *(ballena)*, on the other hand, were classed as sea monsters *(bellua* or *ceta)* and were linked to hell via the story of Jonah and the whale.[30] Elephants could be tamed to carry soldiers into battle,[31] while whales were deceptive and could not be tamed, at least not by ordinary humans. The size of the whale also led to stories of their being mistaken for islands.[32]

According to a medieval legend well known to the Anglo-Saxons, the whale would float on the surface of the water like an island, luring unsuspecting ships to its shores. The whale, then, is uncannily like the place of its own death, a place that is other and opposite to, but also expressive of, the real space of England. The whale dies on the island of England; the whale is an island of death. The Old English poem *The Whale* is but one of the texts that details its deceptive nature:

Is þæs hiw gelic hreofum stane.

swylce worie bi wædes ofre,

sondbeorgum ymbseald, særyrica mæst.

swa þæt wenaþ wægliþende

þæt hy on ealond sum eagum wliten,

ond þonne gehydað heahstefn scipu

to þam unlonde oncyrrapum,

setlaþ sæmearas sundes æt ende,

ond þonne in þæt eglond up gewitað

collenferþe; ceolas stondað

bi staþe fæste, streame biwunden.

Ðonne gewiciað werigferðe,

faroðlacende, frecnes ne wenað,

on þam ealonde æled weccað,

heahfyr ælað; hæleþ beoþ on wynnum,

reonigmode, ræste geliste.

Þonne gefeleð facnes cræftig

þæt him þa ferend on fæste wuniaþ,

wic weardiað wedres on luste,

ðonne semninga on sealtne wæg

mid þa noþe niþer gewiteþ

garsecges gæst, grund geseceð,

ond þonne in deaðsele drence bifæsteð

scipu mid scealcum …

Þonne se fæcna in þam fæstenne

gebroht hafað, bealwes cræftig,

æt þam edwylme þa þe him on cleofiað,

gyltum gehrodene, ond ær georne his

in hira lifdagum larum hyrdon,

þonne he þa grimman goman bihlemmeð

æfter feorhcwale fæste togædre,

helle hlinduru; nagon hwyrft ne swice,

utsiþ æfre, þa þær in cumað,

þon ma þe þa fiscas faraðlacende

of þæs hwæles fenge hweorfan motan … (lines 8–31 and 71–81)

Its appearance is like a rough stone such as floats (or crumbles) by the water's edge surrounded by sand dunes, mostly seaweed, so that seafarers believe that their eyes are looking at an island; and then they tie the high-prowed ships to that false land [that unland] by anchor ropes, settle their sea-steeds at the water's edge, and then go up onto that island brave-hearted, their ships stand fast by the shore, surrounded by streams. Then the weary seafarers encamp, not expecting harm; they kindle a fire on that island, build a high blaze, worn out and longing for rest. When the one skilled in treachery feels that the sailors are securely settled upon him, have made a camp and are longing for clear weather, then suddenly into the salt sea the ocean spirit dives down with his victims, seeks the depths and in the death-hall drowns ships with their crews … When that evil one has led into that fastness, with evil craft into that fiery whirlpool, those who cleave to him, stained with guilt, those who had eagerly followed his teachings during their lives, then he after their death, those grim jaws snaps fast together, the gates of hell; they are unable to leave nor escape, to depart ever, those who enter there, any more than the swimming fish can escape that whale's grasp.[33]

The poem was not written down until *c.* 1000, but it has its sources in the much earlier Greek *Physiologus* tradition, which was known in Latin translation across Europe from the 4th or 5th century, as were the many texts that derived from it. In the 8th-century *Navigatio Sancti Brendani*, for example, Brendan and his fellow sailors are threatened with drowning when they land on the back of the whale Jasconius.[34] The *Life of Brendan*, however, makes it clear that Brendan's whale is a gift from God, and he and his men return to the whale/island to celebrate Easter during every year of their journey.[35] The *Navigatio* also includes an episode in which Brendan encounters Judas, who is living in isolation on a rocky island and who tells Brendan that a whale (Leviathan) waits nearby ready to swallow sinners; the whale acts as a figure or place of judgement and damnation. Whales, then, had a double nature. They were vehicles that could lead to either salvation or damnation. They could be gifts from God, figures of hell, or both in a single story; they were vehicles and they were places. Given the strength of the whale's association with death and destruction, whalebone would be a problematic substance to use for an object with an exclusively Christian or even syncretic message, especially when only one of the five scenes decorating that object has any obvious Christian content.

In the Anglo-Saxon poem, the whale is both traveller and place (fish and island), but also a place and a not- or no-place (island and unland). The sea monster that swallowed Jonah (another exile on the sea) was also both traveller and place. It moved across the sea but was also likened to a landmass. According to Isidore of Seville, whales had bodies the size of mountains.[36] It is both ironic and appropriate then that the whale of the Franks Casket met its death on a high hill or mountainous shore, or burial mound. Jonah's whale offered the simultaneous possibility of salvation or eternal hell, since Jonah had faith and gained salvation, but the belly from which he prayed was likened to hell. This imagery is echoed in *The Whale*'s description of the beast's jaws as the gates of hell, as well as in the Leviathan of the *Navigatio Sancti Brendani*. The story of Jonah is not depicted on the Casket, however, despite the fact that it does appear on some of the proposed models for the casket, such as the late 4th-century Brescia Casket in the Museo di Santa Giulia at San Salvatore, Brescia.

Perhaps Jonah's story did not need depicting in this instance since the Casket so clearly announces its whale nature in the inscription on the front panel – an inscription whose very positioning, as noted above, is an indication of how crucial the bone, the living matter of the whale, is to the Casket's meaning. But, given the combination of scenes on the Franks Casket, it seems likely that its makers were interested in telling a somewhat different story – or rather, collection of stories. Like the story of Jonah, all the scenes on the Casket remind us that nothing in this world is fixed or permanent. Battle rages on the lid, warriors fall and living men are shown moving inevitably towards death. Weland, pictured hamstrung and imprisoned at his island forge, is in the process of exacting his revenge by murdering the sons of King Nithhad and raping his daughter, Beadohild, before escaping in a flying machine made from the feathers of the birds we see being killed in the background. The Magi recognise the miraculous appearance of the divine in human form, but this moment will also be followed by the Massacre of the Innocents, life turning again to death. Peoples, Weland, the Jews on the Casket's back panel, Romulus and Remus on the left side, become exiles from their homelands; it is striking that the Old English form *Romwalus* literally means a Rome foreigner. Empires or kingdoms are created or fall, religions are born and threatened with destruction.

The Casket is a place or space on or in which peoples, histories, origins, beliefs, kingdoms or empires, and faiths sit side by side – perhaps in harmony, perhaps in conflict – that is left open and unresolved, as it would have been for many in 8th-century Northumbria who could not at this point have been certain either of the lasting victory of the Christian faith or of a united English people, Bede's *gens anglorum*. There is the possibility of peace, harmony and utopia – what is more utopian than salvation, escape from captivity or inhabiting a promised land? But there is also the possibility of conflict, destruction and dystopia – what could be more dystopian than the Massacre of the Innocents that would follow on from the Adoration of the Magi, the fratricide that became part of the founding of Rome or the exile, capture and enslavement of peoples – like the Jews or

Weland, but also like the absent Britons. The Casket imagines the divine – whether Christian, Judaic or polytheistic Roman or Germanic – at work within each of these stories and histories, as well as the here and now of the 8th century in which it was made, but it imagines multiple forms of divinity and multiple possible outcomes to its workings.

Finally, place, *topos*, matters on the Casket almost as much as it mattered in the writings of Bede. The word 'here' (*her* or *hic*) is used three times in the inscriptions, once each in reference to Rome (*her fegtaþ titus end giuþeasu*) and the Holy Land (*hic fugiant Hierusalim afitatores*), and once in reference to an unidentified but distinctly northern Germanic woodland (*Her Hos sitiþ on harmberga*).[37] But in all three cases the word also tells us that these events are taking place here on the Casket. Moreover, *her* in Old English can also be used temporally, so 'here in this time or year', as it is used repeatedly to begin the annual entries in the *Anglo-Saxon Chronicle*. The use of the word on the Casket helps to establish its function as a space or place that brings together disparate things – times and places – that would not normally be found together and carries them into the *her* that is the time and place in which the Casket was made and in which it was (and is) viewed.

It is not the only monument of the early Anglo-Saxon period to do so. Its contemporary, the monumental free-standing stone Ruthwell Cross, with which it is so often compared owing to the length and complexity of their respective inscriptions, does similar work.[38] The narrow sides of the Ruthwell Cross are inscribed with a poem that recounts the events of the Crucifixion. Written in the first-person voice of the True Cross, it translates those events, events that took place long ago and elsewhere, into the present moment and onto what was in the 8th century Northumbrian soil, and it does so using the English language and the runic alphabet. It was another sign of the island's perceived exceptionalism that it could draw other exceptional places and points of origin to it, and it did so not just through language but also through the material and materiality of the monuments. Both the Ruthwell Cross and the Franks Casket are travelling and shifting things. The poem allows Ruthwell to shift between Jerusalem, the city in which the events it recites took place, and Northumbria, through the wood of the True Cross that narrates those events and the Northumbrian stone from which the cross is carved and the soil in which it originally stood. The inscription on the front of the Franks Casket allows the Casket to shift between the living/dying whale and the thing made of its bones, the living vessel/island travelling the seas and the bone of the dead whale stranded on a different island.

Travel across the world is one of the major themes of Anglo-Saxon poetry, as exemplified by texts such as *Beowulf*, *The Seafarer*, *The Wanderer*, *Elene* and *Widsith*. Both *Beowulf* and *Widsith* allude to Weland, who remained a popular figure throughout the Anglo-Saxon period. He was the maker of the miraculous mail shirt that saved Beowulf from the deadly water-monsters, and he was the father of Widia, whose heroism is described in *Widsith*.[39] In the latter, the poet/narrator, Widsith, whose name translates as 'far-

traveller', has journeyed across the world and catalogued its rulers and heroes, from Alexander the Great to Caesar to Offa of the Angles. He has been with the Israelites, the Romans and the Sea-Danes. Peoples and places become one with each other, territories to be traversed and brought back to and for England in the form of his poetic catalogue.

The Franks Casket is more limited in the territories and histories it collects but, like Widsith, it is a traveller, a traveller across the sea. As a box, it is also a vessel that carries things, stories and histories. Each and every one of its panels tells stories of travellers, though admittedly not all are travellers by sea. Weland has been kidnapped and imprisoned on an island but is about to escape. The Virgin Mary and the Magi have travelled separately to Bethlehem, from which they will all shortly move on. The army on the lid is in movement, confronting the archer who stands his ground. Titus' troops travel to Jerusalem, while the Jews flee into capture or exile and the treasures of the temple are carried back to Rome. Romulus and Remus, as the inscription that surrounds that panel makes clear, are 'far from their native land', and whatever is happening on the right side panel includes a flying bird, a walking horse, a burial mound enclosing a body whose soul has travelled to the otherworld and, at far right, a figure who appears to be in the process of being captured and led away. The Franks Casket sets these traveller's tales alongside each other, like passengers in a ship, carrying them to shore enclosed perhaps harmoniously, perhaps discordantly, within the bones of a whale. Its images, languages and scripts are collected from different faiths and past empires and set alongside each other, narratives of struggle, triumph and spiritual or historical homelands on which a new idea of Northumbria and, eventually, of England could be built.

Notes

1 Waxenberger 2017. The attribution to Whitby is based on a comparison of the Casket's runes with those of a bone comb from the site. Ripon (Wood 1990) and Wearmouth-Jarrow (Lowe 1958; Parkes 1982) have also been suggested.
2 See esp. Niles 2015.
3 Simmons 2010.
4 Page 1999.
5 Bredehoft 2011: 181–2.
6 Waxenberger 2011: 165.
7 Webster 2010: 25.
8 See e.g. Lang 1999; Webster 1999; Abels 2009; Cross 2017: 192.
9 Webster 2010: 14.
10 Bately 1986: 50.
11 See e.g. Webster 2010; Karkov 2017; Paz 2017.
12 Gildas 1978: 27.
13 McCulloch 2012. See also Schneider 1959; Vandersall 1975.
14 See further Karkov 2017.
15 See Gildas 1978: 27–9.
16 Lavezzo 2006, 21.
17 See especially Mehan and Townsend 2001; Lavezzo 2006; Staley 2012: 15–70.
18 Bede 1969: 14–15.
19 'At ille: "bene" inquit; "nam et angelicum habent faciem, et tales angelorum in caelis decet esse coheredes".' Bede 1969: 134–5.
20 Howe 1999: 52.

21 Foucault 1984: 4.
22 Miller 2016: 150.
23 Ashe 2007: 37–47; Karkov 2017 and 2020.
24 Smith 2014.
25 Howe 1999.
26 See Bede 1969: 14, 15.
27 Ælfric 1991: 29–30.
28 Riddler 2014.
29 Isidore of Seville 2006: 252.
30 Isidore of Seville 2006: 260, commenting on Jonah 2:3.
31 Isidore of Seville 2006: 252.
32 This is a phenomenon that has continued well into the modern era according to the stories archived by institutions such as the Icelandic Sea Monster Museum, Skrímslasetrið. See http://skrimsli.is (accessed 29 November 2018).
33 Muir 1994: vol. 1, 272–3. Translation author's own.
34 The earliest extant version of the *Navigatio* is late 8th century, but it is likely to have been in circulation orally prior to that.
35 For variations in surviving versions of the two texts, see Mac Mathúna 2000.
36 Isidore of Seville 2006, 12.6.8.
37 Howe 1999: 50 suggests that, for the Anglo-Saxons, Germania was a past to be evoked rather than a place to be mapped.
38 Karkov 2013.
39 Muir 1994: 245–6, lines 124b–30.

Bibliography

Abels, R. 2009. 'What has Weland to do with Christ? The Franks Casket and the articulation of Christianity in early Anglo-Saxon England', *Speculum* 84(3), 549–81.

Ælfric, Abbot of Eynsham 1991. *Colloquy*, ed. G.N. Garmonsway, Exeter.

Ashe, L. 2007. *Fiction and History in England, 1066–1200*, Cambridge.

Bately, J. (ed.) 1986. *The Anglo-Saxon Chronicle: A Collaborative Edition. MS A*, Cambridge.

Bede 1969. *Bede's Ecclesiastical History of the English People*, ed. B. Colgrave and R.A.B. Mynors, Oxford.

Bredehoft, T.A. 2011. 'Three new cryptic runes on the Franks Casket', *Notes and Queries* n.s. 58(2), 181–3.

Cross, K. 2017. 'Christianity in the British Isles', in J. Elsner, S. Lenk *et al.*, *Imagining the Divine: Art and the Rise of World Religions*, Oxford, 167–99.

Foucault, M. 1984. 'Of other spaces: utopias and heterotopias', *Architecture/Mouvement/Continuité*, 1–9.

Gildas 1978. *Gildas: The Ruin of Britain and Other Works*, ed. and trans. M. Winterbottom, London.

Howe, N. 1999. *Migration and Mythmaking in Anglo-Saxon England*, New Haven.

Isidore of Seville 2006. *The Etymologies of Isidore of Seville*, ed. and trans. S.A. Barney, W.J. Lewis, J.A. Beach and O. Berghof, Cambridge.

Karkov, C.E. 2013. 'The arts of writing: voice, image, object', in C.A. Lees (ed.), *The Cambridge History of Early Medieval English Literature*, Cambridge, 73–98.

—2017. 'The Franks Casket speaks back: the bones of the past, the becoming of England', in E. Frojmovic and C.E. Karkov (eds), *Postcolonising the Medieval Image*, Farnham, 37–61.

—2020. 'Conquest and material culture', in L. Ashe and E.J. Ward (eds), *1016 to 1066: New Perspectives on England's Eleventh-Century Conquests*, Woodbridge, 183–205.

Lang, J. 1999. 'The imagery of the Franks Casket: another approach',

in J. Hawkes and S. Mills (eds), *Northumbria's Golden Age*, Stroud, 247–53.

Lavezzo, K. 2006. *Angels on the Edge of the World: Geography, Literature, and English Community 1000–1534*, Ithaca.

Lowe, E.A. 1958. 'A key to Bede's scriptorium: some observations on the Leningrad manuscript of the *Historia ecclesiastica gentis anglorum*', *Scriptorium* 12, 182–90.

Mac Mathúna, S. 2000. 'Contributions to a study of the voyages of St Brendan and St Malo', in J.M. Wooding (ed.), *The Otherworld Voyage in Early Irish Literature: An Anthology of Criticism*, Dublin, 15–74.

McCulloch, J.H. 2012. 'The Franks Casket: a celebration of the founding and destiny of England', https://www.asc.ohio-state.edu/mcculloch.2/arch/FranksCasket/ (accessed 29 November 2018).

Mehan, U. and Townsend, D. 2001. '"Nation" and the gaze of the other in eighth-century Northumbria', *Comparative Literature* 53(1), 1–26.

Miller, J. 2016. 'Zooheterotopias', in M. Palladino and J. Miller (eds), *The Globalization of Space: Foucault and Heterotopia*, London, 149–64.

Muir, B.J. (ed.) 1994. *The Exeter Anthology of Old English Poetry: An Edition of Exeter Dean and Chapter MS 3501*, 2 vols, Exeter.

Niles, J.D. 2015. *The Idea of Anglo-Saxon England 1066–1901: Remembering, Forgetting, Deciphering, and Renewing the Past*, Chichester.

Page, R.I. 1999. *An Introduction to English Runes*, 2nd ed., Woodbridge.

Parkes, M.B. 1982. *The Scriptorium of Wearmouth-Jarrow*, Jarrow.

Paz, J. 2017. 'The riddles of the Franks Casket: enigmas, agency and assemblage', in J. Paz (ed.), *Nonhuman Voices in Anglo-Saxon Literature and Material Culture*, Manchester, 98–138.

Riddler, I. 2014. 'The archaeology of the Anglo-Saxon whale', in S.S.

Klein, W. Schipper and S. Lewis-Simpson (eds), *The Maritime World of the Anglo-Saxons*, Tempe, AZ, 337–54.

Schneider, K. 1959. 'Zu den Inschriften und Bildern des Franks Casket und einer ae. Version des Mythos von Balders Tod', in H. Oppel (ed.), *Festschrift für Walther Fischer*, Heidelberg, 4–20.

Simmons, A. 2010. *The Cipherment of the Franks Casket Woruldhord*, http://poppy.nsms.ox.ac.uk/woruldhord/items/show/144 (accessed 4 November 2018).

Smith, E.C. 2014. *Foucault's Heterotopia in Christian Catacombs*, New York.

Staley, L. 2012. *The Island Garden: England's Language of Nation from Gildas to Marvell*, Notre Dame.

Vandersall, A.L. 1975. 'Homeric myth in early medieval England: the lid of the Franks Casket', *Studies in Iconography* 1, 2–37.

Waxenberger, G. 2011. 'The cryptic runes on the Auzon/Franks Casket: a challenge for the runologist and lexicographer', in R. Bauer and U. Krischke (eds), *More than Words: English Lexicography and Lexicology Past and Present: Essays Presented to Hans Sauer on the occasion of his 65th Birthday – Part 1* (Frankfurt am Main), 161–70.

— 2017. 'Date and provenance of the Auzon or Franks Casket', in S. Semple, C. Orsini and S. Mui (eds), *Life on the Edge: Social, Political and Religious Frontiers in Early Medieval Europe*, Studien zur Sachsenforschung 6, Wendeburg, 121–33.

Webster, L. 1999. 'The iconographic programme of the Franks Casket', in J. Hawkes and S. Mills (eds), *Northumbria's Golden Age*, Stroud, 227–46.

— 2010. *The Franks Casket*, London.

Wood, I. 1990. 'Ripon, Francia and the Franks Casket in the early Middle Ages', *Northern History* 26, 1–19.

Response to C. Karkov, 'Empire and Faith: The Heterotopian Space of the Franks Casket'

Katherine Cross

The Franks Casket has bewitched early medievalists for over a century and half, ever since its appearance in Auzon, France, in the 1850s. Their – and our – fascination with this object can act as an index for changing ideas about the 'Anglo-Saxons' as a people or nation. Interpretations of the Casket's inscriptions and imagery, form and function, have been cast and re-cast as the key components of an imagined Anglo-Saxon culture.[1] I would like to respond to Professor Karkov's evocative chapter by situating it within a long history of scholarly reflection on the Franks Casket. The Casket has always been received as a puzzle to be solved, but she releases us from the possibility of a single solution.

As with all origin stories, we begin with confusion. The Casket is first known to historians as a family sewing box, which fell apart when one of the sons exchanged the silver hinges for a signet ring.[2] Such was the report of Professor Mathieu of Clermont-Ferrand, who then acquired most of the whalebone pieces; others suggested that it had previously been owned by the church at Clermont, or by the church of St Julien at Brioude.[3] More confusion has been perpetuated by the Casket's name. It is ironic that an object iconic of Anglo-Saxon culture is regularly assumed to relate to the early medieval inhabitants of modern France and Germany, the Franks. The name, of course, has nothing to do with this people, but is owed to the British Museum curator first responsible for 'national antiquities', Augustus Wollaston Franks. It was he who recognised the Casket's significance and, unable in 1858 to convince the British Museum that it was worth the purchase price, bought it himself, donating it to the Museum in 1867.[4] From this beginning, we see early medieval material culture through the eyes of the Museum's mid-19th-century Trustees: a niche interest, not of national relevance, and not suitable for consideration alongside the monumental Assyrian sculptures from Nimrud that had, only a few years earlier (1849–51), moved into their new home in the British Museum. As the post-war British Museum curator Thomas Kendrick suggested, alongside these exciting new acquisitions, 'you really could not expect anybody, apart from a few cranks, to take much notice of the poor British antiquities'.[5]

Once the Casket had come to the notice of those 'few cranks', the antiquaries, the first task was that of deciphering its inscriptions and identifying its narrative scenes. Scholars delighted in the realisation that the front left-hand scene was not, as they had originally supposed, the story of Salome demanding the head of John the Baptist, but that of Weland the Smith: a real pagan tale from the north. George Stephens, the eminent philologist, was particularly happy to reject an argument for John the Baptist based on a passage by Gregory of Tours, the 6th-century historian and bishop of Tours: 'I cannot see that this obscure local *Franco-Keltic* tale has anything to do with the subject on the *Scando-Anglic* Casket.'[6] Stephens' emphasis on Scandinavian connections in distinction to Germanic reflects his own, idiosyncratic, views – and desire to separate English ancestors from those of modern Germans – but it is also one example of a major source of antiquaries' interest in early medieval material culture: as holding the potential to illuminate the pure, originary, national culture of the Anglo-Saxon people, linked to the modern English through a perceived racial

connection. Here, at exactly the right moment for 19th-century nationalists, was tangible evidence of Anglo-Saxon pagan heritage. The scenes on the lid and the right side panel promised similar revelations. But, for these panels, no such certainty has ever been reached. The task remains incomplete. The Casket tantalises us with its links to narratives unknown, visible but still inaccessible.

Scholars set to work on specific problems. Each runic character, each element of iconography, was puzzled over and debated. The Casket, partially re-assembled from broken pieces, further fragmented. Throughout the 20th century, interpreters competed over the cultural heritage of its early medieval producers. Achilles and the *Aeneid*, Hengest and Horsa, competed for space alongside the *Mabinogion* and the biblical Book of Daniel. Through the details, scholars hashed out the scope of the sources of Anglo-Saxon culture, and weighed the place of a northern or Germanic pagan element within this compendium. Of course that element remained inextricable and never fully identifiable. The wide net that could be cast in order to search for possible models and literary inspirations enmeshed early medieval Northumbria in an intricate web of far-flung connections, mythological, religious, scholarly and cultural heritage.

Subsequent work attempted to reconfigure the Franks Casket by proposing programmatic interpretations that acknowledged the diverse sources of narratives, texts and iconographies, but united them thematically or within a coherent narrative.[7] Ian Wood and Richard Abels positioned the Casket within a cultural milieu engaged in reconciling tensions between Christian monasticism and Northumbrian aristocratic values and traditions.[8] Both drew on Patrick Wormald's influential essay 'Bede, *Beowulf*, and the conversion of the Anglo-Saxon aristocracy' (1978): the Casket began to assume a position akin to that of *Beowulf* in material form. The Anglo-Saxons now emerged as a people who needed to reconcile their mixed heritage of Germanic paganism and Roman Christianity, whose individuality came from their particular synthesis of these contrasting world-views. The Anglo-Saxons of the 1990s and 2000s were creative syncretics, combining disparate traditions into a coherent, functioning whole. But, as Professor Karkov states, the Casket resists such attempts at linear progression or harmonious resolution.

Alongside these processes of deconstruction and reconstruction has developed another interpretive scheme, one which emphasises esoteric aspects of the Franks Casket's design. The presence of cryptic runes on the right side panel was recognised early on, but numerology has also provided a key to meaning.[9] This strand of analysis can be linked to a vision of the Dark Ages as secret, magical, pagan – as something to be unlocked in order to be known. But there is no magic key, and there should be no single definition of the Casket's producers and their culture. Professor Karkov moves us away from attempts at neat solutions, whether programmatic or syncretic or according to a numerological formula. She reminds us that the Casket was created in a moment of becoming. The relationships between the disparate elements on the Casket were not worked out, though nor were they completely disassociated. She suggests an uncomfortable approach: we don't need to reconcile

them. If we see Bede's influential idea of the *gens anglorum* as an innovation, then it was never the only option. It is hard to see beyond and before Bede, to the differing visions and experiments of the 7th and 8th centuries. The Franks Casket may not give us a clear alternative model, but it shows and encourages reflection on contemporary uncertainties.

For me, what makes Professor Karkov's piece so powerful is the way it resituates the Casket, not as a reconciliation of diverse influences or a statement of a distinct people, but as a product of the messiness of identities and cultures. Are we not always in the middle of a process of 'coming into being'? Peoples are always shifting, and moments of 'ethnogenesis' are only identified much later, when a coherent story can be told about the past in the service of (or resistance to) present dynamics. We just have insight into a moment, one expression. The Franks Casket cannot bear the weight of interpretation it has received (and perhaps this is where it really is like *Beowulf*) – but it does present us with a constant stimulus for our own reflections.

The description of the Casket as a heterotopia also opens it up to the global turn in medieval studies, making it speak to the other chapters in this volume ranging from Ireland to India. The idea of the 'Global Middle Ages' places Britain within a connected world, just as the Casket shows us Britain's extended and imagined connections across the late antique Mediterranean. The Casket itself is a traveller, though more provincially: it was carried from Northumbria to the southern Loire, perhaps soon after its creation; and now one side of it (recovered after Mathieu's original acquisition) resides in the Museo Nazionale in Florence.[10] Tracing these connections, and taking a global view, also reminds us of Britain's marginal place in the medieval world. The Casket, as heterotopia, visualises that peripherality and formlessness.

The Franks Casket gives us the opportunity to explore what 'Anglo-Saxon culture' meant at a given moment and in a particular conversation.[11] But it also challenges those ideas: they could never quite fit into that box.

Notes

1 Visitors may now view the Franks Casket as a 'highlight' object in the British Museum's Gallery 41: 'Sutton Hoo and Europe, 300–1100'. For discussion of early medieval collections in the British Museum, see Cross 2020.

2 Augustus Franks, reporting the words of Professor Mathieu of Clermont Ferrand in Auvergne in a letter of 10 March 1867, printed in Stephens 1866–1901: vol. I, 470–1.

3 Napier 1901: 362–3. Mathieu suggested the church at Auzon would be a likely origin.

4 Caygill 1997: 160–3; Caygill also indicates the multiple hands which the Casket passed through between Auzon and London.

5 Kendrick 1954: 136.

6 Stephens 1866–1901: vol. III, 201, emphasis in original.

7 Lang 1999: 247–55; Webster 1999: 227–47.

8 Wood 1990; Abels 2009.

9 Becker 1977.

10 Napier 1901: 362–3.

11 Paz 2017: 134: 'It is indeed a talkative thing: a thing that talks, a thing to talk about, a thing to talk with.'

Bibliography

Abels, R. 2009. 'What has Weland to do with Christ? The Franks Casket and the acculturation of Christianity in early Anglo-Saxon England', *Speculum* 84, 549–81.

Becker, A. 1977. *Franks Casket. Zu den Bildern und Inschriften den Runenkästchens von Auzon*, Regensburg.

Caygill, M. 1997. '"Some recollection of me when I am gone": Franks and the early medieval archaeology of Britain and Ireland', in M. Caygill and J. Cherry (eds), *A. W. Franks: Nineteenth-Century Collecting and the British Museum*, London, 160–83.

Cross, K. 2020. 'Barbarians at the British Museum: Anglo-Saxon art, race, and religion', in J. Elsner (ed.), *Empires of Faith in Late Antiquity: Histories of Art and Religion from India to Ireland*, Cambridge, 396–433.

Kendrick, T. 1954, 'The British Museum and British antiquities', *Antiquity* 28, 132–42.

Lang, J. 1999. 'The imagery of the Franks Casket: another approach', in J. Hawkes and S. Mills (eds), *Northumbria's Golden Age*, Stroud, 247–55.

Napier, A.S. 1901. 'Contributions to Old English literature 2: the Franks Casket', in *An English Miscellany Presented to Dr Furnivall in Honour of His Seventy-Fifth Birthday*, Oxford, 362–81.

Paz, J. 2017. *Nonhuman Voices in Anglo-Saxon Literature and Material Culture*, Manchester.

Stephens, G. 1866–1901. *The Old-Northern Runic Monuments of Scandinavia and England*, 4 vols, London.

Webster, L. 1999. 'The iconographic programme of the Franks Casket', in J. Hawkes and S. Mills (eds), *Northumbria's Golden Age*, Stroud, 227–47.

Wormald, P. 1978. 'Bede, *Beowulf*, and the conversion of the Anglo-Saxon aristocracy', in R.T. Farrell (ed.), *Bede and Anglo-Saxon England: Papers in Honour of the 1300th Anniversary of the Birth of Bede*, 32–95.

Wood, I. 1990. 'Ripon, Francia and the Franks Casket in the early Middle Ages', *Northern History* 26, 1–19.

Chapter 6
Buddhapada: The Enlightened Being and the Limits of Representation at Amarāvatī

Jaś Elsner

This paper, arising from the many investigations and discussions within the *Empires of Faith* project, explores what might be called the visual theology of early Buddhist relief sculpture.[1] It takes as its specific topic some panels showing the Buddhapada, or footprints of the Buddha, from the great stupa at Amarāvatī, on the Krishna river close to the eastern coast of India, quite a way to the south in Andhra Pradesh, much of which is now in the British Museum. These are major icons made of white limestone, each with its own framing border, picking up and developing imagery that was used within the visual narratives of the other rich relief sculpture that adorned this stupa. Similar and equally rich sculptural enhancement framed many other stupas of about the same period elsewhere in central India (for example at Kanaganahalli in Karnataka) or in the north along the Ganges (Sanchi and Bharhut, for instance) and in Gandhara far away to the north-west, spanning the border of modern Pakistan and Afghanistan. These monuments, often mounted over relics, marked centres of Buddhist practice and pilgrimage, frequently connected with monasteries. Given the uncertainty about the specific and indeed relative dating for early Buddhist art, let us assume a broad chronological spectrum from at least the 1st century BCE to the 3rd century CE, with any date being provisional unless supported by strong epigraphic or archaeological context.

My theoretical assumptions are as follows: the visual arts of early Buddhism follow an eclectic pattern whereby artists borrowed motifs and styles from a wide range of earlier and external influences to create works of art that suited particular rhetorical needs in given contexts. Although the distances are huge, and the local artistic traditions in any given part of the Indian subcontinent or the Silk Road to its north-west were substantially different and subject to very divergent influences, there is likely to be greater interconnection than might otherwise be expected because monks travelled and transmitted Buddhism across this area. They translated texts, carried objects and brought teachings in ways that are difficult to evidence empirically today but were clearly parallel to the well-recorded and remarkable Chinese ventures into India later in the period.[2] That is, these arts follow a pattern not entirely dissimilar from that which has been described for Roman art as a visual system across a huge geographic and multicultural territory (in that case spanning the entire Mediterranean), where existing visual vocabularies could be continually repurposed in a variety of eclectic and creative manners to enable a cohesive visual language of both power and religion (categories not easy to separate at any period in antiquity).[3] In the case of India, while there may not have been a single imperial system lasting as long as the Roman empire, a number of religions supported by various monarchs, which affirmed themselves visually and acquired some model of identity through visual and material culture, at least operated in something like this manner within their own cultural contexts and in relation to the multiple other religions of the region.

The Buddhapada is a motif that falls directly within the most venerable historiographical topic in Indian Buddhist art,[4] namely the question of the origins of the Buddha image and the uses of aniconism.[5] This subject has been fundamentally vitiated by the Protestant and Catholic

Plate 6.1 Slab carved with the Buddhapada, from Amarāvatī, 2nd century CE, white limestone, h. 67.5cm, w. 61.8cm, d. 8cm (following Knox). British Museum, London, 1880,0709.43

assumptions of the European scholars of the colonial era who created the literature,[6] and is arguably a red herring for the understanding of Buddhist art. It is not only that it carries too much 'baggage',[7] but also that it genuinely confuses the issues by introducing Judeo-Christian problems about anthropomorphism and aniconicity in sacred representations into the visual culture of Buddhism. Moreover, the obsession with origins (did the aniconic come first? And when was the first image of the Buddha in human form?) focuses on questions that cannot be answered in the light of our poor evidence in matters of precise dating.

At the same time, the necessary resistance to Eurocentrism in writing the history of the arts of South Asia should not blind us to the fact that especially north of India, where the Silk Road ran, but also throughout the subcontinent, culture was visually receptive to artistic influences from everywhere and was immensely creative in refashioning those influences for its own purposes. There were certainly artistic forms and styles from the Persian and the Hellenistic worlds to the west of India that made a significant difference to the development of Buddhist art. A series of recent interventions have shown at least the availability of some Roman models, including through coins and Indian Ocean trade, and suggest the possibility that Mediterranean influences were available for appropriation by Amarāvatī sculptors.[8] In the case of my own theme, there

was a long history of feet and footprints carved in stone and made in clay and mosaic in the religious culture of the ancient Mediterranean, which certainly anticipates and runs concurrently with the Buddhapada.[9] This does not mean that the possibility, even the likelihood, that such things were precursors, even iconographic models, for what ultimately became the Buddhapada has any significance for how such imagery was appropriated, re-used and made to function in contexts that had nothing to do with Greco-Roman religion. But it is certainly the case that the Buddhapada was taken as an iconic theme in its own right, enlarged, given a frame and celebrated at the site – usually in the form of two footprints together but occasionally perhaps as a single footprint (or as a pair of panels where one has now been lost).[10] That process reached beyond Amarāvatī to a series of other key stupa sites along the Krishna river and the Andhra coast, notably Nāgārjunkonda (which is usually dated a little later than Amarāvatī),[11] Thotlakonda[12] and Kesanapalli.[13]

My purpose here is not the study of the origins of the motif, nor of the style or developments of iconography. Instead – following the lead of some of the more interesting recent writing on Greco-Roman religion – I want to explore the way in which images offered acute reflections on the nature of religious life through their uses of the visual discourses they appropriated.[14] While most study of theology

Plate 6.2 Slab carved with the Buddhapada, from Amarāvatī,
1st century BCE–2nd century CE, white limestone, h. 67.5cm,
w. 46.25cm, d. 15cm. British Museum, London, 1880,0709.57

has been resolutely textual – not surprisingly in the context
of the scriptural nature of the world religions – the impetus
for looking at images to construct theology is particularly
motivated in the ancient Mediterranean world by the
absence of scriptural religions (with the exception of
Judaism) until the emergence of Christianity.[15]

Some Buddhapadas at Amarāvatī

Let us begin with the object of focus. The great stupa of
Amarāvatī may date back as far as the emperor Asoka in the
3rd century BCE, but its earliest architectural and sculptural
remains are no earlier than the middle of the 2nd century
BCE. This early stupa was enlarged, refurbished and
surrounded by a limestone railing between 50 BCE and 250
CE.[16] It was one of a series of major sacred sites in Andhra
Pradesh – both Buddhist and Brahmanical,[17] and sat at the
centre of a rich local religious culture between city and
monastery.[18] Its sculptural decoration from this phase of
successive refurbishment in particular is immensely rich – it
has been described as the 'finest monument of the Buddhist
world in the second century of the common era'.[19] Within
the visual complex, there are many representations of the
Buddha's footprints – both as isolated icons within frames
and as features within larger historiated reliefs and
narratives. In all these cases there is ambivalence as to
whether these Buddhapadas represent the presence of the

Buddha himself by what has been called 'synecdochic' logic
(whereby a part stands for the whole)[20] or are intended as
images of his footprints as such.[21]

For my purposes, the most striking representation of the
Buddhapada is carved in low relief on a square slab of
limestone, dated to 'the early phase' of Amarāvatī sculpture
in the 2nd century CE (**Pl. 6.1**).[22] The feet point downwards,
as is the case in the great majority of examples of this
iconography,[23] and are bordered by a meandering design of
large lotus blossoms which appear to emerge from the mouth
of a *makara*, a fish-tailed sea monster somewhat like a Greco-
Roman *ketos* but with an elephant's head, to the lower right.[24]
The feet are marked with a series of auspicious signs (as are all
Buddhapadas) – notably the large fine-spoked and double-
rimmed wheels (*dharmacakras*) at the central hollow of each
foot, with an ω-motif and wheel (identified variously as a
triratna or *nandyavarta*) between beaded *svastikas* and two pairs
of six-petalled flowers at the heel.[25] Beneath the *dharmacakra* on
each foot is a further beaded *svastika* between two hour-glass-
shaped objects. The joints between toes are marked with
engraved wrinkles, while their tips are decorated with
svastikas, except for the big toes which appear to have the
ω-symbol. The relief of all these symbols except the wheels at
the hollow of the feet is very light and much abraded,
especially on the damaged left-hand side. Note that most, but
not all, the *svastikas* turn to the right.

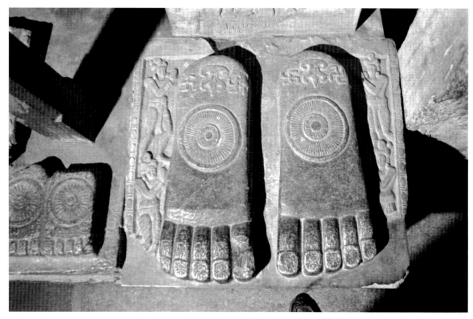

Plate 6.3 Slab carved with the Buddhapada, from Amarāvatī, perhaps 1st–2nd century CE, white limestone, dimensions not available. Government Museum, Chennai (Sivaramamurti 1956: no. I D 3). Image: courtesy of the Huntington Archive, scan no. 27696

Plate 6.4 Slab carved with the Buddhapada, from Amarāvatī, perhaps 2nd–4th century CE, white limestone, dimensions not available. Government Museum, Chennai (Sivaramamurti 1956: no. I D 5). Image: courtesy of the Huntington Archive, scan no. 27695

It is worth remarking that if this image is meant to represent footprints then it is a very odd representation indeed. Whereas the majority of Buddhapadas from Gandhara are incised into the stone with the auspicious symbols carved in relief,[26] as are those in the northern gateway at Sanchi (probably from the 1st century BCE),[27] this one – indeed like all those in Andhra Pradesh – stands out in relief from the stone behind it.[28] Only the *dharmacakra*s are carved in further relief; the remaining symbols are incised. It is thus a very strange kind of footprint – a monument where a footprint might have been or once was. Moreover, while the image must depict the base of the foot (as indeed a footprint should, and of course it makes no reference to any leg emerging from the upper foot), with the wrinkles which appear on the small toes to mark their joints again implying the under part of the foot, the large toes in particular seem to revert to representing the upper foot since they clearly show nails.[29] Given the extensive visual imagery at the rest of the site, which shows sufficient command of the logic of realism

in the representation of figures to prove that the kind of surrealism present here cannot be some kind of mistake or act of incompetence, I want to suggest that the disruption of normal expectations in terms of the naturalistic representation of feet in this large iconic image is deliberate and substantive. The 'rules' of what should be normal – an imprint rather than a raised relief for a footprint and the logic of distinction between the upper part of the foot and the bottom – are abandoned to create an icon that evokes the miraculous. In addition to the many auspicious signs, the icon posits the presence of the Buddha and his continuing presence through an image-type that defies the rules of nature.

A second, smaller but thicker, slab of the Buddhapada from the same site, with very similar iconography and probably similar date, also survives in the British Museum collection (**Pl. 6.2**).[30] Again the feet are carved in relief, with delicately incised symbols and finely spoked *dharmacakra*s with double rims carved at the centre of each foot. The

Plate 6.5 Fragment of a slab carved with the Buddhapada, from Amarāvatī, perhaps 2nd century CE, white limestone, h. 32.5cm, w. 33.75cm, d. 8cm. British Museum, London, 1880,0709.42

iconography of the symbols is close but not identical to the other panel – ω-motif and whirl-shaped *cakra*s between *svastika*s at the heel, elaborately curling *svastika*s between hour-glass-shaped symbols beneath the *dharmacakra*s, toes with incised wrinkles at the joints, *svastika*s at the tips of the little toes and ω-symbols with wheels at the big toes. The toes are very abraded but look to be marked with faint toenails (most clear on the big toe and the small one next to it on the left foot as you look at the sculpture). Knox concluded that this sculpture, too, shows the upper parts of the toes and indeed the whole foot.[31] The frame is more complex than its sister panel, with elaborate lotus buds to left and right and lotus flowers at the top that seem to emerge from a *makara* at the lower left. At the lower border is a fat *yakśa* or local deity on the right-hand side, with a vine that appears to emerge from his navel and become part of a complex design of garlands, lotus heads and intersecting circles, and to the far left are a pair of plinths with *naga* serpents mounted on them. At the lower left of the border are the remains of a largely destroyed inscription which seems to name the donor. This panel's representation of the Buddhapada defies nature in exactly the same way as its sister slab, breaking the rules of the normal in the same way.

We know nothing about the function or placement of these objects, although scholars agree (perhaps wrongly) that they were probably not part of the main stupa.[32] The resemblance of the Amarāvatī Buddhapadas to the intriguing fragment of an *āyāgapata* (tablet of worship) made in the brown sandstone associated with the sculpture of Mathura, and found in excavations at the Ghositārāma Monastery in Kauśāmbī near modern Allahabad, which has

been dated on stylistic grounds to *c.* 75 BCE, may imply some link. The Buddhapada on this tablet, whose inscription records its donation by the monk Phagula, is also carved in low relief at the centre of an icon-like slab with a fine floral border.[33] The footprint has a wheel at the sole and auspicious symbols on the toes. It is assumed that *āyāgapata* tablets of this kind – used in Jain as well as Buddhist contexts – were sacred objects of worship,[34] and that may hold true also for the Amarāvatī panels.

The majority of the Buddhapadas from Amarāvatī appear to have been found at the eastern and western gates to the complex in the excavations of 1880 and 1881,[35] and it has been surmised that they were part of the decoration of the processional path between the main stupa monument and its inner railing, which allowed circumambulation.[36] These are a series of more schematic Buddhapada icons that have generally been dated later than the two panels so far discussed.[37] These include an interesting high relief of the footprints now in the Government Museum in Chennai showing *dharmacakra*s with single rims, various other symbols and, instead of a border, four standing worshippers, two on each side (**Pl. 6.3**).[38] This object also appears to show nails, implying that the naturalism-challenging model of the two British Museum panels was replicated at a later period in the site.[39] One other fragmentary panel in Chennai has a lotus border with *makara* (**Pl. 6.4**).[40] Of particular interest is a further fragmentary relief in the British Museum which has been dated to perhaps the 2nd century CE and presents only the top of a single foot of the Buddha (**Pl. 6.5**). This represents an entirely abstract visualisation of the footprint where the central wheel, with many spokes, is rimmed by a

Plate 6.6 Earlier face of a double-sided drum slab (cut down for re-use) with relief of the Buddhapada beneath the Bodhi tree with celestial figures and five male worshippers, perhaps the ascetics to whom the Buddha preached the first sermon, 1st century BCE, white limestone, h. 124.37cm, w. 86.25cm, d. 12.5cm. British Museum, London, 1880,0709.79

swastikas and footprints. But the fact that the Buddhapada is an item regularly claimed and named indicates the normative iconographic status of the theme and its availability to donor choice as well as potential central planning. The Buddhapada inscriptions appear on pillars that do not necessarily include the imagery themselves, although they may.[45] But from my point of view here, what matters most about the inscriptions is that they independently confirm, within the terminology generated by the culture at the time of the stupa's making, the iconic status of the image which is suggested by the surviving material culture.

Before turning to a discussion, it is worth noting that, at the site itself, these icons, which clearly proliferated over the years, coexisted with a series of further miniature representations of the Buddhapada within historiated reliefs. The replication of large icons of the Buddhapada as discursive segments – both meaningful in their own right and reflexive of the large panels in the context – within the greater decorative programme of the site, has parallels with the frequent representation of stupas in the relief panels that adorned the drum of the main stupa – a practice which has been described as the making of 'meta-stupas'.[46] Among the plethora of richly carved slabs around the vast drum (48.75m in diameter and 1.8m in height) that supported the dome, many depict stupas or the act of worship. Of these, several include the Buddhapada. Almost certainly the earliest drum slab in the British Museum (later reversed and recut with a fine stupa relief) shows the Buddha's Enlightenment beneath the Bodhi tree with five worshippers around the throne, perhaps representing the five ascetics to whom he later preached the first sermon (perhaps from the 1st century BCE, **Pl. 6.6**). The throne is empty, with just a lotus stem in its centre and the Buddhapada beneath, depicted as miniature footprints with rimmed wheels and in a framed footstool, facing out and downwards towards the viewer as if impressed by an invisible person seated on the throne.[47] A fragment of a similar panel perhaps of the same date at the Amarāvatī Museum shows four devotees, two male and female couples, worshipping the throne with a Buddhapada beneath and a series of auspicious symbols in the centre.[48] Part of the charm of the British Museum panel is the contiguity of the Buddhapada with the foot of the worshipping ascetic to the immediate right (from the viewer's perspective) which is without wheels or the iconic formality of the footprints. In these cases there is at least a strong possibility that the footprints represent the presence of the Buddha himself. A series of later panels, perhaps from the 3rd century CE, show stupas whose decoration includes images of Buddhapadas – for instance beneath parasols on the dome of the depicted stupa in a number of examples (**Pl. 6.7**),[49] or in the central gateway beneath an empty throne below a column surmounted by a wheel (*dharmacakra*),[50] or below the Bodhi tree.[51]

Further Buddhapadas appear in a variety of narrative contexts within the decoration of the Amarāvatī stupa: Quagliotti counts 42 examples preserved in the British Museum, the Amarāvatī Museum and the Chennai Museum.[52] Striking examples include a panel from the inner face of the magnificently sculpted railing decoration, which

double border within which sits a row of broad lotus petals. The outer rim of this border turns into tendrils that become the five toes of the foot depicted as a series of half-open lotus buds, one for each toe, with *svastika*s beneath the toes on the right and the left.[41] This offers a much more abstract, even symbolic, model for envisaging the Buddhapada, which is emulated by a number of later examples.

The proposal that the Buddhapada motif developed into a form of icon at Amarāvatī is significantly supported by the epigraphic evidence from the site. When the Brahmi inscriptions (mostly in Prakrit but a few in Sanskrit, many fragmentary or unreadable) were collected and translated in 1912, 5 out of 120 specified the Buddha's footprints as the object of donation, as well as naming the donors; the number of deciphered inscriptions has now risen to 277 and the reading of one of the five Buddhapada examples has been contested.[42] Clearly the stupa was funded by numerous donations from varieties of devotees,[43] a significant number of them female, who cover a vast social range from monks and nuns via laypeople including workmen to high officials, and family groups are frequently named.[44] The inscriptions often cite such architectural elements as coping stones, parasols, pillars, slabs and rails (including ones with the characteristic circular panels of the site), or the provision of pillars for lighting, but also relics and more iconographically inflected offerings such as panels with wheels, vases,

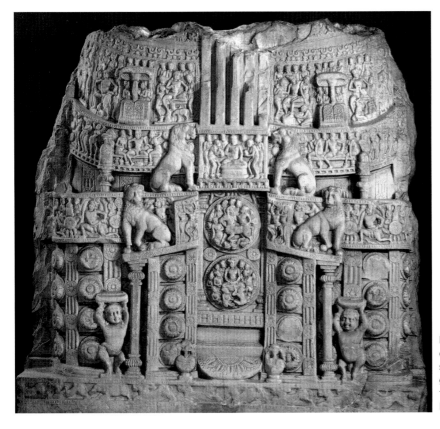

Plate 6.7 Drum slab, damaged at the top, with depiction of a stupa decorated with narrative scenes, boasting external railing and large gate, 3rd century CE, white limestone, h. 103.3cm, w. 83.75cm, d. 14.5cm. British Museum, London, 1880,0709.80

includes an image of the Buddha himself and of a stupa with a platform to the left bearing the Buddha's footprints.[53] A dome slab with large-scale relief of a monarch with a horse and a pair of ladies is framed below by a frieze of seated Buddhas over a frieze of horizontal Buddhapadas with toes pointing to the left.[54] A fine roundel from a railing pillar or crossbar in the Amarāvatī Museum has a devotional scene, perhaps showing the Buddha's son Rahula being presented

to the empty throne with the Buddhapada beneath it (**Pl. 6.8**).[55] In particular, the Buddhapada appears at the bottom of a number of drum pilasters showing a *dharmacakra* on a high pillar over an empty throne with cushions and Buddhapada below, surrounded by worshippers, dwarfs and seated deer (**Pl. 6.9**).[56] This use of the motif places it where the feet might be if the pillar were a person – as is famously the case on the northern gateway at Sanchi.[57]

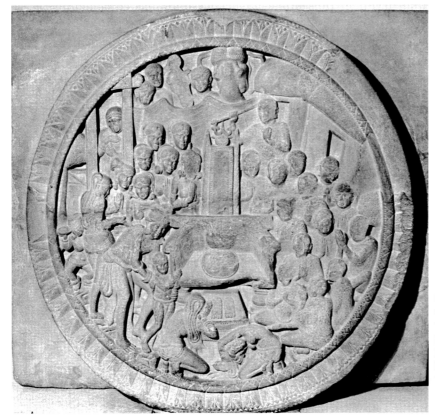

Plate 6.8 Roundel from a railing pillar or crossbar, showing devotion before the empty throne with Buddhapada beneath it and a child, possibly the Buddha's son Rahula, being presented to the throne at lower left, perhaps 2nd or 3rd century CE, white limestone, h. 94cm, w. 85cm, d. 28cm. Amarāvatī Archaeological Museum, acc. no. 20. Image: courtesy of the Huntington Archive, scan no. 21300

Plate 6.9 (left) Drum pilaster with a *dharmacakra* wheel on a high pillar above a throne with Buddhapada beneath, 3rd century CE, white limestone, h. 131.25cm, w. 26.25cm, d. 9cm. British Museum, London, 1880,0709.71

Plate 6.10 (right) Railing pillar with two lotus half-roundels at top and bottom and three scenes in the central portion, showing from top to bottom: the Bodhisattva crossing the Nairanjana river; a roundel of adoration of the empty throne, perhaps with the girl Sujata offering food to the Bodhisattva; and the Buddhapada beneath the Bodhi tree, flanked by worshippers, 2nd or 3rd century CE, white limestone, h. 266.2cm, w. 85.6cm, d. 26cm. British Museum, London, 1880,0709.4

The richness in elaboration of the Buddhapada motif across the early Buddhist sculpture of the site is rivalled only by the repetition and elaboration of the stupa theme, in the form of meta-stupas. What the two share is a very substantive emphasis on representing veneration in numerous forms – both within the mythological or narrative tradition (such as Rahula before the throne) and in the visualisation of perhaps contemporary 'reality', or at least of times after the Buddha's life, as envisaged by some of the sculptures – with numerous worshippers performing different kinds of devotions. The visual emphasis on

devotion, apparent also in the iconography of the meta-stupas, is arguably a significant cue to understanding the large icons of the Buddhapada that are my focus here.[58]

Let us test what might be called a visual commentary on the meanings of the Buddhapada by looking at an example of the motif as employed on a small scale in the figurative sculpture of a single pillar from the interior of the railing set up around the stupa in the 2nd or 3rd century CE (**Pl. 6.10**).[59] Sandwiched between two lotus half-roundels with framing borders of floral, vine and lotus motifs with fantastic animals and *makara*s are three historiated scenes.

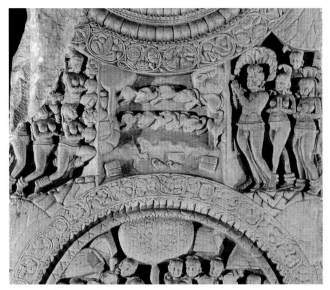

Plate 6.11 Detail of Plate 6.10, upper scene, the crossing of the Nairanjana river. British Museum, London, 1880,0709.4

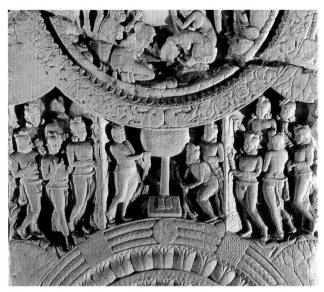

Plate 6.12 Detail of Plate 6.10, lower scene, devotees before the Buddhapada beneath the Bodhi tree. British Museum, London, 1880,0709.4

At the top the Bodhisattva – represented only as a series of Buddhapadas, two together at left and right, two singles in the centre – crosses the Nairanjana river near Bodh Gaya in an event that took place before his Enlightenment (**Pl. 6.11**). There are two lines of geese above the rendition of the river and a remarkable disembodied hand emerging from what may be a tree on the right; this has been interpreted as a tree god granting aid to the miraculous crossing. To the left are female worshippers and to the right the *naga* king with his wives, and snakes behind his head. In the roundel below, in its lotus border, is the Bodhi tree with a throne on which is placed the Buddhapada, now damaged. This is surrounded by figures, including what has been interpreted as the offering of food by the girl Sujata to the Bodhisattva before his Enlightenment. In the scene at the bottom is the tree again with throne and Buddhapada flanked by further figures (**Pl. 6.12**). In this case, the throne is presented as a square frame with its own incised border around the footprints, making them a version of the large icons we have been examining.

Effectively, the Buddhapada is central to every scene, whether seen as an element within the narrative (as in the Nairanjana episode at the top) or potentially within a theme of largely devotional significance, with the footprints depicted as a framed icon in the lowest scene. All may represent events before the Enlightenment, but the bottom and central scenes may well be meant to evoke the Buddha after his Enlightenment. In terms of vertical thrust, accentuated by the trees one on top of the other in the lower scenes and by the shape of the pillar itself, the Buddhapada is not only at the central place of worship in each image, but proliferates across the middle section of the river-crossing at the top. In this collection of images, despite the rich figural iconography, the Buddha himself only appears as the Buddhapada, although in many other scenes from the stupa (including railing pillars probably of the same date) his figure is fully present. Interestingly, the fragmentary Brahmi inscription at the top records the donation of two footprints by a lady, described as the mother of Anada.[60] The donor's

wishes may in part explain the iconographic emphasis, but there can be no doubt of the pillar's power in offering a repeated and multifaceted reflection on the larger Buddhapada panels in the site.

Two general conclusions about the Buddhapada motif in Amarāvatī arise. First, it is most often a standalone icon implying the image and presence of the Buddha himself: this is so in the many narrative instances within the decorative reliefs where the motif appears beneath a throne (e.g. **Pl. 6.8**), often under the Bodhi tree (e.g. **Pls 6.6** and **6.9**); and it is very likely (if unprovably) the case in the large independent panels which have been my main focus. But, in those drum slabs where it appears twice under a parasol in the dome sculpture to either side of the gateway in a meta stupa (e.g. **Pl. 6.7**) and on the railing coping where it stands on a base to either side of the outer railing gate of a mini-stupa,[61] the motif features as a miniature image of a Buddhapada slab. The question whether, in this last set of instances, the small relief image of a slab-icon carries the same weight and presence of the Buddha as the narrative use of Buddhapadas to represent the Buddha in other imagery of the same period carved by the same sculptors at the same site is not easily soluble. But the phenomenon certainly reflects the way that representations of representations characteristically play on each other at Amarāvatī (as meta-stupa images play on the main stupa, which they adorn). The issue is parallel to the way in which Byzantine icons may represent their subjects holding miniature icons whose sacred efficacy may be no less powerful because they are copies.

Second, the motif never appears with the toes pointing upwards. This means that it is never perceived from the point of view of a person looking down at her or his own feet but usually as if one were face to face with the holy presence of the Buddhapada's invisible possessor. In those cases (the vast majority), the Buddhapada offers a confrontation with a sacred presence – perhaps implying an invitation to obeisance in the way that one might do homage to the feet of a holy person through prostration, as is indeed depicted in a fragmentary relief at the site (**Pl. 6.13**). In the few instances

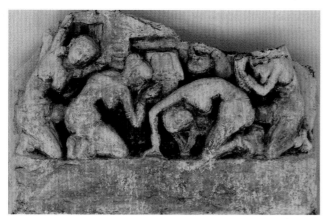

Plate 6.13 Fragmentary scene showing prostration before the Buddhapada (compare Pls 6.8 and 6.12), perhaps 2nd or 3rd century CE, white limestone, dimensions not available. Amarāvatī Archaeological Museum. Image: Krishna Chaitanya Velaga (Creative Commons licence)

where Buddhapadas are seen from the side (as a framing frieze or in narratives such as the Buddha's birth or the crossing of the Nairanjana river, **Pl. 6.11**),[62] it remains the case that the viewer is not in a position to identify with them as potentially his or her own feet, seen as one would see one's own.

There is a remarkable insistence on the Buddhapada motif in the sculptural decoration of Amarāvatī – greater than that shown at other stupas of the same period. In the narrative reliefs, there is a striking emphasis on veneration, well evidenced in a fine fragment from the Amarāvatī Archaeological Museum (**Pl. 6.13**). When it comes to the creation of the large-scale icon of the footprints, there is some substantial variation in particular between the symbolic forms reflected in the British Museum fragment (**Pl. 6.5**) and the principal objects on which I have focused, which are probably the earliest. The two major early pieces (**Pls 6.1–6.2**) are remarkable and thoughtful gestures in the discourse of visual theology. They take the naturalistic models for representing people and animals in narrative figure or representations and turn them on their head. Instead of being imprints, these footprints emerge from the rock; instead of being footprints, they combine elements of the upper and the lower part of the foot that are impossible in the real world; in addition to being feet they are medleys of auspicious signs. My contention is that, in a visual culture that insistently emphasises veneration in connection to a monument designed for devotion, these icons are intended to depict the miraculous nature of the Buddha as one who cannot be defined by the discursive norms of representation. They may also potentially refer to miraculously made and lasting footprint relics of the Buddha and, by this means, to the Buddha himself.[63] The impossibility of the image – and yet its existence as an image, a trace of the real, realised in reality – is an attempt by visual means to define the supranormal and supernatural nature of Buddhahood.

The theological context

We are fortunate that a number of the early Buddhist texts relevant to the Buddhapada theme have been collected and discussed recently by Bikkhu Anālayo.[64] Of particular interest in relation to the theological thinking of the

Amarāvatī Buddhapadas is the *Dona Sutta*, preserved in the *Anguttara nikaya* of the Pali tradition, but also found in a series of other recensions, including Karosthi fragments in Gandhari, and several Chinese versions.[65] I give here Bikkhu Bodhi's translation of the *Anguttara nikaya*.

The brahmin Dona was travelling along the highway … [and] saw the thousand spoked wheels of the Blessed One's footprints, with their rims and hubs, complete in all respects, and thought: 'It is astounding and amazing! These surely could not be the footprints of a human being!'

… Tracking Blessed One's footprints, the brahmin Dona saw the Blessed One sitting at the foot of the tree – graceful, inspiring confidence, with peaceful faculties and peaceful mind, one who had attained the highest taming and serenity, [like] a tamed and guarded bull elephant with controlled faculties. He then approached the Blessed One and said to him:

'Could you be a deva, sir?'

'I will not be a deva, brahmin.'

'Could you be a gandhabba, sir?'

'I will not be a gandhabba, brahmin.'

'Could you be a yakkha, sir?'

'I will not be a yakkha, brahmin.'

'Could you be a human being, sir?'

'I will not be a human being, brahmin.'[66]

'When you are asked: 'Could you be a deva, sir?' you say: 'I will not be a deva, brahmin.' When you are asked: 'Could you be a gandhabba, sir?' you say: 'I will not be a gandhabba, brahmin.' When you are asked: 'Could be a yakkha, sir?' you say: 'I will not be a yakkha, brahmin.' When you are asked: 'Could you be a human being, sir?' you say: 'I will not be a human being, brahmin.' What, then, could you be sir?'

'Brahmin, I have abandoned those taints because of which I might have become a deva; I have cut them off at the root, made them like palm stumps, obliterated them so that they are no longer subject to future arising. I have abandoned those taints because of which I might have become a gandhabba …. I have abandoned those taints because of which I might have become a yakkha …. I have abandoned those taints because of which I might have become a human being. I have cut them off at the root, made them like palm stumps, obliterated them so that they are no longer subject to future arising. Just as a blue, red or white lotus flower, though born in the water and grown up in the water, rises above the water and stands unsoiled by the water, even so, though born in the world and grown up in the world, I have overcome the world and dwell unsoiled by the world. Remember me, Brahmin, as a Buddha.'[67]

This text – with its focus on defining what kind of being a Buddha is, by virtue of negating the kinds of beings he is not – has strong parallels to the visual negation of the possibilities of naturalistic figural norms in the Amarāvatī Buddhapadas. We may say that the Buddhapadas develop a form of visual apophaticism, in a different medium but with discursive similarities to the kinds of negation found in the *Dona Sutta*. Anālayo remarks of the text that this 'episode of the footprints reveals the limitations of the brahmin's reliance on external physical marks',[68] but one might put it another way and argue that the marvellous Buddhapadas that Dona saw – with their perfect wheels and, in the

Gandhari version of the 1st century CE, their 'shining brilliance'[69] – are the spur to his correct intuition that the being who made them was not human, to his search for that being and to the interrogation that will at last bring him to the point of discerning that the being he seeks is a Buddha.

This spur to the path is itself sufficient justification for creating the Buddhapada as a distinct icon, for its veneration and for the depiction of it across the site as an object of worship. In the case of the Amarāvatī panels, their strange play with naturalism is a means of performing the discourse of negation that characterises the Buddha's conversation with Dona. Moreover the framing borders, with their lotuses in both slabs, out of which the feet rise in relief, enact visually the spatial dynamic of the Buddha rising above the world, like a lotus flower rising above the water, to overcome the world, unsoiled by it. The reference within the text to the various beings that the Buddha is not plays out against the beings – *makara*s (including one with an elephant's head), *naga*s and a *yakśa* (i.e. *yakkha*) – found among the lotuses of the frames. Effectively the panel performs the ending simile of the passage in which – just as the lotus, though born of the water, rises above the water – the Buddha (here symbolised by his feet) rises above the world, including its lotuses and all of its beings that he is not. Were the lotuses in the decorative borders ever to have been coloured – blue, red or white (as in the *sutta*) – then the direct parallel with the *sutta* would have been stronger still.

A second textual tradition related to the Buddha's feet concerns the 32 marks of a great man (either a wheel-turning monarch, *chakravartin*, who is not a Buddha according to the tradition, or a fully awakened Buddha, who has renounced the worldly pleasures in which the *chakravartin* delights); this is presented by the *Brahmayu Sutta* of the *Majjhima nikaya*, which survives in Pali and in two Chinese versions.[70] Here the Brahmin Brahmayu sends his young student Uttara to visit the recluse Gautama to see if he has indeed been endowed with the 32 marks of the great man. After spending four summer months in company with the Buddha, Uttara returns to give his account to Brahmayu. The first five marks concern the feet: the feet are well placed; on their soles are 'wheels with a thousand spokes and ribs and hubs all complete';[71] the toes are long and slender; the feet straight all around; and the heels and the ankles are evenly filled on both sides.[72] Clearly all visual depictions of the Buddhapada make a general reference to this textual tradition – above all the wheels of the second mark with their rims and spokes, but arguably in the large icons from Amarāvatī also the well-placedness, the long and slender toes, the straightness all around and the evenness of the heels. In this sense these images are not only a synecdoche for the Buddha by representing him through his feet but, more esoterically, they take 5 of the marks to reflect all 32. The well-placedness of the first mark arguably emphasises the groundedness of the Buddha on the earth – firmly grounded enough to make an imprint; this is important because it differentiates the Buddha from deities (*devas*) who float above the ground. So, like the *Dona Sutta*, this tradition supports the visual apophaticism of the Buddhapada as taking a very human physical feature (the firmly planted foot) and denaturalising it in order to imply a being that is neither man nor god.

A further Pali *sutta*, the *Lakkhana Sutta*, the 30th in the *Dighanikaya* (III.142–79), surviving also in a Chinese version, opens with the list of marks and treasures belonging to the great man, whether monarch or Buddha.[73] It proceeds to enumerate the karmic qualities and deeds in previous lives that give rise to each of the signs, and the benefits that the sign confers on its possessor in his new existence. When speaking of the wheels on the soles of his feet, the *sutta* says: 'how does he benefit? He has a large retinue: he is surrounded by monks, nuns, male and female lay-followers, *devas* and humans, *asuras*, *nagas*, and *gandhabbas*. That is his benefit as a Buddha.'[74]

In this case, a range of the kinds of beings negated in the *Dona Sutta* are integrated into the Buddha's retinue – constituting his accompaniment both on the low-relief borders of the two Amarāvatī slabs on which I have focused and in the large extent of the imagery at the site, not to speak of the range of human devotees outlined in the many votive inscriptions. Likewise, his projecting heels and long toes are a protection so that no foe 'whether an ascetic or brahmin, a *deva*, *mara*, or Brahma, or anyone in the world can possibly take his life'.[75] Again, here (and repeatedly in its affirmation of the qualities conveyed by the marks), the text reintegrates the miraculous being into the world by means of positive relational qualities to all classes of other beings. And, again, we might see the relations of the footprints to their border imagery in the Amarāvatī Buddhapadas as picking up on this.

The theology of these texts sets out the Buddha as an utterly different kind of being from any other and yet one with material manifestations (in his miraculous footprints and physical presence). The Amarāvatī Buddhapada reliefs place their version of this within a vast and rich narrative elaboration of the Buddha's previous lives as the Bodhisattva (the Buddha-to-be, as recounted in the *Jataka* Tales), the story of his life as the Buddha – from his birth in miraculous circumstances and bearing the 32 marks, to his Enlightenment and death – and copious images of the veneration of his monuments, relics and stupa, as well as many images of supernatural beings.[76] That is, the choice to make and reiterate a large icon of the supreme being through footprints is cast within the larger scope of his many lives and the universal context of the salvation that his Enlightenment brings. Within the context of these many beings, whose representation is subject to the normative rules of realistic depiction, the Buddhapadas mark the Buddha's difference. Since he is not subject to those rules, it may be that in their strange impossibility they can simultaneously represent both footprints and feet, both the upper and the lower part of the foot, both the trace of a former presence and its perpetual continuity, precisely through their disruption of the visual conventions that govern the rest of the stupa's regime of representation.

My claim is not that these panels illustrate specific texts in this rich tradition, or their many commentaries. Rather, in a monastic context where many viewers were steeped in the learnings of the Buddhist tradition, the resonances of these scriptural texts would have been present and available. Moreover, it is in the quality of thinking through a discourse of the miraculous, in relation to a unique being whose

transformative coming changed the world of those called to his Dharma, that the artistic construction of the Buddhapada icons at Amarāvatī reflects the creativity, intelligence and learning of the scriptural tradition in visual terms.

Icons of emptiness

One final area of exploration, necessarily hypothetical because all issues of dating are so uncertain, is worth considering. It is likely that the Buddhist sect predominant (though by no means exclusive) along the Krishna river, the Mahāsāṃghikas, promoted in that environment a number of the philosophical moves that led to the creation of what has come to be known as Mahāyāna Buddhism.[77] In particular, the great philosopher monk Nagarjuna – whose historical chronology is as obscure as are his places of origin and habitation – is most likely to have produced his hugely creative development of the philosophy of emptiness in Andhra Pradesh during the 2nd or 3rd century CE.[78] In his philosophy, Nagarjuna extended the models of negation found in earlier Buddhist writings, such as the *Dona Sutta*, discussed above. In his great poetic text the *Mūlamadhyamakakārikā*, for instance, he writes:

> Everything is real and is not real;
>
> Both real and not real;
>
> Neither real nor not real.
>
> This is the Lord Buddha's Teaching.[79]

The 'four-cornered logic' (*Catuṣkoṭi*) employed here opens a space around any object of attention (in this case, 'everything') – emptying it of intrinsic, substantive or essentialist identification with anything that can be projected onto or attributed to it.[80]

Now certainty is not possible, but the least unlikely scholarly best-guess at present is that Nagarjuna formulated this model of thinking at the period when the Amarāvatī stupa was being decorated with much of the sculpture we have been discussing, and in its vicinity. His philosophical creativity (and that of his interlocutors, whom he taught and with whom he debated) went side by side with that of the stupa's artists. Since we are equally uncertain about the dates of the sculptures, it is possible that the two British Museum Buddhapadas on which I have focused are of roughly the same date as the birth of Nagarjuna's philosophy of emptiness; scholarly consensus puts them a touch earlier on stylistic grounds but without the grounding of external confirmation. Nonetheless, they were certainly available to later viewing in contexts where the fourfold logic of Nagarjuna was known and applied, and one might argue that their careful formal creation of a kind of object that was not a foot and not a footprint, yet might be thought both, and was not in itself a negative, anticipates or draws on something of the energies of the school of thought around Nagarjuna.

If we apply the four-cornered logic to the Buddhapada, we get something like this:

> The Buddhapada is a footprint and is not a footprint.
>
> It both is and is not a footprint.
>
> It is neither a footprint nor not a footprint.

Each of these statements is true in itself and in combination with the others; it is also true if we substitute 'foot' for 'footprint'. The Buddhapadas of Amarāvatī create something real – as in a series of sculpted works of art – which in some respects refer to the real (to feet and footprints) but in fundamental and deliberate ways refute any possibility of fixing on these icons as things of a mundane or normal kind. They evoke a supernatural being, whether in the objects themselves, in the Buddha from whom they emanate or in the actual and venerated footprints of the Buddha elsewhere that they may evoke, yet a being who is by definition empty of any of the normal rules by which the upper and lower parts of a foot are defined, by which what is imprinted and what emerges in relief are differentiated. Arguably the same kind of thinking that in philosophical terms ended up by generating Nagarjuna's logic of emptiness was in material terms being channelled into the making of the artistic culture of Amarāvatī. In this sense, and in the context of the vibrant intellectual life of the Buddhist communities of the Krishna valley, we may wonder whether the Buddhapadas are not icons of emptiness.

Comparison

I want to end by a brief comparison of the Amarāvatī Buddhapada icons with a somewhat later Christian parallel. At the Monastery of St Catherine at Mount Sinai, during the 6th century CE, an extremely learned group of patrons and artists created a unique iconography for the mosaic in the apse of the church.[81] They made fine images of the visions of God given to Moses at the Burning Bush and when he received the law on the top of Mount Sinai, and they 'completed' these with the vision of the Incarnate Christ that was vouchsafed to Moses and Elijah in the presence of Peter, James and John during the Transfiguration on Mount Tabor. No surviving sermon, commentary or textual exegesis puts these episodes together in exactly this way, but there is little doubt that the Sinai artists were constructing a visual theology of ever greater theophanies (founded on a rich commentarial tradition, and some of it conceived by scholars at the site itself), in the highly relevant local context where Moses had received both his visions of God and where Elijah also saw God in his cave in Horeb, according to scripture and local tradition.[82] That trio of visions would be repeatedly copied at the site through icons, frescoes and work in wood and metal in a highly self-referential genuflection to the great sanctity of Sinai as a site and to the remarkable visual culture it had created.[83]

My suggestion is that – in the life of what was a vast sacred and monastic complex in eastern India – the visual theologies of the Buddhapadas, which emerge in relief and defy naturalism at Amarāvatī, created an icon-model no less potent than that of Sinai and no less theologically complex, although of course within an entirely different but no less learned exegetic and scholarly religious tradition in a period of similar philosophical creativity. Just as the Transfiguration icon may not have been invented at Sinai but was appropriated by the site and became part of its visual identity, so the Buddhapada is likely to have originated elsewhere in early Buddhist art, its models borrowed perhaps from as far away as the Hellenistic world,

but became particularly characteristic in the philosophical dimension I have been attempting to describe at Amarāvatī.

Like the Sinai imagery, the icon was relentlessly replicated across an extensive variety of contexts at the site (although only the limestone survives today), both on a small scale and in large panels. The theophany of Christ in the Transfiguration fulfilled the absence of God, never wholly available before the Incarnation, by offering him fully visible as a man. The Amarāvatī Buddhapadas, concerned not with a simple man/God pairing but with a refutation of all manner of beings in the affirmation of the supreme Blessed One as of a fundamentally different order from anything that can be depicted with the means of depiction available to us, perform their theology differently – one may say negatively – since they discombobulate the norms of realistic representation. They may even come to encapsulate visually some aspects of the uses of reason and contradiction to forge the philosophy of emptiness. But they are concerned with very similar issues to those of Sinai in trying to find a material and artistic model for depicting a being whose reality is beyond the materials and discourses of the world, and cannot be constrained by any form of artistic representation that depends on them. As at Sinai, the success of the icon can be measured by its many and various representations at the site, and indeed its long life beyond the site within its religious tradition.

I should end by saying that the argument here deliberately bypasses, even ignores, the normative model of an aniconic early Buddhism developing towards an anthropomorphic religion. The Buddhapada is not aniconic:[84] it is a synecdochic use of certain human features to make an argument about a transcendent and miraculous being. It could certainly sit side by side with fully human versions of the Buddha (just as marks, including wheels, *svastikas* and ω-symbols, appear on the feet of several very early seated Buddhas in Mathura[85]), as indeed it did in relation to the rich range of meta-stupas – some with Buddhas and some without – that adorned the drum at the site.[86] Given the precision of the 32 marks in defining a being that is either a wheel-turning monarch or a Buddha, we need not resort to aniconism, some kind of abstract symbolism or relatively modern theories of semiotics to explain either the narrative uses of the Buddhapada to represent aspects of the birth and life of the Bodhisattva in his final lifetime before and when he became a Buddha, or its functions as a visual declaration of the special status of the being celebrated at Amarāvatī. These frequent images of devotion prove that this bearer of the marks was a Buddha who had appeared to save the world from suffering.

Three key points are worth emphasising. First, in its own context at Amarāvatī, the Buddhapada is a vibrant and creative visual symbol. Second, it represents a level of theological thinking characteristic of major monastic centres of learning that has found its way into the visual sphere and functions in relation to material forms, using their semiotics and discourses to powerful effect. Finally, on a comparative level, it offers a potent parallel to the most complex and creative uses of theology to generate visual culture in Christianity. The mosaic icons made for the Sinai apse were the centrepiece for the major worshipping space in one of the great centres of pilgrimage and monastic learning of the Christian world; the limestone icon of the Buddhapada, created and much replicated at Amarāvatī, was a powerful thinkpiece within the liturgical and theological culture of one of Buddhism's greatest Indian sites.

Notes

1 Thanks to Sarah Shaw, Hugo Shakeshaft, Deven Patel, Richard Gombrich, Milette Gaifman, Wendy Doniger and Alice Casalini.

2 The fundamental accounts are by Faxian (4th–5th century), Song Yun (6th century), Xuanzang (7th century), Yijing (7th–8th century). See Beal 1884; Legge 1886; Takakusu 1896; Li 1996. On Amarāvatī in particular, see e.g. Shimada 2013: 132–5. For cultural intercourse as far as Gandhara or Mathura, see Zin 2016a: 47–8 and 2016b; Stone 2016 on borrowings from the Roman world; and Becker 2016 on connectivity to the south.

3 The 'system' is brilliantly described by Hölscher 2004, although his account is limited by being focused on Greek models rather than also including eclectic borrowings from elsewhere (see Elsner 2006).

4 See especially Quagliotti 1998 and Huntington 2020.

5 In this vast literature one might begin with Lohuizen-de Leeuw 1979; Huntington 1990, 1992 and 2015; Dehejia 1991; Linrothe 1993; Rhi 1994; Karlsson 1999; Seckel 2004; Fogelin 2015; DeCaroli 2015. For the Buddhapada and aniconism, see Quagliotti 1998: 125–42 and Anonymous 2016. For acute discussion of the larger question of aniconism in comparative perspective, see e.g. Gaifman 2017.

6 On the historiography, see esp. Bracey 2020; also Abe 1995; Falser 2015; Huntington 2015.

7 Dehejia 1997: 42 and 54.

8 On trade see e.g. McLaughlin 2014 and Andrade 2017. For archaeology, see Nagaswamy 1981 and 1995; Ray 1983: 24–37. For art history, see Stone 2005; Zin 2016a: and the references above in n. 2.

9 The Greek *ichnos* means both foot and footprint. Famous textual discussions include Herodotus, *History* 4.82; and Lucian, *True Histories* 1.7. See e.g. Guarducci 1942–3; Castiglione 1968 and 1970; Dunbabin 1990; Takács 2005; Petridou 2009, 81–93; Christodoulou 2011, 18–21; Platt 2011, 58–60; Revell 2016; Krumeich 2020; and Petridou 2015: 76–82 for divine footprints as synecdoche and the message of divine bodily presence. For comparative natural footprints across religious cultures, see Monaci Castagno 2011 and Hegewald 2020.

10 An example in the Amarāvatī Museum (acc. no. 145) looks as if it the slab was certainly conceived as a single left foot: Quagliotti 1998: 27; Gupta 2008: no. 699 and pl. LIII.

11 To the 3rd and 4th centuries CE: see Stone 1994: 3–9, 21–4, on style and relations to Amaravati. On the Nagarjunakonda examples, see Quagliotti 1998: 25–6, no. I.15.

12 Sastri, Subrahmanyam and Rao 1994: 34 and 94, pls LXIV–LXVI.

13 See Quagliotti 1998: 36–43, nos I.16–19.

14 See for instance Adrych and Dalglish 2020a and b, with bibliography.

15 See e.g. Osborne 2011: 185–215; Platt 2011: 77–123; Squire 2011: 154–201; Gaifman 2015 and 2016; Mack 2018.

16 For detailed discussion, see Shimada 2013: 59–112, broadly accepted e.g. by Becker 2015: 24, n. 3.

17 See the list in Shimada 2013: 208–35.

18 See Shimada 2013: 171–204. For archaeological reflections on Thotlakonda Monastery, somewhat further north in Andhra Pradesh, in relation to local networks and landscapes, see Fogelin 2006.

19 Dehejia 1997: 151.

20 Cf. Petridou 2015, 76.

21 The classic parallel of a *pars pro toto* iconic image in a religious tradition – choosing head rather than foot – is the Mandylion or Veronica icon of Christ, complete with the legends of its miraculous facture. See e.g. Kuryluk 1991: 28–33; Belting 1994: 47–77; Kessler and Wolf 1998; Wolf 2002: 16–33.

22 As with further references to examples with British Museum numbers, see also the respective entry in the British Museum Collection Online, available at https://www.britishmuseum.org/ collection (accessed 12 May 2020). See Fergusson 1873: 209; Barrett 1954: 64–5, no. 19; Knox 1992: 211–12, no. 120; Quagliotti 1998: 22–6, no. I.6, with more bibliography. The dimensions I report in the caption are after Knox 1992, but the online catalogue records h. 70.2cm; w. 64.8cm; d. 10.5cm. Note that this relief is made from a recycled piece of stone which was itself part of an earlier decorative scheme in the sculptural ornamentation of the site: see Knox 1992: 177–8, no. 99 (where a photograph of the wrong Buddhapada is supplied at p. 178) and Quagliotti 1998: 25–6.

23 Although not as the object is currently illustrated in the British Museum Collection Online entry, nor how it was displayed on the posters or catalogue cover of the *Imagining the Divine* exhibition.

24 On the *makara* motif at Amarāvatī, see Stern and Bénisti 1961: 37–42.

25 For *triratna*, see Knox 1992: 211; for *nandyavarta*, Quagliotti 1998: 83–94.

26 See Kurita 1988: vol. I, nos 283, 290–1 and vol. II, nos 754–5, 782–9; Quagliotti 1998: 50–63, also 188–93, nos I.21–33. Note that several of these have worshippers carved in relief to the sides which determine that the foot be aligned upwards and away from the viewer (I.25, I.32 and the example recently purchased by the Yale University Art Gallery, 2015.141.1): are these authentic or modern fakes made for the market? The Roman examples in Dunbabin 1990 are incised.

27 See Marshall and Foucher 1940: 37 and 40. A number of fine Buddhapadas from the 1st century BCE inserted in larger narratives appear in scenes on the railing pillars at Bharhut, e.g. The Huntington Archive of Buddhist and Asian Art (https:// huntingtonarchive.org (accessed 12 May 2020), henceforth HABBA), scan nos 4790, 11537 and 4783.

28 Interestingly, Buddhapadas are thought to refer to naturally occurring 'footprints' of Buddha, known to have been venerated from very early: see Strong 2004: 85–97. These are particularly known from the evidence of the Chinese pilgrims, on which see e.g. Quagliotti 1998: 110–18. Insofar as such 'relics' may be related to fossilised footprints, for instance of dinosaurs, these exist in both imprint and relief form, providing potential natural models for both incised and relief Buddhapadas. See for example Xing *et al.* 2011; Xing *et al.* 2014.

29 The nails of the large toes lead Knox 1992: 211 to see nails in all the toes (not at all clear to me) and to aver that the image shows 'the upper surface of the foot' although this is not possible, not least because there is no leg.

30 See Barrett 1954: 65, no. 20; Knox 1992: 212–13, no. 121; Quagliotti 1998: 20–2, no. I.5.

31 Knox 1992: 212.

32 The evidence of the drum slabs showing Buddhapadas beneath parasols in the dome of the stupas represented in several reliefs might suggest that the large panels could have appeared on the main stupa itself. See e.g. Gupta 2008: no. 339, pl. 19; Knox 1992:

141–9, nos 73, 75 and 76, respectively British Museum 1880.0709.80, British Museum 1880.0709.83 and British Museum 1880.0709.85 (= Quagliotti 1998: 32–3); Becker 2015: 38–41, fig. 1.6 (a drum slab now in Chennai). The excavators certainly believed that some of the Buddhapadas they found were displayed vertically, as opposed to horizontally, 'fixed, perhaps against a wall, by iron bolts'; see Burgess 1887: 98.

33 See Quagliotti 1998: 17–18 no. I.1; Quintanilla 2007: 108–9, fig. 130 and appendix II.6.

34 See Quintanilla 2007: 97–103. If there is a link between the Ghositārāma Buddhapada panel and those in Amarāvatī, it is not at all clear (given the uncertainties of dating based entirely on style) which had the priority and which influenced the other.

35 See Burgess 1887: 97–9; Barrett 1954: 38; Quagliotti 1998: 119.

36 Barrett 1954: 38; Roy 1994: 120.

37 They include the following now in the Chennai (formerly Madras) Museum: Quagliotti 1998: 30, I.10 (=Sivaramamurti 1956: 161, no. I D 1); Quagliotti 1998: 30, I.11 (=Burgess 1887: 98, pl. 52.8 and Sivaramamurti 1956: 161, no. I D 2), an interesting piece without a border, with very large *dharmacakra*s and multiple symbols, clear wrinkles for the toe-joins and clear nails; Quagliotti 1998: 30, I.12 (=Burgess 1887: 98, pl. 52.6 and Sivaramamurti 1956: 162, no. I D 4); Quagliotti 1998: 31, I.13 (=Burgess 1887: 98, pl. 43.14; Sivaramamurti 1956: 162, no. I D 5; Roy 1994: pl. 30); Quagliotti 1998: 31–2, I.14. In the Amarāvatī Museum: Gupta 2008: no. 64, pl. 41 (dated there to the 6th century CE); no. 699, fig. LIII (one foot only with an inscription and damaged at the toes, said to be 1st– 2nd century CE); nos 841, 843, 845 and 846 (all fragmentary and said to be 3rd century CE).

38 Burgess 1887: 98–9, pl. 53.1; Sivaramamurti 1956: 162, no. I D 3; Roy 1994: 29; Quagliotti 1998: 28–9, no. I.8, (and cf. I.9). See HABBA, scan nos 27696 and 12182. Karlsson 1999: 115–16 and fig. 24 (contra Roy 1994: 120) dates this earlier than the two British Museum panels, which would simply confirm the formal moves I have analysed but for a somewhat earlier moment.

39 See also from the Chennai Museum, Burgess, 1887: 98, pl. 52.8 (=Sivaramamurti 1956: 161, no. I D 2 and HABBA, scan no. 27701).

40 See Burgess 1887: 98, pl. 52.8 (=Sivaramamurti 1956: 162, no. I D 5, with a fragmentary inscription, no. 8, p. 274, reported also by Lüders 1912: 155, no. 1308; Quagliotti 1998: 31, no. I.13; HABBA, scan nos 12179 and 27695). It is unclear why Quagliotti (1998: 31) maintains that this piece was found inside the inner railing.

41 British Museum 1880,0709.42. See Ferguson 1873: 209, pl. 87.4; Barrett 1954: 65, no. 21; Knox 1992: 214; Quagliotti 1998: 27–8, no. I.7.

42 The publications are Lüders 1912 and Francis 2016. The five that specify footprints (*patuka*, in one case *paduka*, and in one case a 'slab with footprints', *patukapata*) are Lüders 1912: no. 1209 (a gift of two footprints); no. 1217 (a slab with footprints); no. 1219 (a gift of two footprints); no. 1225 (a gift of three footprints); and no. 1286. These are respectively Francis 2016: nos 248, 256, 250, 252 and 194. It is this last (Lüders 1912: no. 1286 and Francis 2016: no. 194) in which the word Lüders reads *paduka* (footprint) Francis reports as *pendaka* (slab); but, as Richard Gombrich notes (pers. comm.), 'it is a bold scholar who would dare to disagree with Lüders'. To Lüders' list we may add Chanda 1919–20: no. 44 (*paduko*).

43 Lüders 1912: 141–57, esp. nos 1206–1326; Shimada 2013: 237–42; Francis 2016: 45–58.

44 E.g., using the numbers in Lüders 1912: monks and nuns: 1223, 1224, 1237, 1240, 1242, 1246, 1250, 1252, 1257, 1258, 1262, 1264, 1267,

1270, 1272, 1280, 1286, 1289, 1295, 1315; laypeople: 1206, 1211, 1218, 1222, 1239, 1268, 1276, 1281, 1284, 1303; scribes: 1291; merchants: 1213, 1214, 1229, 1230, 1278, 1281, 1285, 1292; a perfumer: 1210; artisans and artists: 1273, 1298; teachers: 1273; bankers: 1261; officials: 1274, 1279, 1297; generals: 1266; families: 1206, 1209, 1214, 1215, 1216, 1220, 1221, 1222, 1225, 1229, 1230, 1239, 1243, 1244, 1247–52, 1254, 1255, 1256, 1260, 1268, 1269, 1271, 1277, 1278, 1287, 1300–2.

45 Compare Knox 1992: 44, no. 1 (= Lüders 1912: no. 1209; Francis 2016: no. 248 – a fluted pillar with lotus roundels) or Knox 1992: 114–15, no. 55 (= Lüders 1912: no. 1225; Francis 2016: no. 252 – a long drum panel with narrative scenes) or Knox 1992: 157–8, no. 83 (= Lüders 1912: no. 1217; Francis 2016: no. 256 – a drum pilaster with images of the Buddha) with Knox 1992: 50–2, no. 6 (= Lüders 1912: no. 1219; Francis 2016: no. 250, which has relentless Buddhapada imagery, as discussed below).

46 Becker 2015: 23–77.

47 See Barrett 1954: 15, 64; Knox 1992: 119, no. 60.

48 Gupta 2008: 55, no. 338, pl. 18; Karlsson 1999: 112–13, fig. 22. In Chennai there is also a fragment from the dome showing worship of the empty throne with Buddhapada, beneath which was a donative inscription: see Roy 1994: 202, no. 204, pl. 73. In the British Museum collection, a version appears as a depiction of the first sermon: Knox 1992: no. 38, British Museum 1880.0709.22 (see also Knox 1992: no. 63, British Museum 1880,0709.74; Knox 1992: no. 88, British Museum 1880,0709.93; and Knox 1992: no. 89, British Museum 1880,0709.94). Versions of this iconography on drum slabs from the later refurbishment of about the 3rd century with a *dharmacakra*, throne and Buddhapadas within the central gateway of miniature stupas now at the Amarāvatī Museum appear as Gupta 2008: nos 352 and 353, figs XXIV and XXV, and in the British Museum as Knox 1992: no. 77, British Museum 1880,0709,87; Knox 1992: no. 78, British Museum 1880,0709,120 – in this case with a *naga* on which the Buddhapada is placed.

49 Gupta 2008: no. 339, pl. 19; Knox 1992: 141–9, nos 73, 75 and 76, respectively British Museum 1880.0709.80, British Museum 1880.0709.83 and British Museum 1880.0709.85 (= Quagliotti 1998: 32–3); Becker 2015: 38–41, fig. 1.6 (a drum slab now in Chennai).

50 Such as Gupta 2008: nos 340–1, 351–2, 362; Knox 1992: 149–51 and 152–5, nos 77 and 79, respectively British Museum 1880.0709.87 and 1880.0709.121; or the fine slab now in Chennai, on which see Burgess 1887: 70–3 and Sivaramamurti 1956: 263–4, no. IV C 1.

51 See Gupta 2008: no. 342 (pl. 22), although this is from a small stupa at the site, and 353 (fig. XXV).

52 Quagliotti 1998: 173–86, with bibliography. To these we should add the wonderful example of one of the characteristic lotus medallions from the site's railings which has a Buddhapada carved at the centre: it is not published anywhere I have found, but is available at the Alamy website (www.alamy.com), represented wrongly with the toes upwards, as image AoBCFD.

53 Knox 1992: 93–5, no. 36, British Museum 1880,0709.19/20; Quagliotti 1998: 34–5.

54 Knox 1992: 184–5, no. 102, British Museum 1880,0709.53; Quagliotti 1998: 178–80 (no. 15).

55 Gupta 2008: 24, no. 79, pl. 8; HABBA, scan no. 21300.

56 If, as has been suggested by Knox (1992: 156–7) and on the British Museum website, this iconography represents the first sermon of the Buddha, or the turning of the wheel of Dhamma (in the absence of any depiction of the five ascetics to whom he preached the sermon), then the imagery of these pilasters may refer to the last part of the *Dhammacakkappavattana Sutta* (*Sutta Nipata* 56.11), where

the entire universe is presented as shaking before the auspicious nature of the event: 'When the Wheel of Truth had thus been set rolling by the Blessed One the earth gods raised the cry: 'At Benares, in the Deer Park at Isipatana, the matchless Wheel of Truth has been set rolling by the Blessed One, not to be stopped by monk or divine or god or death-angel or high divinity or anyone in the world. On hearing the earth-gods' cry, all the gods in turn in the six paradises of the sensual sphere took up the cry till it reached beyond the Retinue of High Divinity in the sphere of pure form. And so indeed in that hour, at that moment, the cry soared up to the World of High Divinity, and this ten-thousandfold world-element shook and rocked and quaked, and a great measureless radiance surpassing the very nature of the gods was displayed in the world.' (Translated by Bikkhu Ñanamoli.)

57 See British Museum 1880,0709.71 and British Museum 1880,0709.123 with Knox 1992: 156–7, nos 81 and 82. For other examples of similar pilasters with Buddhapadas in the same place at the Chennai Museum, see HABBA, scan nos 27623, 27624, 27626, 27627, 27643, 27644, 27648, 27710 (=27711) and also 27703 (a pillar relief); and in the Amarāvatī Museum, see HABBA, scan nos 21351 and 21369. On Sanchi, see also Marshall and Foucher 1940: vol. I, 137–44 and vol. II, pl. 37; for the same motif at Bharhut (now in the Allahabad Museum), see HABBA, scan no. 2876.

58 See esp. Becker 2015: 31, 33, 36, 48–56, 66–77; also Kinnard 2008: esp. 97–100 on physical and visual pilgrimage.

59 Knox 1992: 50–2, no. 6, British Museum 1880,0709.4; Quagliotti 1998: 177–8, no. 10.

60 See Lüders 1912: 143, no. 1219; Francis 2016: 162–3, no. 250.

61 Panels with Buddhapadas in the dome: Gupta 2008: no. 339, pl. 19; Knox 1992: 141–9, nos 73, 75 and 76, respectively British Museum 1880.0709.80, British Museum 1880.0709.83 and British Museum 1880.0709.85 (=Quagliotti 1998: 32–3). Railing coping: Knox 1992: 93–5, no. 36, British Museum 1880,0709.19/20; Quagliotti 1998: 34–5.

62 Frieze: Knox 1992: 184–5, no. 102, British Museum 1880,0709.53; Quagliotti 1998: 178–80, no. 15. Birth narrative: Knox 1992: 119–20, no. 61, British Museum 1880,0709.44. Nairanjana river: the upper relief of Knox 1992: 50–2, no. 6, British Museum 1880,0709.4; Quagliotti 1998: 177–8, no. 10.

63 Strong 2004: 85–97.

64 Anālayo 2017. Much information on later Buddhapada commentaries and traditions is available in Cicuzza 2011.

65 Anālayo 2017: 15–17 with full details.

66 In the Chinese version translated by Anālayo 2017: 17–20, the options of the Buddha being a *naga* and Brahma are added to these.

67 *Anguttara Nikaya*, Book of the Fours II.38, *sutta* 36 (Dona), trans. Bodhi 2012. Compare the very early Pali *Sutta Nipata* 3.4, where the Buddha also presents himself through negation (of caste affiliations): 'I am certainly not a brahman, nor a prince, nor a *vessa* (merchant), nor am I anyone else' (trans. Norman 1984: 76).

68 Anālayo 2017: 20.

69 Anālayo 2017: 23–5.

70 *Majjhima nikaya* II.136–7, *sutta* 91. See Anālayo 2017: 43–135 for lengthy discussion. On the marks generally see Griffiths 1994: 68, 97–101.

71 Ñanamoli and Bodhi 1995: 745.

72 I give the marks here according to Anālayo's list and translation: 2017: 47.

73 Anālayo 2017: 103–35.

74 *Lakhana Sutta*, 30. 1.8, as translated in Walsh 1987: 444.

75 *Lakhana Sutta*, 30. 1.11, as translated in Walsh 1987: 445.

76 Note that the Buddhapada is used for the scene of Gautama's birth before he become a Buddha, where his first footprints are incised in his swaddling clothes in e.g. Knox 1992: 119–20, no. 61, British Museum 1880,0709.44. See also Knox 1992: 100–1, no. 41, British Museum 1880,0709.23 and HABBA, scan nos 26949 and 26963, both in the Chennai Museum.

77 Wayman and Stone 1990: 49–66; Padma and Barber 2008.

78 Mabbett 1998: esp. 345; and Walser 2005: esp. 61–9, 79–88.

79 Garfield 1995: 49.

80 See Kalupahana 1986: 270 for the way in which Nagarjuna uses his four-cornered logic to *reject* metaphysical assumptions rather than to establish something or some theory. See also Cotnoir 2015.

81 On the art and archaeology, see Forsyth and Weitzmann 1973. For interpretation of the mosaic, see Elsner 1994 and Nelson 2006.

82 The Transfiguration appears in Matt. 17:1–8, Mark 9:2–8 and Luke 9:28–36; the Burning Bush in Exod. 3:1–22; the vision of God to Moses in the cleft of rock in Exod. 33:12–22; and Elijah's vision at Horeb in 1 Kings 19:8–14.

83 For the culture of iconic replication of the main mosaic, see Elsner and Wolf 2010: 37–71.

84 Broadly speaking, I agree with Huntington 1990: 405–7 and 2015: 180–3 on the question of aniconism, though would want to extend the interpretation of Buddhist imagery beyond both narrative and liturgy/ritual to more abstract theology.

85 See Quagliotti 1998: 46–50, nos 1.2–21.

86 See esp. Becker 2015: 38–41.

Bibliography

Abe, S. 1995. 'Inside the wonder house: Buddhist art and the west', in D. Lopez Jr (ed.), *Curators of the Buddha: The Study of Buddhism under Colonialism*, Chicago, 63–106.

Adrych, P. and Dalglish, D. 2020a, 'Mystery cult and material culture in the Graeco-Roman world', in Elsner 2020: 81–109.

— 2020b, 'Writing the art, archaeology and religion of the Roman Mediterranean', in Elsner 2020: 51–80.

Anālayo 2017. *Buddhapada and the Bodhisattva Path*, Hamburg.

Andrade, N. 2017. 'Drops of Greek in a multilingual sea: the Egyptian network and its residential presences in the Indian Ocean', *Journal of Hellenic Studies* 137, 42–66.

Anonymous 2016. *Anikonismus in der frühbuddhistischen Kunst am Beispiel der 'Buddhapada'*, Bonn.

Barrett, D. 1954. *Sculpture from Amaravati in the British Museum*, London.

Beal, S. 1884. *Si-Yu-Ki: Buddhist Records of the Western World*, London.

Becker, C. 2015. *Shifting Stones, Shaping the Past: Sculpture from the Buddhist Stūpas of Andhra Pradesh*, New York.

— 2016. 'Mahinda's visit to Amaravati? Narrative connections between Buddhist communities in Andhra and Sri Lanka', in Shimada and Willis 2016: 70–8.

Belting, H. 1994. *Likeness and Presence: A History of the Image before the Era of Art*, Chicago.

Bodhi 2012. *The Numerical Discourses of the Buddha: A Translation of the Aṅguttara Nikāya*, Bristol.

Bracey, R. 2020, 'The Gandharan problem', in Elsner 2020: 27–50.

Burgess, J. 1887. *The Buddhist Stupas of Amaravati and Jaggayyapeta*, London.

Castiglione, L. 1968. 'Inverted footprints: a contribution to the ancient popular religion', *Acta Ethnographica Academiae Scientiarum Hungaricae* 17, 121–37 and 187–9.

— 1970. 'Vestigia', *Acta Archaeologica Academiae Scientiarum Hungaricae* 22, 95–132.

Chanda, R. 1919–20. 'Some unpublished Amaravati inscriptions', *Epigraphia Indica* 15, 258–75.

Christodoulou, P. 2011. 'Les reliefs votifs du sanctuaire d'Isis à Dion', in L. Bricault and R. Veymiers (eds), *Bibliotheca Isiaca II*, Bordeaux, 11–22.

Cicuzza, C. 2011. *A Mirror Reflecting the Entire World: The Pāli Buddhapādamaṅgala or 'Auspicious Signs on the Buddha's Feet'. Critical Edition with English Translation*, Bangkok and Lumbini.

Cotnoir, J. 2015. 'Nāgārjuna's logic', in K. Tanaka, Y. Deguchi, J. Garfield, and G. Priest (eds), *The Moon Points Back*, Oxford, 176–88.

DeCaroli, R. 2015. *Image Problems: The Origin and Development of the Buddha's Image in Early South Asia*, Seattle.

Dehejia, V. 1991. 'Aniconism and the multivalence of emblems', *Ars Orientalis* 21, 45–66.

— 1997. *Discourse in Early Buddhist Art: Visual Narratives of India*, New Delhi.

Dunbabin, K. 1990. '*Ipsae deae vestigia* …: footprints divine and human', *Journal of Roman Archeology* 3, 85–109.

Elsner, J. 1994. 'The viewer and the vision: the case of the Sinai apse', *Art History* 17, 81–102.

— 2006. 'Classicism in Roman art', in J. Porter (ed.), *Classical Pasts: The Classical Traditions of Greece and Rome*, Princeton, 270–97.

— (ed.) 2020. *Empires of Faith: Histories of Image and Religion in Late Antiquity, from India to Ireland*, Cambridge.

Elsner, J. and Wolf, G. 2010. 'The transfigured mountain: icons and transformations of pilgrimage at the Monastery of St Catherine at Mount Sinai', in S. Gerstel and R. Nelson (eds), *Approaching the Holy Mountain: Art and Liturgy at St Catherine's Monastery in the Sinai*, Turnhout, 37–71.

Falser, M. 2015. 'The Graeco-Buddhist style of Gandhara – a 'storia ideologica', or: how a discourse makes a global history of art', *Journal of Art Historiography* 13, 1–53.

Fergusson, J. 1873. *Tree and Serpent Worship*, London.

Forsyth, G. and Weitzmann, K. 1973. *The Monastery of St Catherine at Mt Sinai: The Church and Fortress*, Ann Arbor.

Fogelin, L. 2006. *The Archaeology of Early Buddhism*, Lanham, MD.

— 2015. *An Archaeological History of Indian Buddhism*, Oxford.

Francis, N. 2016. *A Source Book of the Early Buddhist Inscriptions of Amarāvatī*, Shimla.

Gaifman, M. 2015. 'Visual evidence', in E. Eidinow and J. Kindt (eds), *Oxford Handbook of Greek Religion*, Oxford, 51–66.

— 2016. 'Theologies of statues', in E. Eidinow, J. Kindt and R. Osborne (eds), *Theologies of Ancient Greek Religion*, Cambridge, 249–80.

— 2017. 'Aniconism: definitions, examples and comparative perspectives', *Religion* 47, 335–52.

Garfield, J. 1995. *The Fundamental Wisdom of the Middle Way: Nāgārjuna's Mūlamadhyamakakārikā*, Oxford.

Griffiths, P. 1994, *On Being Buddha: The Classical Doctrine of Buddhahood*, Albany.

Guarducci, M. 1942–3. 'Le impronte del *Quo Vadis* e monumenti affini, figurati ed epigraifici', *Rendiconti della Pontificia Accademia Romana di Archeologia* ser. 3, 19, 305–44.

Gupta, S. 2008. *Sculptures and Antiquities in the Archaeological Museum, Amarāvatī*, New Delhi.

Hegewald, J. 2020. *In the Steps of the Masters: Footprints, Feet and Shoes as Objects of Veneration in Asian, Islamic and Mediterranean Art*, Berlin.

Hölscher, T. 2004. *The Language of Images in Roman Art*, Cambridge.

Huntington, S. 1990. 'Early Buddhist art and the theory of aniconism', *Art Journal* 49(4), 401–8.

— 1992. 'Aniconism and the multivalence of emblems: another look', *Ars Orientalis* 22, 111–15.

— 2015. 'Shifting the paradigm: the aniconic theory and its terminology', *South Asian Studies* 31(2), 163–86.

— 2020. 'Footprints in the Early Buddhist art of India', in Hegewald 2020, 425–516.

Kalupahana, D. 1986. *Nagarjuna: The Philosophy of the Middle Way*, Albany.

Karlsson, K. 1999. *Face to Face with the Absent Buddha: The Formation of Buddhist Aniconic Art*, Uppsala.

Kessler, H. and Wolf, G. (eds) 1998. *The Holy Face and the Paradox of Representation*, Bologna.

Kinnard, J. 2008. 'Amaravati as lens: envisioning the Buddha in the ruins of the Great Stupa', in Padma and Barber 2008: 81–103.

Knox, R. 1992. *Amaravati: Buddhist Sculpture from the Great Stupa*, London.

Krumeich, R. 2020. '"Footprints" and sculpted feet: enduring marks of human presence and divine epiphany in classical antiquity', in Hegewald 2020, 143–220.

Kurita, I. 1988. *Gandhāran Art*, 2 vols, Tokyo.

Kuryluk, E. 1991. *Veronica and Her Cloth*, Oxford, 28–33.

Legge, J. 1886. *A Record of Buddhist Kingdoms*, Oxford.

Li, R. 1996. *The Great Tang Dynasty Record of the Western Regions*, Berkeley.

Linrothe, R. 1993. 'Inquiries into the origin of the Buddha image: a review', *East and West* 43(4), 241–56.

Lohuizen-de Leeuw, J. van 1979. 'New evidence with regard to the origin of the Buddha image', in H. Härtel (ed.), *South Asian Archaeology*, Berlin, 377–400.

Lüders, H. 1912. 'A list of Brahmi inscriptions from the earliest times to about 400 AD', *Epigraphia Indica* 10, appendix, 1–226.

Mabbett, I. 1998. 'The problem of the historical Nāgārjuna revisited', *Journal of the American Oriental Society* 118, 332–46.

Mack, W. 2018. 'Vox populi, vox deorum: Athenian document reliefs and the theologies of public inscription', *Annual of the British School at Athens* 113, 365–98.

Marshall, J. and Foucher, A. 1940. *The Monuments of Sanchi, Vol. II*, Calcutta.

McLaughlin, R. 2014. *The Roman Empire and the Indian Ocean*, Barnsley.

Monaci Castagno, A. (ed.) 2011. *Sacre impronte e oggetti 'non fatti da mano d'uomo' nelle religioni*, Alessandria.

Nagaswamy, R. 1981. 'Roman sites in Tamil Nadu: recent discoveries', in M.S. Nagaraja Rao (ed.), *Madhu: Recent Researches in Indian Archaeology and Art History*, New Delhi, 337–9.

— 1995. *Roman Karur: A Peep into Tamils' Past*, Madras.

Ñanamoli and Bodhi 1995. *The Middle Length Discourses of the Buddha*, Kandy.

Nelson, R. 2006. 'Where God walked and monks pray', in R. Nelson and K. Collins (eds), *Holy Image, Hallowed Ground: Icons from Sinai*, Los Angeles, 1–37.

Norman, K, 1984. *The Group of Discourses (Sutta-nipata)*, vol. 1, London.

Osborne, R. 2011. *The History Written on the Classical Greek Body*, Cambridge.

Padma, S. and Barber, A. (eds) 2008. *Buddhism in the Krishna River Valley of Andhra*, Albany.

Petridou, G. 2009. '*Artemidi to ichnos*: divine feet and hereditary priesthood in Pisidian Pogla', *Anatolian Studies* 59, 81–93.

— 2015. *Divine Epiphany in Greek Literature and Culture*, Oxford.

Platt, V. 2011. *Facing the Gods: Epiphany and Representation in Graeco-Roman Art, Literature and Religion*, Cambridge.

Quagliotti, A.M. 1998. *Buddhapadas: An Essay on the Representations of the Footprints of the Buddha with a Descriptive Catalogue of the Indian Specimens from the 2nd Century B.C. to the 4th Century A.D.*, Rome.

Quintanilla, S.R. 2007. *History of Early Stone Sculpture at Mathura, ca 150 BCE –100 CE*, Leiden.

Ray, A. 1983. *The Life and Art of Early Andhradesa*, Delhi.

Revell, L. 2016. 'Footsteps in stone: variability within a global culture', in S. Alcock *et al.* (eds), *Beyond Boundaries: Connecting Visual Cultures in the Provinces of Ancient Rome*, Los Angeles, 206–21.

Rhi, J. 1994. 'From Bodhisattva to Buddha: the beginning of iconic representation in Buddhist art', *Artibus Asiae* 54(3–4), 207–25.

Roy, A. 1994. *Amarāvatī Stūpa: A Critical Comparison of Epigraphic, Architectural, and Sculptural Evidence*, New Delhi.

Sastri, V.K., Subrahmanyam, B. and Rao, N.R.K. 1992. *Thotlakonda: A Buddhist Site in Andhra Pradesh*, Hyderabad.

Seckel, D. 2004. *Before and Beyond the Image: Aniconic Symbolism in Buddhist Art*, Zurich.

Shimada, A. 2013. *Early Buddhist Architecture in Context: The Great Stūpa at Amarāvatī (ca. 300 BCE–300 CE)*, Leiden.

Shimada, A. and Willis, M. (eds) 2016. *Amaravati: The Art of an Early Buddhist Monument in Context*, London.

Sivaramamurti, C. 1956. *Amaravati Sculptures in the Madras Government Museum, Bulletin of the Madras Government Museum* 4, Madras.

Squire, M. 2011. *The Art of the Body: Antiquity and its Legacy*, London.

Stern, P. and Bénisti, M. 1961. *Évolution du style Indien d'Amarāvatī*, Paris.

Stone, E.R. 1994. *The Buddhist Art of Nagarjunakonda*, Delhi.

— 2005. 'Spatial conventions in the art of Andhra Pradesh: classical influence?', in G. Kamalakar (ed.), *Buddhism: Art, Architecture, Literature & Philosophy*, 2 vols, New Delhi, vol. 1, 67–72.

— 2016. 'Reflections of Roman art in southern India', in Shimada and Willis 2016: 59–69.

Strong, J. 2004. *Relics of the Buddha*, Princeton, 2004.

Takács, S. 2005. 'Divine and human feet: records of pilgrims honouring Isis', in J. Elsner and I. Rutherford (eds), *Pilgrimage in Graeco-Roman and Early Christian Antiquity: Seeing the Gods*, Oxford, 353–70.

Takakusu, J. 1896. *A Record of the Buddhist Religion as Practised in India and the Malay Archipelago (A.D. 671–695)*, Oxford.

Walser, J. 2005. *Nāgārjuna in Context: Mahāyāna Buddhism and Early Indian Culture*, New York.

Walsh, M. 1987. *Thus Have I Heard: The Long Discourses of the Buddha*, Boston.

Wayman, A. and Stone, E.R. 1990. 'The rise of Mahayana Buddhism and inscriptional evidence at Nagarjunakonda', *Indian Journal of Buddhist Studies* 2(1), 49–66.

Wolf, G. 2002. *Schleier und Spiegel. Traditionen des Christusbildes und die Bildkonzepte der Renaissance*, Munich, 16–33.

Xing, L., Mayor, A., Yu Chen, Harris J., and Burns, M. 2011. 'The folklore of dinosaur trackways in China: impact on paleontology', *Ichnos* 18(4), 213–20.

Xing, L., Lockley, M., Zhang, J., Klein, H., Kim, Y., Scott Persons IV, W., Matsukawa, M., Yu, X., Li, J., Chen, G. and Hu, Y. 2014. 'Upper Cretaceous dinosaur track assemblages and a new theropod ichnotaxon from Anhui Province, eastern China', *Cretaceous Research* 49, 190–204.

Zin, M. 2016a. 'Buddhist narratives and Amaravati', in Shimada and Willis 2016: 46–58.

— 2016b. 'Nur Gandhara? Zu Motiven der klassischen Antike in Andhra', *Tribus: Jahrbuch des Linden-Museums* 64, 178–205.

Response to J. Elsner, 'Buddhapada: The Enlightened Being and the Limits of Representation at Amarāvatī'

Alice Casalini

Jaś Elsner's paper attempts to think beyond iconography in the study of Buddhist art, and especially beyond the work of iconographical study as solely the identification of motifs. The details of the iconography of the Buddhapadas are rightly identified with their proper names, but the roles they play within the visual realm of the icons are brought to the forefront of the analysis, and these are investigated against the broader spectrum of Buddhist philosophical tenets. The paper reminds us that there is nothing truly casual about religious images, and that naturalism and realism in art (or lack thereof) can be addressed without referring to a model that favours *mimesis*. This response is structured around three aspects of the Buddhapada icons that are raised by the paper but can be further investigated: the relationship between body and space, the positionality of the icon and its materiality.

The Buddhapada sits at the nexus between body and space. It is not concerned with any type of body or space, but specifically with the body of the Buddha and the Buddhist space. Elsner points out the miraculous surrealism that permeates the image: neither a foot nor a footprint, showing neither the top nor the bottom of a foot. The Buddhapada simultaneously represents none of these and all of these: it performs a play between the miraculous space and the miraculous body.

Śakyamūni's body and physicality are different: his skin, his hair, his eyes are fundamentally different from anyone else's. Even when he was not enlightened, he had marks on his body that showed his alterity, as he was destined to become something else. Some of these marks are those very attributes that fill the frames of Buddhapadas. The upper part of a panel from the stupa of Kanaganahalli in Karnataka, for example, shows the presentation of the infant Gautama to Śākhyavardhana, the *yakṣa* of the family: a woman is standing at the centre of the panel, surrounded by her attendants, and she is holding a piece of cloth whose surface bears the baby Gautama's footprints. They are marked with *dharmacakra*s and *triratna*s.[1] Several other beings in the Buddhist pantheon have marks on their bodies. Bodhisattvas, for example, have *urṇa*s on their foreheads and *uṣṇīṣa*s on top of their heads and their presentation overlaps with that of the *cakravartin*, the perfect ruler.[2]

There are subtler signs of a fantastic body, even when it is fully covered. The figure of the Buddha in *parinirvāṇa* scenes in Gandhāra offers a wonderful example (**Pl. 6.14**). The Buddha is shown on a bed, reclining on his right side. The folds of his garment, nevertheless, do not follow the rules of reality, and cover the body of Śakyamūni as if he was standing and not lying down. There are enough representations of the Buddha's mother dreaming about the white elephant piercing her side to show that the artists were perfectly capable of carving drapery that followed the rules of physics.[3]

The Buddha inhabits a dimension that is close enough to reality to elicit familiarity, but that, at a second look, reveals all of its incongruities and illogical missteps. The making of a miraculous space, nevertheless, goes beyond its relationship to the utter alterity of the Buddha. The Buddha and his body are unique, but his world is also unique. The Buddhapada speaks of a broader Buddhist agenda of

constructing a new cosmology, perhaps even a new cosmogony. The process is subtle, as it often makes use of elements that are already part of traditional imagery. This allows the Buddhist visual system and those who promote it to insert themselves within the Brahmanical tradition, to fit comfortably (and legitimately) alongside it, but at the same time it allows it to subvert from within.

One of the figures inhabiting the Amarāvatī Buddhapada's frame seems to perform the interplay between old and new traditions – and simultaneously shows the limits of iconographical studies that coincide with the identification of stories, personages and motifs. The figure in the lower right frame of one of the British Museum's Buddhapadas is a pot-bellied human-like creature reclining in a corner of the decorated frame (**Pl. 6.2**). The detail of the lotus sprouting from his navel recalls a cosmogonic myth: Viṣṇu is sleeping on the floor of the cosmic ocean and a lotus sprouts from his navel: inside the lotus is Brahma, who in turn creates the world.[4] While the *yakṣa*-like figure is not Viṣṇu nor Brahma – and his exact identity might not even matter – there appears to be a certain degree of overlap with visual elements that were embedded in more traditionally Brahmanical imagery. The Buddha is not only physically and spiritually rising above the world, but is also making a statement about rising above old traditions, trampling them and crushing them under his feet. The Buddhapada icon thus speaks of a fight for power among competing doctrines, schools and sects.

Distortions and confusions about time and space are found everywhere in a monastic complex. A photo taken at the site of excavation of Amarāvatī shows one of the votive stupas with several carved panels *in situ*, attached to the drum of the monument (**Pl. 6.15**). On each of these relief panels, a stupa was carved. Is it a portrait of this specific votive stupa? Is it another specific stupa at Amarāvatī? Perhaps. Its identity does not matter. What matters is the way in which these relief panels are constructing the space by multiplying it indefinitely. They are creating a multiverse that can potentially expand *ad infinitum*, on both the microscopic and the macroscopic scale. In a drum panel representing a stupa, part of a *chattravali* (the burst of umbrellas at the top of a stupa), the top portion, peeks out from behind the frieze on the external railing and the lion sculpture on top of the pillar on the left (**Pl. 6.16**). The space becomes a Russian doll, a striking visual version of the multiverse described in the *Avataṃsaka sūtra*:

> [The Buddha] addressed the great assembly: 'Buddha-children, know that the oceans of the worlds have as many spans of existence as there are atoms in an ocean of worlds. ... I see the oceans of lands in ten directions; some abide for eons numerous as atoms, some for one eon, some for numberless, ... in each atom are infinite bodies, transforming like clouds, circulating everywhere.'[5]

The space of and around the stupa is multiplied to the point where it becomes tiresome to spell it out: the architectural stupa bears several panels with depictions of stupas and, within the depictions on the panels, miniature panels with stupas are carved in turn, expanding the space into the infinitesimal. In the same way, the space multiplies on the macroscopic level too: as if the architectural stupa and those

Plate 6.14 *Parinirvana*, Pakistan, *c.* 3rd century CE, schist, h. 66cm, w. 66cm, d. 7.6cm. Metropolitan Museum of Art, New York, acc. no. 2015.500.4.1, Gift of Florence and Herbert Irving, 2015

who are circumambulating it are depictions within a panel on a larger monument.

Space and body have so far been discussed within the confines of the Buddhapada icon – that is, by focusing on the constraints (or lack thereof) of logical space in relation to the body of the Buddha. However, the idea that the icon is constructing an illogical space is worth exploring outside the boundaries of the icon's frame too. While Elsner stresses the surrealism of the space that the footprints inhabit by paying particular attention to the conflicting points of view of the feet themselves, much remains to be said about the surrounding space and about how possible beholders fit themselves into it. As a matter of fact, the positionality of the icon plays a fundamental role in shaping the relationship between the object of ritual focus and its viewers.

Different encounters between the Buddha and his devotees seem to be implied by the varying directionality of

Plate 6.15 Votive stupa at Amaravati, Andhra Pradesh. Image: from A. Rea, 'Excavation at Amaravati', in *Annual Report of the Archaeological Survey of India 1905–6*, Calcutta, 1909, pl. La

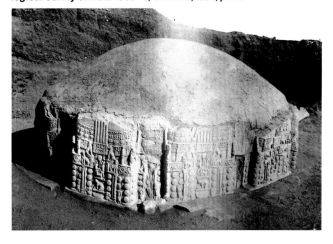

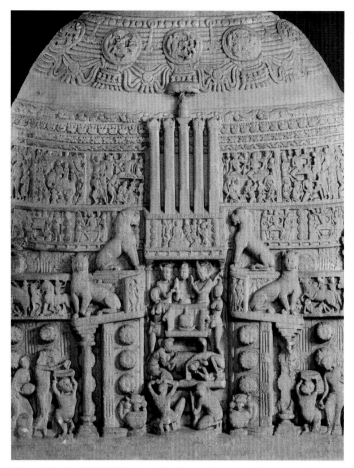
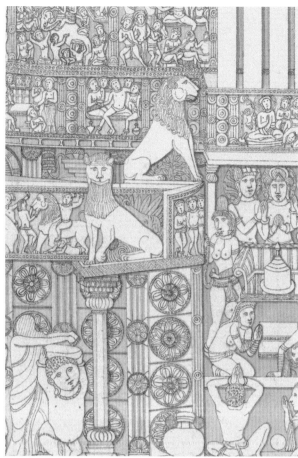

Plate 6.16a–b a) (left) Slab from the drum of a stupa, devotees adoring a reliquary at the centre, Amarāvatī, Andhra Pradesh, 3rd century CE, limestone, h. 138.7cm, w. 113.75cm, d. 17.5cm. British Museum, London, 1880,0709.69; b) (right) Detail of a drawing of Plate 6.16a. The British Library, London, WD1061, f. 47. Image: The British Library Board

different Buddhapadas. The footprints from Amarāvatī, with the toes pointing downwards, clearly recall the miniature *pada* icons within several of the narrative reliefs that were attached to stupa drums from the same site, also mentioned by Elsner above. In these scenes, the feet stand for the Buddha himself and signal his presence: seeing them equates to seeing the Buddha sitting on the throne, for

example. It is as if he were standing in front of his audience, both within and without the panel. The encounter is silent but immediate – even though the ineffable face of the Tathāgatha is not depicted.

However, the encounter implied by another type of Buddhapada, with toes pointing upwards, is completely different.[6] A beholder might look at these feet in the same

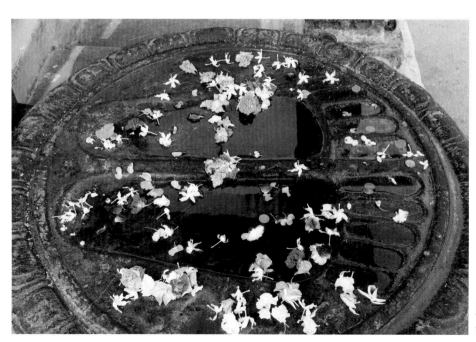

Plate 6.17 Buddhapada, Bodh Gaya Temple, Bihar. Image: Maciej Wojtkowiak / Alamy Stock Photo

way they would look at their own, and they would find themselves not only in the Buddha's presence, but also quite literally in his shoes – or behind him, as a loyal follower on the righteous path that will lead them to rise above the mud of the world. The case would be even stronger were the icon displayed in a horizontal configuration, rather than a vertical one, as the bodily association between Buddhapadas and actual feet would be even more immediate. Even though not much is known about the original location and display of the Buddhapada panels from Amarāvatī discussed here, I believe it is an attractive connection to make.

The possibility of a horizontal display finally brings us to the third and last aspect of my discussion, that of materiality. The issue is raised in the negative, as it starts from Buddhapadas that are carved in and do not project outwards from the stone surface, as do the ones analysed by Elsner. A concave space is, first and foremost, an empty space. As such, it can be filled. The consequences of this simple observation for the analysis of Buddhapada icons become clear if one looks at some later displays of the panel, as those in Bodh Gaya.[7] The well-known Buddhapada standing in front of the Mahābodhi Temple serves here as the most apt example: the footprints are hollowed out, the void left by the stone is filled with water, and offerings of flowers are floating on the surface (**Pl. 6.17**). The presence of the water is evocative for its translucent and transparent quality: it also recalls the tales of shining brilliance emanating from the Buddha's body, which itself left radiant shadows or reflections on various surfaces.[8] The transparency of the water further evokes the transparency of crystal, which was itself used as a material for reliquaries. Crystal not only protected the relics, but also made them visible, even if only for a short time. Bigger stone or metal reliquaries, in fact, would almost invariably encase the smaller crystal ones, in a subtle and ineffable interplay between transparent and opaque materials (**Pl. 6.18**).

Circling back to the objects at hand, the Buddhapadas in Amarāvatī seem to reject the material interplay engendered by the hollowed-out cavities of other icons. They are, in fact, carved out, and the footprints project from the surface of the limestone panel. The consequences of the different carving choice are difficult to discern in detail, especially as it is unclear whether the Andhra Pradesh icons were in direct conversation with other Buddhapadas throughout the rest of the Buddhist world. If it is the case that Buddhapadas were displayed in a horizontal configuration – regardless of whether they were carved in or out – the sensorial experience of the two was undeniably different. Surfaces of water are not the same as surfaces of limestone. Stone is unforgiving and motionless, cold to the touch in the shadow and scorching hot under the sun. Water, instead, moves when it is hit by a gust of wind, and it wets the tip of the fingers of the devotee who dares to touch the Buddha's feet. It dries out and evaporates under the sun, and might even start to smell foul if it is stagnant. What is the visual theology – to use Elsner's own term – gaining or losing through these dramatic changes in materiality?

Even though the discussion on the mechanisms that stand behind the making of a visual theology can be further expanded and refined, Jaś Elsner's paper makes an

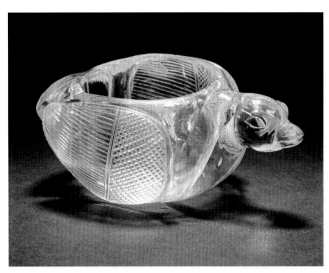

Plate 6.18 Reliquary in the shape of a goose, from stupa 32, Taxila, Pakistan, 1st century CE, rock crystal, h. 3.8cm, l. 10cm, w. 6.9cm. British Museum, London, 1867,0427.2

important statement about the major role that images played in the construction of religious meaning and in the generation of religious content. The visual theology, though perhaps more difficult to grasp today, can be as subtle or ineffable as that expressed by religious texts.

Notes

1 Zin 2018: 58–61 and 208, pl. 8.
2 For a discussion of the *cakravartin* motif, see Anālayo 2017: 43–77.
3 For a compendium of *parinirvāṇa* scenes from Gandhāra, see Kurita 2003.
4 Doniger 2009: 85 and 101–2.
5 Cleary 1993: 182–201.
6 Some examples from Gandhāra are discussed in Quagliotti 1998: 50–64 and Sensabaugh 2017.
7 For an overview of the Bodh Gaya icons, see Paul 1985 and Quagliotti 1998: 64–72.
8 Faxian, *Foguo ji* 佛國際, Book XIII, Book XXXI, Xuanzang, 大唐西域記 *Da Tang Xiyuji*, Book VII, but see also Wang 2014.

Bibliography

Anālayo 2017. *Buddhapada and the Bodhisattva Path*, Hamburg.
Cleary, T. 1993. *The Flower Ornament Scripture: A Translation of the Avatamsaka Sutra*, Boston.
Doniger, W. 2009. *The Hindus: An Alternative History*, New York.
Kurita, I. 2003. *Gandhāran Art I: The Buddha's Life Story*, Tokyo.
Paul, D. 1985. 'Antiquity of the Viṣṇupāda at Gaya: tradition and archaeology', *East and West* 35(1/3), 103–41.
Quagliotti, A.M. 1998. *Buddhapadas: An Essay on the Representations of the Footprints of the Buddha with a Descriptive Catalogue of the Indian Specimens from the 2nd Century B.C. to the 4th Century A.D.*, Rome.
Sensabaugh, D.A. 2017. 'Footprints of the Buddha', *Yale University Art Gallery Bulletin*, 84–9.
Wang, E. 2014. 'The shadow image in the cave: discourse on icons', in W. Swartz (ed.), *Early Medieval China Sourcebook*, New York, 405–27.
Zin, M. 2018. *The Kanaganahalli Stūpa: An Analysis of the 60 Massive Slabs Covering the Dome*, New Delhi.

Chapter 7
From Serapis to Christ to the Caliph: Faces as Re-Appropriation of the Past

Ivan Foletti and Katharina Meinecke

What makes a face? What makes a body? In this essay we will reflect, in a two-person dialogue, on the shift in forms and concepts from the pagan visual world to that of the early Christians and the Umayyad caliphate. Our aim is to investigate how authority was created through the appropriation of images from the past. We do not wish to present a complete panorama – that would be impossible in these few pages – but rather concentrate on certain types. We will begin with the face of a man (and god) with a long beard and long hair, present across the three religious cultures considered. Then we will complete the argument with the introduction of the whole body, with particular attention to the standing figure.

The face

The invention of the face of Christ

The face of Christ in the late antique period had many forms and cannot be unequivocally defined.[1] Especially in the period around the year 400, there was great *varietas*: Christ could have a long beard and long hair or could be beardless with short hair; he could be blond or dark-haired (**Pls 7.1, 7.3**). We can explain this diversity, for example, through the words of St Augustine. When he discussed the images of Christ in Hippo, he told believers that no one image of Christ could represent his true face and that the function of such images was to stimulate the imagination in order to enhance piety.[2] In any case, an image could not be perceived as the true presence of Christ. Thus the late antique position, as presented by Augustine, is completely different from the ideas that would emerge from the iconoclasm controversy.[3] Augustine was reacting to the material images he saw in existence around him – such as sarcophagi and the first depictions of Christ in catacombs and monumental buildings.[4] The abovementioned *varietas* therefore seems to have already existed before Augustine and other Christian theoreticians began to discuss Christian images.

We can begin to explain this diversity by looking at the work of André Grabar. As early as 1936, Grabar posited that the figure of Christ reflected imperial imagery, while Thomas Matthews argued, to the contrary, that the models used for the invention of Christ's image were images of philosophers and/or pagan divinities.[5] Whichever of these two approaches we prefer, we can all agree that the construction of the Christian divinity combined pre-existing visual and conceptual patterns from the imperial or pagan worlds.[6] It is interesting to remark that in another case – images of the Virgin Mary – the situation was different. In representations of the Virgin there were also many variations, but the differences mainly concerned her clothing, which refers to her social status.[7] In the case of Christ, the variation appears in the face. If we accept Hans Belting's notion that human beings are essentially walking faces, this variation reflects various and sometimes conflicting ways of conceiving Christ and makes perfect sense.[8] It is, however, interesting to note the different attitudes to the two main Christian figures. For a woman, what was important was the social status; for a man, it was the face.

Migration of faces: Christians, pagans and power?

We are justified in speaking of a 'rhetoric of faces' used for
Christ's images. It is even possible to identify in which way
different faces were used: in the case of the box of San
Nazaro in Milan, Christ's face is extremely imperial
(**Pl. 7.1**).[9] On this object, created shortly before the year 386,
probably during the years of sharp conflict between Bishop
Ambrose of Milan (376–97) and the imperial court, this
image seems to have a political meaning.[10] The emperor was
a partisan of the Arian heresy, while the donor of the casket
– certainly linked to the Ambrosian party, since the precious
box was offered for the consecration of the Church of the
Holy Apostles by Ambrose during the spring of 386 –
adhered to Nicene orthodoxy.[11] From the point of view of the
probable donor, the consecrated virgin Manlia Dedalia, the
emperor was therefore a heretic.[12] Giving Christ an imperial
face could thus be read as a sort of substitution – the bad
emperor replaced by the good divine sovereign. Christ with
an imperial face can, in this specific context, be seen as a sort
of reminder to the erroneous imperial party. By following
Christ – the divine emperor – the human emperor can
return to the right path.

As far back as 1947, Katzenellenbogen proposed a similar
explanation for the lid of the sarcophagus from the Basilica
di Sant'Ambrogio, also in Milan. On this work, the friends
of Daniel are depicted refusing to adore King
Nebuchadnezzar's gold statue (Daniel 3:3–30); the sculpture
of the king is a Roman imperial bust (**Pl. 7.2**).[13] The bust is
not a specific emperor from the 4th century, but it is more
than just an adaptation of an event from the Old Testament
to the Roman cultural world. This iconography can be
interpreted as the visual relativisation of imperial authority:
if an emperor adores a false god, he should not be followed
by true believers. The other side of the lid shows the
Adoration of the Magi. Again, if we follow
Katzenellenbogen, the two parallel motifs are there to

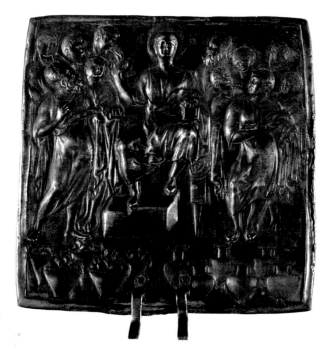

Plate 7.1 Christ plaque from the box of San Nazaro, Milan, before
386 CE, silver, 20.5 × 20.5 × 20.6cm. Museo Diocesano, Milan, inv. MD
2004.115.001. Image: © Museo Diocesano

remind the viewer of the orthodox position: the visible Son
of God of the New Testament and the invisible Father of the
Old Testament must be adored in the same way.

There is another noteworthy image like this – that of
Christ in Santa Pudenziana in Rome (**Pl. 7.3**), dating to
401–17, who really seems to be a visual twin of the pagan god
Serapis. Their position on the throne is very similar, as are
the haircuts and the faces themselves.[14] Though these
elements can also be found in representations of Jupiter from
the 2nd and 3rd centuries, the similarities with Serapis are
much more significant. Apart from the face, the clothing is
generally similar; in addition, standing figures of Serapis

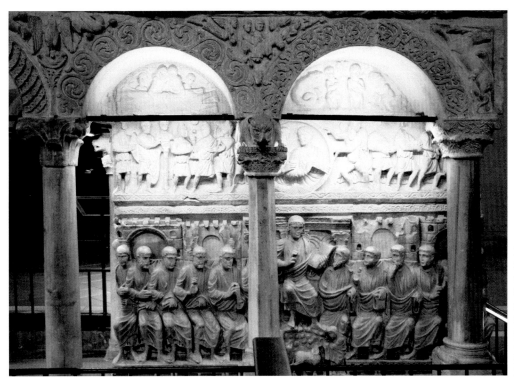

Plate 7.2 Sarcophagus
showing Christ among the
Apostles, Basilica di
Sant'Ambrogio, Milan, last
quarter of the 4th century CE,
marble. Top left: Adoration
of the sculpture of
Nebuchadnezzar; top right:
Adoration of the Magi.
Image: Wikimedia Commons

Plate 7.3 Christ among the Apostles, 401–17 CE, mosaic, Basilica di Santa Pudenziana, Rome. Image: I. Foletti

seem to have inspired other images of Christ in Rome around the year 400, as we will see below. This resemblance cannot, we think, be the result of the accidents of how workshops made images. Contemporary Roman viewers must have been able to recognise the pagan god in the face at Santa Pudenziana.[15] In addition, Serapis was not exactly popular among Christian authors.[16] Ivan Foletti has recently tried to explain this situation as the context for the destruction of the Serapeum in Alexandria in 391.[17] According to contemporary authors – Socrates, Theodoretus and Sozomenos – the destruction of the statue of the pagan god was followed by numerous conversions of his adherents to the Christian faith.[18] This event was allegedly caused by the appearance, on the walls of the

Plate 7.4 Fragment of a funerary relief, 4th century CE, marble, w. 113cm, h. 92cm. Palazzo Massimo alle Terme, Museo Nazionale Romano, Rome, inv. 67607. Image: Deutsches Archäologisches Institut, Abteilung Rom, D-DAI-ROM-1957.0073 (Sansaini)

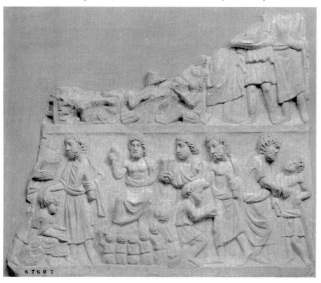

ancient Serapeum, of the hieroglyph ANKH, which has the shape of a cross. Interpreted by the Egyptians as a prophecy – the meaning of ANKH is 'the word which has to come' – this appearance was explained by some pagans as a sign of shared identity between Serapis and Christ.[19]

Even if this hypothesis was rejected by all the Christian authors of the period, a very strange relationship between Christ and Serapis is perceptible in the literature of the time.[20] The position of St Jerome, as expressed in one of his famous letters from the year 403, is a good example. Describing the end of pagan worship, Jerome writes: 'Even the Egyptian Serapis converted to Christianity.'[21] In using this metaphor, he means, of course, that Egypt was converted. However, identifying Egypt with Serapis creates a mental space in which a pagan god can convert. This paradox is also present in the words of Augustine, who, in the same decades, presents Serapis (often seen as one of the worst enemies of Christ) as a demon who nevertheless was capable of announcing the coming of Christ.[22] In this context, Christ with the face of Serapis has to be explained as a kind of ecumenical gesture. Christ is taking in Serapis in every respect, including Serapis' own face. In other words, Christ accepts pagans who wish to convert. This sponge-like capacity of Christ to integrate the charisms and believers of other gods is also visible, for example, in Christ's appropriation of the face and body of father gods such as Asclepios at the beginning of the 4th century. In the sepulchral relief in the Palazzo Massimo alle Terme (**Pl 7.4**), Christ performs miracles in the likeness of Asclepios. Matthews saw the appropriation of the pagan god's features as a sign of rivalry, understandable at the very beginning of the 4th century. However, since it was created after the Edict of Theodosius and the massive conversions around the turn of the century, the Christ-Serapis in Santa Pudenziana must be seen as a sign of Christian victory and, possibly, unity.

St Jerome describes another (and completely different) way in which faces were appropriated.[23] Writing about what happens after rulers are dethroned, he says that, in the process of *damnatio memoriae*, their faces were destroyed and replaced in their sculptures by those of their successors.[24] This is also the case in the famous mosaic portrait of the emperor Justinian in the Basilica of Sant'Apollinare Nuovo in Ravenna (**Pl. 7.5**).[25] As convincingly demonstrated by Maria Andaloro, this portrait was originally one of King Theodoric.[26] After his death, Ravenna was conquered, and the memory of the king became the object of a particularly violent *damnatio memoriae*.[27] His body was cut into four parts, which were sent to the four corners of the empire. The Basilica of Sant'Apollinare, built and decorated by that king, was heavily restored in order to remove all traces of Theodoric. However, some details were left as a reminder of his downfall. In the representation of his imperial palace, where the ruler and his family had originally been represented in the posture of *orantes*, a pair of hands stuck onto the columns were left to remind every viewer that the images of those bodies had been replaced (see Settis, this volume, p. 13).[28] In this very context, another portrait of Theodoric, today placed on the western wall, was not destroyed, but his name was replaced by Justinian's.[29] This theft of Theodoric's features must have had an explicit

meaning: Justinian's victory was total and he could steal the face of his enemy, demonstrating his power even over the memory of the dethroned Ostrogothic king.

In the late antique world, we can therefore identify three important procedures for the migration of faces. The first is a violent humiliation of the losers by the winners through appropriation. The second, in contrast, is an ecumenical movement where the use of another face symbolises one community being integrated into another. The third seems to be more pedagogical: God assumes the face of rulers in order to serve as a good example for them to follow.

The return of the enigmatic bearded face: the 'Standing Caliph'

Almost 300 years after the image of Christ created in Santa Pudenziana, which by then had become one of the dominant types of representations of the Lord, the enigmatic bearded face with long hair returned. This time it is attested on an early Islamic gold coin, a dinar minted by 'Abd al-Malik, the fifth caliph of the Umayyad dynasty (685–705), between 693/4 and 696/7 (**Pls 7.6–7.7**). Only a few examples of this coin – which was probably struck in Damascus, the capital of the Umayyad empire – are known today.[30] On its obverse, it carries one of the rare Umayyad attempts to create an individual iconography on coins before introducing aniconic money (which then became the Islamic standard for centuries). On the reverse is a staff on steps, modelled after the cross-on-steps motif on Byzantine coins, which can be read as a statement against both the Byzantine empire and the divinity of Christ. It is surrounded by an Arabic legend giving the date of the coin. The obverse shows a standing male figure in frontal view, surrounded by the Arabic *shahāda*, the Islamic creed, in the legend. The man is dressed in a long garment and with his right hand he holds a sword, still in its scabbard and placed diagonally in front of his body. Apart from the prominent sword, the focus of the image on this small coin is on the figure's face, disproportionately large in relation to the body. It is characterised by large eyes under a pronounced brow, a long beard and long flowing hair which falls onto the man's shoulders, just like the long hair of Serapis-Christ in Santa Pudenziana in Rome and in subsequent images of Christ.[31] Because there were copper coins minted in various provinces of the Middle East which show the same standing figure, labelled with the name 'Abd al-Malik and his caliphal title 'commander of the faithful' (*āmīr al-mū'minīn*), the image on the gold dinars has been interpreted as a portrait of the reigning caliph.[32]

André Grabar, Jaś Elsner and others have linked this dinar to a contemporary *solidus* of Justinian II (r. 685–95 and 705–11), probably issued between 690 and 695 (**Pl. 7.8**).[33] For the first time in Roman-Byzantine coinage, this *solidus* bore an image of Christ, whose bust took the place of the emperor's portrait on the obverse. Dressed in the Greek garments of *chiton* (tunic) and *himation* (mantle) wrapped tightly around his shoulders, Christ makes a gesture of oration with his right hand, while he holds a codex in his left. He is depicted with a long beard, though not quite as long as the caliph's on the dinars, and long hair parted in the middle and falling behind his neck. The bars of the cross are visible

Plate 7.5 Mosaic of the emperor Justinian. 561. Basilica of Sant'Apollinare Nuovo, Ravenna. Image: Wikimedia Commons

behind his head. This image is labelled as *rex regnatium* ('king of those who rule') in the legend.

The portrait of the emperor is relocated to the reverse of the coin. It is a full-figure standing portrait of Justinian, who holds onto a cross-on-steps with his right hand. He is wearing an embroidered toga with a *loros*, a narrow embroidered scarf, wrapped around his left arm. In contrast to Christ on the obverse and the caliph on the dinars, his hair and beard are short. In the legend, he bears the rare title of *servus Christi* ('slave of Christ'), referring directly to the image on the coin's other side.

Scholars have seen a connection between the figures of Justinian II on this *solidus* and 'Abd al-Malik on the dinars. On the one hand, Justinian's rare title *servus Christi* has been interpreted as a deliberate reaction to 'Abd al-Malik's name, which means 'slave of the king', the king being God.[34] On the other hand, a similarity has been noted between the silhouettes of the two figures, with the caliph's sword reminding us of the emperor's protruding *loros*.[35] Yet this comparison is not really convincing, as we shall see shortly. The emperor's very different beard and hairstyle on the *solidus* is further evidence that his figure was not the model for the 'standing caliph' on the dinar. What is much more striking is the parallel between the portrait of Christ on the obverse and the caliph's face, in combination with the coins' legends.[36]

Christ's title, *rex regnatium*, king of all rulers on earth, is a peculiar parallel to Umayyad royal representation, which perhaps was not intended. It recalls the Sasanian king's official title as *shāhanshāh* or 'king of kings'. At the time of

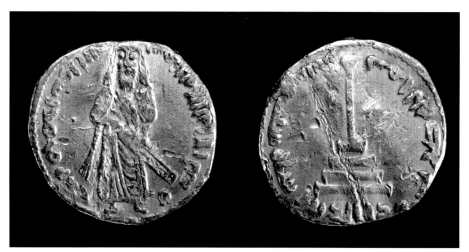

Plate 7.6 'Standing caliph' gold dinar, obverse and reverse, 695, weight 4.03 g, d. 18mm. British Museum, London, 1954,1011.2

Plate 7.7 Detail of Plate 7.6, showing the caliph's face

Justinian II, the Sasanian king had already been defeated by the Muslim Arabs, and his empire had subsequently been incorporated into the caliphate. The Umayyad caliphs were thus his successors and appropriated his place in the late antique world. That they perceived themselves as the Sasanian king's heirs becomes evident from their visual representation. An example is provided by the wings in the mosaics of the Dome of the Rock (started or completed 691/2), whose patron was also 'Abd al-Malik, the caliph who issued the 'standing caliph' dinars. The wings recall Sasanian royal insignia, especially since the crowns of most of the late Sasanian kings were adorned with a pair of wings. Traditionally, following a hypothesis first offered by Oleg Grabar, the wings together with Byzantine crowns and jewels in the Dome of the Rock's interior decoration have been interpreted as symbols of Islam's triumphs over its unbelieving enemies.[37] Yet the juxtaposition of Byzantine and Sasanian iconographic motifs may also be read as an appropriation of Sasanian and Greco-Roman-Byzantine history and sovereignty into the Islamic empire, which, for the first time in history, united former Byzantine territories and the Sasanian realm.

Further examples emphasise the caliph's role as successor to the Sasanian king: on the façade of the 'desert castle' Qasr al-Hayr al-Gharbi near Palmyra, an almost life-size stucco figure in the guise of the Sasanian king of kings presumably represented the palace's patron, the caliph Hishām (r. 724–

43). In addition, the concept of the 'king of kings' is illustrated in the small bathhouse of Qusayr 'Amra, east of the modern Jordanian capital of Amman, which was erected around the same time as Qasr al-Hayr al-Gharbi under the reign of the same Hishām.[38] In the large vestibule, thought to have been used as an audience hall, one of the frescoes covering the building's interior walls and ceilings shows six sovereigns of the late antique world. Labelled by bilingual inscriptions in Greek and Arabic, four of which are preserved, and distinguished by their diverse headgear, they can be identified as Kaisar (the Byzantine emperor), Khosro (the Sasanian king), Roderic (the king of the Visigoths defeated by the Umayyads) and the Negus (the Ethiopian king).[39] They are paying homage to the caliph and his heir apparent, al-Walid b. Yazid, both of whom are depicted – assuming the identification of the images is correct – in a dominant position on the rear wall of the room. The foreign sovereigns are expressing their respect to the caliph and his designated successor by stretching out their open right hands, a gesture which is familiar from imperial Roman *clementia* scenes where barbarians submit to the emperor.[40]

In Arab literature, the universalist ideal of the 'king of kings' is attested from the very beginning of Islam. According to Ibn Ishāq's (*c.* 704–67) biography of Muḥammad, the Prophet wrote letters to eight sovereigns of his time – the Byzantine emperor Heraclius; the Sasanian king Khosro II; the rulers of Yemen, Bahrain and Oman;

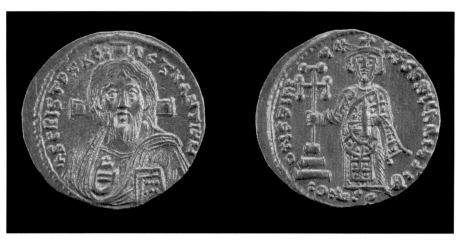

Plate 7.8 Gold *solidus* of Justinian II, obverse and reverse, 690–5, weight 4.35 g, d. 19mm. British Museum, London, 1852,0903.23

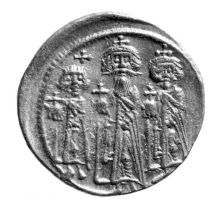
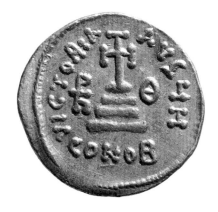

Plate 7.9 Gold *solidus* of Heraclius with Constantine III and Heraclonas, 635–6, weight 4.42g, d. 19.5mm. Kunsthistorisches Museum, Vienna, inv. MK 204497. Image: Kunsthistorisches Museum, Wien

the phylarch of the Arab Ghassanids; the Ethiopian Negus; and the Muqawqis, the patriarch of Alexandria – wishing to convince them to convert to Islam.[41] In the light of several anachronistic historical and linguistic details, the recorded letters are usually considered fakes and were probably drafted in the Umayyad period.[42] They thus attest to the Umayyads' universalist royal ambitions.

Was this universalist ideal the caliph's motivation for appropriating the facial features of Christ on his dinars, to deliberately take his place as *rex regnantium*, ruler over all worldly kings? This would fit with the Umayyad opposition to the divinity of Christ, made clear by the omission or alteration of the crosses on the Umayyad coins, as well as in the pious Arabic inscriptions on the walls inside the Dome of the Rock which focus on denying Christ's divinity.[43] Against this backdrop, the appropriation of Christ's face could be read as a triumphal gesture. The predominantly Christian population of Syria-Palestine was familiar with the image of Christ and may have recognised his face on the new caliphal coins.[44] In addition, images of Christ continued to exist in the early Islamic caliphate. In Syria-Palestine, mosaics and frescoes on the walls and domes of churches, where the Son of God would have been depicted, have unfortunately not survived.[45] A bust of Christ, however, painted in the 6th or 7th century, is preserved in the semi-dome of the south lobe of the Red Monastery Church near Sohag in Egypt.[46] Post-Umayyad sources even record that there was a picture of Mary with the baby Jesus in the Kaaba in Mecca which Muhammed himself ordered to be spared when he had the images of pagan gods removed from the traditional Arab sanctuary.[47]

What was it, exactly, that 'Abd al-Malik wanted to appropriate for his royal representation? The facial features of Christ? Or was it simply the enigmatic bearded face associated with experience, wisdom and authority? The contemporary Byzantine emperors wore beards – if we can believe the way they are depicted on their coins – but these Byzantine beards were not as long as the caliph's on the dinars.[48] In the Sasanian realm, the beard even formed a part of the king's royal insignia, as no one could have a beard longer than the king.[49] Consequently, the Sasanian king – not only in his images on coins, but also in his Umayyad portrait in the fresco of the six kings in Qusayr 'Amra – is always depicted with a beard. In Sasanian iconography, the king's beard was matched by long hair falling onto his shoulders, carefully styled in voluminous

locks and not as free-flowing as the caliph's hair on the dinars or Christ's hair in Santa Pudenziana. Thus, while the inspiration for this 'face of power' might have been the Sasanian *shāhanshāh*, the actual model for the image must have been a different one.

In Umayyad late antiquity, as in the Christian world of the 4th to 6th centuries, we can detect several possible motivations for the migration of a face. The first, as we have seen before, may have been to extol the triumph of a new religion over a previous one. But could this, too, be read as an ecumenical gesture, the caliph thus not competing with, but embracing the believers of the old faith into the new empire and its new religion by appropriating the face of their Son of God (which according to Islamic belief did not exist in this divine form)? And finally, there is the aspect of power associated with the bearded face, which was already present in the pagan father gods.

The body

Imperial models

Like the face, the 'standing caliph's' body relies heavily on older models. As remarked above, the silhouette of the standing caliph on the coins is slightly reminiscent of the figure of Justinian II on the contemporary *solidi*, with the protruding sword corresponding to the *loros*. If we take a closer look at the caliph's costume, we see that the caliph is not dressed in the Byzantine embroidered toga costume with the *loros* as worn by Justinian. And yet, he is not wearing an individual garment either. Instead, the caliph's body more closely imitates an earlier figure-type used for the Byzantine emperor on *solidi* depicting Heraclius (r. 610–41) with his two sons Constantine III and Heraclonas (**Pl. 7.9**).[50] On these gold coins, the emperor and his sons are depicted in three-quarter view, standing in contrapposto, the weight placed on the right leg while the left leg is advanced. All three figures are dressed in a long tunic under an open *chlamys* (cloak) fastened at the right shoulder. The diagonal folds on the caliph's chest correspond to the part of the *chlamys* covering the left shoulder, while the parallel folds on the bottom part of the garment above his left leg match the folds created on the tunics by the advanced left legs of the emperors, even though the caliph seems to be standing equally on both legs. The back hem of the *chlamys* was misinterpreted as an ornamental trimming by the creators of the Umayyad dinar. It therefore seems that this is the Byzantine figure-type that

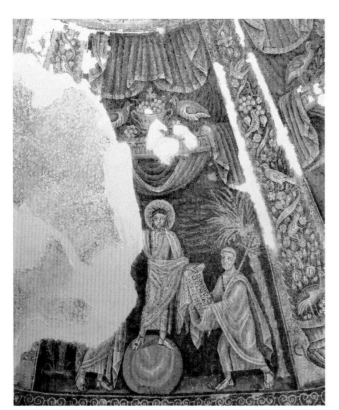

Plate 7.10 Mosaic showing standing Christ, Baptistery of San Giovanni, Naples, 357–400 CE. Image: Domenico Ventura

coins, following the Sasanian traditions of the eastern part of the Umayyad empire. However, unlike the busts of the Sasanian king regularly depicted on pre-Islamic silver coins from the Sasanian empire, this bust includes both arms holding a sword. Like the standing caliph's sword, the sword on this *dirham* is still in its scabbard, which is decorated with the same wavy scroll as on the dinars or the *follis* of Heraclius. The sword was part of the royal representation of both the Byzantine emperor – as we have seen – and the Sasanian king, who is frequently depicted with a sword on rock reliefs and precious silver vessels.[54] In late antique south Arabia, the sword is also attested on a relief from the Himyarite capital of Zafar interpreted as a king of the 5th or early 6th century CE.[55] Here, the sword has again been added to an image where it originally did not belong. The figure is clearly derived from depictions of east Roman consuls – who did not carry a weapon – sitting on their characteristic folding chair, the *sella curulis*.[56] On this south Arabian relief, as on the Umayyad coins, the sword can thus be interpreted as part of the royal insignia.

It is clear that the iconography of the 'standing caliph' was not derived from the standing figure of Justinian II on his famous *solidus*. Instead, the figure integrates various models and their relevant connotations: the face, which may well have been inspired by the image of Christ on the obverse of Justinian's *solidus*; as well as the body and the sword recalling imperial models.

The standing cosmocrator: a Mediterranean concept?

There may have, however, been another source of inspiration for the 'standing caliph': the figure of Christ as the standing *cosmocrator* (ruler of the world), a type that was especially common and thus influential in the eastern part of the late antique world. The standing Christ, with his right arm raised and a scroll in his left hand, in the urban Roman context surrounded by Peter and Paul, appears during the second half of the 4th century – an original image in the Christian world documented for the first time on the funerary slab of Anagni and, perhaps, in the primitive decoration of St Peter's in the Vatican, both monuments rather imprecisely dated.[57] This composition has been called the *traditio legis* ('transmission of the law'), based on the inscription DOMINUS LEGEM DAT ('the Lord gives the law') on the scroll held by Christ in the baptistery of Naples, the oldest preserved monumental depiction of this iconography (**Pl. 7.10**).[58] It is one of the oldest compositions known in the Christian world that has no relation to the Gospels. Moreover, given the fact that many researchers are convinced that this composition once adorned the ancient apse of St Peter, the subject has been much studied over the years.[59] Early on, a conflict emerged between Catholic scholars, who saw in this iconography a visualisation of the Petrine primacy, and Protestant scholars, who instead saw it as a celebration of both Apostles.[60] The latter hypothesis seems more plausible, especially considering the fact that Peter is on the left of Christ. What is more, the gesture of handing down an open scroll – a gesture which has often been read over the years as the giving of the law to Peter – is actually very difficult to understand: in the ancient world, the left hand was considered impure and certainly would not

served as a model for the caliph's portrait, but that the drapery of the garment depicted was not understood, making it clear that this was not a garment actually worn by the caliph. The *solidus* of Heraclius and his two sons circulated in the Umayyad empire and seems to have been quite influential, since it had been imitated in the earliest Umayyad gold coinage even before the creation of the 'standing caliph' dinar.[51]

The one thing without a parallel on either Heraclius' or Justinian's *solidus* is the caliph's sword. This attribute is attested on other Byzantine coins, though, especially on a very rare copper *follis* minted in Thessaloniki and Constantinople in the year 629/30.[52] On the obverse, next to Constantine III (portrayed with an open *chlamys* like Heraclius and his sons on the abovementioned *solidus*), Heraclius is depicted in a short military dress with, over his left shoulder, a *paludamentum* (military cloak). In his right hand he is holding a lance, while his left hand clutches a sword. This sword is still in its scabbard, which is decorated with the same wavy scroll as the caliph's scabbard on the dinar. Just as on the Umayyad coins, the sword diagonally protrudes from the standing figure's silhouette. Since this *follis* was very rare, 'Abd al-Malik or his die-carver may not have seen it, but the figure-type may have circulated in other media that could have served as models, such as illuminated manuscripts.

The sword was obviously important, not only because it is rather large in relation to the figure's body, but also because it was added to an iconographic model to which it originally did not belong. In addition, it finds a parallel on 'Abd al-Malik's silver *dirhams* of the *'miḥrāb* and *'anaza*' type that bear a Sasanian-style bust on the obverse which is most likely a portrait of the caliph.[53] These *dirhams* were an equivalent attempt to create an individual caliphal iconography on

have been suitable for passing down the law.[61] It is no coincidence that when Christ is seen giving the keys to Peter on a sarcophagus now kept in Avignon, he does it with his right hand, even though the Apostle is on his left.[62]

In order to explain this composition, we must first acknowledge the fact that – as was indicated by L'Orange in 1982 – Christ standing with his arm raised could indeed be read as a representation of divine authority.[63] Among the examples mentioned by L'Orange, there are various ancient gods, some imperial images imitating divine patterns and also the figure of Serapis (**Pl. 7.11**). We have seen above how, in Rome after 391, the image of Christ seems to overlap with that of Serapis. This moment is also the conclusion of a process begun in 380 by Theodosius I, who made Christianity the state religion.[64] During the same period, in Milan, the *sedes imperii* (seat of power) of the west, there was a sharp conflict between Arian members of the imperial court and the Nicene Bishop Ambrose; the question was only solved in the summer of 386.[65]

In 2004 Jean-Michel Spieser suggested (and reaffirmed in 2015) that the standing figure of Christ with the raised arm may have been read as visual evidence of his divine nature, and that the figure should therefore be understood as a visual reaction to Arianism.[66] The decision to represent Christ on his feet could have been an attempt to dissociate him from previous patterns where he was depicted sitting down and with the features of a (human) philosopher.[67] L'Orange, too, saw the standing Christ with raised arm as a much more explicit reference to the *cosmocrator* than any enthroned Christ could be. Once again, Serapis could be one of the possible models; if he was, this would make it even more likely that the standing Christ was supposed to be seen as *cosmocrator*. Can the development and the diffusion of this iconography be understood in the context of the progressive victory of the Nicene party as a kind of orthodox manifesto? In the Edict of Thessalonica of 380, in which Theodosius proclaimed Christianity as state religion, the emperor had already shown his inclination towards Nicene orthodoxy.[68] This position would then be confirmed at the Council of Constantinople convoked the following year. There Theodosius anathematised all heresies, including Arianism.[69] Giving Christ not only the face of Serapis but, in some cases, even the posture of the *cosmocrator* god could therefore have had a double effect: Christ's divine nature was emphasised, as was his encompassment of vanquished rivals.

Given the state of conservation of these various monuments, as well as the impossibility of accurately dating most of them, we must be realistic and admit that much of the above remains speculation. The only monumental building of those years still decorated with the so-called *traditio* and in a good state of preservation is the baptistery of Naples, whose dating to the years of Severus (357–400), and more precisely to the last years of the century, now seems relatively secure.[70] But, in addition to the evidence from that building, Ivan Foletti and Irene Quadri have reconstructed similar decor for the apse of the Basilica Ambrosiana in Milan (after 386), with Peter and Paul replaced by the martyrs Gervasio and Protasio.[71] The hypothetical presence of Simpliciano, Bishop of Milan, in the same decoration

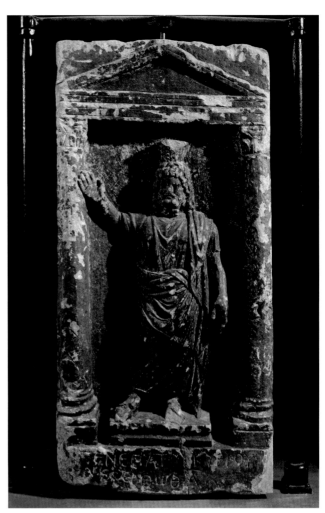

Plate 7.11 Back of a *stele* with the figure of Serapis, from an Alexandrian necropolis, Ptolemaic period, sandstone, h. 80cm. Egyptian Museum, Turin. Image: © 2020 DeAgostini Picture Library/ Scala, Florence

would put the conclusion of the work within the years of the latter's episcopate, namely 397–401.[72] Even more recently, Serena Romano has proposed that, at the end of the papacy of Damasus (366–84), the Vatican basilica underwent an important restoration in the possible addition of a narrative cycle in the nave, perhaps (we can add) following the decoration of the apse.[73] Thus, it would seem that it was between the mid-380s and the year 400 that the first and fundamental examples of the iconography of the standing Christ appeared. This would make sense both in the context of the struggle against the Arian heresy – the standing position and the raised arm are the indicators of the fact that Christ is *cosmocrator* and has the same substance as the Father – and as part of the promotion of a triumphant, universal Christianity.

To give further support to what has been formulated here, another element has to be mentioned: the decoration of the two apses in the mausoleum of Constantina (**Pls 7.12 –7.13**).[74] Generally dated to the 370s, they contain two different images of Christ: one seated on the globe and with a face very similar to that of Santa Pudenziana, the other standing with his right arm raised, between Peter and Paul. Both mosaics have been damaged by modern restorations; in particular, the face of the standing Christ has been completely ruined.[75] Moreover, the commonly accepted

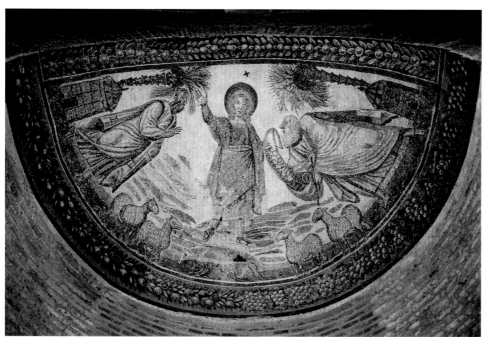

Plate 7.12 Mosaic showing standing Christ, Mausoleum of Santa Costanza, Rome, last quarter of the 4th century CE. Image: I. Foletti

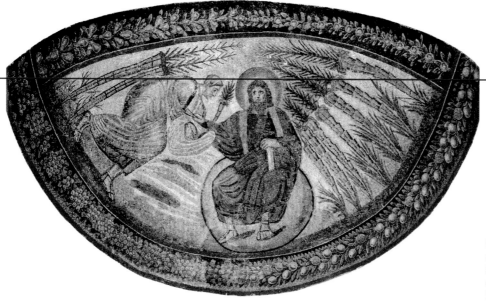

Plate 7.13 Mosaic of Christ *cosmocrator*, Mausoleum of Santa Costanza, Rome, last quarter of the 4th century CE. Image: I. Foletti

dating of the images to the 370s has no secure historical basis. Nevertheless, it seems plausible to assume that the standing Christ was originally beardless, just as he is today. In light of what Augustine wrote at about that same time (see above), the existence of two images of Christ with different faces, side by side, poses no particular problem. Spieser has suggested that giving Christ two different faces, directly across from each other, could have been a way to show that his face could not possibly be revealed in one image.[76]

It is probably no coincidence that we find something very similar on the sarcophagus of Sant'Ambrogio in Milan: on one prominent side is a seated Christ, on the other is a standing Christ; one has a beard, the other does not (**Pls 7.2, 7.14**).[77] The only difference from Santa Costanza lies in whether the seated or standing Christ has the beard. This sarcophagus has been dated to the end of the 380s and has been convincingly linked to the anti-Arian Milanese party.[78] The images at Santa Costanza, like those on this

sarcophagus, seem to fit the context we are describing: in Milan, the seated Christ could represent his human (philosophical and traditional) side. The standing figure with beard and raised arm, on the other hand, represents the *cosmocrator*, a perfectly divine Christ. In Rome, the situation is more complex, since it is the bearded Christ who is sitting on the cosmos, while the standing one is beardless. But both figures, in different ways, insist on Christ's divinity: one follows the solution conceived after the middle of the century, the other embodies a more modern fashion. This coexistence seems to be absolutely natural and logical within the Roman context, which was always very traditionalist while still open to novelty. As mentioned above, the mosaics at Santa Costanza have not been dated with precision and, considering their poor state of preservation, it is difficult to pin them down to any particular decade. If we admit that these mosaics could be from the same period as the Milanese sarcophagus – that is, after 380 – it might just be possible

that all four images reflect the Edict of Thessalonica. Had the image of the standing Christ become a way to emphasise his divine nature, as well as his (inclusive) victory over all his rivals?[79]

We must continue our story a bit further in time and space in order to complete this panorama. In the west, except for Rome, the standing Christ seems to disappear during the 5th century. In the east, however, the situation is different: we find the image on the reliquary of Thessalonica, dated to the end of the 4th century, and then maybe in Syria and Palestine, hidden in the miniatures of the Rabbula Gospels, which were probably painted in the mid-6th century.[80] What is fascinating, however, is that the composition reappears, between 620 and 670, in both Tsromi (in present-day Georgia) and in Arukhavank and Mren in historical Armenia (**Pl. 7.15**).[81] There is no space here to give a complex explanation of this phenomenon. We know, though, that one of the main sources for the art of the Caucasus was that of Syria and Palestine, where the Rabbula Gospels attest to the presence of the standing figure of Christ in the mid-6th century.[82] In fact, the presence of this almost identical iconography in Rome, Milan, Thessalonica, Syria and the Caucasus, and even the same biblical quotations on the scrolls held by Christ in Rome and Georgia, indicates that we might be dealing with a more global phenomenon.[83]

This particularly prestigious composition, as demonstrated above, depicts Christ's divinity and power. Since it recalled the antique gods, as well as the face of Serapis, it may have been conceived as a visual reaction to struggles against Arianism and the victory of the Nicene Creed. This would explain the spread of the standing Christ, probably in the years of Theodosius, throughout the Mediterranean. Its existence in the Caucasus confirms the breadth of this diffusion, its endurance over time and its effectiveness. The surviving eastern examples have long hair and a beard (Tsromi and Rabbula), so this may have been the standard form for the standing Christ in those regions.

Before the arrival of the caliphate, then, a very significant and incisive image of the Christian God was widespread throughout the Christian world and especially in Syria, where it was present in illuminated manuscripts, a class of artefacts that was especially influential in the dissemination of visual patterns. It is this standing Christ which seems to pre-figure the 'standing caliph' on 'Abd al-Malik's dinars. Although the correspondence is not exact (the caliph lacks the raised arm), this scheme of a standing figure in frontal view, especially with a bearded face recalling Christ (as on the *solidi* of Justinian II), was familiar in Syria-Palestine through these images of Christ. The standing bearded figure was therefore a powerful image for both heavenly and earthly rulers. Its familiarity meant that it was immediately understood as authoritative by the beholders, whether they knew about the exact development and origins of the motif or not.

Creating authority: some concluding remarks

In this essay, we have explored how and why images of faces and bodies were appropriated to create authority in the late antique world. The motivations were as diverse as the

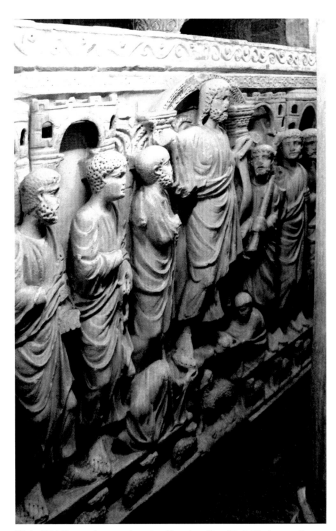

Plate 7.14 Sarcophagus showing the standing Christ between the Apostles, Basilica of Sant'Ambrogio, Milan, last quarter of the 4th century, marble. Image: Wikimedia Commons

contexts in which these images were used. Christ taking the face of the pagan god Serapis in Santa Pudenziana in Rome in the early 5th century, or the Umayyad caliph taking the face of Christ for his coins in the late 7th century, may represent a triumphal demonstration of power while at the same time being an ecumenical gesture of embracing former enemies and unbelievers into the new community. Christ in the guise of the Arian emperor on the box of San Nazaro is a pedagogical replacement of a bad emperor with the good

Plate 7.15 Mosaic showing standing Christ, Basilica of Tsromi, Tsromi, 626–34. Image: drawing from Smirnov 1935

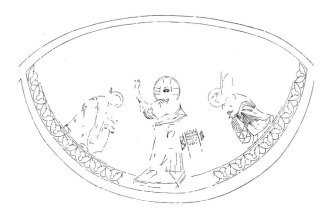

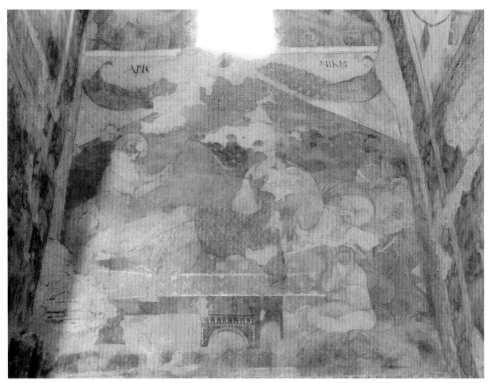

Plate 7.16 Fresco of reclining heir apparent, 'audience hall', Qusayr 'Amra, Jordan, 724–43. Image: K. Meinecke

Lord, while in *damnatio memoriae* a bad ruler was directly replaced by his successor. In all these cases, standing and seated figures allude to heavenly as well as earthly sovereigns, and thus their appropriation has to be read as an attempt to create and declare authority.

While the focus of this essay so far has been on the bearded face and the standing figure, the mechanisms outlined above for appropriating images from the past in order to create authority operated for other figural representational schemes as well. The motivation behind the choice of these images may have been slightly different, though, as we shall show with one last example: the reclining man on the rear wall of Qusayr 'Amra's audience hall (**Pl. 7.16**), to the left of the 'family of kings' discussed above. This man is probably the heir apparent, al-Walid b. Yazid, later caliph Walid II (r. 743–4).[84] In this image, authority was created through the appropriation of a motif from the distant past that linked the Umayyad ruler to a legendary and prestigious Arab history within the territory of their caliphate.

The prince reclines on a *kline* (couch) with a lavishly decorated mattress. Recent restorations have revealed that he has a short beard. He is dressed in light blue baggy trousers, a light blue shirt with wide sleeves, and a red-brown cloak. His legs are stretched out side by side on the bed, while his upper body is upright, and he leans on a large cushion with his left elbow. In his right hand, he is holding a long, thin stick that may have had an attachment on the end where the fresco is now damaged. This young man is surrounded by his entourage: a servant stands behind the bed, waving a fan made out of peacock feathers; an old scribe writes from left to right on an open scroll as he stands at the head of the *kline*; and two individuals sit cross-legged on cushions in front of the *kline*.

A man lying on a *kline* is a well-known image commonly used for banquet scenes, which originated in Phoenicia and were widely diffused in Greco-Roman visual culture from

the 6th century BCE onwards.[85] Obviously derived from Hellenistic depictions, the scene is sometimes also found in the Persian realm, where it was used to represent a dining individual.[86] In the case of the heir apparent at Qusayr 'Amra, there is no evidence of a banquet, since the reclining prince is not holding a drinking vessel as characteristic of this iconography, nor is there a table with food or an assistant serving wine anywhere to be seen in the image.

The best parallels for the image at Qusayr 'Amra are from Palmyra, where the motif of the reclining banqueter was very common in funerary sculptures from the 1st to the 3rd centuries CE. Funerary reliefs and sarcophagus lids usually show the male head of the family lying on the *kline*, holding a drinking cup and surrounded by his relatives.[87] Characteristic for the Palmyrene images is Parthian dress for the deceased, including the same baggy trousers that the heir apparent at Qusayr 'Amra is wearing. In some examples, the diner is also dressed in a *himation* over his trousers, similar to the Umayyad figure discussed here. Even the features of the figure's posture that seem to vary from the standard Hellenistic iconography of the banqueter, such as the parallel outstretched legs, or the right arm held in front of the body, find parallels in Palmyra (**Pl. 7.17**).[88]

That the Umayyads were familiar with Palmyrene funerary sculpture is obvious from the 'desert castle' of Qasr al-Hayr al-Gharbi, where the abovementioned stucco statue of the caliph in Sasanian guise was found. In the stucco decoration on the palace facade, a partially preserved group shows two figures, one reclining, the other (clearly a woman) sitting at her partner's feet. The posture and position of the seated woman differ from most of the Greco-Roman banquet scenes, but are characteristic of Palmyrene sculpture, revealing the group's models.[89] Qasr al-Hayr al-Gharbi is only about 60km away from Palmyra, but Qusayr 'Amra is about 500km away. The appropriation of

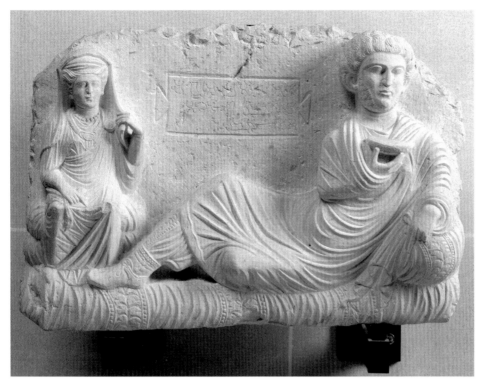

Plate 7.17 Funerary relief of Taimé and his wife, Hadira, from Palmyra, 1st half of the 3rd century CE, limestone, h. 43cm, w. 63cm, d. 18cm. Musée du Louvre, Paris, inv. AO 2093. Image: RMN-Grand Palais (Musée du Louvre)/Franck Raux

Palmyrene motifs cannot, it seems, be explained by the proximity of the site alone.

Palmyrene sculptures were appreciated in early Islamic times, as is attested in literary sources from the Abbasid period onwards. A sculptural group in Palmyra showing two women embracing each other like lovers, seemingly unmarked by time, even became a literary *topos*. Arabic authors of the 9th and 10th centuries, as well as Yaqut's topographical dictionary (late 12th/early 13th century), record a poem which an Arab tribal leader from Khurasan is said to have written when he passed through Palmyra and which he later recited for the Umayyad caliph Yazid I (r. 680–3); many others who saw the group are said to have done the same.[90] One reason why Palmyra and its sculptures were beloved may have been the fact that the city had been the capital of a celebrated Arab kingdom. Its queen Zenobia was praised in pre-Islamic Arabic poetry from the 6th century.[91] By appropriating the Palmyrene images, the Umayyads appropriated this legendary Arab past from a part of their territory and made it their own. It could well be that they deliberately appropriated the reclining figure as a Palmyrene motif, as an allusion to the glorious Arab history of the Umayyad heartland.

Small alterations reveal that the original model of the banqueter was transformed into an image of power for the portrait of the heir apparent. Through the addition of the scribe at the head of the *kline* (which has no parallel in Palmyrene funerary sculpture) and the omission of the drinking cup, the banqueter of the Hellenistic models has been converted into a respectable statesman. In the resulting image, there is no trace of the 'partying playboy', as later Abbasid sources and modern scholarship portray Walid (although the Palmyrene model would have been ideal for this characterisation).[92]

Finally, the *kline* might also have been perceived as an allusion to the *kline*-shaped throne of the Sasanian king.

This throne is depicted, for example, on the abovementioned silver dishes and rock reliefs depicting the enthroned Sasanian sovereign.[93] The figure of the reclining heir apparent would thus unite two images of power. On the one hand, it refers to the Palmyrene funerary relief, in itself an image of the head of the family and the tomb owner and an allusion to the glorious Arab history of that region. On the other hand, it alludes to the Sasanian king, whose successors the Umayyad caliphs perceived themselves to be. Just as was the case when Christ took on the face of the pagan god Serapis, authority and legitimisation are derived from images appropriated from a distant, yet still visible past, in this context perhaps combined with a more recent and still vital tradition from the east of the Umayyad territory.

The examples discussed in this essay show that, when a face migrated, the task was undertaken for reasons that varied depending on the historical circumstances. The way in which the new face was interpreted also differed according to the context. There were no obvious boundaries restricting the choice of models. But while these three things – the motive, the new interpretation and the choice of models – varied and were linked to the exact moment of migration, they also reflect several anthropological constants; not surprisingly, similar processes can be observed in the tribal use of masks in different cultures and continents.[94] Many of the appropriated images were authoritative in themselves: the experienced bearded man, the enthroned sovereign, the standing frontal figure. These may be understood by the late antique and post-Roman beholder as images of power, even without knowledge of the actual models, although they are often clearly discernible. The exact interpretation of the authoritative images thus may have differed between those familiar with the motif's history and those who were not.

Notes

1 Belting 1990: 148–59; Mathews 2003: 118–38; Bacci 2014: 97–196; Spieser 2015: 399–479.

2 Augustine, *De consensu evangelistarum* 1.10.16 in Weihrich 1904: 15–16; Augustine, *De Trinitate* 8.4.7, 8.5.7 in Agaësse 1995: 40–1. On Augustine's perception of the Christ face, see Spieser 2007.

3 Belting 1990: 185–95; Antonova 2016: 63–102; Belting 2016.

4 Spieser 2015: 27–98.

5 A. Grabar 1936: 207–9; Mathews 2003: 100–14.

6 Andaloro 2006b.

7 Lidova 2015 and 2017.

8 Belting 2013.

9 Sena Chiesa 2009.

10 For the political meaning see Foletti 2016, 76–84, for the dating of the events see Ambrose, Epistula 77, 1–2, in Banterle 1988, 154–5, for the events see San Bernardino 1998. For the figure of Ambrose see, for example, McLynn 1994.

11 Paulinus, *Vita Ambrosii* 14.1, in Banterle 1991: 42–3; McLynn 1994: 158–219; San Bernardino 1998.

12 Gaggetti 2009.

13 Katzenellenbogen 1947.

14 On the decoration of the church, see the synthesis, with all the previous bibliography, of Andaloro 2006a. For the recent publications, see Braconi 2012; Foletti 2017. A good comparative example for an enthroned Serapis is the statuette in the Vatican Museums (inv. 1863) from the 3rd century.

15 The cult of Serapis was widespread in Rome: see Karter-Sibbes 1973: 115–34, esp. 114–15 for the plan of the city, with all the documented monuments of the god.

16 Duprez 1970, 172–6.

17 Foletti 2017.

18 Socrates of Constantinople, *History of the Church* 5.16–17, in Périchon and Maraval 2006: 194–203; Sozomenos, *History of the Church* 7.15, in Sabbah 2008: 132–45; Theodoretus, *History of the Church* 5.22, in Martin and Canivet 2009: 432–7.

19 Socrates of Constantinople, *History of the Church* 5.17. For the context, see Schwartz 1966.

20 Apart from the authors already mentioned, see Rufinus, *Historia Ecclesiastica* 11.22–30, in Mommsen 1908: 1025–36; and Flavius Vopiscus, *Historia Augusta* 8, in Chastagnol 1994: 1122–3. For the historical background, see Schmidt 1966; Thekamon 1981: 159–60; and Baldini 1995.

21 'Iam et Aegyptius Serapis factus est Christianus': see Jerome, *Letters* 107.2, in Labourt 1955: 145–6.

22 Augustine, *The Divination of Demons*, 1.1 and 6.11, in Bardy, Beckaert and Boutet 1952: 654–5, 662–3.

23 Jerome, *In Abacuc* 2.3.14, *PG* 25, 1329.

24 Prusac 2016.

25 Longhi 2012.

26 Andaloro 1992.

27 Hedrick 2000; Urbano 2005: 95–9.

28 Urbano 2005.

29 Andaloro 1992: 560–3, figs 7–8.

30 On this coin, see, for example: Walker 1956: xxxi–xxxii; Miles 1967; Johns 2003: 429–30, fig. 9; Hoyland 2007: 13–16; Heidemann 2010; Foss 2012: 142; Treadwell 2017: 99–101.

31 Walker 1956: xxviii and xxx, and, following him, Miles 1959: 210 and 1967: 216, instead interpreted the hair as a *kūfiyyah*, the traditional Arabic headdress.

32 Miles 1959: 211; Walker 1956: xxviii–xxx; Treadwell 2015. Some bronze coins from Jerusalem, Harran and al-Ruha (Edessa) carry the legend 'Muḥammad' or 'Muḥammad rasūl Allāh' ('Muḥammad, messenger of God'), which is why the standing figure on the coins has been interpreted not as the caliph but as the Prophet Muḥammad by some scholars (see Hoyland 2007: 13–16; Foss 2012: 142; Humphreys 2013: 242–3 (on copper coins)); see a discussion of their arguments by Schulze and Schulze 2010: 334, 342–3; Treadwell 2015. I find more convincing the interpretation in Schulze and Schulze 2016: 49 that this legend is simply an abbreviated *shahāda* or, as Treadwell 2015 puts it, a 'pious phrase' instead of the name of the portrayed figure. I would not rule out the possibility that the die-cutter misunderstood the image or deliberately re-interpreted it, so that the standing figure was sometimes perceived as an image of Muḥammad. The image could also have developed a life of its own and have been used with this new meaning on pilgrim flasks from 7th-century Jerusalem (Raby 1999). An argument against the interpretation of the standing figure as Muḥammad on the gold dinars is the fact that the same person seems to be represented in busts on silver *dirhams* of the *'mihrāb* and *'anaza'* type (see n. 53 below), where it is combined with the name of the Sasanian king Khosro; it is difficult to imagine the portrait of the Prophet Muḥammad combined with this imperial name, as Treadwell 2015 has also noted.

33 Type II *solidus* of Justinian II, following Breckenridge 1959: 22, 90. A connection between the two coins was established, for example, by A. Grabar 1984: 77–84 (1st ed. 1957); Miles 1967: 215, 227 (with further literature); Hoyland 2007: 13–16; Schulze and Schulze 2010: 349–50; Elsner 2012: 374; Humphreys 2013.

34 Heilo 2010, 61; Elsner 2012: 374. Generally on the legend on the reverse of Justinian's *solidus* and the Umayyad caliph's title, see Breckenridge 1959: 64–7.

35 For example, Schulze and Schulze 2010: 350 (following an unpublished paper by M. Phillips). A. Grabar 1984: 81 instead sees the ornamental trimming on the caliph's dress as an adaptation of the *loros*.

36 This similarity has already been commented on by Hoyland 2007: 14 and Schulze and Schulze 2010: 350.

37 O. Grabar 1973: 58–61 and 2005: 21–34.

38 Schlumberger 1939: 328–9, 352–4 nn. 3–4 and 1986: 15, 22, pl. 64a; Talgam 2004: 22, 65, fig. 69; Fowden 2004: 121–2, fig. 39.

39 O. Grabar 1954; Fowden 2004: 203–5; Di Branco 2007; Imbert 2016: 343–6.

40 On Roman imperial *clementia* scenes and private representations following this scheme, see Reinsberg 2006: 86–94.

41 Di Branco 2007: 597–8, 609, 611–12, 617–19 identifies the image of the six kings in Qusayr 'Amra as an illustration of this episode; he thus interprets the enthroned figure in the central niche of the audience hall not as the caliph but as the Prophet Muḥammad. For the text of Ibn Isḥāq, see Guillaume 1978: 652–9; it is recorded in al-Tabari's annals (early 10th century: see edition in Fishbein 1997: esp. 99–100 (1560–1561)). See also Heilo 2010: 72–3.

42 Serjeant 1983: 141–2. He concludes that the letters were drafted under the caliph 'Umar II (r. 717–20).

43 Milwright 2016.

44 On Umayyad Syria's Christian population, see Shboul and Walmsley 1998.

45 On preserved fragments of wall mosaics from Jordan, see Hamarneh 2015.

46 Bolman 2012: 76, fig. 27.

47 King 2004: 219–23.

48 Compare Justinian's II *solidus* (see n. 33 and Pl. 7.9), the *solidus* of Heraclius and his two sons (see n. 50) and Heraclius' *follis* (see n. 52).

49 Abka'i-Khavari 2000: 55.

50 Foss 2012: 136, fig. 62.

51 Miles 1967: 210–1; Treadwell 2017: 97–9.

52 Phillips 2015: 59–60, figs 6b–c. I would like to thank Federico Montinaro for calling this coin to my attention.

53 Miles 1952: 171 and 1959: 208; Johns 2003: 431, fig. 11; Treadwell 2005: esp. 8 and 13; Treadwell 2017: 102.

54 Harper 1979: 49–51, 58–62; Harper and Meyers 1981: 100, 102–3, 111–12, 115–20; Wood 2017.

55 Yule 2013: 126–9, 136, figs 7.3–7.7; Japp 2013: 311.

56 Japp 2013: 311 n. 64; Yule 2013: 126–7, figs 7.3 and 7.6.

57 Testini 1973–4; Romana Moretti 2006; Foletti and Quadri 2013a; Cascianelli 2014.

58 Croci 2017: 48–118.

59 The immense bibliography on this subject includes Garrucci 1876: 147–50; Wilpert 1916: 237–8; Schumacher 1959; Davis-Weyer 1961; Nikolasch 1969; Franke 1972; Berger 1973; Christe 1976 and 1996: 63–5; Pietri 1976: 1414–42; Engemann 1997; Bøgh Rasmussen 1999 and 2001; Spera 2000; Bisconti 2003; Spieser 2004; Rasch and Arbeiter 2007: 109–52; Foletti and Quadri 2013b; Cascianelli 2014; Couzin 2015; Noga-Banai 2016; Bergmeier 2017.

60 Bøgh Rasmussen 2001: 32–3.

61 Schumacher 1959; Spieser 2004.

62 Foletti and Quadri 2013b: 24; Christern-Briesenick 2003: 84 and 154.

63 L'Orange 1982: 152–6.

64 King 1961; Curta 2017.

65 San Bernardino 1998.

66 Spieser 2004; Spieser 2015: 244–67.

67 Spieser 2015. The idea to represent a more divine Christ was, indeed, already present in 359 on the sarcophagus of Junius Bassus. In this case, the adopted solution harmonises more with the previous tradition: Christ is sitting as a philosopher and his divinity can be recognised thanks to the personification of the Cosmos under his feet. However, owing to the very traditional design, this solution was probably still not radical enough (Elsner 2008; Rezza 2010).

68 *Codex Theodosianus* 16.1.2 in Krüger and Mommsen 1954.

69 Von Hefele 1869; Alberigo 2006, 35–70.

70 Croci 2017: 116–17.

71 Foletti and Quadri 2013a.

72 Foletti 2018: 39.

73 Romano 2019.

74 Piazza 2006a and b; Rasch and Arbeiter 2007: 109–52.

75 For the situation before the restorations, see Ugonio 1594: 1104.

76 Spieser 2015: 399–405.

77 Brandenburg 1987; Dresken-Weiland 1998: 56–8; Foletti and Quadri 2017: 308–10.

78 Katzenellenbogen 1947.

79 Spieser 2015: 266–7.

80 Panayotidi and A. Grabar 1975; Noga-Banai 2008: 9–38; Bernabò 2008 and 2014.

81 Smirnov 1935; Skhirtladze 1990–1; Alpago-Novello, Beridze and Lafontaine-Dosogne 1980: 88; Maranci 2013.

82 Kleinbauer 1972; Maranci 2001.

83 Foletti and Quadri 2013a: 20–2.

84 During the recent restoration, an inscription was found in the lunette above the reclining figure containing blessings for Walid. Since it includes none of the characteristic caliphal titles, Walid was probably only heir apparent at the time it was made; see Imbert 2016: 331–6. The inscription cannot be interpreted as a label for the image of the reclining figure, however, because it is located too far away from the figure and significantly differs in size and style from the other inscriptions in the bath house that clearly act as labels (with thanks to Nadia Ali for discussion of this inscription). Rather than the inscription, it is the iconographic programme of representational figures in the audience hall that makes it likely that the reclining figure actually depicts the heir apparent.

85 Dentzer 1982; Matthäus 1999–2000.

86 Compare two Parthian rock reliefs in Elymais, one of which shows the king of Elymais: Mathiesen 1992: 122–3 n. 4, fig. 3, 158–61 and 174–5; Haerinck 2003.

87 Audley-Miller 2016.

88 An example of the parallel outstretched legs and the *himation* existed until recently on the facade of the tower tomb of Kitot (*c.* 40), which remained visible until 2015 when it was blown up by ISIS (Henning 2013: 185–6, n. 44, and pl. 41). Another example of the *himation* over baggy trousers is found in the Tomb of Artaban, burial 5, south-eastern necropolis: Parlasca 1987: 279, fig. 3.

89 O. Grabar 1964: 78, fig. 9; Schlumberger 1986: 15 and 21, pls 41 and 64b; Meinecke 1996: 143, pls 6c–d; Talgam 2004: 22–3 and 95, fig. 77.

90 Fowden 2004: 253; Vida 2012.

91 Shahîd 2012; Sartre and Sartre 2014: 247–52.

92 Hamilton 1969; Hillenbrand 1982. This tradition is put into perspective by Judd 2008.

93 See n. 54.

94 Soleilhavoup 1991; Jordàn 1993; Adler 1998.

Bibliography

Abka'i-Khavari, M. 2000. *Das Bild des Königs in der Sasanidenzeit*, Hildesheim.

Adler, A. 1998. 'Des rois et des masques: essai d'analyse comparative (Moundang du Tchad, Bushong de l'ex. Taïre)', *L'Homme* 145, 169–203.

Agaësse, P. (ed.) 1995. *Augustine. De Trinitate*, Paris.

Alberigo, G. (ed.) 2006. *Conciliorum oecumenicoum generaliumque decreta*, vol. 1, Turnhout.

Alpago-Novello, A., Beridze, V. and Lafontaine-Dosogne, J. 1980. *Art and Architecture in Medieval Georgia*, Louvain-la-Neuve.

Andaloro, M. 1992. 'Tendenze figurative a Ravenna nell'età di Teoderico', in *Teoderico il Grande e i goti d'Italia. Atti del XIII Congresso internazionale di studi sull'Alto Medioevo, Milano, 2–6 novembre 1992*, vol. 2, Spoleto, 555–83.

— 2006a. 'Il mosaico di Santa Pudenziana', in Andaloro 2006b: 114–24.

— (ed.) 2006b, *L'orizzonte tardo antico e le nuove immagini*, Milan.

Antonova, C. 2016. *Space, Time, and Presence in the Icon: Seeing the World with the Eyes of God*, New York.

Audley-Miller, L. 2016. 'The banquet in Palmyrene funerary contexts', in C.M. Draycott and M. Stamatopoulou (eds), *Dining and Death: Interdisciplinary Perspectives on the 'Funerary Banquet' in Ancient Art, Burial and Belief*, Leuven, 553–90.

Bacci, M. 2014. *The Many Faces of Christ: Portraying the Holy in the East and West, 300 to 1300*, London.

Baldini, A. 1995. 'L'epistola pseudoadrianea nella vita di Saturnino',

in G. Bonamente and G. Paci (eds), *Historiae Augustae. Colloquium Maceratense. Atti dei Convegni sulla Historia Augusta*, Bari, 33–54.

Banterle, G. (ed.) 1988. *Ambrose, Discorsi e Lettere II/III. Lettere (70–77)*, Milan and Rome.

—1991. *Le fonti latine su Sant'Ambrogio*, Milan and Rome.

Bardy, G., Beckaert, J.-A. and Boutet, J. (eds) 1952. *Mélanges Doctrinaux*, Paris.

Belting, H. 1990. *Bild und Kult. Eine Geschichte des Bildes vor dem Zeitalter der Kunst*, Munich.

— 2013. *Faces. Eine Geschichte des Gesichts*, Munich.

— 2016. 'Iconic presence: images in religious traditions', *Material Religion* 12(2), 235–7.

Berger, K. 1973. 'Der traditionsgeschichtliche Ursprung der "traditio legis"', *Vigiliae Cristianae* 27, 104–22.

Bergmeier, A.F. 2017. 'The *traditio legis* in late antiquity and its afterlives in the Middle Ages', *Gesta* 56(1), 27–52.

Bernabò, M. 2008. *Il Tetravangelo di Rabbula. Firenze, Biblioteca Medicea Laurenziana, Plut. 1.56; l'illustrazione del Nuovo Testamento nella Siria del VI secolo*, Rome.

— 2014. 'The miniatures in the Rabbula Gospels: postscripta to a recent book', *Dumbarton Oaks Papers* 68, 343–58.

Bisconti, F. 2003. 'Variazioni sul tema della *Traditio legis*: vecchie e nuove acquisizioni', *Vetera christianorum* 40, 251–70.

Bøgh Rasmussen, M. 1999. 'Traditio legis?', *Cahiers archéologiques* 47, 5–37.

— 2001. '*Traditio legis* – Bedeutung und Kontext', in J. Fleischer, N. Hannestad, J. Lund and M. Nielsen (eds), *Late Antiquity: Art in Context*, Copenhagen, 21–52.

Bolman, E.S. 2012. 'The White Monastery federation and the angelic life', in Evans and Ratliff 2012: 75–7.

Braconi, M. 2012. *Il mosaico del catino absidale di S. Pudenziana. La storia, i restauri, le interpretazioni*, Todi.

Brandenburg, H. 1987. 'La scultura a Milano nel IV e V secolo', in C. Bertelli (ed.), *Milano una capitale da Ambrogio ai Carolingi*, Milan, 80–127.

Breckenridge, J.D. 1959. *The Numismatic Iconography of Justinian II (685–695, 705–711 A.D.)*, New York.

Cascianelli, D. 2014. 'Pasquale Testini e la "traditio legis" di Anagni: una copia del mosaico absidale dell'antica basilica di S. Pietro in Vaticano in una lapide romana', in F. Bisconti and M. Bracon (eds), *Incisioni figurate della tarda antichità*, Vatican City, 623–46.

Chastagnol, A. 1994. *Flavius Vopiscus. Histoire Auguste. Les empereurs romains des IIᵉ et IIIᵉ siècles*, Paris.

Christe, Y. 1976. 'Apocalypse et "Traditio legis"', *Römische Quartalschrift für christliche Altertumskunde und Kirchengeschichte* 71, 42–55.

— 1996. *L'Apocalypse de Jean. Sens et développements de ses visions synthétiques*, Paris.

Christern-Briesenick, B. 2003. *Repertorium der christlich-antiken Sarkophage 3. Frankreich, Algerien und Tunesien*, Mainz.

Couzin, R. 2015. *The Traditio Legis: Anatomy of an Image*, Oxford.

Croci, C. 2017. *Una 'questione campana'. La prima arte monumentale cristiana tra Napoli, Nola e Capua (secc. IV–VI)*, Rome.

Curta, F. 2017. 'Theodosius I declares Nicene Christianity the state religion of the Roman empire (AD 380)', in F. Curta and A. Holt (eds), *Great Events in Religion: An Encyclopaedia of Pivotal Events in Religious History*, vol. 1: *Prehistory to AD 600*, Santa Barbara, 239–40.

Davis-Weyer, C. 1961. 'Das Traditio-Legis-Bild und seine Nachfolge', *Münchner Jahrbuch der bildenden Kunst* 3(12), 7–45.

Dentzer, J.-M. 1982. *Le motif du banquet couché dans le Proche-Orient et le monde grec du VIIᵉ au IVᵉ siècle avant J.-C.*, Rome.

Di Branco, M. 2007. 'I sei principi di Qusayr 'Amrah: fra Tardoantico,

Ellenismo ed Islam', *Rendiconti dell'Accademia nazionale dei Lincei, Classe di scienze morali, storiche e filologiche* 18, 597–620.

Dresken-Weiland, J. 1998. *Repertorium der christlich-antiken Sarkophage, II. Italien, Dalmatien, Museen der Welt. Mit einem Nachtrag Rom und Ostia*, Mainz.

Duprez, A. 1970. *Jésus et les dieux guérisseurs. À propos de Jean, V*, Paris.

Elsner, J. 2008. 'Framing the objects we study: three boxes from late Roman Italy', *Journal of the Warburg and Courtauld Institutes* 71, 21–38.

— 2012. 'Iconoclasm as discourse: from antiquity to Byzantium', *Art Bulletin* 94(3), 368–94.

Engemann, J. 1997. *Deutung und Bedeutung frühchristlicher Bildwerke*, Darmstadt.

Evans, H.C. and Ratliff, B. (eds) 2012. *Byzantium and Islam: Age of Transition 7th–9th Century*, New York.

Fishbein, M. (trans.) 1997. *The History of al-Ṭabarī 8: The Victory of Islam*, New York.

Foletti, I. 2016. 'Des femmes à l'autel? Jamais! Les diaconesses (veuves et prêtresses) et l'iconographie de la Théotokos', in F. Abbot and E. Pibiri (eds), *Féminité et masculinité altérées. Transgression et inversion des genres au Moyen Age*, Florence.

— 2017. 'God from God: Christ as the translation of Jupiter Serapis in the mosaic of Santa Pudenziana', in I. Foletti and M. Gianandrea, *The Fifth Century in Rome: Art, Liturgy, Patronage*, Rome, 11–29.

— 2018. *Oggetti, reliquie e migranti. La basilica Ambrosiana e il culto dei suoi santi (386–972)*, Rome.

Foletti, I. and Quadri, I. 2013a. 'L'immagine e la sua memoria: l'abside di Sant'Ambrogio a Milano e quella di San Pietro a Roma nel Medioevo', *Zeitschrift für Kunstgeschichte* 76(4), 475–92.

— 2013b. 'Roma, l'Oriente e il mito della *Traditio legis*', *Opuscula historiae artium* 62 suppl., 16–37.

— 2017. 'Un dialogo inevitabile: l'ambone palinsesto di Sant'Ambrogio a Milano', in N. Bock, I. Foletti and M. Tomasi (eds), *Survivals, Revivals, Rinascenze*, Rome, 305–21.

Foss, C. 2012. 'Arab-Byzantine coins: money as cultural continuity', in Evans and Ratliff 2012: 136–43.

Fowden, G. 2004. *Qusayr 'Amra: Art and the Umayyad Elite in Late Antique Syria*, Berkeley.

Franke, P., 1972. 'Traditio legis und Petrusprimat: eine Entgegnung auf Franz Nikolasch', *Vigiliae Christianae* 26, 263–71.

Gaggetti, E. 2009. 'La tecla di Manlia Dedalia: la devozione di una nobildonna mediolanense', in Sena Chiesa 2009: 73–95.

Garrucci, R, 1876. *Musaici cimiteriali e non cimiteriali. Storia dell'arte cristiana nei primi otto secoli della chiesa*, Prato.

Grabar, A. 1936. *L'Empereur dans l'art byzantin. Recherches sur l'art officiel de l'Empire d'Orient*, Paris.

— 1984. *L'iconoclasme byzantin. Le dossier archéologique*, 2nd ed., Paris.

Grabar, O. 1954. 'The painting of the six kings at Qusayr 'Amrah', *Ars Orientalis* 1, 185–7.

— 1964. 'Islamic art and Byzantium', *Dumbarton Oaks Papers* 18, 67–88.

— 1973. *The Formation of Islamic Art*, New Haven.

— 2005. *Jerusalem*, Aldershot.

Guillaume, A. 1978. *The Life of Muhammad: A Translation of Isḥāq's Sīrat Rasūl Allāh*, 5th ed., Oxford.

Haerinck, E. 2003. 'Again on Tang-i Sarvak II, NE-side: goddesses do not have moustaches and do not wear trousers', *Iranica Antiqua* 38, 221–35.

Hamarneh, B. 2015. 'The visual dimension of sacred space: wall mosaics in the Byzantine churches of Jordan', in *Atti del XII Colloquio internazionale per lo studio del mosaico antico, Venezia 11–15 Settembre 2012*, Verona, 239–48.

Hamilton, R.W. 1969. 'Who built Khirbat al Mafjar?', *Levant* 1, 61–7.

Harper, P.O. 1979. 'Thrones and enthronement scenes in Sasanian art', *Iran* 17, 49–64.

Harper, P.O. and Meyers, P. 1981. *Silver Vessels of the Sasanian Period 1: Royal Imagery*, New York.

Hedrick, C. 2000. *History and Silence: Purge and Rehabilitation of Memory in Late Antiquity*, Austin.

Heidemann, S. 2010. 'The standing caliph-type: the object on the reverse', in A. Oddy (ed.), *Coinage and History in the Seventh Century Near East 2: Proceedings of the 12th Seventh Century Syrian Numismatic Round Table Held at Gonville and Caius College, Cambridge on 4th and 5th April 2009*, London, 23–34.

Heilo, O. 2010. 'Seeing eye to eye: Islamic universalism in the Roman and Byzantine worlds, 7th to 10th centuries', PhD dissertation, Vienna, http://othes.univie.ac.at/10921/ (accessed 9 September 2018).

Henning, A. 2013. *Die Turmgräber von Palmyra. Eine lokale Bauform im kaiserzeitlichen Syrien als Ausdruck kultureller Identität*, Rahden.

Hillenbrand, R. 1982. '*La dolce vita* in early Islamic Syria: the evidence of later Umayyad palaces', *Art History* 5, 1–35.

Hoyland, R. 2007. 'Writing the biography of the Prophet Muhammad: problems and solutions', *History Compass* 5, 1–22.

Humphreys, M. 2013. 'The 'War of Images' revisited: Justinian II's coinage reform and the caliphate', *Numismatic Chronicle* 173, 229–44.

Imbert, F. 2016. 'Le prince al-Walīd et son bain: itinéraires épigraphiques à Quṣayr ʿAmra', *Bulletin d'études orientales* 64, 321–63.

Japp, S. 2013. 'Cultural transfer in south Arabia during the first half of the first millennium CE', *Zeitschrift für Orient-Archäologie* 6, 300–19.

Johns, J. 2003. 'Archaeology and the history of early Islam: the first seventy years', *Journal of the Economic and Social History of the Orient* 46(4), 411–36.

Jordàn, M.A. 1993. 'Le masque comme processus ironique: les makishi du nord-ouest de la Zambie', *Anthropologie et Sociétés* 17(3), 41–61.

Judd, S. 2008. 'Reinterpreting al-Walīd b. Yazīd', *Journal of the American Oriental Society* 128(3), 439–58.

Karter-Sibbes, G.J.F. 1973. *Preliminary Catalogue of Sarapis Monuments*, Leiden.

Katzenellenbogen, A. 1947. 'The sarcophagus in S. Ambrogio and St. Ambrose', *Art Bulletin* 29(4), 249–59.

King, G.R.D. 2004. 'The paintings of the pre-Islamic Kaʿba', *Muqarnas* 21, 219–29.

King, N.Q. 1961. *The Emperor Theodosius and the Establishment of Christianity*, London.

Kleinbauer, W.E. 1972. 'Zvartʾnots and the origins of Christian architecture in Armenia', *Art Bulletin*, 54(3), 245–62.

Krüger, P. and Mommsen, T. 1954. *Theodosiani libri XVI cum Constivtionibvs Sirmondianis*, Berlin.

L'Orange, H.P. 1982. *Studies on the Iconography of Cosmic Kingship in the Ancient World*, New Rochelle, NY.

Labourt, J. (ed.) 1955. *Jérôme. Lettres*, Paris.

Lidova, M. 2015. 'The imperial Theotokos: revealing the concept of early Christian imagery in Santa Maria Maggiore in Rome', *Convivium* 2(2), 60–81.

— 2017. 'Chaire Maria: Annunciation imagery in the making', *Ikon* 10, 45–62.

Longhi, D. 2012. 'Regalità di Cristo e regalità di Teodorico nei mosaici di Sant'Apollinare Nuovo a Ravenna', *Ikon* 5, 29–46.

Maranci, C. 2001. 'Byzantium through Armenian eyes: cultural appropriation and the church of Zuartʾnocʾ', *Gesta*, 40(2), 105–24.

— 2013. 'New observations on the frescoes at Mren', *Revue des études arméniennes* 35, 203–25.

Martin, A. and Canivet, P. (eds) 2009. *Théodoret. Histoire Ecclésiastique*, vol. 2, Paris.

Mathews, T.F. 2003. *The Clash of Gods: A Reinterpretation of Early Christian Art*, rev. and expanded ed., Princeton.

Mathiesen, H.E. 1986. 'The rock reliefs at Tang-I Sarvak', *Acta Archaeologica* 57, 153–76.

— 1992. *Sculpture in the Parthian Empire: A Study in Chronology*, Aarhus.

Matthäus, H. 1999–2000. 'Das griechische Symposion und der Orient', *Nürnberger Blätter zur Archäologie* 16, 41–64.

McLynn, N.B. 1994. *Ambrose of Milan: Church and Court in a Christian Capital*, Berkeley.

Meinecke, M. 1996. 'Die frühislamischen Kalifenresidenzen: Tradition oder Rezeption?', in K. Bartl and S.R. Hauser (eds), *Continuity and Change in Northwestern Mesopotamia from the Hellenistic to the Early Islamic Period: Proceedings of a Colloquium Held at the Seminar für Vorderasiatische Altertumskunde, Freie Universität Berlin, 6th–9th April 1994*, Berlin, 139–64.

Miles, G.C. 1952. 'Mihrab and ʿanazah: a study in early Islamic iconography', in G.C. Miles (ed.), *Archaeologica orientalis in memoriam Ernst Herzfeld*, New York, 156–71.

— 1959. Review of J. Walker, *A Catalogue of the Arab-Sasanian Coins (Umaiyad Governors in the East, Arab-Ephthalites, ʿAbbasid Governors in Tabaristan and Bukhara)*, Oxford, 1941, and Walker 1956, *Ars Orientalis* 3, 207–13.

— 1967. 'The earliest Arab gold coinage', *Museum Notes, American Numismatic Society* 13, 205–29.

Milwright, M. 2016. *The Dome of the Rock and its Umayyad Mosaic Inscriptions*, Edinburgh.

Mommsen, T. 1908. *Rufinus. Historia Ecclesiastica*, Leipzig.

Nikolasch, F. 1969. 'Zur Deutung der "Dominus Legem dat" szene', *Römische Quartalschrift* 64, 35–73.

Noga-Banai, G. 2008. *The Trophies of the Martyrs: An Art Historical Study of Early Christian Silver Reliquaries*, Oxford.

— 2016. 'Dominus legem dat: von der Tempelbeute zur römischen Bildinvention', *Römische Quartalschrift für christliche Altertumskunde und Kirchengeschichte* 110(3/4), 157–74.

Oddy, A., Schulze, W. and Schulze, I. (eds) 2015. *Coinage and History in the Seventh Century Near East 4. Proceedings of the 14th Seventh Century Syrian Numismatic Round Table Held at The Hive, Worcester, on 28th and 29th September 2013*, London.

Panayotidi, M., and Grabar, A. 1975. 'Un reliquaire paléochrétien récemment trouvé près de Thessalonique', *Cahiers archéologiques* 24, 33–48.

Parlasca, K. 1987. 'Aspekte der palmyrenischen Skulpturen', in E.M. Ruprechtsberger (ed.), *Palmyra. Geschichte, Kunst und Kultur der syrischen Oasenstadt*, Linz, 276–82.

Périchon, P. and Maraval P. (eds) 2006. *Socrate de Constantinople. Histoire ecclésiastique*, Paris.

Phillips, M. 2015. 'Coinage and the early Arab state', in Oddy, Schulze and Schulze 2015: 53–71.

Piazza, S. 2006a. 'La *Traditio clavium* nell'absidiola nord', in Andaloro 2006b: 81–4.

— 2006b. 'La *Traditio legis* nell'absidiola sud', in Andaloro 2006b: 84–6.

Pietri, C. 1976. *Roma Christiana. Recherches sur l'église de Rome, son organisation, sa politique, son idéologie de Miltiade à Sixte III*, Rome.

Prusac, M. 2016. *From Face to Face: Recarving of Roman Portraits and the Late-Antique Portrait Arts*, Leiden and Boston.

Raby, J. 1999. 'In vitro veritas: glass pilgrim vessels from 7th-century Jerusalem', in J. Johns (ed.), *Bayt al-Maqdis: Jerusalem and Early Islam*, Oxford, 113–90.

Rasch, J.J. and Arbeiter, A. 2007. *Das Mausoleum der Constantina in Rom*, Mainz.

Reinsberg, C. 2006. *Die Sarkophage mit Darstellungen aus dem Menschenleben 3. Vita romana, Antike Sarkophagreliefs 1*, Berlin.

Rezza, D. 2010. *Un neofita va in paradiso. Il sarcofago di Giunio Basso*, Vatican City.

Romana Moretti, F. 2006. 'I mosaici perduti di San Pietro in Vaticano di età costantiniana', in Andaloro 2006b: 87–90.

Romano, S. 2019. 'San Pietro, San Paolo, e la narrazione cristiana: riflessioni su una possibile storia', in M. Angheben (ed.), *Les stratégies de la narration dans la peinture médiévale. Ve–XIIe siècles, Culture et société médiévales* 37, Turnhout.

Sabbah, G. (ed.) 2008. *Sozomène. Histoire ecclésiastique*, Paris.

San Bernardino, J. 1998. 'Sub imperio discordiae: l'uomo che voleva essere Eliseo (giugno 386)', in L.F. Pizzolato and M. Rizzi (eds), *Nec timeo mori. Atti del Congresso internazionale di studi ambrosiani nel XVI centenario della morte di sant'Ambrogio (4–11 Aprile 1997)*, Milan, 709–38.

Sartre, A. and Sartre, M. 2014. *Zénobie de Palmyre à Rome*, Paris.

Schlumberger, D. 1939. 'Les fouilles de Qasr el-Heir el-Gharbi (1936–1938): rapport préliminaire', *Syria* 20, 195–238, 324–73.

— 1986. *Qasr el-Heir el Gharbi*, Paris.

Schmidt, W. 1966. 'Die Koexistenz von Sarapiskult und Christentum im Hadrianbrief bei Vopiscus (Quadr. tyr. 8)', in J. Matthews (ed.), *Historia Augusta Colloquium Bonn 1964/65*, Bonn, 153–84.

Schulze, I. and Schulze, W. 2016. *The Standing Caliph Coins of Jerusalem: A Study Based on the Preparatory Work of Shraga Qedar*, Munich.

— 2010. 'The standing caliph coins of al-Jazīra: some problems and suggestions', *Numismatic Chronicle* 170, 331–53.

Schumacher, W.N. 1959. 'Dominus legem dat', *Römische Quartalschrift* 54, 1–39.

Schwartz, J. 1966. 'La fin du Sérapéum d'Alexandrie', in *Essays in honor of C. Bradford Welles*, New Haven, 97–111.

Sena Chiesa, G. (ed.) 2009. *Il Tesoro di San Nazaro. Antichi argenti liturgici dalla basilica di San Nazaro al Museo Diocesano di Milano*, Cinisello Balsamo.

Serjeant, R.B. 1983. 'Early Arabic prose', in A.F.L. Beeston, T.M. Johnstone, R.B. Serjeant and G.R. Smith (eds), *The Cambridge History of Arabic Literature: Arabic Literature to the End of the Umayyad Period*, Cambridge, 114–53.

Shahîd, I. 2012. 'Al-Zabbā'', in P. Bearman, T. Bianquis, C.E. Bosworth, E. van Donzel and W.P. Heinrichs (eds), *Encyclopaedia of Islam*, 2nd ed., http://dx.doi.org/10.1163/1573-3912_islam_SIM_8058 (accessed 14 May 2020).

Shboul, A. and Walmsley, A. 1998. 'Identity and self-image in Syria-Palestine in the transition from Byzantine to early Islamic rule: Arab Christians and Muslims', *Mediterranean Archaeology* 11, 255–87.

Skhirtladze, Z. 1990–1. 'À propos du décor absidal de Cromi', *Revue des études géorgiennes et caucasiennes* 6–7, 163–83.

Smirnov, J.I., 1935. *Cromskaja Mozaika*, Tiflis.

Soleilhavoup, F. 1991. 'À propos des masques et visages rupestres du Sahara', *Archéo-Nil* 1, 43–58.

Spera, L. 2000. 'Traditio legis et clavium', in F. Bisconti (ed.), *Temi di iconografia paleocristiana*, Vatican City, 288–93.

Spieser, J.-M. 2004. *Autour de la 'Traditio Legis'*, Thessaloniki.

— 2007. 'Invention du portrait du Christ', in A. Paravicini Bagliani, J.-M. Spieser and J. Wirth, *Le portrait. La représentation de l'individu*, Florence, 57–76.

— 2015. *Images du Christ. Des catacombes aux lendemains de l'iconoclasme*, Geneva.

Talgam, R. 2004. *The Stylistic Origins of Umayyad Sculpture and Architectural Decoration*, Wiesbaden.

Testini, P. 1973-4, 'La lapide di Anagni con la "Traditio Legis": nota sull'origine del tema', *Archeologia Classica* 25–6, 718–40.

Thekamon, F. 1981. *Païens et chrétiens au VIe siècle. L'apport de l'Histoire ecclésiastique' de Rufin d'Aquilée*, Paris.

Treadwell, L. 2005. '"Mihrab and 'anaza" or "sacrum and spear"? A reconsideration of an early Marwanid silver drachm', *Muqarnas* 22, 1–28.

— 2015. 'Symbolism and meaning on the early Islamic copper coinage of greater Syria', in Oddy, Schulze and Schulze 2015: 73–95.

— 2017. 'The formation of religious and caliphal identity in the Umayyad period: the evidence of the coinage', in F.B. Flood and G. Necipoğlu (eds), *A Companion to Islamic Art and Architecture 1: From the Prophet to the Mongols*, Hoboken, 89–108.

Ugonio, P. 1594. *Theatrum Urbis*, (Romae), Ferrara, Biblioteca Comunale Ariostea, ms. Cl. I, 161.

Urbano, A. 2005. 'Donation, dedication, and *damnatio memoriae*: the Catholic reconciliation of Ravenna and the Church of Sant'Apollinare Nuovo', *Journal of Early Christian Studies* 13(1), 71–110.

Vida, G. della 2012. 'Taym Allāh', in P. Bearman, T. Bianquis, C.E. Bosworth, E. van Donzel and W.P. Heinrichs (eds), *Encyclopaedia of Islam*, 2nd ed., http://dx.doi.org/10.1163/1573-3912_islam_SIM_7468 (accessed 14 May 2020).

von Hefele, K.J. 1869. 'Le second concile œcuménique tenu à Constantinople en 381', in *Histoire des conciles d'après les documents originaux*, vol. 2, Paris, 187–220.

Walker, J. 1956. *A Catalogue of the Arab-Byzantine and Post-Reform Coins*, London.

Weihrich, F. (ed.) 1904. Augustine, *De consensu evangelistarum*, CSEL 43, Vienna and Leipzig.

Wilpert, J. 1916. *Die römischen Mosaiken und Malereien der kirchlichen Bauten vom IV–XIII. Jahrhundert*, Freiburg.

Wood, R. 2017. 'The Khosro Cup', in J. Elsner, S. Lenk *et al.*, *Imagining the Divine: Art and the Rise of the World Religions*, Oxford, 206–8.

Yule, P. 2013. *Late Antique Arabia. Zafar, Capital of Himyar. Rehabilitation of a 'Decadent' Society: Excavations of the Ruprecht-Karls-Universität Heidelberg 1998–2010 in the Highland of the Yemen*, Wiesbaden.

Response to I. Foletti and K. Meinecke, 'From Serapis to Christ to the Caliph: Faces as Re-Appropriation of the Past'

Nadia Ali

In his famous essay *The Life of Forms* (1943), Henri Focillon argues that artistic form is not sign, symbol, icon or index. It can become any of these things, but such semiotic entailments are usually joined to form as an unnecessary addition. Focillon insists that there are really only two significations that adhere to form: a specifically formal signification that is always an allusion to other forms; and a 'non formal' signification, which is always present but whose relation to form is largely arbitrary. In other words, nothing explains the genesis of images, nothing except forms themselves and their encounters with other forms. The impression that the art history of late antiquity has made too little theoretical use of Focillon's radical distinction between form and meaning prompted the organisation of a session on 'the life of forms in late antique art' as part of the *Imagining the Divine* conference, for which Ivan Foletti and Katharina Meinecke boldly took up the challenge and from which their comparative essay, 'From Serapis to Christ to the Caliph: Faces as Re-Appropriation of the Past', has developed.

Using a type-related approach to meaning, Foletti and Meinecke's inquiry into the selective adoption and reinterpretation of pre-existing images of authority by the early Christians and the Umayyads moves the discussion away from issues of style, influence or text-based iconography to a much more precise and incisive description of how typological borrowings and appropriation of schemata work in the visual arts of late antiquity across a range of cultures and religious affiliations. They argue that figural images of power in both early Christian and Umayyad art worked like a sort of language in which particular pre-existing types of face, body or posture were consciously used and recombined in order to communicate specific messages. For instance, early depictions of Christ with the face of the pagan god Serapis, or Umayyad representations of caliphs replicating Christ's face, become an ecumenical and/or triumphal gesture of the new religion. What had once been conceived as an undifferentiated and linear process of evolution from pagan to Christian and early Islamic figural imagery is effectively broken up into smaller units (types of face, body and posture) and recombined as a new mix of visual elements, each of which was potentially capable of a quite precise meaning within the new systems. The use of 'visual clichés' associated with authority both facilitated the recognisability of general themes by viewers and enabled all kinds of replicative claims to collective culture, power and identity.[1] Foletti and Meinecke's model offers a highly dynamic, positive and innovative vision of early Christian and Islamic image-making.

The model proposed by Foletti and Meinecke for what we may call a typological language of referents can perhaps be creatively extended.[2] To take an Umayyad example: in the analysis of the so-called 'reclining banqueter' depicted in the frescoes of Qusayr ʿAmra (an early Islamic bath-house in Jordan) (**Pl. 7.16**), Foletti and Meinecke argue that the artists deliberately drew on older Palmyrene images of banqueting in order to appropriate 'the legendary Arab past' of Palmyra and to allude to the 'glorious Arab history of the Umayyad heartland' (p. 127).[3] The typological parallel between the Umayyad image and its Palmyrene visual

Plate 7.18 Wall painting from the north aisle of Faras cathedral (Nubia) depicting a Nativity scene, dated 8th–10th century. Sudan National Museum in Khartoum. Image: Alamy

ancestors is very convincing; yet it is also the case that other ancient or late antique images depicting a reclining figure could also have been equally among the image types that were borrowed to create this banqueter, potentially building a polyvalent pattern of earlier cultural reference and resonance. Among the possibilities is the very popular iconography of the Nativity. If we adduce types from a wide array of Nativity scenes drawn from Coptic wall paintings (such as Abd al-Nerqi and Bawit in Egypt, later instantiations of this theme at Faras cathedral in Sudan (**Pl. 7.18**), or in the monastery of Deir al-Suryani in northern Egypt) with our Umayyad painting that depicts the so-called 'reclining banqueter', striking similarities become apparent: the general composition showing a reclining figure flanked by a noble looking man and another figure holding a fan; the position and gesture of the reclining figure; the costume which covers Mary's legs; the couch decorated with a diamond pattern; and the low table adorned with an arcade, which strongly recalls the depiction of altars on some Coptic Nativity scenes. Moreover, the small figures at the front of the Qusayr ʿAmra fresco, one sitting and veiled and the other standing, resemble the figures of Salome and the midwife bathing the Infant common to Coptic Nativity scenes in their headgear and position within the composition. Additionally, the bearded man holding a scroll is similar to depictions of Joseph or Zachariah writing the name of John the Baptist on an unfurled scroll found on later Byzantine icons.[4]

One may object that the Umayyad painting clearly depicts a reclining man (perhaps the caliph al-Walid himself, identified by the accompanying inscription), not a woman. However, cases of basic visual types used equally in the depiction of male and female figures are well documented. To take just one example from Roman sarcophagi, 'the image type of Endymion lying nude on Roman sarcophagi is adapted – with breast added, penis removed, and some necessary contextual changes – to becoming Ariadne or Rhea Silvia'.[5] My point here is not to argue that the Umayyad image was explicitly or intentionally modelled on that of the Nativity, but rather to stress the range of possible uses of a basic scheme or type and the methodological questions these raise. A number of matters are at stake here. To what extent do the kind of typological borrowings so astutely analysed by Foletti and Meinecke imply that chosen types from the past were associated with a unique or privileged model (and its significations), and to what extent was there a wide range of options, subject largely to viewer preferences? How can we tell? If the basic type of a reclining figure may be used for royal or funerary banqueting scenes, but also for numerous mythological reclining figures, or birth scenes (such as the Nativity of Christ or of John the Baptist), how can we determine which of these specific subjects was appropriated and reinterpreted by the new system? This difficulty raises another set of questions: do typological borrowings always refer to a privileged past or do they sometimes refer to other imagery from the present that may itself look back to the past? And to what extent is a practice of visual allusion, quotation or reference one of reverence for what is alluded to (as opposed to polemic or one-upmanship)?[6] By emphasising the Palmyrene banquet scene as the privileged source of inspiration for the Umayyad image, Foletti and Meinecke align their reclining figure with an important ethno-political historical context. But are there any incongruities between the historical context and the visual material, potentially occluding other problems which are perhaps no less important?[7]

The theory of visual types as bearers of meaning is an approach well established in the scholarship of Roman art since Tonio Hölscher's celebrated essay *The Language of Images in Roman Art*, first published in 1987.[8] As rightly pointed out by Katharina Lorenz, 'this approach borrows from semiotic linguistic the idea of the system that organises vocabulary and syntax'.[9] This linguistic model was adopted 'to dissect the emulation of Greek templates within Roman art and the meaning associated with those templates'[10] within the long stability of Greco-Roman culture, and it has been criticised for excluding all non-Greek models for Roman classicism (such as Egyptian art).[11] How applicable is it when dealing with transitional periods and contexts, such as the reinterpretation of late antique models in early Islamic art? Regarding the mosaics of the Dome of the Rock, Oleg Grabar argues that 'the significant novelty is the *syntax* or the ordering of the elements, not the elements themselves, which are all visual *phonemes* for a classical text dismantled and recomposed to be made into an early medieval one'.[12]

Writing of the mosaics of the Great Mosque of Damascus, Barry Flood explains:

> the overall Byzantine flavor of Umayyad visual culture in the eighth century should not be seen as the random product of chance. On the contrary, such similarities represent the deliberate appropriation of a pre-existing *vocabulary*, a

translation which reconfigures the order and sense of that vocabulary in accordance with Muslim beliefs and Umayyad aspirations …. Such selective translations invariably imply rejections and a reworking of selected elements in a culturally appropriate manner, a change in *syntactic structure* to borrow Grabar's phrase.[13]

One problem in all this is a tendency to treat images and objects of material culture as 'texts', decoded according to the linguistic structures by which texts are themselves deciphered.[14] The difficulty is not only to stress that images do not necessarily communicate in the same manner as texts, but also to find alternative modes of thinking about images within the cultures that produced them. Regarding Islam and the images of the bath house of Quṣayr 'Amra, one might refer to the discussion of Muḥammad b. Zakariyya' al-Razi (d. 925), who was deeply immersed in Stoic philosophy and took the range of visual significance in perhaps surprising directions. Al-Razi was at pains to show that paintings in bath houses have a healing power:

> When beautiful pictures also contain, apart from their subject, beautiful, pleasant colours – yellow, red, green, and white – and the forms (*aškāl*) are reproduced in exactly the right proportions, they heal melancholy humours (*afkār sawdāwiyya*) and remove the worries to which the human soul (*nafs*) is prone, as well as gloomy spirits (*wasāwis*). The gloom in which it finds itself dissolves. Consider only how the ancient philosophers who invented the bath realised, thanks to their subtle mind and sound intellect, that a considerable part of the powers of a man who enters a bath relaxes *(taḥallala)*. Their wisdom enabled them to discover through their intelligence how this can be accomplished swiftly, and they therefore had artistically made pictures, with beautiful, pleasing colours (*mufriḥa*), painted in the baths. In addition, they were not content with a single subject but undertook a division into three, since they knew that the body possesses three sorts of spirits, animal, psychological, and physical. Hence, they arranged that each subject of painting should serve to strengthen and increase one of the above-mentioned powers. For the animal power, they have depicted battles, fights, hunts on horseback, and the chase of beasts. For the psychological power, they have depicted love, themes of lovers and beloved, how they accuse one another or embrace and other scenes of this sort. And for physical power they have depicted gardens, trees pleasant to look at, a mass of flowers in charming colours. If one asks a discerning painter why painters use only these three subjects for the painting of baths, he cannot give a reason for this; he would not remember those three qualities (of the mind/soul) as the reason. This is due to the fact that the earliest beginnings lie so far back, and hence the cause is no longer known.[15]

We can never be certain about the meanings imputed to particular forms or iconographic types in the distant past, especially when they crossed cultural and religious divides. What Al-Razi shows is that some of the expectations and understandings brought to the images used to decorate baths in late antique and medieval Islam were quite different from those modern scholarship may imagine.

Notes

1 Marvin 1989. For the notion of visual clichés, see especially 34.

2 Lorenz 2016: 97–8.

3 The theoretical model is indebted to Hölscher 1987 for the discussion of the semantic nature of the language of Roman images, an approach recently extolled for its usefulness in ancient Indian art by Stoye 2020.

4 See e.g. Ali 2017.

5 Elsner 2006: 293.

6 For similar questions in the study of classicism in Roman art, see Elsner 2006: 275–6.

7 For an illuminating theoretical use of the notion of 'incongruity', see Smith 1978: 206.

8 Hölscher 1987.

9 Lorenz 2016: 160–1.

10 Lorenz 2016: 160.

11 Elsner 2006.

12 Grabar 2005: 414–15, emphasis in original.

13 Flood 2000: 203. For more recent reiterations of this linguistic model in the study of Umayyad art, see Flood 2012: esp. 253–4.

14 Squire 2009: 85–7.

15 Al-Rāzī, quoted by al-Ghuzūlī, *Matāli al-Budūr fi-manāzil al-surūr*, 2.7–8. See also Fowden 2004: 316ff.

Bibliography

Ali, N. 2017. 'Qusayr 'Amra and the continuity of post-classical art in early Islam: towards an iconology of forms' in A. Lichtenberger and R. Raja (eds), *The Diversity of Classical Archaeology*, Turnhout, 161–97.

Elsner, J. 2006. 'Classicism in Roman art', in J. Porter (ed.), *Classical Pasts: The Classical Traditions of Greece and Rome*, Princeton, 270–97.

Flood, F.B. 2000, *The Great Mosque of Damascus*, Leiden.

— 2012. 'Faith, religion and the material culture of early Islam', in H.C. Evans and B. Ratliff (eds), *Byzantium and Islam: Age of Transition 7th–9th Century*, New York, 244–58.

Fowden, G. 2004. *Quṣayr 'Amra: Art and the Umayyad Elite in Late Antique Syria*, Berkeley.

Al-Ghuzūlī, 1930. *Matāli al-Budūr fi-manāzil al-surūr*, Cairo.

Grabar, O. 2005. *Constructing the Study of Islamic Art I: Early Islamic Art, 650–1100*, Aldershot.

Hölscher, T. 1987. *Römische Bildsprache als semantisches System*, Heidelberg.

Lorenz, K. 2016. *Ancient Mythological Images and Their Interpretation: An Introduction to Iconology, Semiotics, and Image Studies in Classical Art History*, Cambridge.

Marvin, M. 1989. 'Copying in Roman sculpture: the replica series', *Studies in the History of Art 20: Symposium Papers VII: Retaining the Original: Multiple Originals, Copies and Reproductions*, 29–45.

Smith, J.Z. 1978. *Map is Not Territory: Studies in the History of Religions*, Chicago.

Squire, M. 2009. *Image and Text in Graeco-Roman Antiquity*, Cambridge.

Stoye, M 2020. 'On the crossroads of disciplines: Tonio Hölscher's theory of understanding Roman art images and its implications for the study of western influence(s) in Gandhāran art' in W. Rienjang and P. Stewart (eds), *The Global Connections of Gandhāran Art*, Oxford, 2020, 29–49.

Chapter 8
Use of Decorated Silver Plate in Imperial Rome and Sasanian Iran

Richard Hobbs

This paper is part of research undertaken under the auspices of the *Empires of Faith* project to study the manner in which belief is represented on late antique silver plate from approximately the 3rd century to the 8th, embracing a number of cultures from late Roman/Byzantium and post-Roman 'barbarian' cultures to the Sasanian empire and early Tang China. Of particular interest was the manner in which representations of belief related to vessel forms, and to explore how different cultures embellished and subsequently employed and interacted with these decorated vessels. The primary research question centred upon examining whether silver vessels were made for display, dining or religious purposes, or for other reasons, and how this differed across the late antique world.

The focus in the following discussion is on silver plate produced in imperial Rome and Byzantium, in the period from broadly the 3rd century to the 7th, and how it compares to silver plate made in Sasanian Iran and Central Asia.[1] In particular, this paper will attempt to compare how objects made from silver plate (mainly vessels) differed between Rome/Byzantium and Sasanian Iran and what this might tell us about the different ways in which these objects may have been used in their respective empires. Equally importantly, it will look at interactions between the empires as evidenced by this class of material. For example, are parallels between vessel forms and decoration suggestive of the copying/borrowing and adaptation of ideas of form and display? Indeed, were these objects directly exchanged between these two empires, or were they only used and circulated within their imperial confines? And what influence did social interactions and cultural practices in the late Roman/Byzantine empires and the Sasanian empire have on the manner in which this material was used?

Manufacture

'Silver plate' is a technical term that refers to the thin sheets of silver that were formed primarily into vessels and utensils.[2] In the Roman and Sasanian empires, silver plate was used to produce these functional objects, most of which were plain or only lightly decorated, while a smaller proportion were heavily embellished with geometric or figurative designs and also subjected to surface treatments such as gilding and niello inlay.

Silver plate occupies a rather niche position within the material culture of late antiquity, and indeed the ancient world more broadly. Next to nothing is known about its production, in comparison to, for instance, that of metal coinage or ceramics, and yet silver plate has much in common with both classes of material.[3] It is known that coinage was made in workshops (mints) under the ultimate direction of the emperor or a designated officer, for example the office of the *Comes Sacrarum Largitionum* in the late Roman world.[4] Numismatists are able to integrate historical data with the evidence of the surviving coinage to construct detailed commentaries on mint outputs down to specific issues and places of production, including when mints were active or inactive, and are usually able to precisely date the production of particular coinage issues. It seems highly likely that some silver plate was also produced in officially sanctioned workshops, perhaps even in conjunction with the

striking of coin, and yet to make specific links between the two activities has proved next to impossible.

I have argued in another paper that some forms of silver plate made in the late Roman world should be viewed as an extension of the Roman precious metal currency system – largely on the basis of metrological comparison – but this only applies to a specific type of silver vessel, and so does not cover the vast majority of the surviving material.[5] The matter of private production is crucial here: what was the balance between official production – that is, vessels made under the direction of the emperor, to fulfil an imperial objective – and private production, to satisfy the demand of the market place? This is where silver plate and coinage start to drift apart, for few if indeed any would argue for the private production of coinage (although locally made copies of official issues might arguably fall into this category). In the *vicus argentariorum* ('street of silversmiths') in Carthage,[6] was one able to purchase silver vessels 'off the shelf'? Were such objects simply sitting there waiting to be bought on whim, reflecting the tastes and skills of the craftsmen (presumably men) who made them? Or were workshop activities strictly limited to works made to commission, supported only by those who had the means able to instruct silversmiths as to what they required? If so, how was this squared with royal offices: in other words, how tightly was the use of silver (and gold) controlled by the state?[7] All these questions exemplify how, although there are clearly links between the production of precious metal coinage and precious metal plate, it is far trickier to decide what precise mechanisms underlay the production of the latter in comparison to the issue of state currency in all its various guises. In fact, the only vessels in late antiquity that we can be absolutely certain were official products are the series of *largitio* vessels produced under late Rome (discussed further below).

The parallels with the production of ceramics are also important. These parallels primarily relate to vessel forms and the manner in which vessels were decorated; both silver plate and clay were made in a range of forms that can be organised into useful typologies and assigned probable functional usages. Sometimes clear parallels between certain ceramic series and silver plate can be found: one example of this is the series of red slipware vessels produced in North Africa in the late Roman period.[8] The forms are very similar to those of the larger vessels of late Roman silver, and the decoration used on the rims of the vessels can also be paralleled. Were these vessels mimicking precious metal equivalents? Might we view them as affordable alternatives to the silver wares employed by the elites, allowing those of lesser means to express their aspirations through their usage? Exploring the relationships between elite material culture and that of mass production is important because it reminds us that social stratification and one's place within it was as important in the ancient world as it is today.

Vessel forms, decoration and object function

Bearing in mind the uncertainties surrounding the manufacture of silver plate, how does one assess the purpose of a particular vessel yet avoid being too prescriptive? It is necessary to be mindful that intended purpose may differ from actual use, which itself could vary over time. There are a number of factors that need to be taken into consideration. The first is the vessel's form: this will provide an indication of the intended function, although not necessarily the context in which the vessel was actually used. To take a simple example, a silver strainer can unequivocally be considered as intended for straining the lees from wine, but the context could have been a domestic or secular one such as a dinner party, but also a ritualistic one such as a libation ceremony. Or plates and bowls: these are clearly intended for the short-term containment of other substances, but this cannot always be assumed to be consumables such as food or drink in either a domestic or ritual context, but might also be non-consumables such as gold coins gifted as an imperial donative. The size, normally measured by rim diameter, and weight are very important for assessing both intended impact and use: as an example, plates were used by individuals at the dining table, whereas platters were for communal sharing of courses, and yet both could be of precisely the same form. Vessel weight, and where possible metal purity (obtained using a scientific technique such as X-ray fluorescence), allows for an assessment of the quantity of precious metal invested in a particular object. When looked at collectively, the changing nature of the size and weights of vessels in late antiquity over time raises some interesting questions, unfortunately beyond the scope of this paper.[9]

The second factor in assessing the purpose of a particular piece is its decoration – or, rather, the lack of it. It would seem logical to assume that plain vessels were intended to have a more functional use than heavily decorated ones. Those vessels bearing detailed iconographic designs clearly offered further possibilities for aesthetic interactions as well as more prosaic ones. Here it might be useful, however, to quote from Sidonius Apollinaris, who in his letters refers to silver plate in passing in a number of insightful contexts. Writing from his villa at Avitacum in Gaul, he describes his winter dining room with a couch and 'glittering sideboard', which suggests that precious metal plate was used for display.[10] But when writing of his experience of dining with the Gothic king Theoderic, he emphasises that it was the 'skilful cookery' on offer that was the most important thing, not the weight of the vessels being used, although their 'brightness' was important, implying that the domestic slaves were expected to polish the silver and not allow it to tarnish. Silver plate being used in a utilitarian manner for dining is the point here, although of course we are not told if Theoderic was using plain or decorated vessels or both – nor indeed what Sidonius himself had on his sideboard.[11] Epigrams in the *Anthologia Latina*, however, provide some amusing insights into this matter: the waiters being urged to quickly cover the silver vessels with sauces because semi-erotic imagery might be too arousing for the diners and distract them from the meal.[12]

Aside from consideration to the degree of decoration, naturally the manner and content of the decoration itself is important, although it must always be considered in relation to vessel or utensil form. There is an enormous range of types and styles of decoration on gold and silver plate in late antiquity. In the broadest terms, it was either geometric or figurative, both types inspired by both the real and the

imagined world, and might feature exclusively or in combination on particular pieces. There is a large body of research regarding how different types of decoration that appear on gold and silver plate (particularly figurative) can be interpreted, and this is not the place for the interrogation of these studies.[13] Therefore in this paper I have restricted myself to specific examples of decoration where these relate to general trends across the period and cultures under discussion and how decoration relates to vessels form and dimensions. In turn, this can inform the likely scenarios in which such vessels might have been used. Related to decoration and a further factor to consider are inscriptions, which could be either integral to the design (e.g. dedications) or graffiti (e.g. weight inscriptions).

The third factor that needs to be considered when assessing vessel use is archaeological context. Provenance and contextual information for discoveries of precious metal plate dating to late antiquity is enormously variable, from entirely lacking or so vague as to be meaningless to precise provenances with detailed contextual information on stratigraphic relationships (although the only example of this that springs to mind is the Hoxne treasure).[14] The lack of basic provenance information for finds enormously limits their interpretation, whereas provenance and decent contextual data greatly improves our chances of understanding elements such as likely intended use. Regrettably, because of the high commercial value of this material, it has tended to more often fall into the former category than the latter, as these objects are invariably discovered by accident rather than via systematic and controlled archaeological investigation. The infamous 'Seuso' treasure is a good case in point.[15]

The final factor – which can also be considered contextual – is the literary and contemporary illustrative evidence for the use of silver and gold plate in late antiquity. There are no specific discussions of plate in the ancient texts, but it is mentioned in passing in a number of different types of document. The letters of Sidonius Apollinaris have already been mentioned, but plate is also referenced in Greek and Latin panegyrics, in historical and political commentaries and epigrams, such as those from the *Anthologia Latina* mentioned above, and in documents written in the languages of the Sasanian empire.[16] The visual evidence includes wall painting, mosaics and rock carvings that sometimes depict vessels which can be paralleled within the surviving corpus of evidence.

These four factors mean that there is no set formula for deciding how a particular piece of silver plate was employed in late antiquity. In any case, intended use did not necessary relate to actual use; vessels could have had more than one use and use could have changed owing to time and circumstance. The important point, however, is that all the factors outlined above should be considered when interrogating this material. In the past, particularly when regarding the heavily decorated items, there has been an overemphasis on art-historical interpretations, rather than examining the possible contexts of use. We have already touched on ostentatious display or what we might call conspicuous consumption, which is also related to elite dining practices, both of which take place within a broadly

domestic or secular context (see above for Sidonius' winter dining room). Religious and ritualistic use has also been mentioned: this means the use of these objects within pagan shrines and temples (e.g. for the pouring of libations, or the conducting of a funeral feast) and later in Christian contexts (e.g. the serving of bread for the Eucharist) or in Iranian rituals (e.g. drinking rituals before embarking on military campaigns). The display purpose of these items was also important. It has to be remembered that, in addition, silver plate was used for toilet and hygiene purposes, and again this could be in both secular contexts, both private and public (e.g. washing at home or at the public baths), and religious ones (e.g. washing for symbolic spiritual cleansing).

Another dimension of precious metal plate concerns what might be described as use as the currency of social relations and wealth storage. Social relations could be defined and displayed through the gifting of these objects between peers within political entities and possibly between them as diplomatic exchanges, while wealth storage means the secretion of these objects as stores of bullion. Subsequently, after any preliminary function, these items might then have been re-employed for other more practical purposes. For example, a wedding gift, which can be considered as part of the currency of social relations, is then re-employed for both ostentatious display and dining on special occasions.

These categories can be therefore be summarised as follows (note the overlaps):
- Domestic use: ostentatious display, dining, personal hygiene and wealth storage;
- Religious/ritual use: ostentatious display, symbolic consumption, ritualised washing and wealth storage;
- Maintenance of social relations, diplomatic exchange and wealth storage.

Thus the job of the interpreter is twofold: first, to weigh up all these various factors in deciding how particular vessels and/or utensils were employed as individual pieces and the part they played within a larger assemblage; and second, to look at the body of surviving material as a whole to examine what the overall trends are in likely function within particular cultural settings. For example, from the surviving evidence, does it appear that most late Roman silver was intended for use in a domestic or a religious setting, and how does this change over time, if at all? And how does this compare with Sasanian Iran?

I will begin by discussing the category of material that is easiest to identify: the products of the respective imperial courts, which can normally be associated with a primary use for the maintenance of social relations.

Social relations and diplomatic exchange

As outlined in the discussion of the factors associated with interpreting the function of silver plate, evidence for the use of silver plate for the maintenance of social relations among elites in late antiquity comes from three types of evidence: literary sources, visual evidence and the material itself. What we are concerned with here is the gifting of these objects from individuals of either higher, equal or lower status in the social structure to curry favour, cement loyalty or demonstrate generosity to a peer. This topic is substantial and much has been written on it, so all that is offered here

Plate 8.1b Plate from Strelka, Russia, with enthronement of Khosro II, early 7th century, silver, d. 260mm. The State Hermitage Museum, St Petersburg, inv. S.250. Photograph © The State Hermitage Museum /photo by Alexander Lavrentyev, Vladimir Terebenin, Leonard Kheifets, Yuri Molodkovets

Plate 8.1a Platter from Almandralejo, Spain, commemorating the *decennalia* of Theodosius I, 388 CE, silver, d. 740mm. Real Academia de la Historia, Madrid. Image: © Real Academia de la Historia

are some observations specific to the dataset gathered for this study.[17] Much of what we can surmise regarding this issue concerns the use of silver plate within the social hierarchies of Rome and Sasanian Persia independently, but there are also interesting questions regarding exchange between the courts, which are addressed below.

Imperial gifts

In the Roman empire, a number of objects have been identified as imperial *largitio*, produced by the incumbent emperor to present to subjects, normally on the occasion of an anniversary such as a *decennalia*. Examples include the so-called *missorium* of Theodosius I (**Pl. 8.1a**),[18] the Kerch plate probably depicting Constantius II (**Pl. 8.2a**)[19] and the plate from Geneva showing either Valentinian I or II.[20] These gifts formed part of a donative that probably also included gold coins and possibly silver bullion, as illustrated in the *Notitia dignitatum*.[21] Wealthy members of the elite also presented silver vessels to their peers: the actions of Symmachus provides an oft-cited example in the literature.[22] Although the precise vessels used for such purposes are not as readily identified as *largitio*, I have argued that they may be a type of flanged bowl with beaded rim produced in the late Roman period.[23] We might include silver vessels likely to have been presented as wedding gifts under the same umbrella, such as the eponymous platter in the 'Seuso' treasure (and perhaps the rest of the treasure),[24] and parts of the Rome (Esquiline) treasure.[25] Although not explicitly discussed as such, one wonders if the small number of surviving Sasanian vessels that show noble couples seated on a banqueting couch both grasping a wreath, a symbol of divine favour and accord, and by extension marriage, might also therefore be wedding gifts: an unprovenanced example in Washington dated to the 7th century provides a good example.[26]

No examples of imperial *largitio* have been identified that date to the 3rd century. This does not mean that the practice did not exist at this time, only that no silver plate can be identified with certainty as *largitio* dating to this period. The first *largitio* vessels that can be positively identified appear at the beginning of the 4th century and consist of a series of hemispherical bowls, largely plain except for portrait busts of the emperor accompanied by inscriptions (or just the inscriptions alone) (**Pl. 8.3a**).[27] What is particularly interesting about these vessels is the fact that very similar hemispherical bowls, also carrying busts in their basal medallions, were made in Sasanian Persia at around this time. The forms of these bowls are identical to the Roman equivalents and they are of similar size.[28] Harper's detailed examination of this small group of vessels (only seven are known) concludes that they date to the late 3rd to early 4th century CE, falling mostly within the reign of Narseh (292–303 CE) (**Pl. 8.3b**).[29] She suggests that the subjects of the profile busts in the bases are likely to be members of the landed aristocracy, since they cannot be certainly identified with royal personages. Harper does not speculate on the function of these bowls, and does not appear to have noted the parallel with the Roman *largitio* vessels, although she does note that there are stylistic parallels with late Roman cut glass bowls.[30] Might these Sasanian vessels have been produced for a similar purpose to the Roman silver bowls, as part of a gift-exchange system? Is it possible that the inspiration for these vessels came from early imperial *largitio*, or the other way around? Interestingly, the production of such hemispherical bowls appears to have been short lived in the Roman empire, which gives weight to this argument as they are an atypical Roman form.[31] It can also be noted that, on the obelisk of Theodosius in Constantinople, the Persian envoys making obeisance before the emperor and his court on the west face are holding what look like hemispherical bowls, suggesting that they were considered to be a Persian type.[32]

In the Sasanian empire, the bowls with profile busts are superseded by the long series of small plates depicting the royal personage as hunter-king – as Harper notes, if it is

Plate 8.2a *Largitio* plate from Kerch, Ukraine, with Constantius II, 337–61 CE, silver, d. 245mm. The State Hermitage Museum, St Petersburg, inv. 1820/79. Photograph © The State Hermitage Museum /photo by Alexander Lavrentyev, Vladimir Terebenin, Leonard Kheifets, Yuri Molodkovets

Plate 8.2b Plate from Malaia Pereshchepina, Russia, probably with Shapur II, early 4th century CE?, gilded silver, d. 230mm. The State Hermitage Museum, St Petersburg, S272. Photograph © The State Hermitage Museum /photo by Alexander Lavrentyev, Vladimir Terebenin, Leonard Kheifets, Yuri Molodkovets

correct to think of the busts in the hemispherical bowls to represent the landed aristocracy, then from about the mid-4th century onwards 'the production [of silver plate] became … an instrument of royal propaganda' – the implication being that the Sasanian kings took much closer control over the production of silver plate after this time.[33] Although there is much discussion of the nature of the imagery on this long series of vessels, the reasons underlying their production has rarely been discussed.[34] Marshak suggested that 'In general, the vessels … seem to have been gifts to high personages on various occasions', giving as a theoretical example the presentation of such vessels to noble ladies on the occasion of marriage or the birth of a male son. But, as he also concedes, 'the ideals and customs of the Sasanian laity are scarcely known'.[35] Canepa is rather more circumspect, suggesting distribution of these vessels 'to their own subjects and client kings'.[36] If we are to accept that the hunter-king plates are indeed almost entirely the products of the court, then effectively they can be considered to be the equivalent of Roman imperial *largitio*.[37]

After the short period during which hemispherical *largitio* vessels were made in the Roman empire, all later examples of *largitio* are figurative plates and platters, sometimes accompanied by inscriptions. There is only one example of a plate that depicts a mounted emperor, the aforementioned plate from Kerch (**Pl. 8.2a**). The vessel in question is believed to depict a nimbate Constantius II (r. 337–61) in all his finery, astride his heavily bejewelled mount.[38] A soldier is in attendance carrying the emperor's spear and a shield emblazoned with the chi-rho symbol, and before Constantius a rather awkward looking Victory approaches with a wreath. The similarity of this vessel in form, size and style to the hunter-king Sasanian vessels is surely of note. If we take, for example, the fragmentary vessel from Malaia Pereshchepina, Ukraine, the headdress of which has been

identified as that most closely resembling Shapur II (r. *c.* 325–79), here too we see a nimbate king in all his finery astride an equally elaborately dressed horse (**Pl. 8.2b**).[39] The king is, as is customary, engaged in a hunting expedition, with rams the quarry. Both vessels employ gilding to accentuate the figures, while leaving the background plain, and the two vessels are of almost identical size (rim diameters of 245 and 230mm respectively). If the short-lived adoption of the hemispherical bowl by a small number of Roman emperors at the beginning of the 4th century took inspiration from Sasanian Persia (see p. 139), might the Constantius II vessel have also been inspired by the Sasanian hunter-king vessel type? And yet Canepa makes the point that the nimbus is a symbol of divine rule in the Roman world from Diocletian onwards, and thus would predate its use in Sasanian Persia on vessels such as this.[40] Nevertheless, given the clear parallels between hemispherical bowls and the vessels under discussion here, the idea of familiarity of material between these realms must at the very least have merit, and one might go so far as to suggest that the weight of evidence points to Roman silversmiths being inspired by both forms and decoration prevalent in the Sasanian empire rather than vice versa. This is a good point at which to move on to the topic of the role of silver plate in inter-state diplomacy.

Silver plate and inter-state diplomacy

Silver plate may have played a part in diplomatic exchanges between Rome and Persia in late antiquity, as suggested by scattered allusions in the literary sources. The *Scriptores historiae Augustae* (*SHA*) informs us that Shapur I presented a silver vessel to the Roman emperor Aurelian (r. 270–5):

> Furthermore when he [Aurelian] had gone as envoy to the Persians, he was presented with a sacrificial saucer, of the kind that the king of the Persians is wont to present to the emperor,

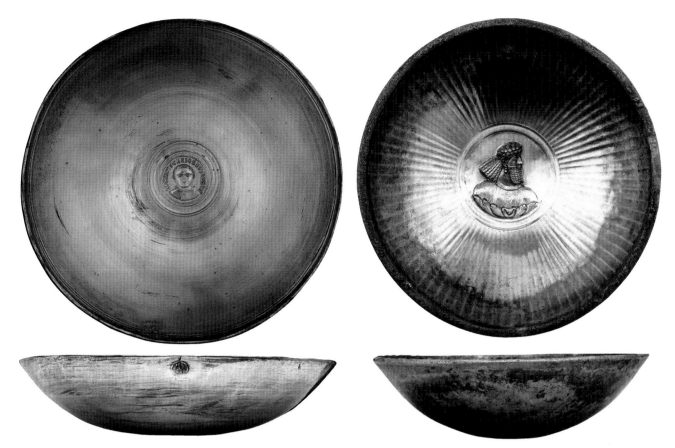

Plate 8.3a Hemispherical bowl from the 'Munich' treasure, 321 CE, silver, d. 179mm. Archäologische Staatssammlung, Munich, 1998,8126. Image: © Archäologische Staatssammlung München, photographs by Manfred Eberlein and Stefanie Friedrich

Plate 8.3b Bowl from Qasr i-Shirin, Iran, late 3rd to early 4th century CE, silver, d. 210mm. Freer Gallery of Art, Smithsonian Institute, Washington D.C.: Purchase – Charles Lang Freer Endowment, F1957.20

on which was engraved the Sun-god in the same attire in which he was worshipped in the very temple where the mother of Aurelian had been a priestess.[41]

Canepa has stated with confidence that 'by at least the fourth century plates were understood to be one of the customary items exchanged between the Sasanian king of kings and the Roman emperor',[42] an assertion that appears to be largely based upon the evidence of the *SHA*, which is considered a highly unreliable source, particularly for the later empire.[43] He goes on to suggest that the constant repetition of the theme of the hunter-king in pursuit of, or in the act of killing, both docile and ferocious animals, presented a 'veiled threat to the king of kings' adversaries, including the Roman emperor, demonstrating the sovereign's military prowess and asserting that such a fate could befall any who defy him'.[44] Additionally, Cutler suggests that there is literary evidence for precious metal plate moving in the other direction: 'As regards Roman gifts to Persia, earlier in the sixth century we have the account of "Joshua the Stylite" of a table service "entirely of gold" sent by Anastasius to Kavâd II while suing for peace'; he suggests that Persia was the prime beneficiary of Roman silver in the 6th century.[45]

The primary concern with the idea that silver plate was a common element of diplomatic exchanges is that there is little archaeological evidence to support this.[46] Surely if it was common for these vessels to be exchanged in this manner, then one would expect that they would have been discovered within the territorial boundaries of their

respective empires? And yet this has never occurred, or at least the examples that we might expect to be found have not yet come to light.[47] There are, however, two possible instances of silver plate being discovered within the territory of the Roman empire that might be Sasanian imports and therefore perhaps diplomatic gifts. The first is a set of vessels in the Carthage Treasure (some of which is in the British Museum), lidded cups that sit on high foot-rings.[48] This type of vessel is, like the hemispherical bowl discussed above, an atypical Roman form. However, even these curious vessels cannot straightforwardly be considered as imports, as their precise form is slightly different from the ones known from Sasanian Persia itself (for example, the rims curve inwards) and so Baratte offers the interpretation that they might have been produced by Sasanian metalworkers to suit the tastes of Carthaginian clients.[49]

Arguably more convincing is the second example: an intriguing small silver plate on a high foot-ring, a typical feature of Sasanian silver, that is decorated with a boar advancing to the left with a tree behind, encircled by a *kymation* border (**Pl. 8.4a**).[50] This bears strong stylistic similarities with a series of Sasanian silver pieces that also show animals as the dominant motif, placed in front of trees or other plants. They include silver plates from Onoshat, near Perm, Russia, bearing a highly stylised lioness and birds,[51] and another from Komarovo, also near Perm, depicting a lion in the act of bringing down an ox,[52] The best parallel is a plate from Klimova, once again in the Perm region, with a tigress advancing to the right and a tree

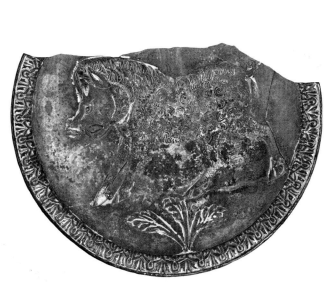

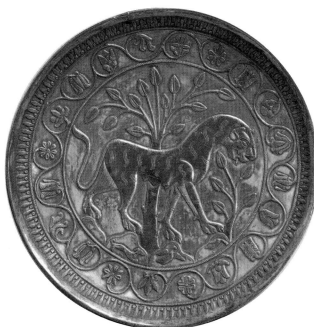

Plate 8.4a Boar plate from Toulouse, 5th century?, silver, d. 180mm. National Museum, Warsaw, inv. 147080. Image: © National Museum, Warsaw

Plate 8.4b Plate from Klimova, Russia, 7th century?, silver, d. 228mm. The State Hermitage Museum, St Petersburg, inv. S.41. Photograph © The State Hermitage Museum /photo by Alexander Lavrentyev, Vladimir Terebenin, Leonard Kheifets, Yuri Molodkovets

behind, enclosed within an almost identical *kymation* border (in addition to a vine scroll) (**Pl. 8.4b**).[53] The boar plate was not an isolated discovery, but was found in Toulouse in the 19th century with another vessel that incorporates a gold medallion of Theodosius II, dated to *c.* 430, crimped into the vessel's centre. They may well have been in the possession of an immigrant from the eastern Mediterranean, given the appearance of a Greek name on the latter vessel,[54] but a diplomatic exchange between Persia and Rome cannot be entirely ruled out. A more focused study of the vessels that fall within this stylistic group is clearly needed.

The evidence for diplomatic exchanges therefore relies largely upon stylistic comparisons suggesting that silversmiths had familiarity with design schemes or subject matter which inspired a re-imagining of the standard subject matter. This has already been discussed in the context of late Roman *largitio* and Sasanian hunter-king plates, but can also be exemplified by the small number of Roman and Sasanian vessels that depict enthronement scenes. The enormous platter from Almandralejo, commonly known as the Madrid *missorium*, depicts an enthroned Theodosius I (r. 379–92) flanked by his co-emperors, Arcadius and Valentinian II, all nimbate, while Tellos reclines in the register below (**Pl. 8.1a**).[55] An inscription informs us that the vessel was made to celebrate Theodosius' *decennalia* in 388. The message of divinely sanctioned rule and dominion over the world (represented by Tellos) is crystal clear, not least because the vessel can only be orientated one way to be viewed.[56]

The composition of the design on a plate in the Hermitage, found at Strelka, Russia, in 1908, is strikingly similar to the Theodosius *decennalia* vessel when the two pieces are set side by side (**Pl. 8.1b**).[57] The vessel shows a nimbate and enthroned king (thought to be Khosro II, early 7th century) with a pair of attendants on either side, a similar

composition to that shown on the Theodosius platter. In the field below, the familiar trope of the hunter-king, this time hunting rams using a Parthian shot, may be a metaphor for the world over which the king has ultimate dominion, just as the world as the Roman emperor sees it is represented by Tellos on the other vessel. So it is not beyond the realms of possibility that the silversmith responsible for the Strelka vessel took inspiration from something like the Almandralejo platter – it would be pushing the evidence too far to suggest the actual vessel itself – but equally, it might simply be entirely coincidental, or have been inspired by something else entirely.[58] The only thing that is certain is that the Strelka plate is far more modest in size and was produced perhaps as much as two centuries later than the Theodosius platter.[59] At the very least, it may have been a diplomatic gift like the Theodosius platter, for a Hepthalite graffito on its reverse records the name and title of its owner, implying that it had been received from the incumbent Sasanian king (or one of his officers) by a Hepthalite nobleman.[60]

In summary, the fleeting literary references to the use of silver plate for diplomatic exchanges between Rome and Persia and vice versa may reflect real processes but do not sit entirely easily with the surviving material culture evidence. All we have are hints of such exchanges in the form of a small number of possible but not unequivocal gifts in a restricted number of discoveries in the western Roman empire, and in design elements which might suggest familiarity with the material produced in the other's respective realms.

Returning to vessels primary intended for gifting within polities: if it is accepted that the few surviving examples of Roman imperial *largitio* and the series of hunter-king vessels in Sasanian Persia were produced to bestow favour and reward loyalty among their subjects, what did the

Plate 8.5a Plate from Kaiseraugst, Switzerland, 4th century CE, silver, l. 258mm, w. 140mm. Römersmuseum, Augst, inv. 62.25. Image © Römermuseum in Augst

Plate 8.5b Plate, no provenance, 6th–7th century?, silver, l. 182mm. The State Hermitage Museum, St Petersburg, inv. S.34. Photograph © The State Hermitage Museum /photo by Alexander Lavrentyev, Vladimir Terebenin, Leonard Kheifets, Yuri Molodkovets

recipients do with such vessels once received? Were they openly displayed as a means of demonstrating status to others within their peer group? If so, how? No vessels of either late Roman *largitio* or the Sasanian hunter-king series seem designed for vertical display, since all sit on foot-rings. I have encountered only one Sasanian vessel that has a suspension hole, a 5th-century plate from Kercheva, Russia, but in any case this was almost certainly added at a much later date, possibly half a millennium later, since the vessel also bears additional imagery scratched into its surface.[61] The implication of the forms of these vessels is that they were intended to be displayed flat, in the manner of vessels used for dining, yet one would surmise that they retained their function as display pieces, since it is hard to imagine that they took on a secondary use as elements of dining services; surely it was not the 'done thing' to serve the *hors d'œuvres* on top of the personification of a divine ruler?

Although they are not considered to be examples of late Roman *largitio*, Leader-Newby has discussed late Roman vessels that display Homeric myth, such as the Achilles platter from the Kaiseraugst treasure, as examples of *paideia*, 'offering viewers [i.e. their owners and peer group] an opportunity to display their knowledge of the literary tradition'. Might we see some of the hunter-king vessels in a similar light, particularly those late examples that depict the legend of Bahram Gur (r. 421–39)? That is, might their owners have used them as ways of emphasising their rank and status in Sasanian society through their open display?[62] It is unfortunate that we have so little supplementary evidence in the ancient sources or contemporary art that might provide clues to the use of this material, unlike for the late Roman period (see p. 139). It must also be borne in mind that these vessels were more often than not kept hidden in private treasuries, as stores of bullion, their portability and mutability a distinct advantage since they could easily be melted down and recast when the political situation changed and if their courtly associations became a liability. In fact, this may be why so relatively little of this type of material survives into the modern era.[63] Their probable use for taxation is also important: alongside two other forms of intrinsically valuable material – precious metal coins and bullion – we can surmise that these objects would have been

passed back up the chain when taxes needed to be paid, even if, at least in the late Roman empire, the focus of taxation was on the reformed gold coinage.[64] Therefore such silver vessels may not have been retained in private hands for very long.

'Non-official' silver plate

Besides what can be categorised as 'official' silver plate, produced to serve a specific state purpose, what of the majority of surviving silver plate in both the late Roman/ Byzantine world and that of the Sasanian empire? How is one to interpret the use of this material? As has been repeatedly stressed in this paper, it all comes down to context. As set out above, consideration must be taken of vessel form, decoration or its absence, archaeological context and the context provided by the literary and contemporary art historical sources. These may lead us to conclude likely use of particular vessels within, for example, a domestic or a religious setting, although one must be cautious not to be too prescriptive. This is an enormous topic and there is only space here to make some observations and impressions.

The first point is that there is far more contextual information for late Roman and Byzantine silver plate than there is for the Sasanian and related material. A number of hoards of late Roman and Byzantine silver have enough associated information to allow for a likely use-context to be established. For instance, the enormous and spectacular discovery from Berthouville, France, provides a clear example of the range of vessels that one can associate with a rural sanctuary, in this instance a shrine dedicated to Mercury;[65] while the Kaiseraugst treasure, despite the unfortunate circumstances following its discovery,[66] provides us with a clear image of a tableware service in use by a middle-ranking military officer on the Rhine frontier in the mid-4th century.[67] Church treasures from Riha/Stuma in Syria and Kumluca, Turkey – even if their archaeological contexts are far from satisfactory – in turn provide valuable insights into the types of vessels in use in a Christian context in the 7th century – including patens (for the symbolic laying of the host) with self-referential imagery of Christ breaking bread with the Apostles.[68] No such hoards, in contrast, as far as I am aware, have been discovered of Sasanian silverware that might provide similar context.[69] Therefore, to interpret

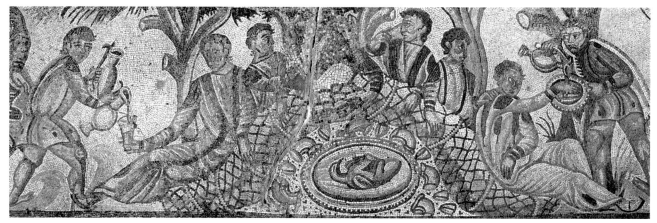

Plate 8.6 Outdoor dining scene, using silver vessels, from the hunt mosaic, Villa Caddeddi, Sicily, late 4th century CE. Image: courtesy of Roger Wilson, University of British Columbia

the latter material, one is heavily reliant on the vessel forms themselves, their decoration and some of the illustrative material in the literary and art-historical sources, although, yet again, the surviving corpus appears to be much sparser than in the late Roman/Byzantine world. Some examples of the problems that arise from this contrasting contextual picture are provided here.

Some decorated Sasanian silver vessels might be considered as being intended for use in a domestic dining context by comparison with Roman equivalents. For example, a number of late Roman vessels are of rectangular or occasional other unusual shapes (e.g. cordate[70]) and these were almost certainly used for the serving of fish at the dining table. A silver platter in the Kaiseraugst treasure has recesses to accommodate a piscine head and tail (**Pl. 8.5a**). Interestingly, the silversmith seemed to think it necessary to include an image of a fish in the base, just to be clear as to its intended function. An unprovenanced Sasanian silver vessel in the Hermitage Museum also bearing the image of a fish might therefore have been designed for the same purpose (**Pl. 8.5b**).[71]

Vessels intended for the serving of complete courses to be shared among diners are relatively common finds in the surviving corpus of Roman material, and context is provided by numerous contemporary illustrations (**Pl. 8.6**).[72] It is easier to view largely undecorated vessels as more suited to this purpose, and no heavily decorated vessels are unequivocally replicated in wall paintings or mosaics (see p. 137),[73] but that the latter were used for dining is implied by some passing literary allusions; or, to put it another way, there is no reason to think that heavily decorated vessels were never used for dining. I have argued elsewhere that the Bacchic platter in the Mildenhall treasure, part of a set of silver that sits most comfortably in the context of domestic dining use, might within its two distinct figural friezes of processing worshippers – the marine *thiasos* in the centre and a Bacchanalian revel in the outer frieze – allude to the bounty of both sea and land (**Pl. 8.7a**)[74] The Sasanian corpus of decorated silver cannot offer anything similar (namely platters with a clear dining connection implied by their decoration), unless a silver-gilt plate from Rasht, Iran, with fish, nereids, capricorns and fishermen was intended to invoke the bounty of the seas, and so was perhaps therefore also intended for use at the dining table (**Pl. 8.7b**).[75] But the

Plate 8.7a Bacchic platter from Mildenhall, England, 4th century CE, silver, d. 605mm. British Museum, London, 1946,1007.1

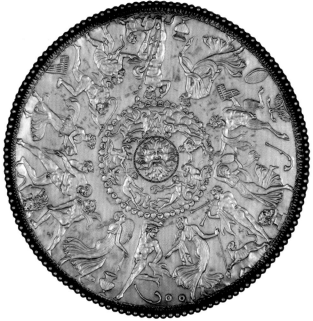

Plate 8.7b Plate from Rasht, Iran, 6th–7th century, silver, d. 205mm. Iran-e Bastan Museum, Tehran, inv. 4115. Image: © Iran-e Bastan Museum

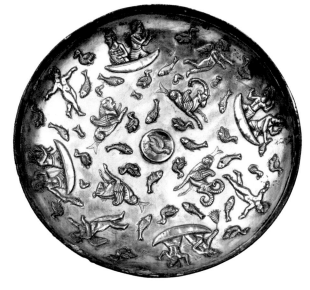

limited range of extant forms make slotting Sasanian vessels into a domestic dining context much trickier than for the Roman material: what I have defined as platters – vessels with a rim diameter greater than 300mm – intended for the sharing of courses, have not been found in Sasanian silver, where vessels are always far more modest in size.[76] This might simply be a consequence of survival – larger Sasanian vessels for some reason have not yet been discovered – or a real pattern that implies a different emphasis on the use of silver vessels for eating and drinking. This is a topic that warrants more investigation.[77]

Another example of this problem is vessels that display hunt scenes. These are quite common in the late Roman material,[78] and again can be viewed in the context of a late Roman dining party and the leisure activities of the late Roman elite. Thus mosaics such as that from Caddeddi (**Pl. 8.6**), or the more well-known Mosaic of the Small Hunt from Piazza Armerina,[79] both from Sicily, provide a context for such silver vessels within the narrative of a hunting expedition, where they are depicted in use during picnics, the culmination of the successful conclusion of the hunt. But can a vessel such as a silver-gilt plate from Polovodoro, Russia, with a lion overpowering a stag, be placed in a similar context (**Pl. 8.8**)?[80] Is the image intended as a metaphor for a successful hunt, allowing us to imagine it being used as part of a feast that dined upon the bounty of the natural world? Or should we rather follow Marshak's interpretation that the imagery relates to ideas of rebirth in the context of a spring festival, placing it in the hands of a religious practitioner enacting an appropriate ritual?[81] Once again, the problem is a lack of context, and without further discoveries that might provide this, we are unlikely to ever reach a satisfactory conclusion.

The only area where contextualising Sasanian silver plate within the spheres of both ritual practices and dining improves marginally relates to the use of drinking vessels (and associated objects) in noble Sasanian society. So, for instance, the vessel being held by the goddess Anahita in the famous investiture scene of Khosro II at Taq-e Bostan, Iran, of the early 7th century, from which flows water, is perhaps a silver ewer.[82] But there is not enough detail on the relief to

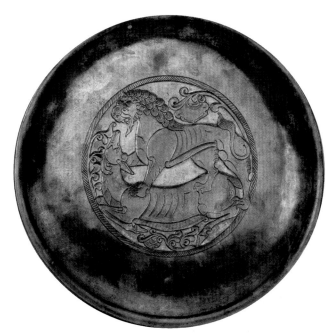

Plate 8.8 Plate from Polovodoro, Russia, 8th century, gilded silver, d. 275mm. The State Hermitage Museum, St Petersburg, inv. S.23. Photograph © The State Hermitage Museum /photo by Alexander Lavrentyev, Vladimir Terebenin, Leonard Kheifets, Yuri Molodkovets

ascertain if the ewer is of a particular type: for example, is it synonymous with the series of decorated ewers that show vine decoration and dancing female figures, which have been suggested as 'used, or given as gifts, at the time of seasonal festivals celebrating the general prosperity of plant, animal and human life'?[83] We simply cannot know. Nevertheless, it does at least allow us to think of Sasanian silver vessels in the context of a highly ritualised kingly ceremony, which is not possible just from examining the vessels in their own right.

Perhaps more intriguing is the depiction of crescent-shaped drinking vessels in a wall painting from Panjikent, Tajikistan, dated to the 6th or 7th century, which shows a group of Sogdian noblemen enjoying a drinking party (**Pl. 8.9**).[84] Setting aside the fact that this illustration is not strictly 'Sasanian' in nature (and indeed just demonstrates how widely in both regional and chronological terms such vessels forms

Plate 8.9 Mural showing Sogdian noblemen using 'Sasanian' style vessels, Panjikent, Tajikistan, 6th–7th century. Image: courtesy of Qi Xioqing, Dunhuang Research Academy

were in use) it does at least allow a clear link to be made between precious metal vessels and a drinking party (or perhaps noble feast). The drinking vessels appear to be made of gold, but can be convincingly matched with the boat- or crescent-shaped vessels that survive in silver plate.[85] A bowl depicted on the left side of the painting is of typical Sasanian form with a fluted reverse on a high foot-ring. It is perhaps being used to serve food, or possibly for washing the diner's hands. But can we go so far as to suggest that literary evidence for highly ritualised drinking bouts, which often lasted many days and preceded military campaigns, should also be invoked here? Probably not, because this literary evidence relates specifically to such drinking ceremonies in the presence of a king.[86] Thus the difficulties of making links between the surviving corpus of evidence and the contemporary art historical and literary evidence are again highlighted.

Conclusions

There has not been much space within this paper to look specifically at vessels in both the late Roman/Sasanian worlds that can be linked to use within what might be described as a purely religious context. In some cases, this is possible: the vessel forms, such as *paterae* for pouring libations, or dishes for serving symbolic foods, are often combined with relevant imagery, such as depictions of rural sanctuaries on the rims of 3rd-century vessels from Berthouville, or Christ and the Apostles depicted on the patens from Riha/Stuma.[87] But this is very difficult within the corpus of Sasanian silver plate – again because of problems with context. For example, what is one to make of an unprovenanced plate in the Al-Sabah collection, interpreted as the only 'Sasanian' vessel that depicts rituals association with Manicheism?[88] If the vessel is genuinely ancient, then in what context was it in use? We simply do not know. This problem bedevils much of the Sasanian material because of the lack of associated information on provenance, let alone archaeological context.

In summary, this paper has shown that there are some intriguing links to be made between decorated late Roman/ Byzantine and Sasanian silver plate. Sometimes the forms of vessels chosen and the nature of decoration – for example, the depictions of emperors and kings – are strikingly similar between the cultures, and hint at the transfer of ideas via exchanges either of personnel or of the objects themselves, although archaeological evidence for such transfers is difficult to define. Other objects suggest shared pragmatic approaches to functional use: for instance, the production of certain types of bespoke vessel for the serving of food. Throughout it has been stressed that, when interpreting this imagery, it is vital that vessel forms and any other associated contextual information must be taken into account, if we are to avoid over-interpreting the imagery in question. Unfortunately, the poor quality of contextual information for the Sasanian corpus of material limits what can be achieved. Nevertheless, it is hoped that this paper at least raises some interesting questions to which further research in this area might provide more satisfactory answers. The next step is a full re-assessment of all the available evidence, so that justice can be done to the rich corpus of surviving material: such a study would also aim to include objects

found in the zones where the two empires met, namely Central Asia, and extend its remit further east towards China. An interrogation of the dataset that includes both the material itself and the supplementary archaeological and contextual evidence would lead to a fuller understanding of this important category of object in late antiquity.

Notes

1 'Sasanian silver plate' is convenient shorthand for silver plate that was made during the Sasanian period, but rather obscures the likelihood that it was produced over a large region that covered not only the modern countries more readily associated with Sasanian Persia, namely Iran and parts of Iraq, but also Black Sea states such as Georgia and Armenia and the Central Asian states of Turkmenistan and Afghanistan. As Harper proposes, in her discussion of the Bahram Gur plate in the British Museum (BM 1897,1231.187), such vessels 'were not part of controlled silver production that may be called "Sasanian" but rather … were provincial works … in the area east of Merv and Herat' (Harper and Meyers 1981: 137).

2 In many ways the term is unhelpful, because silver plate was often made into 'plates', i.e. flat circular vessels used in dining or for other purposes. This means that on occasion non-specialists have mistakenly taken the term to mean the vessel form ('silver plates') rather than the metalworking technique.

3 For a summary of evidence for the production of silver plate in the late Roman world, see Hobbs 2016: chap. 15. That there is little direct evidence for state controls over the production of silver plate under the Sasanian dynasty is discussed by Harper (1992), who points out that the variety of vessels is also more restricted for Sasanian silver (147).

4 Leader-Newby 2004: 15ff., with references.

5 Hobbs forthcoming. Vessels made of silver plate 'would have functioned as large denomination coinage' (Cutler 2009: 10). See also Vickers 1995.

6 After Heather 2006: 279, quoting the *Expositio totus mundi* 61.

7 See also Hobbs 2016: 265 for a discussion of the possible operation of the office of the *Comes Sacrarum Largitionum*.

8 Hayes 1972.

9 In simplistic terms, there is a trend in late Roman and Byzantine silver vessels to become larger and heavier between the 3rd and 7th centuries (see also Hobbs 2016: 37–9). A similar trend does not seem to happen in Sasanian Persia: for example, the hunter-king plate series remain modest in size and weight throughout their production history. Grierson 1992 makes some interesting observations regarding the use of gold and silver in Rome/ Byzantium and the Sasanian empire, for instance that in Rome there was a 'meagre silver coinage' but 'a generous use for silver plate' (138), in contrast to the Sasanian empire, which had 'one of the hugest silver coinages known to history and considerable use of silver for plate' (ibid.). I am not sure if I would entirely agree with the latter assessment.

10 Visser 2014.

11 It may seem odd to emphasise a dining use for silver plate, but in fact it has been stated in the past that silver plate, both plain and decorated, was solely intended for display (Toynbee and Painter 1986: 15).

12 Summarised in Hobbs 2016: 274.

13 See, among others, Harper and Meyers 1981; Schneider 1983; Raeck 1992; Leader-Newby 2004.

14 Plouviez 2010.

15 Mango and Bennett 1994; Visy 2012; Nagy 2014 and 2015. After being in private hands for some decades, the treasure is now on permanent display in the National Museum of Hungary, Budapest.

16 For example, the sources drawn on by Melikian-Chirvani 1992; see also Canepa 2009: xvii–xx.

17 A good starting point, at least for the Roman material, is Wood 2000.

18 Almagro-Gorbea *et al.* 2000.

19 Toynbee and Painter 1986: no. 14.

20 Toynbee and Painter 1986: no. 15.

21 See, for example Hobbs, 2016: 270, pl. 409.

22 Symmacchus, *Epistles* 7.76: 'I present you with a … small two pound silver bowl' (translation after Cameron 1992: 180).

23 These bowls are all of a standard weight that follows on from the silver coinage denomination system, being produced at half a Roman pound, one pound and then multiples. They are also depicted in the insignia of the *Comes Sacrarum Largitionum* in the *Notitia dignitatum*. For a full discussion, see Hobbs forthcoming.

24 See n. 15.

25 Shelton 1981: 28.

26 Gunter and Jett 1992: cat. no. 18, online at https://asia.si.edu/object/S1987.113/ (accessed 15 May 2020). On another unprovenanced vessel in Baltimore, dated to the 6th to 7th century CE, the marriage alliance scene of a couple on a couch exchanging a wreath dominates the whole vessel surface (https://art.thewalters.org/detail/20943/plate-2/ (accessed 15 May 2020)). It should however be noted that in Melikian-Chirvani's discussion of the hemispherical bowl in the Sackler Collection (Gunter and Jett 1992: cat. no. 25; Demange 2006: cat. no. 70; online at https://asia.si.edu/object/S1987.105/ (accessed 15 May 2020)) there is a similar 'marriage alliance' scene which he interprets quite differently, suggesting that it is as a libation scene, with the wreath actually a metal ring/torque which is being handed to him by the woman (Melikian-Chirvani 1992: 103).

27 Examples include two dishes both with a portrait of Licinius found at Červen Breg in Romania in 1952 (Toynbee and Painter 1986: nos 10–11).

28 The four bowls from Qasr-i Shirin, reportedly found in a stack 'at a mound near Kermanshah in western Iran' (Gunter and Jett 1992: 157) have rim diameters ranging from 184 to 236mm; four similar bowls in the 'Munich' treasure range from 179 to 244mm.

29 Harper 1974: 76.

30 Harper 1974: 67–8. Cutler does seem to have noted the similarities (Cutler 2009: 14).

31 But hemispherical bowls continued to be used in central and south Asia: for example, two 'Hepthalite' bowls in the British Museum, dated between 400 and 600, both from Pakistan (BM 1963,1210.1–2).

32 Reproduced in Canepa 2009: 114, fig. 22.

33 Canepa 2009: 80. See also Harper in Harper and Meyers 1981: 126–7.

34 Normally the hunter-king is shown on horseback in the process of firing an arrow from a bow (e.g. vessels from Vereino: Harper and Meyers 1981: 61–3, 171, pl. 15, and Gunter and Jett 1992, cat. no. 13; and from Qazvin: Harper and Meyers 1981: 64–6, 172, pl. 17); sometimes the king is turning back and firing at his quarry using the so-called 'Parthian shot' (e.g. a plate from Sari: Harper and Meyers 1981: 52–5, 169, pl. 10; Demange 2006: cat. no. 26). Occasionally he is engaging with a beast at close quarters, using a sword (e.g. a vessel from Kercheva: Harper and Meyers 1981: 72–4,

133–4, 175, pl. 23; Trever and Lukonin 1987: cat. no. 7). Instead of a horse, the king might be riding a camel (e.g. a vessel from Turusheva: Trever and Lukonin 1987, cat. no. 13). Less commonly the king is shown on foot in the act of capture and dispatch of a beast (e.g. a vessel provenanced only to Iran: Harper and Meyers 1981: 63–4, 127, 172, pl. 16; Demange 2006: cat. no. 28). A different type of vessel – a hemispherical bowl on a high pedestalled foot and handles, with medallions depicting Bahram II and his wife and son, found in a grave at Sargveshi in Georgia – is a rare example of a vessel form with royal imagery that is not a small plate (Harper 1974: 63–4, cat. no. 2; Harper and Meyers 1981: 24–5, 125–6, 165, pl. 2). An unprovenanced example in the Al-Sabah collection shows in the central roundel a king spearing a boar encircled by a frieze of a horseback hunt in progress; the composition and style is so unusual, one has to wonder if this vessel is authentic (Carter 2015: cat. no. 83).

35 Marshak 1998: 90.

36 Canepa 2009: 156. Elsewhere he argues that silver vessels 'served as diplomatic gifts to foreign and internal potentates' (33).

37 Some vessels of unusual style, if they are given the benefit of the doubt with regard to their authenticity, have been suggested as being of provincial production – for example an unprovenanced plate in Washington, DC (Gunter and Jett 1992, cat. no. 15). The proportion of surviving vessels that might be considered to fall into the category of *largitio* or royal gifts varies between Rome and Sasanian Persia. I recorded around 500 vessels of Roman plate dated to the 4th century in my study of the Mildenhall treasure (Hobbs 2016: 260, table 26) but have only come across around 20 items of certain *largitio*, so roughly 4%. Of the *c.* 120 examples of decorated Sasanian silver, 34 vessels are of the 'hunter-king' type, so around 28%. Short of a comprehensive survey of surviving silver plate from each area, it is too early to say if much should be read into these contrasting figures.

38 For a description of the grave group from which this vessel derives, see Toynbee and Painter 1986: 25–6.

39 Harper and Meyers 1981: 81–2, 178, pl. 28; Trever and Lukonin 1987: cat. no. 2.

40 Canepa 2009: 192–201.

41 *SHA*, Aurelian 5.5–6, translation from Magie 1932. There is also an interesting quote in one of the letters of Sidonius Apollinaris, which, although a description of an embroidered textile, does invoke the common motif of the hunter-king on silver plate: 'Let foreign furnishings … show the hills of Ctesiphon and Niphates and beasts rushing … where the Parthian, wild eyed and cunning leaning over with face turned backwards, makes his horse go [forward] and his arrow return, flying from or putting to flight the pictured beasts' (*Epistulae* 9.13, translation from Dalton 1915).

42 Canepa 2009: 156–7.

43 See https://www.britannica.com/topic/Augustan-History (accessed 15 May 2020).

44 Canepa 2009: 158. Also 'its message [i.e. the hunter-king imagery] of sublimated violence and battlefield prowess was an important element of Sasanian official ruler representation destined for foreign consumption' – which rather assumes that these vessels were indeed made for an external audience, particularly a Roman one.

45 Cutler 2009: 13. He also refers to a quotation from Procopius concerning the transfer of silver to the Sasanian court in *c.* 540, to buy back hostages taken at Antioch by Khosro: 'the colourful vignette of the whores of Edessa stripping themselves of the adornment they had about their person' (10).

46 Cutler also makes this observation, although he goes on to state that 'vessels in this metal could well have travelled to and fro across the Euphrates' (Cutler 2009: 15).

47 In fact, Sasanian silver hunter-king plates seem more likely to have ended up much further east, as exemplified by a vessel found in the tomb of a Chinese official, Feng Hutu, found at Xiaozhan, Datong province, China (Harper 1990; Watt 2004: cat. no. 62).

48 Baratte *et al.* 2002: cat. nos 5–8.

49 Baratte *et al.* 2002: 45: 'It is indeed one of the few forms that expressly testifies to the relationship between silversmiths in the western world and Iranian artisans' (author's translation from the French). This idea is also given more weight by the fact that two other vessels in the assemblage have pieces of metal crimped into place to raise their profile, as noted by Lang in her study of the manufacture of the hoard: adding extra pieces in this manner to increase the height of relief decoration is a typical feature of Sasanian silver plate, not of Roman (Lang in Baratte *et al.* 2002: 99).

50 Zelazowski and Zukowski 2005; Boudartchouk and Genevieve 2010.

51 Trever and Lukonin 1987: cat. no. 39.

52 Trever and Lukonin 1987: cat. no. 40; Marshak 1998: 87, pl. XIC.

53 Trever and Lukonin 1987: cat. no. 23.

54 A theory proposed by Boudartchouk and Genevieve 2010: 93.

55 Almagro-Gorgea *et al.* 2000, with references. The platter is 740mm in diameter and weighs almost 50 Roman pounds.

56 Brown 2012: 96.

57 Harper and Meyers 1981: 67–8, 110–11, 173, pl. 19; Trever and Lukonin 1987: cat. no. 9; Demange 2006: cat. no. 34.

58 As Cutler puts it, 'If … [a] Sasanian silversmith took his cue from something like the missorium, the clue to its origin lies in the overall organization of his work rather than the appropriation of a single element' (Cutler 2009: 18).

59 The vessel is 260mm in diameter and weighs less than 1 kg.

60 Cutler 2009: 17.

61 Harper and Meyers 1981: 72–4, 133–4, 175, pl. 23; Trever and Lukonin 1987: cat. no. 7.

62 Hanaway 1988.

63 See n. 37.

64 Banaji 2012: 600–1.

65 Lapatin 2014.

66 Much of the discovery was dispersed and it may be the case that there are more pieces still out there than those published in the 1980s (Cahn and Kaufmann-Heinimann 1984) and more recently, when further pieces emerged from a local person's attic (Guggisberg and Kaufmann-Heinimann 2003).

67 Rütti and Aitken 2003: 34–6.

68 Dodd 1961: nos 20 and 27.

69 A number of hoards that contain Sasanian silver have been found in the Ural Mountains region in Russia (for example Klimova (Noonan 1982: appendix III, no. 3), Malt'seva (Trever and Lukonin 1987) and Sludka (Noonan 1982: appendix III, nos 2, 9, 16) but these hoards are a mixture of Sasanian and Byzantine pieces sometimes combined with locally produced objects. The hoard from Qasr-i Shirin (Harper and Meyers 1981: 25–6, 166) has already been mentioned in n. 28; a recently published hoard from Kermanshah, western Iran, has limited contextual information (Alibaigi *et al.* 2018); St John Simpson knows of some vessels from Afghanistan found together, currently unpublished (pers. comm.).

70 A fragment of a vessel in the Traprain Law discovery (Curle 1923: no. 108) and a complete vessel from the Vinkovci treasure (Vulić *et*

al. 2017: 143–5). One can imagine that these vessels were intended to serve flat fish such as plaice.

71 Trever and Lukonin 1987: cat. no. 35.

72 Dunbabin 2003.

73 Hobbs 2010.

74 Hobbs 2016: 54–5. Schneider took a similar view (1983: 130).

75 Demange 2006: cat. no. 48.

76 See also n. 9.

77 My impression is that Sasanian vessels are of a size that would imply individual rather than collective use (although vessels could be passed between individuals) and that there is more emphasis on vessels for the containment of liquid (implying drinking) than the presentation of solids (implying eating).

78 Exemplified by the rim of the sea-on-city platter from the Kaiseraugst treasure (Cahn and Kaufmann-Heinimann 1984: cat. no. 62) or the upper register of the central medallion in the eponymous platter in the 'Seuso' treasure (Mango and Bennett 1994: cat. no. 1) or the rims of four bowls in the Mildenhall treasure (Hobbs 2016: cat. nos 5–8).

79 Dunbabin 2003: fig. 86.

80 Demange 2006: cat. no. 72.

81 Marshak in Demange 2006: 130.

82 Harper 2006: fig. 40.

83 Harper 1992: 149. For example, two unprovenanced vessels in Washington (Gunter and Jett 1992, cat. nos 35 and 36, online at https://asia.si.edu/object/S1987.117/ and https://asia.si.edu/object/S1987.118a-b/ (accessed 15 May 2020)); and a vessel possibly from Iran (Weitzmann 1979: cat. no. 132).

84 Dr Qi Xiaoqing, pers. comm.

85 Harper 1988.

86 Melikian-Chirvani 1992. Although the main source from which this study is drawn dates to shortly before 1000, it is argued that it harks back to a tradition which goes back at least to the late Sasanian period. Thus the vessel is deliberately designed, when filled with wine, 'to symbolize the conjunction of the new moon and the sun, the orb of the sun being represented by the wine sung in Persian literature as liquid sunlight, alternatively golden as the sun [i.e. white wine] or red as the sunset light'. The author goes so far as to suggest that the wine itself was the symbolic of the blood of bulls drunk during pre-Zoroastrian religious ceremonies.

87 Baratte and Painter 1989: cat. no. 24; on the patens from Riha/Stuma, see n. 69.

88 Carter 2015: cat. no. 85.

Bibliography

Alibaigi, S., Moradi Bisotuni, A., Rahimi, F., Khosravi, S. and Alibaigi, H. 2018. 'The late Sasanian treasury of Qouri Qaleh Cave: votive offerings for a Mithra tmple in Kermanshah, western Iran', *Iran* 55(2), 227–52.

Almagro-Gorbea, M., Álvarez Martínez, J.M., Blázquez Martínez, J.M. and Rovira, S. 2000. *El disco de Teodosio*, Madrid.

Banaji, J. 2012. 'Economic trajectories', in S.F. Johnson (ed.), *The Oxford Handbook of Late Antiquity*, Oxford, 597–624.

Baratte, F. and Painter, K.S. (eds) 1989. *Trésors d'orfevrerie gallo-romains, Museum du Luxembourg Paris 8 Fevrier–23 April 1989; Musee de la civilisation gallo-romaine Lyon 16 Mai–27 Août 1989*, Paris.

Baratte, F., Lang, J., la Niece, S. and Metzger, C. 2002. *Le trésor de Carthage. Contribution à l'étude de l'orfèvrerie de l'antiquité Tardive*, Paris.

Boudartchouk, J.-L. and Genevieve, V. 2010. 'À propos de l'article de J. Zelazowski et R. Zukowski, "Deux plats en argent de l'antiquité

tardive au musée national de Varsovie": quelques données complémentaires', *Mémoires de la Société archéologique du Midi de la France* 70, 81–95.

Brown, P. 2012. *Through the Eye of a Needle: Wealth, the Fall of Rome, and the Making of Christianity in the West, 350–550 AD*, Princeton.

Cahn, H. and Kaufmann-Heinimann, A. 1984. *Der spätrömische Silberschatz von Kaiseraugst*, Derendingen.

Cameron, A. 1992. 'Observations on the distribution and ownership of late Roman silver plate', *Journal of Roman Archaeology* 5, 178–85.

Canepa, M.R. 2009. *The Two Eyes of the Earth: Art and Ritual of Kingship between Rome and Sasanian Iran*, Berkeley.

Carter, M. 2015. *Arts of the Hellenized East: precious metalwork and gems of the pre-Islamic era. Dar al-Athar al-Islamiyyah, the al-Sabah Collection, Kuwait*, New York.

Curle, A.O. 1923. *The Treasure of Traprain*, Edinburgh.

Cutler, A. 2009. 'Silver across the Euphrates: forms of exchange between Sasanian Persia and the late Roman empire', in A. Cutler (ed.), *Image Making in Byzantium, Sasanian Persia and the Early Muslim World*, Aldershot, 9–21.

Dalton, O.M. (ed. and trans.) 1915. *The Letters of Sidonius*, 2 vols, Oxford.

Demange, F. (ed.) 2006. *Les Perses sassanides. Fastes d'un empire oublié (224–642)*, Paris.

Dodd, E.C. 1961. *Byzantine Silver Stamps*, Washington, DC.

Dunbabin, K.M. 2003. *The Roman Banquet: Images of Conviviality*, Cambridge.

Grierson, P. 1992. 'The role of silver in the early Byzantine economy', in S. Boyd and M. Mango (eds), *Ecclesiastical Silver Plate in Sixth-Century Byzantium*, Cambridge, MA, 137–46.

Guggisberg, M.A. and Kaufmann-Heinimann, A. 2003. *Der spätrömische Silberschatz von Kaiseraugst. Die neuen Funde, Forschungen in Augst 34*, Augst.

Gunter, A.C. and Jett, P. 1992. *Ancient Iranian Metalwork in the Arthur M. Sackler Gallery and the Freer Gallery of Art*, Washington, DC.

Hanaway, W.L., Jr 1988. 'Bahrām V Gōr in Persian legend and literature', in *Encyclopedia Iranica*, vol. 3.5, 514–22, http://www.iranicaonline.org/articles/bahram-05-lit (accessed 15 June 2019).

Harper, P.O. 1974. 'Sasanian medallion bowls with human busts', in D.K. Kouymjian (ed.), *Near Eastern Numismatics, Iconography, Epigraphy and History: Studies in Honor of George C. Miles*, Beirut, 61–81.

— 1988. 'Boat-shaped bowls of the Sasanian period', *Iranica Antiqua* 23, 331–45.

— 1990. 'An Iranian silver vessel from the tomb of Feng Hutu', *Bulletin of the Asia Institute* n.s. 4, 51–9.

— 1992. 'Evidence for the existence of state controls in the production of Sasanian silver vessels', in S. Boyd and M. Mango (eds), *Ecclesiastical Silver Plate in Sixth-Century Byzantium*, Cambridge, MA, 147–53.

— 2006. *In Search of a Cultural Identity: Monuments and Artifacts of the Sasanian Near East, 3rd to 7th Century A.D.*, New York.

Harper, P.O. and Meyers, P. 1981. *Silver Vessels of the Sasanian Period*, New York.

Hayes, J.W. 1972. *Late Roman Pottery*, London.

Heather, P. 2006, *The Fall of the Roman Empire: A New History of Rome and the Barbarians*, Oxford.

Hobbs, R. 2010. 'Platters in the Mildenhall treasure', *Britannia* 41, 324–33.

— 2016. *The Mildenhall Treasure: Late Roman Silver Plate from East Anglia*, London.

— forthcoming. 'Forms of *largitio* and "denominations" of silver plate in late antiquity: the evidence of flanged bowls', in J. Mairat, A. Wilson and C. Howgego (eds), *Coin Hoards and Hoarding in the Roman World*, Oxford.

Lapatin, K. (ed.) 2014. *The Berthouville Silver Treasure and Roman Luxury*, Los Angeles.

Leader-Newby, R.E. 2004. *Silver and Society in Late Antiquity: Functions and Meanings of Silver Plate in the Fourth to Seventh Centuries*, Aldershot.

Magie, D. (ed. and trans.) (1932). *Scriptores historiae augustae, Volume 3*, Loeb Classical Library 263, London and New York.

Mango, M.M. and Bennett, A. 1994. *The Sevso Treasure, Part 1, Journal of Roman Archaeology* supplementary series 12, Ann Arbor.

Marshak, B.I. 1998. 'The decoration of some late Sasanian silver vessels and its subject-matter', in V.S. Curtis, R. Hillenbrand and J.M. Rogers (eds), *The Art and Archaeology of Ancient Persia: New Light on the Parthian and Sasanian Empires*, London, 84–92.

Melikian-Chirvani, A.S. 1992. 'The Iranian *bazm* in early Persian sources', in R. Gyselen (ed.), *Banquets d'orient, Res Orientales 4*, Bures-sur-Yvette, 95–120.

Nagy, M. 2014. 'Lifting the curse on the Sevso treasure: part I', *Hungarian Review* November 2014, 108–21.

— 2015. 'Lifting the curse on the Sevso treasure: part II', *Hungarian Review* January 2015, 109–23.

Noonan, T.S. 1982. 'Russia the Near East, and the steppe in the early medieval period: an examination of the Sasanian and Byzantine finds from the Kama-Urals area', *Archivum Eurasiae Medii Aevi* 2, 269–302.

Plouviez, J. 2010. 'Discovery and archaeological investigation of the site,' in C.M. Johns, *The Hoxne Late Roman Treasure: Gold Jewellery and Silver Plate*, London, 9–22.

Raeck, W. 1992. *Modernisierte Mythen. Zum Umgang der Spätantike mit klassischen Bildthemen*, Stuttgart.

Rütti, B. and Aitken, C. 2003. *Der Schatz. Das römische Silber aus Kaiseraugst neu entdeckt, Augster Museumshefte 32*, Augst.

Schneider, L. 1983. *Die Domaine als Weltbild*, Frankfurt am Main.

Shelton, K.J. 1981. *The Esquiline Treasure*, London.

Toynbee, J.M.C. and Painter, K.S. 1986. 'Silver picture plates of late antiquity: AD 300 to 700', *Archaeologia* 108, 15–65.

Trever, K.V. and Lukonin, V.G. 1987. *Sasanidskoye serebro, sobraniye Gosudarstvennogo Ermitazha. Khudozhestvennaya kultura Irana III–VIII vekov*, Moscow.

Vickers, M. 1995. 'Metrological reflections: Attic, Hellenistic, Parthian and Sasanian gold and silver plate', *Studia Iranica* 24, 163–85.

Visser, J. 2014, 'Sidonius Apollinaris, *Ep.* II.2: the man and his villa', *Journal for Late Antique Religion and Culture* 8, 26–45.

Visy, Z. (ed.) 2012. *A Seuso-Kincs és Pannonia (The Sevso Treasure and Pannonia)*, Pécs.

Vulić, H., Doračić, D., Hobbs, R. and Lang, J. 2017. 'The Vinkovci treasure of late Roman silver plate: preliminary report', *Journal of Roman Archaeology* 30, 127–50.

Watt, J.C.W. (ed.) 2004. *China: Dawn of a Golden Age, 200–750 AD*, New York.

Weitzmann, K. (ed.) 1979. *Age of Spirituality: Late Antique and Early Christian Art, Third to Seventh Century*, New York.

Wood, I. 2000. 'The exchange of gifts among the late Roman aristocracy', in Almagro-Gorbea *et al.* 2000: 301–14.

Zelazowski, J. and Zukowski, R., 2005. 'Deux plats en argent de l'Antiquité tardive au Musée National de Varsovie', *Archeologia* 61, 107–26.

Response to R. Hobbs, 'Use of Decorated Silver Plate in Imperial Rome and Sasanian Iran'

Rachel Wood

In the 12th century, the philosopher Ibn Zafar al-Siqillī conceived of a scenario 800 years before, in the 4th century, where the Sasanian *shāhanshāh* (king of kings) Shapur II, in disguise at the Roman court, was found out through his resemblance to his own portrait depicted on a silver dish.[1] The dish was one of many such Persian vessels and textiles avidly collected by Ibn Zafar's imagined Roman emperor in Constantinople. Although a fictional account intended to demonstrate the illustrious behaviour of bygone rulers, this narrative in Ibn Zafar's *Sulwān al-Muṭā fī* could be taken as an indicator of how, in the medieval Islamic world, it was credible to conceive of a late antique connected visual repertoire between the Roman and Sasanian worlds, facilitated by networks where the long-distance exchange and movement of objects could take place, at least on an imperial level. The account seems to concur with findspots of Sasanian and post-Sasanian silver plate and its iconographic representation, such as in the wall paintings at Panjikent (**Pl. 8.9**), that suggest a wide-reaching participation in Sasanian-inspired elite dining and display.

While Ibn Zafar's story is highly evocative, as is the tale in the *Historia Augusta* of Shapur I's gift to Aurelian of a silver plate bearing the sun god's image (see p. 140), employing these 'external' sources to discern evidence about Sasanian uses of silver plate is a complicated matter. In addition to the usual difficulties of the geographical and temporal distance of Ibn Zafar's narrative from its Sasanian and late Roman subjects, in the centuries following the mid-7th-century Islamic conquest, the empires of late antiquity were romanticised as emblematic of a golden age of noble and virtuous rulers. At the centre of caliphal court display, elements were included that made overt reference to the Sasanian *shāhanshāhs* and built upon aspects of their royal ideology, and motifs inspired by Sasanian art were popular on luxury items from Central Asia to Spain for many centuries after the fall of the dynasty. Ibn Zafar's text, as an instructive guide to contemporary rulers, can be seen as part of this conception of imperial inheritance. After the fall of the Sasanian Empire, Persian antecedents could be invoked as pointed signifiers of long-established practice and continuity, or, conversely for some, as a lamented contrast to the current state of affairs. The *Sulwān al-Muṭā* is one of several post-Sasanian texts that refer to the use of precious silver vessels in court practice and, in the absence of contemporary contextual written, visual or archaeological information, these snippets or distant echoes become even more tantalising, yet remain precarious sources for the study of Sasanian silver, as Richard Hobbs has outlined above.[2]

Hobbs's close engagement with Sasanian silver plate helps to refocus us on the methodological complications of studying the material evidence itself, objects which often form the dazzling centrepieces of museum displays and illustrated volumes yet often lack secure provenance or defy attempts to pinpoint their date of creation. While there are connections in the materiality of Roman and Sasanian silver plate, in their decorative forms and in their manufacturing technique, it is difficult to be confident whether this can equate to similar usage or associated cultural connotations. As is suggested in Matthew Canepa's ground-breaking study, royal use and direct gift exchange appear to be the

clearest point of connection between the material practices of the two empires with regard to gilded silver plate, a connection deliberately encouraged in the diplomatic ideology of Rome and Persia as 'the two eyes of the earth'.[3] Certain similarities in functions of these objects within each empire as outlined by Hobbs – as gifts, especially to honour nobles and client kings – are also notable. In these expansive empires where the central dynasty relied upon the support of local power structures, silver plate played a key role in negotiating relationships and fostering loyalty, as it was an effective means of bestowing honour through materially valuable and visually arresting, exclusive markers of status that could be displayed, hidden or monetised (see p. 138).

In his contribution, Hobbs lays out the state of play for silver plate in late antiquity across the Roman and Sasanian empires and elucidates many of the difficulties in embarking upon a comparative study of this prominent yet enigmatic material. From his thorough treatment, it is clear that analysing Roman silver plate comes with plenty of its own complications and issues, just as the Sasanian. Yet, when, as Hobbs notes, the archaeological contextual information and the written sources for each body of material are incommensurate, how can we attempt to make any meaningful comparisons or create a valid comparative framework, let alone negotiate the imbalanced weights of their respective historiographies? In the case of Sasanian silver plate, its role as a symbol of pre-Islamic Persian imperial splendour and as dazzling remnants of Zoroastrianism's last hegemonic period has given the material particular prominence within certain entrenched narratives.[4] Hobbs's paper also demonstrates in practical terms the problem of the imposition of Romanocentric and Christian-centric frameworks and it is worth acknowledging another 'elephant in the room': that classical archaeology's methodological framework is built upon the extraordinary amount of extant material, the associated literary record and the artistic and cultural habits of the Greeks and Romans. Transposing that methodology to the Sasanian world is highly problematic to say the least, despite the indisputable connections in ancient material culture and the tangible and necessary benefits of broadening outlooks in studies of the ancient Mediterranean world.

With this in mind, the place and role of borderlands around and especially between these two empires spring to the forefront of the discussion, as highlighted in Hobbs' study of the dispersal of silver plate. For the elite in the contested territories of upper Mesopotamia, for example, the possession and display of Roman or Persian silver plate must surely have been a more charged affair.[5] Other than royal diplomacy and gift exchange, however, what mechanisms enabled the movement of these objects? They are one category of many (along with, for example, luxury textiles and glass) which were expensive and highly portable, and which were carried along a network of trade and exchange routes, or were acquired or seen by travellers such as itinerant craftsmen, intellectuals or religious figures and envoys. While the creation or movement of these objects was likely subject to some level of court or state control, rather than being static representations of two binary empires, they are part of a more complex story involving many more

stages, roles and agents – a story that is often overtly visible in the damage wrought on them from later repurposing and deposition.[6] As Hobbs questions, what indeed counts as 'Sasanian' silver plate, especially since most of our examples were discovered outside the borders of the Sasanian empire, mostly in Central Asia and the Caucasian steppe? This is one of several areas where, owing to the lack of contextual archaeological information, we are at risk of brushing over heterogeneous features of the material. The eastern border regions of the Sasanian empire, such as Bactria, had their own strong traditions of art and cultural identity, and fluctuated in and out of Persian control. High-value diplomatic gifts and markers of esteem and loyalty would be extremely potent in this changing political environment, and would have distinct and complex significance to local audiences. Given the common provenance of Sasanian silver plate in Central Asia and the complex social and cultural history of the region, as well as its prominent history in shaping Sasanian fortunes, further study of this region's relationship to the Persian Empire, as well as looking further east to China and Southeast Asia, building on recent attention to the Silk Routes, would provide key insights into how this material was received and used.[7] Hephthalite agency is surely a key consideration in this story.

Another potentially homogenising aspect of the extant material record is the absence of firmly dated silver plate, compounded by the aforementioned paucity of Sasanian-period written accounts. It is unfortunate that suggesting contemporary contextual matters or other archaeological comparanda should be taken into account in order to interpret themes in Sasanian art – to account for ever-evolving relationships with images – is still a remarkably contentious issue in this field, especially when it comes to religion. And yet, pieces of evidence from disparate parts of the Sasanian empire or from without, or from different centuries, are often aligned in order to make a logical narrative. Identification of narrative strands traced from pre-Achaemenid Iranian lands through to the medieval Islamic empires, with associated interpretations from one context applied to another, is not uncommon. Recently, however, a more nuanced approach has been championed in the area of religious studies: heterogeneity and fluctuations are identified and emphasised in new histories of Zoroastrianism and also in studies of Sasanian relationships with material culture in sacred contexts.[8]

Relations with material culture were, of course, neither stable nor stagnant during the more than four centuries of the Sasanian empire: economic and functional dynamics, levels and centres of production, and the significance of the historical environment, to name but a few factors, all create different environments for the interpretation of an object. The major iconographic shifts on silver plate are a clear reminder of this. By the time of Shapur II (309–79), and for the following century, medallions depicting nobles no longer featured, and only the *shāhanshāh* was represented, with the royal hunter becoming the predominant royal motif on plates by the mid-4th century.[9] It is notable that, as Harper observes, this change in the use of ruler iconography coincided with Shapur II's increased centralisation of government and a modification in the use of imperial titles

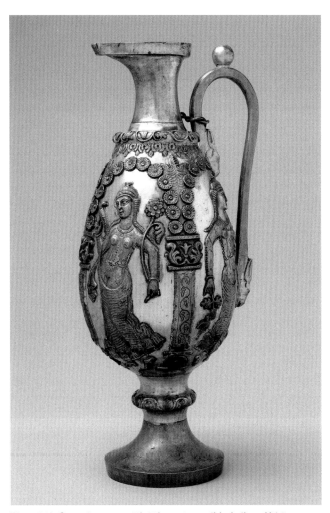

Plate 8.10. Sasanian ewer, 6th-7th century, gilded silver, H.34cm, Metropolitan Museum of Art, New York, 67.10a, b, Purchase, Mr. and Mrs. C. Douglas Dillon Gift and Rogers Fund, 1967

An added complication in analysis of late Sasanian silver plate is that much metalwork from the 7th and 8th centuries is difficult to date precisely even as Sasanian or post-Sasanian. The early Islamic elite favoured and patronised aspects of Sasanian luxury dining and display, blurring distinctions between one religio-political epoch and the next, without the assistance of more detailed scientific analysis of individual case studies, such as by using X-ray fluorescence. Images associated with Zoroastrianism continued to be commissioned and used by patrons and audiences under Islamic rule, most likely by wealthy Muslims as much as by members of the diminished Zoroastrian community. Motifs from Zoroastrian tradition, such as the *senmurw* (a mythical female creature formed of a winged dog with lion's forelegs and a peacock's tail), still featured on gilded silver vessels, as well as on other forms of luxury decorated products and in architectural ornament (see, for example, the cover image of this volume, a stucco plaque from Chal Tarkhan, and the Mshatta façade in Berlin). Whether continuation of form and image suggest the precise continuation of function and meaning, however, is another matter. In the decades immediately after the Islamic conquest, we might imagine that commissioning and displaying recognised and established markers of elite status and accepted ritual behaviour might be highly attractive in an era of anxiety surrounding changing power structures.

With these complications in mind, how can we incorporate the study of Sasanian silverware – a major component of the material record for the late antique Persian empire – into the study of religious practice, belief and experience? Gilded silver plate, whether as elegant and embellished bowls and plates, cups and rhytons (drinking horns), or ewers and vases, feature as the star pieces in museum collections: decontextualised, aesthetically appealing and embodying high-end luxury. Hobbs's initial research question – whether representations of belief relate to vessel forms – prompts many further lines of enquiry. Can we be confident, however, in the underlying premise that there are identifiable representations of 'belief' in the iconography of Sasanian silver plate? Scenes of bountiful viticulture, of the royal hunter or of animals that align with avatars of various *yazatā* (divine beings) may indeed bear positive connotations in Zoroastrianism that suit the function of the vessels as part of celebratory ritual activities of thanksgiving by the elite. But it is striking that images of *yazatā* do not feature for certain on silverware, as they do on rock reliefs and coins, despite optimistic identifications of numerous nimbate female figures as possible Anahitas (**Pl. 8.10**). Inclusion of the nimbus bestows a divine quality to scenes – seemingly presenting the figures as bearers of divine glory (*farr*) – but it is less clear what precisely this means for the identification of those figures and the implications for objects that bear such images. A syncretism of elements from Iranian religion with Dionysiac ritual was proposed to explain images of the divine intertwined with images of viticulture on objects for dining.[13] Other propositions take a more allegorical approach: the ordered and formal arrangement of the iconography may be demonstrative of the Zoroastrian dualistic view of the cosmos and the desire for truth (*aša*);[14] while inhabited vines and the general atmosphere of bounteous prosperity may be

on coinage, perhaps indicating a shift in the ideology surrounding Sasanian kingship. Shapur II was the last king to use the title *ke chihr az yazdan* ('from the lineage of the gods') on his coins, and it was phased out during his reign.[10]

By the late Sasanian period, there were a broader range of commissioners and more sources of silver exploited for the production of silver plate.[11] A new popularity in iconography on later Sasanian silverware for scenes predominantly composed of viniculture and female figures creates a strikingly different suggestion of the priorities in place that determined their decoration. Additionally, in the 6th and early 7th centuries, a gift of a silver dish from the king would have a very different collection of associations, bearing the weight of precedent, tradition and expectation by recalling practice before the turbulent 5th century, when production declined. Harper identifies the recommended production in the late Sasanian period as emblematic of a renaissance under Kavad I and Khosro I, the vessels and dishes being 'status symbols of a confident and prosperous elite'.[12] Given the presumed function as gifts to honour loyal members of the elite, it may be that the increased quantity of silverware indicates a new economic stability where there were reliable spare resources to allocate to this form of production yet at the same time intense insecurities surrounding political relations that required physical, visible gestures of prestige and loyalty.

illustrations of the rewards of living according to the Good Religion,[15] or act as visual allegories for the *hom* tree (the 'Tree of Life' and source of immortality) and *haoma* (the drink prepared by Zoroastrian priests),[16] and may align with the popular late Sasanian blessing of *abzōn* (increase) that appears on coins and seals of the period, often accompanied by abbreviated vine motifs.[17] It is also worth noting that Sasanian decorated silver vessels bearing scenes of nature's fecundity and youthful, beautiful and luxuriously dressed female figures have been interpreted as demonstrative of the moral decline of the kings into perpetual dining at the expense of pious behaviour.[18]

While Zoroastrianism of this period was a universalising religious philosophy inextricably linked to the rule of the Sasanian kings and the preservation of the empire, *Ērānšahr*, a more cautious approach to the precise relationship of the iconography on silver plate could be advanced. Bearing in mind the vast extent of the empire and the peoples, languages, and religions that it encompassed, and the political prominence of Christian, Jewish, Manichaean and Mandaean communities, including instances of members of those communities taking prominent roles in the imperial court at certain times in Sasanian history, it is possible that more ambivalent decorative schemes were desirable on objects functioning as diplomatic or political gifts.[19] Are silver vessels then not important for the study of Sasanian religion? In light of the caveats already discussed, keeping to the constructive side of cautious is quite a task. A focus on these silver vessels, objects presumed to have been commissioned and owned by the uppermost levels of society, might indeed be counterproductive by compounding the image of Sasanian Zoroastrianism as a 'state church' – of a centralised authority issuing carefully controlled products that align with orthodox practice – a characterisation that has been convincingly nuanced and argued against.[20]

Can we say anything about silver plate's connection to religion beyond use in a 'ritual banquet', or the iconography's emphasis on the ruler's divine glory or the prosperity and blessing with which the user might wish to connect themselves? While we can concede that what is ambivalent to the modern audience may not likely have been to the contemporary viewer, if we are to get anywhere at all with the extant evidence, it seems that we must embrace this ambiguity, rather than attempting to pin down one meaning.[21] As Hobbs has discussed, there is not enough information to determine whether objects bearing the king's image were intended for a distinctly different purpose from those bearing nimbate animals or female figures. It may be productive, however, to assume some intentional ambivalence. Use of dining ware in the socio-religious settings of ritual banquets – such as the *bazm* – provides some contextual allusions. In a religious environment where issues of purification and pollution were so central (Zoroastrian priests, for example, wear face coverings in order to avoid polluting the sacred fire), it would be credible that portraying images of divine beings on dining equipment, especially on a surface intended to make contact with the mouth, would not be acceptable. This lends additional support to the identification of a functional aspect of these gilded silver vessels, beyond that of display. Silver vessels

were intended to be touched, to be held in the hands. These more ambivalent images signifying the recognition and acknowledgement of divine favour and prosperity would also create fewer complications if the object were prone to be damaged during use or required to be melted down.

The materiality of the objects themselves is also suggestive. Silver's reflective qualities are multiplied by the curves of a lobed drinking vessel (the *rekāb*), with warmth provided by gilding imitating sunlight.[22] The *rekāb*'s lobes do not immediately suggest practicality for drinking, but they do create depth and movement in the reflection of light. Analogy to the light of the moon and sun provides sacred connotations in Zoroastrian thought, but the object's own reflectivity may be enough to associate it with the divine (see also, for this reason, the study of pearls as possibly bearing associations with light and divine glory).[23]

In order to deepen our understanding of how silver plate may have played a role in Sasanian religious experience, study of other media in conjunction with silver plate might be profitable.[24] Relationships between the production and use of silver plate and other media, especially expensive and portable items such as woven patterned silks and elaborate glass vessels, may provide fruitful avenues of enquiry, as well as enlightening other aspects of cultural exchange between the Roman and Persian empires. St John Simpson, for example, has shown how Roman glassware was imported into the Persian empire and then cold-worked to adapt it to Sasanian styles, elucidating a further complexity in the story of trade and the proactive reception of luxury goods from outside the empire.[25] Silver plate was unlikely to have been used or seen in isolation, and its relation to other visual demonstrations of elite status and resources would certainly have contributed to its impact upon contemporary viewers. Thus, Hobbs draws our attention to a complex yet vital avenue of research in the role of objects in late antique religious experience.

Notes

1 Kechicinian and Dekmejian 2003.

2 See, for example, Melikian-Chirvani 1992 on sources for the *bazm* ritual.

3 Canepa 2009.

4 For further on the use of pre-Islamic art and archaeology in modern imperial Iranian ideology, see, for example, Abdi 2001 and Grigor 2007.

5 On the character of this and other areas along the borders of the Sasanian empire, see Lawrence and Wilkinson 2017.

6 See Canepa 2009: 24–5 on the regulation of trade.

7 Rezakhani 2017. See Harper 1988 on connections and inspiration for Sasanian boat-shaped bowls from Central Asian and Chinese models. On this, see, for example, the gilded silver ewer discovered in archaeological excavation of a tomb in Guyuan, China, which provides an iconographic mélange, archaeological context and a *terminus ante quem* of 569 (Zhuo 1989).

8 Stausberg and Vevaina 2015. For further on this, see Wood 2020. Boyce 1975; Kreyenbroeck 2011.

9 Harper 1974 and 2006: 81.

10 Harper 2006: 81.

11 Harper 1992: 148 and 2006: 82.

12 Harper 2006: 82.

13 On this issue, see Shepherd 1964; Duchesne-Guillamin 1971; Callieri 2008; Mousavi Kouhpar and Taylor 2008.

14 Harper 1978:62 and 1986.

15 Harper 1986; Marshak 2002.

16 Melikian-Chirvani 1991: 52–3.

17 Harper 2006: 87. For further on this, see Masia-Radford 2013 and Wood 2020.

18 For further discussion, see Wood 2020: 231.

19 Payne 2015.

20 Russell 1986.

21 See Harper 1988: 340 on the identification of Christian crosses on Sasanian silver vessels. One might additionally consider the potential appeal of vine imagery to a Nestorian audience.

22 See Melikian-Chirvani 1992 on silver representing the moon and wine representing the sun, sunlight or liquid fire.

23 Soudavar 2003.

24 See Shaked 1994 and 1997; Simpson 2013.

25 Simpson 2015. See, for instance, the gilded silver vessel in the al-Sabah collection (Carter 2015: cat. no. 86) decorated with small bosses in the manner of Sasanian glass bowls.

Bibliography

Abdi, K. 2001. 'Nationalism, politics, and the development of archaeology in Iran', *American Journal of Archaeology* 105(1), 51–76.

Boyce, M. 1975. 'Iconoclasm among the Zoroastrians', in J. Neusner (ed.), *Christianity, Judaism, and Other Greco-Roman Cults: Studies for Morton Smith at Sixty*, Leiden, 93–111.

Callieri, P. 2008. '"Dionysiac" iconographic themes in the context of Sasanian religious architecture', in D. Kennet and P. Luft (eds), *Current Research in Sasanian Archaeology, Art and History: Proceedings of a Conference Held at Durham University, November 3rd and 4th, 2001 Organized by the Centre for Iranian Studies, IMEIS and the Department of Archaeology of Durham University*, Oxford, 115–25.

Canepa, M. 2009. *Two Eyes of the Earth: Art and Ritual of Kingship between Rome and Sasanian Iran*, Berkeley.

Carter, M.L. 2015. *Arts in the Hellenized East: Precious Metalwork and Gems of the Pre-Islamic Era*, London.

Duchesne-Guillemin, J. 1971. 'Art et religion sous les Sassanides', in *Atti del Convegno internazionale sul tema. La Persia nel Medioevo (Roma, 31 marzo–5 aprile l970)*, Rome, 377–88.

Grigor, T. 2007. '*Orient oder Rom?* Qajar "Aryan" architecture and Strzygowski's art history', *Art Bulletin* 89(3), 562–90.

Harper, P.O. 1974. 'Sasanian medallion bowls with human busts', in D.K. Kouymijan (ed.), *Near Eastern Numismatics, Iconography, Epigraphy and History: Studies in Honor of George C. Miles*, Beirut, 61–81.

— 1978. *The Royal Hunter: Art of the Sasanian Empire*, New York.

— 1986. 'Art in Iran v: Sasanian art', *Encyclopedia Iranica*, http://www.iranicaonline.org/articles/art-in-iran-v-sasanian (accessed 15 May 2020).

— 1988. 'Boat-shaped bowls of the Sasanian period', *Iranica Antiqua* 23, 331–45.

— 1992. 'Evidence for the existence of state controls in the production of Sasanian silver vessels', in S. Boyd and M. Mango (eds), *Ecclesiastical Silver Plate in Sixth-century Byzantium*, Cambridge, MA, 147–53.

— 2006. *In Search of a Cultural Identity: Monuments and Artifacts of the Sasanian Near East, 3rd to 7th Century A.D.*, New York.

Harper, P.O. and Meyers, P. 1981. *Silver Vessels of the Sasanian Period*, New York.

Kechicinian, J.A. and Dekmejian, R.H. (eds and trans.) 2003. *The Just Prince: A Manual of Leadership Including an Authoritative English Translation of the Sulwān al-mutā fī ʿUdwan al-Atba by Muhammad ibn Zafar al-Siqilli*, London.

Kreyenbroek, P. 2011. 'Some remarks on water and caves in pre-Islamic Iranian religions', *Archäologische Mitteilungen aus Iran und Turan* 43, 157–64.

Lawrence, D. and Wilkinson, T.J. 2017. 'The northern and western borderlands of the Sasanian empire: contextualising the Roman/Byzantine and Sasanian frontier', in E.W. Sauer (ed.), *Sasanian Persia: Between Rome and the Steppes of Eurasia*, 99–125.

Marshak, B.I. 2002. 'Zoroastrian art in Iran under the Parthians and the Sasanians', in P. Godrej and F.P. Mistree (eds), *A Zoroastrian Tapestry: Art, Religion & Culture*, Ahmedabad, 135–47.

Masia-Radford, K. 2013. 'Luxury silver vessels of the Sasanian period', in D.T. Potts (ed.), *The Oxford Handbook of Ancient Iran*, 920–42.

Melikian-Chirvani, A.S. 1991. 'From the royal boat to the beggar's bowl', *Islamic Art* 4, 3–111.

— 1992. 'The Iranian *bazm* in early Persian sources', in R. Gyselen (ed.), *Banquets d'Orient, Res Orientales* 4, Bures-sur-Yvette, 95–120.

Mousavi Kouhpar, M. and Taylor, T. 2008, 'A metamorphosis in Sasanian silverwork: the triumph of Dionysos?', in D. Kennet and P. Luft (eds), *Current Research in Sasanian Archaeology, Art and History: Proceedings of a Conference Held at Durham University, November 3rd and 4th, 2001 Organized by the Centre for Iranian Studies, IMEIS and the Department of Archaeology of Durham University*, Oxford, 127–35.

Payne, R. 2015. *A State of Mixture. Christians, Zoroastrians, and Iranian Political Culture in Late Antiquity*, Oakland, CA.

Rezakhani, K. 2017. *ReOrienting the Sasanians: East Iran in Late Antiquity*, Edinburgh.

Russell, J.R. 1986. 'Zoroastrianism as the state religion of ancient Iran', *Journal of the K. R. Cama Oriental Institute* 53, 74–142.

Shaked, S. 1994. *Dualism in Transformation: Varieties of Religion in Sasanian Iran*, London.

— 1997. 'Popular religion in Sasanian Babylonia', *Jerusalem Studies in Arabic and Islam* 21, 103–17.

Shepherd, D. 1964. 'Sasanian art in Cleveland', *Bulletin of the Cleveland Museum of Art*, 83–8.

Simpson, S. 2013. 'Rams, stags and crosses from Sasanian Iraq: elements of a shared visual vocabulary from late antiquity', in A. Peruzzetto, F.D. Metzger and L. Dirven (eds), *Animals, Gods and Men from East to West: Papers on Archaeology and History in Honour of Roberta Venco Ricciardi*, Oxford, 103–18.

— 2015. 'Sasanian glassware from Mesopotamia, Gilan, and the Caucasus', *Journal of Glass Studies* 57, 77–96.

Soudavar, A. 2003. *The Aura of Kings: Legitimacy and Divine Sanction in Iranian Kingship*, Costa Mesa, CA.

Stausberg, M. and Vevaina, Y.S.-D. 2015. 'Introduction', in M. Stausberg and Y.S.-D. Vevaina (eds), *The Wiley-Blackwell Companion to Zoroastrianism*, Oxford, xiii–xiv.

Wood, R. 2020. 'Connecting art and Zoroastrianism in Sasanian studies', in J. Elsner (ed.), *Empires of Faith in Late Antiquity: Histories of Art and Religion from India to Ireland*, Cambridge, 223–59.

Zhuo, W. 1989. 'Notes on the silver ewer from the tomb of Li Xian', *Bulletin of the Asia Institute* 3 61–70.

Chapter 9
Material Religion in Comparative Perspective: How Different is BCE from CE?

Christoph Uehlinger

This chapter seeks to question a hiatus existing in the historical study of religion\s between two fields, one concerned with 'ancient', the other with 'late ancient' or 'post-ancient' religion\s.[1] The distinction between the two is often typological rather than simply chronological. The chronological threshold labelled 'BCE' and 'CE' has of course no immediate relevance for many of the European or Asian societies addressed in this book. Yet it seems that the typological divide of 'ancient' vs 'late' or 'post-ancient' religion is epistemologically related to that threshold, since early Christianity (*the* CE religious formation *par excellence*) often serves as the major paradigm for 'post-ancient' religions. I suggest that scholars should question the threshold as well as its enduring epistemological impact and be as careful in studying continuities as they are in stressing differences between earlier and later forms of ancient religion.[2]

Studies of earlier and later ancient religion are generally carried out by scholars working in distinct disciplines, who rarely come together at conferences or interdisciplinary venues, and accordingly the curricula of students of early or late ancient religion rarely intersect. The perception of a deep hiatus between earlier or later forms of religion is largely rooted in this institutional status quo. Can method and theory, and particularly a strong focus on material and visual religion, help us to bridge the gap between the two fields?

My contribution takes the form of two sections. I shall first summarise the distinction sometimes made by historians of religion regarding two putatively distinct types of religion: on the one side, 'primary', 'locative' or 'ancient' religion; on the other, 'secondary', 'utopian' or 'post-ancient' religion. Such distinctions may help scholars conceptualise important issues; but they can also be misleading, since history rarely supports dichotomies. I will suggest that studying material and visual religion might bring discontinuity and continuities between BCE and CE religion in better balance. The second section will turn to data and summarise insights of a study on ancient 'Canaanite' and 'Israelite' religion which I co-authored with Othmar Keel many years ago.[3] That study focused almost exclusively on material and visual data (occasionally supplemented by epigraphic data); biblical texts were put between parentheses for methodological reasons. This option allowed us to highlight changes in the regional history of religion which text-based studies had never (or not as clearly) noticed before. More than 25 years later, some of our interpretations are necessarily dated or have proven wrong; but many remain, and the methodological option seems not to have been disproved. Looking back at that study with hindsight will allow me to reflect critically upon the place of material and visual culture in the study of religion. I shall argue that an approach based on material and visual culture is profitable to the study of late antique religion\s and, indeed, religion any time anywhere.[4] An exclusive reliance on textual data (much of it 'theological' discourse of elites) distorts the historian's perception of ancient religion, whether BCE or CE, as much as it would do in an anthropologist's or sociologist's study of contemporary religion. Studying religion in terms of artefact-related practices, a material and visual religion approach, can supplement and occasionally correct more conventional

text-based approaches. BCE religion and CE religion\s may differ in many ways from each other; but a consistent methodological agenda taking material entanglements and visual concerns as seriously as literary or theological discourse may help to better assess the difference itself.

The wider theoretical issue: 'ancient' vs 'post-ancient' religion?

Influential voices in the academic study of religion\s have over the past 30 years suggested a number of categorical distinctions between what they consider to reflect two fundamentally different types of religion. Type 1 religion ('T1') can be conceptualised sociologically (following Émile Durkheim) as the collective projection of a given society, well localised in space and time, its value system, hierarchy and power allotments. Rooted in local tradition, custom and habit, T1 conceives non-obvious agents in terms of a meta-social system (a kinship group, a royal household or the like) that often mirrors the social structure of local society, without copying it altogether – the non-obvious is easily granted more latitude and may transcend some of the contingencies and strictures limiting human action. Since the system reflects and seeks to manage a reality full of tensions, threats and unresolved suffering, opponent figures are thought to exist among the non-obvious entities; but they do not, in the final run, question nor undermine the assumed relative order of cosmos and society. The local collective celebrates its cohesion as a society and indeed community in rituals legitimising and stabilising the social and metaphysical regime. T1 is often construed as fully coextensive with social convention, if not 'locally common-sense' altogether; as such it is transmitted and inherited from one generation to the next without too much questioning. If the fabric of a local society is complex, differentiated and hierarchised, T1 will not only run different spaces of residence and interaction (temples) for different deities but will also accommodate cults which need not be equally binding for all members of society; however, such subsets do not generally contest the legitimacy of others.

Type 2 religion ('T2') is characterised by scholars as fundamentally optional and oppositional, based on conviction and conversion, a choice to become a member in an elective community and to adopt belief in the truth of this group's particular myth and its superior potential for salvation. T2 is said to occur historically in the form of different, often rival religions (plural), which generally evolve in competition, each contesting the others' claims to ultimate truth or soteriological capacity. T2 religions are often construed (homogenised) by scholars as '-isms' (such as Buddhism, Judaism, Manichaeism, Zoroastrianism),[5] '-ity' (Christianity) or (in German) an essentialised '-tum' (Christentum, Judentum).[6] This does not rule out their historic segmentation, fragmentation and differentiation into various sub-options, sects or 'heresies' (in the etymological sense of 'options'); on the contrary, the very production of heresies and a dynamic of centrifugal fragmentation vs centripetal disciplining is a systemic characteristic of T2 religions, especially when they are highly institutionalised and can rely on a state apparatus. While the invention of T2 has been attributed by some to

early Judaism (note Jan Assmann's concept of the 'Mosaic distinction', which has not gone uncontested)[7] most scholars draw on Christianity (their views and assumptions about Christianity), and to a lesser extent on Buddhism and on Manichaeism, when characterising T2.[8]

Scholars have theorised the distinction, and indeed the difference between the two types,[9] by a number of characteristics and qualifying adjectives, some of which are listed in **Table 1**. The final column points to basic theoretical implications of the word-pairs mentioned in the first two columns. The table combines categorisations by many different authors; such a list has never, to my knowledge and perhaps for good reasons, been drawn up in such a detailed manner. Each entry would require extensive discussion and refinement, first to credit those authors who have suggested appropriate terminology, second to do justice to those who have refined or criticised the typology or elaborated on a particular concept, and third to introduce nuances and to question the overall presentation's manifest simplicity. Further lines and criteria could be added to characterise differences between two types of religion; but I should point out that scholars generally draw on some criteria only (depending on their particular focus and interest) when discussing them.

The neat typological distinction presented in **Table 1** may, to some, look attractive and compelling at first sight: wouldn't it be tempting to correlate T1 religion with classical antiquity (that is, BCE broadly speaking) and T2 religions with late antiquity? On the other hand, once you compile a list of this kind, you become easily aware of the difficulty of applying the abstract typology to historically documented social formations (such as particular 'religions'). Each line added will increase this difficulty exponentially, to the effect that one starts to question the typology as such. This is precisely what I intend to do here, being convinced that historians of religion should resist the fallacies of binary typology.

Let me briefly comment on the first two distinctions, which have made an impact on the field because they were coined or used by well-recognised authorities.

'Primary' vs 'secondary' religion?

The distinction between 'primary' and 'secondary' religion (or primary vs secondary 'religious experience'; no. 1 in **Table 1**) was suggested in the late 1970s by Theo Sundermeier, then professor of Christian mission studies at the University of Heidelberg. It is based on Sundermeier's observation of a hiatus and mismatch between African traditional, village- or tribe-based religion on the one hand, and 'world religions' imported from the north and east by Christian and Muslim conquerors and missionaries on the other hand. The latter claimed undivided truth for their doctrines, rejected local religion as pagan idolatry, and promised salvation to people whose world-view was neither prepared nor searching for such an offer.[10] Sundermeier's distinction was soon picked up by his then Heidelberg colleague, the Egyptologist Jan Assmann, who first applied it to conceptualise the profound transformation introduced in ancient Egyptian religion by King Akhenaten's (Amenophis IV's) 'monotheist' exclusive cult of Aton (the deified sun-disc). In a later, broader move, Assmann

Type 1 religion	Type 2 religion\s		Comments on emphasis and theoretical implications
primary	secondary	1	temporal sequence (primordial vs subsequent, earlier vs later)
locative	utopian	2	spatial metaphor (here vs there)
embedded	disembedded	3	relation to context (structure vs agency)
world-affirming	world-negating	4	relation to social context (II)
immanentist	transcendentalist	5	cosmological focus
local	transregional, transportable	6	emphasis on (im)mobility (static vs dynamic and adaptive, potentially global)
particular	universalist	7	relevance and claimed validity
traditional	revealed	8	origin and authority of significant knowledge (conjunctive vs disjunctive)
oral, practical, material performance	text-based, scripturalised	9	media and authority, skills required to access relevant knowledge
cumulative or transient	selective, canonical, persistent	10	mode of cultural and religious capitalisation
sacrifice, cult	scripture, prayer, symbol	11	preferred media for ritual communication and value reproduction
imagistic	doctrinal	12	modes of religiosity
material mediation	mediation inside the human subject	13	mode of mediation
habitus (*praxis*)	belief (*doxa*)	14	mode of appropriation
collective (external) effervescence	inner experience	15	primary site of experience
acquired	optional, elective	16	subject position
socialisation	conversion	17	implicit appropriation vs actively reflexive commitment
civitas, ethnos	religious community	18	emphasis on belonging
descent	elective group membership	19	criterion for participation
Inclusive	exclusive	20	dominant mode of boundary-making and group designation (being part of all vs significant others)
social integration	salvation	21	most valuable good promised
cosmotheism, polytheisms	monotheism	22	basic theological frame
'ancient'	'post-ancient'	Σ	note emphasis on temporal sequence and giving way (earlier vs later, old vs new, retrospective vs prospective, past- vs future-oriented, etc.)

Table 1 Distinguishing two 'ideal types' of religion. Note: based on Lincoln 2004, the distinction of 'ancient' vs 'post-ancient' may serve as a kind of summative synthesis of this table

contrasted ancient Egyptian 'cosmotheism' (which he classified as 'primary religion') with the Hebrew Bible's assumed exclusive monotheism, which thus became his model for 'secondary religion'.[11] According to Assmann, the essence of 'biblical religion' is a covenant binding together in uncompromising mutual loyalty and love a chosen people (Israel) and one god (Yahweh), compared to whom all other deities fade to the status of idols, non-gods or 'nothings'.[12]

Based on this opposition of two rather unequal *comparanda* (Egyptian religion as construed from ancient inscriptions vs a theological construct extracted from the Hebrew Bible), Assmann's paradigm has met with some criticism;[13] but the concept of a 'Mosaic distinction', which encapsulates the theory as a whole, has successfully made its way into studies on the ancient world at large. Assmann's use of 'primary' vs 'secondary' religion has encountered occasional scepticism; but the distinction has been adopted by Hebrew Bible scholars to characterise a fundamental divide *within* the materials they deal with.[14] 'Primary religion' here designates *ancient Israelite* religion, whereas 'secondary religion' refers to *early Judaism*, more specifically the religion of those who, according to biblical

historiography, detached Judaism from its Canaanite past and the 'false gods' of its neighbours during the late Persian and Hellenistic periods.

The Babylonian exile is generally considered the major watershed between 'pre-exilic' Israelite religion ('primary') and 'post-exilic' early Judaism ('secondary') – note the pre/post qualification of a historical turning point. This notion of a hinge, or axis, separating the former from the latter and explaining historical (r)evolution from one to the other is another important element in the theory's conceptual makeup. It is indirectly related to axial age theory, another famous Heidelberg paradigm.[15] Depending on the particular historical data and contexts, the hinge may be conceptualised using other cognitive metaphors (crisis, revolution, turn … or conversion).

'Locative' vs 'utopian' religion?

The distinction between 'locative' and 'utopian' religion (no. 2 in **Table 1**) has a different academic origin, namely the University of Chicago. It was influentially developed by J.Z. Smith in studies exploring the emergence of Christianity in its Greco-Roman contexts and the

comparison of early Christianities with other late antique religions.[16] Smith built the assumed contrast of two types of religion on a spatial distinction applied to geographical as well as mental space: as outlined above, 'locative' religion is rooted in a given place, and it is meant to provide a stable social regime to that place here and now; in contrast, 'utopian' religion, a product of multiple diasporas, stands in tension with any actual, immanent regime. Its ideal alternative is some kind of counter-world, a new cosmos or a transcendent reality existing somewhere (beyond) but yet to come (if ever) into this world. Being detached from one particular locale and having its ultimate goal out there in the counter-world, 'utopian' religion can as a rule (except in cases of persecution) be practised anywhere by those who believe in its cosmology, its end and the ways of salvation leading from the deficient here to the hoped-for there.

As Smith and others have argued, the primary location of 'utopian' religion is the believer's inner self[17] and the ritually mediated experience of salvation in a community of believers (as opposed to society as a whole). But 'utopian' religion can be potentially ubiquitous, out of which early Christians, Manichaeans and others would craft an argument for claiming superior truth. The obvious structural problem is how widely diffused cells of a given 'utopian' religion can be coordinated among each other. The answer to diffusion must be communication and, more specifically, the reliance on a restricted set of normative scriptures (or images for that matter) as media of homogenisation. T2 religions tend to define core beliefs and transmit their knowledge through scripture; they are generally conceived as scripturalised 'book religions',[18] to which, in a material and visual culture perspective, we should add the binding power of key icons.

Since T2 religions are meant to be optional and do not generally embrace society as a whole, however, a concomitant problem will be the emergence and coexistence, within a given social space, of rival teachings, whether different T2 religions or variants of one alongside each other. If one particular group takes control of civic order, this will sooner or later lead to the discrimination and/or exclusion of dissenters. Built on the promise of a truth that can only partially be verified through experience here and now, and whose ultimate reality is transcendent and will fully deploy only in another, or the next world, T2 religions inevitably developed an entirely new regime of truth, most notably the management of truth through belief (or a particular version of it: faith), rhetoric, discipline and/or coercion.[19]

Genealogy: 'ancient' vs 'post-ancient' religion?

The question is whether our binary typology should be used exclusively for heuristic purposes, with T1 and T2 serving as 'ideal types' in a purely theoretical sense, or whether particular religions (or 'states of religion' within particular societies) – that is, real-world entities – should be construed as either T1 or T2 religion\s. Can T1 or T2 be identified in real-world history? As noted above, different scholars have referred to different items of **Table 1** with regard to their respective field, interests and research questions. It seems natural to assume that, whenever applied to other fields, any given distinction will tend to fit imperfectly if at all. Another

question is whether the two types should be considered to be mutually exclusive when it comes to real history, and whether T2 should be assumed to have historically supplanted T1 at a given period in time. The latter seems to be taken for granted when Bruce Lincoln, a leading historian of ancient religion, opposes what he terms 'ancient' to 'post-ancient' religion. Take the following quote from the summary of his epilogue to an authoritative collective guidebook entitled *Religions of the Ancient World*:

> As ancient religion gave way to post-ancient, one could observe a *discourse* based on canonic corpora of sacred texts displacing inspired performances of sacred verse; *practices* of prayer, contemplation, and self-perfection displacing material mediations through sacrifice and statues of the deity; deterritorialized elective *communities* constructed on the basis of religious adherence displacing multistranded groups, within which ties of geography, politics, kinship, culture, and religion were isomorphic and mutually reinforcing; and *institutions* that, with some exceptions, had better (also more creative and varied) funding, a wider range of activities, and more autonomy from the state, displacing their weaker, more localised predecessors.[20]

This statement seems to indicate that the typology presented in **Table 1**, despite its many problematic aspects, operates in the mind of even a most critical, and knowledgeable, scholar not just in terms of a heuristic, but as a template for the long-term history of religion\s and its transition from classical to late antiquity, that is, a historical (r)evolution. Lincoln puts considerable emphasis on the claim that significant features of 'ancient religion' (our T1) were *displaced* in 'post-ancient' religion\s (T2). To be sure, he is fully cognisant that changes toward the 'post-ancient' came 'piecemeal'; antiquity broke down gradually and ended – if at all – 'only in fits and starts'.[21] But his summary condenses a dichotomic binary opposition of 'ancient' vs 'post-ancient' religion, and the former's 'giving way' to the latter. Although probably not intended (unless by way of tongue-in-cheek irony?), Lincoln's quote can easily be (mis-?)read as a scholarly version of religious supersessionism.[22]

Dichotomies, real-world history and material mediations

Readers will have understood by now that I am sceptical about the historical validity of this typology when applied to real-world history. The main difficulty I see is its dichotomic structure. Dichotomies tend to overstress differences in terms of contrast and to level out possible nuances, intermediate and transitory states between two end points of a spectrum.[23] When drawn up in a table (as done here), the two-column structure tends to mask tensions, degrees and nuances. No real-world historical formation will identify completely, and exclusively, with either type. More importantly perhaps, the two 'ideal types' and the whole spectrum between them can at times coexist within complex religious formations.

Two aspects of the dichotomy seem particularly unsatisfactory. First, primary/secondary or ante/post language tends to give way to an evolutionary (or revolutionary) subtext rarely made explicit, namely (r)evolution/development from T1 to T2, a discourse

masking the possibility (which history will often demonstrate as a fact) that processes and transitions may as well occur the other way, that is from T2 to T1 (a process which historians will be careful not to interpret in terms of 'regression'). The latter certainly occurred when Christianity rose from minority cult through tolerated movement to ultimately major imperial religion, in which process it incorporated a vast heritage of previous civic and imperial arrangements. 'Old religion' was thus transformed, not simply replaced – but so too was 'new religion'.[24] Second, scholarly and modern religious discourse tend to evaluate T2 religions as more critical, more mature, more individual and more sophisticated: in a nutshell, more fit for modernity than T1. This becomes plain when T1 and T2 formations are distinguished within one particular religious tradition (for example, Judaism vs Christianity, or 'Israelite religion' vs early Judaism); and, on macro-scale, whenever axial age theory and related cognitive metaphors are brought into the discussion. Theories of that kind abound in *religious* discourse legitimising dissociation of later from earlier stages of a religion. They come with a huge amount of normative assumptions and power implications, which historical scholarship should keep at a distance.

Historic religious formations will usually display mixed combinations of T1 and T2 features. It seems reasonable, for instance, to recognise some 'post-ancient' characteristics in late antique Judaism alongside others which, like ethnicity, would rather rank as 'ancient'. It is unclear in the case of the Judaic tradition whether the transition from 'ancient' to 'post-ancient' should be related to the exile (as most Hebrew Bible scholars contend), to the Maccabean crisis and Hasmonean rule in the 2nd and 1st centuries BCE (as many historians of 'ancient' or 'early Judaism' would argue), to the loss of the Jerusalem temple in 70 CE or to the late antique emergence of diverse forms of rabbinic Judaism in Palestine and Mesopotamia. While one might consider that Israelite and pre-exilic Judahite religion had definitely been a case of 'ancient' (or 'primary') religion, early Judaism clearly passed through various stages of transformation towards a state we might characterise as 'post-ancient'; but it never fully abandoned some T1 features such as ethnic definition. Although some openings for optional membership would be introduced in diaspora settings, Judaism never became optional in the same sense as Mithraism or early Christian or Manichaean religion.

One should further acknowledge a variety of simultaneously but locally separate forms and developments within many religious traditions since the Persian period and allow for a great spectrum of diverse local arrangements. All this makes it difficult to consider a given religious formation as 'post-ancient' *per se*, unless it emerged under definitely 'post-ancient' conditions and circumstances. But even the history of early Christianities or Manichaeism(s) needs to account for a great variety of different regional developments. 'Utopian' as they may have been in mind, particular communities developed in specific local contexts and had to arrange themselves with as many constraints as required by their given context.[25] Choosing to join a Christian community might well have implied, at the time of conversion, a disembedding move for an individual,

but the disembedding need not have been complete in each case, and the community itself would remain connected to wider society or sooner or later re-embed itself into the local social fabric. If we follow the rise of Christianity from a great variety of only partially disembedded local communities, each with its own arrangements and entanglements, through pre-Byzantine attempts at coordination and negotiation of diversity to the establishment and consolidation of an imperial Church in the Mediterranean arena, there can be no doubt that this tradition was demonstrably and entirely *re-embedded* into an imperial social order, which in many ways resembled previous T1 religion as much as it contained obvious T2 features.[26]

I therefore suggest that we use our table of distinctions only as a heuristic, and that *for strictly heuristic purposes* we transform our dichotomy into a *triangular* arrangement. Let us consider any historically circumscribed religious formation in terms of its relations to both T1 and T2, taking each feature as a variable. Does a particular set of data point to T1 or to T2, to some intermediate position or to the simultaneous existence of T1 and T2 features? Are these clustered, distinguishable according to social level (such a elite vs popular, imperial vs local) or competing with each other? A given formation will rarely occupy the same relative position with regard to all the features listed in **Table 1**.

According to Lincoln, one of the characteristics of the transition from 'ancient' to 'post-ancient' religion is that '*material mediations of every sort diminished in their import*. They were displaced – although never completely – by practices that relocated the prime site of interest and action inside the human subject.'[27] This statement is crucial for the argument I shall develop in the following section. If Lincoln were right *stricto sensu*, there would be no point in arguing a material religion approach to late antique and any other 'post-ancient' religion. I suspect, however, that a major difference between 'ancient' and 'post-ancient' (or BCE and CE) religion is *not* the progressive vanishing of material mediation or religion-related material culture but, perhaps, the virtual explosion of religious literature and, no doubt, the latter's privileged consideration as an object of study in religio-historical research. *Pace* Lincoln, I submit that material mediation and material culture were no less important in 'post-ancient' religion\s than they had been in 'ancient' religion, but that scholars may have paid less attention to the material as religion\s became increasingly talkative and thus produced an ever-growing amount of textual data. Yet religion never got rid of material mediation completely (as actually conceded by Lincoln). Material mediation always remained and, ultimately, *is* an essential requirement for any social formation dealing with the non-obvious in discourse, practice, community and discipline. The question, then, is how to address material and visual data, and the practices of mediation related to them, as an essential aspect of the study of religion as such.[28]

Questioning premises and assumptions, methodology and theory

Gods, Goddesses and Images of God (henceforth *GGIG*) was co-written with my teacher and colleague Othmar Keel. More than a quarter of a century has passed since its original

publication in 1992, but the book continues to be cited, for better or for worse, as a standard reference for ancient 'Canaanite' and 'Israelite' religious iconography. We were concerned with a more strictly historical, contextualised analysis of material and visual data, especially so-called minor arts from 2nd- and 1st-millennium BCE Palestine: stamp seals, amulets, ivory carvings, metal or terracotta figurines, coinage (attested in Palestine since the late 5th century BCE) and more, retrieved in archaeological excavations. These materials are interesting data for the historian of religion on several grounds: they can be localised and dated individually, classified as groups and studied in terms of production (sometimes 'workshops'), distribution and consumption. Broadly speaking, they demonstrate how much the ancient southern Levant was an integral part of the ancient world, an important node of political, economic and ideational communication networks operating between regions as far apart as Egypt and Mesopotamia, their horizon also including the Arabian peninsula, Iran and Anatolia, the Aegean and the western Mediterranean. Regional small-scale polities operated a variety of more localised networks. It is this tension between the supra-regional and the local, and the degree to which larger conjunctions impacted local social formations while being adopted and adapted by them, that can be studied in detail on the basis of ancient material and visual culture. The latter offers an interesting background, and indeed primary source material, for the study of ancient religion, a background which differs from and usefully supplements the textual data generally studied by historians of religion and exegetes of ancient scriptures.

Methodologically speaking, *GGIG* operated on two basic premises. The first – that visual data can extend and supplement historical research in genuinely different and often surprising ways – has been emphatically welcomed by colleagues in the field, even those who would not integrate it in their own scholarly practice. The other remains contested: that historical research should prioritise datable archaeological evidence over biblical texts, which can rarely be dated and localised with sufficient precision to serve in a strictly historical argument.[29] That said, one should stress that, despite significant advances in absolute dating methods, archaeology generally performs better in dating artefacts by relative rather than absolute chronology. The study of material and visual culture is therefore most rewarding when we address Fernand Braudel's middle ground of history and time: that is social and political conjunctures as distinguished from *histoire événementielle* on the one hand, *histoire de la longue durée* on the other. I shall now try to look back at *GGIG* from the point of view of methodology and theory, with a hindsight of 25 years and a change of disciplinary perspective.[30]

Material basis, data selection, interpretations

To investigate non-textual (and especially non-literary) artefacts makes the student enter what we might term a different dimension of history: instead of language and ideas, one deals with material artefacts in the first place, their physical characteristics, potential and limitations. 'Material' means studying physical transformation and

manipulation and implies a concern for whole 'object-biographies' and their affordances. Questions are raised about the origin of raw material, place(s) of transformation, techniques, skills and tools employed, choices with regard to the object type, its decoration, subsequent circulation, consumption, disposal and so on. The primary interest of *GGIG* was admittedly with iconography. But artefacts should not be simply treated as media – that is, as carriers of messages (let alone messages for us); they were first of all commodities produced and used for particular, socially constructed and negotiated purposes and functions. Almost inevitably then, dealing with artefacts makes one imagine people operating in society (this in stark contrast to those approaches to texts that construe an *implied* author or reader, consciously detaching them from *actual* historical authors and potential readers). The ultimate concern of a historian working with artefacts will be society, even when focusing on religion.

On these grounds, some of the most obvious shortcomings of *GGIG* can be easily identified: the material basis from which we developed our argument was determined by previous work on the *Corpus of Stamp-Seal Amulets from Palestine/Israel*, a long-term project of painstaking documentation initiated by Othmar Keel in the early 1980s.[31] Stamp seals took the lead in our discussion, not only because they represented the class of potentially relevant artefacts that had been the most neglected by previous and contemporary scholarship but also because they were the most easily available data for our study. We did bring in other artefact classes, but in a rather unsystematic way, whenever this seemed appropriate or whenever then-current debates prompted us to do so. Exhaustive documentation was not our aim (which became a problem when later readers limited their involvement to the digest instead of themselves diving into the mass of primary data available). That said, I do not think (and, to my knowledge, reviewers did not point out) that we missed crucial evidence then available.[32]

More importantly, I have come to doubt some of the book's bolder hypotheses: for instance, our theory about a sliding withdrawal of the Israelite goddess (or goddesses) from anthropomorphic imagery to purely symbolical, tree-like representation. Keel and I have also come to rather different views about whether or not Yahweh (the major deity in Israelite and Judahite religion) would have been represented anthropomorphically in his Jerusalem temple.[33] My own research has led me to doubt whether ancient Israelite and Judahite religion significantly differed from that of their neighbours, and whether the usual ethno-national labels are useful classifiers in this regard.[34] While I remain strongly interested, with many others, in understanding religious diversity in the ancient southern Levant, and prepared to re-evaluate any evidence pointing toward peculiar Yahwist formations within a general model of regional diversity, I do not think, for theoretical reasons, that historical reconstruction should operate from premises assuming a fundamental distinctiveness or exceptionality of 'ancient Israel's' religion – of any religion, as it were. Such premises are based on religious discourse itself. That some Judahite scribes among the biblical writers considered their

religion as genuinely distinctive and their god as genuinely different from any other (non-gods or 'nothings', in the view of the hardliners) is a matter to be historically explained, an *explanandum*, by no means an *explanans*.

The move to the wider comparative study of religion has further contributed to create something of an epistemic distance between *GGIG* and my more recent work. Unlike most conventional biblical exegesis (and 'biblical archaeology', for that matter), the academic study of religion\s is a heavily theory-driven, almost obsessively self-reflective discipline, which considers scholarship itself to be a genuinely constructive endeavour (rather than simply a reconstructive one). In such an epistemological framework the critical (at times, deconstructive) engagement with the history and historiography of scholarly research has become the rule rather than the exception in my research. I have become more aware than previously how much the arena in which we produce and publicise our research affects the way we approach, select and analyse our data and turn them into 'sources'. Proper historical methodology requires a methodological bifocalism or double historicisation of sorts, implying a critical awareness and assessment of the concepts and assumptions, institutional settings and disciplinary conventions that frame and impact one's own historical inquiry alongside the more conventional concentration on data or sources from the past.

Unresolved dilemmata: what data should count (or count first) in the history of religion\s?

Studies on the history of ancient Israelite and Judahite religion – more than on the religion of ancient Ammonites, Arabs, Arameans, Edomites, Moabites, Philistines and Phoenicians ('peoples' whose practices and beliefs are often conceptualised as distinct 'religions') – have always had to struggle with the question whether and how to correlate archaeological and epigraphical data with canonical biblical literature.[35] The latter has, over the centuries, acquired such a prestigious status as *sacra historia* and charter myth of modernity (and, lately, of the Jewish state as well) that even hardboiled secular historians will not easily dismiss (nor even bracket temporarily for heuristic purposes) biblical texts when addressing the 1st-millennium BCE political, cultural and religious history of the southern Levant.[36]

Although the days of fierce antagonism between so-called 'minimalist' and 'maximalist' positions regarding the use of the Bible in historical scholarship seem to be counted, books weaving together biblical with non-biblical, literary-traditional with archaeological (that is, recently recovered and contingent, but generally datable and strictly contextualised) data into a kind of harmonious synthesis continue to be published at a regular pace and find relatively large audiences. Nadav Na'aman, an eminent critical historian of ancient Israel, has raised strong protest against some of his colleagues' attempts to rewrite the history of ancient Israel and Judah first and foremost on the basis of archaeological data.[37] Archaeology, he argues, has an important contribution to make but does not deserve a status of high court judging in biblical and historical research (note 'and', which rightly distinguishes 'biblical' from 'historical'). On the other hand, some of the most prominent

'archaeology first' historians seem to have turned into biblical scholars themselves, offering revisionist views and historicising re-dated biblical texts with little consideration for the subtleties of literary analysis.[38] Another group of top-level scholars, who have met over twenty years under the umbrella of the so-called 'European Seminar in Historical Methodology', has recently brought its work to an end.[39] This engaged and sophisticated scholarship has been almost exclusively produced by biblical scholars; it comes as no surprise that the historical reliability or proper historical situation of selected biblical texts should have been the main focus of the group's discussions.

Looking at the three interested subfields (the history of ancient Israel and Judah, the study of biblical historiography, and the archaeology of ancient Israel and Judah from the Iron Ages to the Hellenistic period) from a certain distance (and with great sympathy for all participants), it strikes me that the political, cultural and religious history of the 1st millennium BCE southern Levant remains spellbound by the monumental presence of the Bible in even the most critical scholars' minds. One may also point out that recent reconceptualisation of the Bible as 'cultural memory' has added a further nuance to its status as a prime referent for historical, and especially religio-historical, research.

Proper historical methodology requires that we distinguish between contextualised and datable evidence ('primary data') on the one hand, and heavily edited tradition-literature ('secondary, tertiary … sources') on the other, in terms of both status and analytical procedure.[40] The concept of cultural memory embedded in traditional, ultimately canonical literature – a concept widely discussed in recent cultural theory and usefully applied to biblical literature[41] – in my view strengthens rather than diminishes the need for a rigorous procedural separation. There may of course be instances (perhaps a few, or many) where the (biblical) literary tradition preserves some sort of historically reliable memory of much earlier events, agents, discourses, practices or value settings. Such instances, however, cannot be simply assumed as the generally valid default option; they need to be demonstrated by proper critical argument.

To stick to a procedure based on the procedural(!) analytical priority of 'primary data' (that is, data from the actual chronotopical context that is the focus of an inquiry) is not an easy task, however, since it requires that scholars manage to at least provisionally (heuristically) bracket what they know (or think they know) biblical literature reports about the ancient southern Levant, and especially about Israelite and Judahite societies and religion. Freeing one's mind from the mould of assumptions derived from the Bible, Bible-related religious education and/or diffuse cultural memory requires us to address 'Israelite religion' in the same terms as any other variant of southern Levantine religion (thus making it comparable on equal terms in the first place), and to fully expose religio-historical research to anthropological, culture-historical and sociological theory.

Coming back to *GGIG*, probably no scholar would contest that to take into account the archaeological (and, in our focus, the visual, iconographic) record of ancient Levantine societies is an important, even indispensable aspect of

critical religio-historical research. It seems obvious that material and visual data contain key information about ancient practices and the ancient imaginary that have no direct equivalent in the literary record, whether biblical or extra-biblical. It is the procedural prioritisation, over against the biblical record, of these materials that many scholars working in the highly specialised research environment of biblical studies and 'ancient Israelite religion' find more difficult to accept. One reason is that it requires a very different training from theirs. That said, similar open-mindedness is also required on behalf of scholars with a special training in the study of ancient images: we too will have to learn to look at our data in new and more sophisticated ways. Our studies have long focused on iconography and iconology: that is, the interpretation of images according to their semantic quality and 'meaning'. Text interpreters by training, we may have remained a bit too close to Erwin Panofsky's meaning-oriented methodology for the history of art.[42] We may have to better grasp in future research that images should not be studied in isolation from the objects on which they appear. And, in the same way as the study of ancient texts has recently expanded to consider questions regarding the very materiality of ancient inscriptions and literary texts, the future study of ancient images will have to pay more attention to the materiality of those ancient artefacts preserving religion-related iconography in the first place, and to the new analytical perspectives of new materiality studies.[43]

If approached in a reasonably sophisticated way, material and visual culture will continue to open alternative ways to the study of past religion, whether in terms of preferred deities, cosmological assumptions, ritual practices and contact and exchange with neighbours or hegemons, or in terms of more generally religious concerns shared in a particular location, group, community or region. One particular strength of contextualised ancient artefactual data is that they force and enable scholars to ask questions about geographical, economic and social location, production, distribution and consumption of the relevant artefacts. They allow us to construe (and make us aware that *we* construe) ancient 'religion' not exclusively in terms of ideas, but above all in terms of social communication, including matters of political power and economic exchange. Ancient artefacts, their production, diffusion and consumption can be studied in connection with political, social, economic, cultural and ideological conjunctures. Their seismographic sensitivity may be finer-tuned, historically speaking, than many a literary religious text, especially if the latter has attained canonical, mnemohistorical or otherwise normative status which should make it fit for trans- or metahistorical concerns. A major strength of using artefactual data for the study of ancient religion is of course their relation, in principle, to archaeologically established contexts. Context is crucial, not only for dating purposes, but also to understand how objects were appropriated and how they functioned in the lives of those who used them. Again, we transcend the world of ideas by grounding it in other facets of life, including everyday concerns, special ritual performances and bodily practices.

Artefacts and contexts may be classified and grouped according to criteria which may differ from established, a priori religion-related historical taxonomies. Studies in religion often tend to categorise their material according to religious 'traditions' and/or conformity to standard expectations about them. Categories are frequently either ill-defined or otherwise unhelpful, restrictive and potentially misleading. In the study of religion in the southern Levant BCE, container categories are easily ethnicised in terms of 'Israelite', 'Judahite', 'Moabite' or 'Philistine' religion.[44] Yet the model of such classification alongside ethnic or ethno-political categories is not inscribed in the data; it is directly derived from the Bible.[45] Previous generations of scholars tended to classify putatively 'non-conformist' features of religious practice (that is, features not fitting normative expectations based on an often limited knowledge of biblical literature and its own normative stance) as 'Canaanite', 'syncretistic', 'popular' or otherwise 'folk'.[46] (In studies on religion in late antiquity, comparable labels would read 'Christian', 'Judeo-Christian', 'pagan', or 'Gnostic', 'orthodox' vs 'heterodox', etc.). When considering whether or not to adopt such classifications, one must ask and critically evaluate to what extent they are required by data and help to better explain those data, or whether they are prompted by assumptions that are extraneous to the data and do not necessarily improve our critical understanding of ancient religious history.

Theoretical challenge I: diversity, spheres and levels in ancient religion

In spite of all the criticism expressed above, the study of ancient southern Levantine religion has significantly progressed over the last two or three decades. In addition to new material, visual and epigraphic finds, major advances concern terminological differentiation and theoretical sophistication. One significant issue in the discussion has been the move away from earlier approaches which addressed southern Levantine religions (plural) as relatively homogeneous units distinguished according to ethno-polities, towards an increasing recognition of religion (singular) as a broad social field characterised by internal tensions and diversity.[47] How that diversity should best be accounted for terminologically, theoretically and methodologically is an important question.

One striking feature, which appeared at the turn of the 21st century, has been the use of the plural 'religions' with reference to what had previously been conceptualised as one ethno-national religion, namely 'Israelite religion'. To mention two major examples: first, the magisterial synthesis of 'parallactic approaches' to the history of religion in ancient Israel and Judah published by Ziony Zevit, which is based on archaeological as much as on selected biblical data, entitled *The Religions of Ancient Israel*.[48] The plural here serves to signal diversity and make sense of many different sets of archaeological data which cannot easily be reduced to a homogeneous overall pattern or framework. According to Zevit, 'Israelite religions are the varied, symbolic expressions of, and appropriate responses to the deities and powers that groups of communities deliberately affirmed as being of unrestricted value to them within their worldview.'[49] Diversity here is founded on a plurality of local (and localised)

communities. A far more conservative approach was followed a few years later by the biblical scholar Richard Hess in a survey entitled *Israelite Religions*.[50] In his book, the plural serves to distinguish various areas of concern, such as historiography, law or cult and ritual, as well as to differentiate chronologically successive phases (pre-Israelite, early Israelite, monarchic, exilic, post-exilic) in the historical evolution of 'ancient Israelite' religion. Diversity remains heavily framed by assumptions of essential unity and continuity.

The strategic use of the plural 'religions' clearly serves two very different purposes in the two books: whereas Zevit's aim is to stress diversity and plurality among largely coeval religious practitioners within a geographical area broadly defined as 'ancient Israel' (note the consistent use of plurals in the quoted phrase), Hess's is an attempt to describe relatively homogeneous, if diachronically sequenced systemic states of equilibrium of a cultural unit 'Israel' going through a number of subsequent transformations but retaining its core identity as 'Israel'. The latter approach stands in continuity with the conventional paradigm of differentiating 1st-millennium southern Levantine societies, cultures and religions according to ethno-political classifiers, whereas the former introduces diversity, variety, plurality and dynamic processes of renegotiation among distinct communities within the one ethno-political unit called 'ancient Israel'.[51]

Needless to say, my own work tends to favour Zevit's innovative approach rather than Hess's conservative one, although I am not sure whether Zevit's use of the plural 'religions' is always helpful in the discussion. After all, it might be understood as referring to the many different datasets he discusses, as if each of them represented a discrete, and to some extent stand-alone, 'religion'. Such a view risks producing new misunderstandings if the field of ancient southern Levantine religious practices is further atomised. Let us recall the distinction discussed above in section 2 between T1 and T2 religion: it makes far more sense, in my view, to attribute the plural 'religions' to T2 situations, where several offers compete with each other for members and recognition within a given society, than to a T1 framework where a religious field as such is identified within the larger fabric of social and cultural communication. 'Religion at Athens' or 'religion in Rome', 'religion in Jerusalem' or 'religion in Samaria', Bethel, Arad or Elephantine may well be described, on the basis of available documentation, as materially different and thus distinct; but should we consider each as a coherent, homogeneous, monolithic religious system? To describe a particular situation and context does not mean that we need elevate it to the status of a discrete taxonomic unit in a theoretical approach aiming at generalisation.

Another, perhaps more significant differentiation based on social stratification has become standard in recent research on ancient southern Levantine religion. What started as the recognition of a discrete level of so-called 'popular', 'non-conformist' or 'private' religion as against 'official', state-run religion four decades ago has been transformed more recently into a much more fine-tuned model distinguishing several kinds of diversity, namely conceptual, 'socio-religious' (royal, urban, rural, household

and personal) and geographical.[52] It is indeed plausible to distinguish different levels of religious concern, practice and belief according to the size of stakeholder communities, the implied social relevance and reach of their religious concerns and the degree of demarcation of spaces conspicuously or exclusively designed for religious ritual. Working along these lines, Rüdiger Schmitt has recently suggested a model of no fewer than eight distinct types and sub-types of cult places:[53]

- IA Domestic (house) cult
- IB Domestic shrines
- II Work-related cults
- III Neighbourhood shrines
- IV Burial grounds and ancestor cult installations
- V Local and village shrines (A intra-mural, B (extra-mural) high places, C gate sanctuaries)
- VI Palace shrines
- VII Regional sanctuaries (A open-air, B temples)
- VIII Supraregional and state sanctuaries

I appreciate Schmitt's attempt at typological differentiation and sophistication but tend to consider his list more as a heuristic rather than a descriptive real-world or normative analytical tool.[54] The typology is not totally consistent, since its defining criteria oscillate between practices (cults), material arrangements (installations, shrines, sanctuaries) and spatial locations; it will often be difficult to precisely identify an archaeologically given situation with one and only one of these types; and the apparent implication that family and household concerns would only be expressed and ritually processed in domestic contexts can easily be proven wrong on both archaeological and textual grounds. Real-life settings will display the combined features of several different types. Still, Schmitt's list can help us to think about such issues as whose agency and which community we should hypothesise behind a given material assemblage, what kind of religious concern (or claim) could have motivated it, and what outreach or significance claim would have been attached to it by those who were responsible for running a particular religious place.

Combining such attempts at conceptualising diversity within ancient religion, and coming back to the material artefacts and visual symbolism on which Keel and I built the religio-historical argument exposed in *GGIG*, I draw the following intermediate conclusion: a material and visual culture approach to ancient religion will always need to combine and hold in balance two aspects of the ancient data we work with – individual objects on the one hand, that is, artefacts which need to be analysed with utmost attention and which by comparison may then be understood as 'nodes' in a web of ancient material, economic, political and cultural relations, in which religion had a role to play; and, on the other hand, the contexts and assemblages in which objects are actually found, and which preserve information about why and to what end a particular artefact was actually used specifically there and then.[55]

Theoretical challenge II: religion before religion, 'embedded religion', non-religion

A last and crucial question to be addressed here is on what grounds we should count particular items or sets of material

and visual artefacts as pertaining to ancient 'religion' in the first place. To illustrate this point with an example related to *GGIG*: in the chapter devoted to Iron Age II B (9th–8th centuries BCE), Keel and I drew attention to what we observed to be a significant characteristic of the period's iconography, namely its strong Egyptianising features, among which were the conspicuous presence of winged hybrid animals and humans and the fact that these were quite often represented with a solar disc on their head.[56] We hypothesised that, since much of this iconography would have been processed in Levantine workshops, it would probably have lost its specifically Egyptian religious or mythological connotations; but the reference to Egypt and solar symbolism as the ultimate origin and reference of these motifs seemed consistent and strong enough to postulate some influence on (or 'solarisation' of) the religious symbol system of the time. The material and visual basis for that claim was provided by dozens of stamp seals but also other image-bearing artefacts from various places. Among other groups of artefacts, we discussed what scholars commonly refer to as the 'Samaria ivories'. Some colleagues have criticised our use, within a religio-historical argument, of materials which in antiquity had been produced to decorate furniture and boxes for jewellery, perfume and other luxury items unrelated to cult or religious ritual. Could it be that, writing in a religio-historical perspective, we might have imposed the category of religion on objects which had no direct relation to religion at all?[57]

At the time, we might have responded to this criticism that elite members of the 1st-millennium societies of the ancient Levant would probably not have distinguished religious from non-religious symbolism as clear-cut and straightforwardly as modern western archaeologists working in thoroughly secularised academic environments. We would have insisted that, even when appearing on luxury toilette items, winged hybrids carrying solar discs represented sufficiently non-obvious entities to count as 'religious' imaginary. And we might have added that religion at the time would obviously not have been conceived as a discrete and self-contained system of communication in the way it has been theorised by sociologists for modern societies; religion would have somehow pervaded all (or at least many different) domains of human life and activity, affecting in its own way such mundane domains as handicrafts and everyday elite aesthetics. We could also have referred to the well-known idea that beyond ritual acts serving to explicitly address deities or *daimones*, significant parts of ancient religion were 'embedded' in all kinds of everyday practices and concerns.

That said, the very concept of 'embedded (ancient) religion' has been thoroughly criticised by the religious studies scholar Brent Nongbri, who argues that we should avoid the (in his view, modern) concept of religion altogether when referring to pre-modern, and certainly ancient, societies. According to Nongbri, there simply was no religion 'before religion' in antiquity.[58] To be sure, people dealt with non-obvious beings in everyday life and on special occasions such as festivals, sacrifices and processions. But these were part of a framework of social communication and meaning-making that did not require a discrete concern that 'we'

(namely, modern westerners) would set apart as specifically 'religious'. If this may sound like quibbling about words and appropriate definitions to some, such is after all an essential part of critical scholarship. I agree with Nongbri that historians (of religion and otherwise) need to be careful not to impose anachronistic notions and certainly not their own world-view on the data and societies they study.[59] It may well be that, having produced our *GGIG* in a biblical studies (and, after all, theological) environment, the discourse rules and expectations of that environment may at times have affected our historical argument, fuelling religion into ancient objects and practices where non-religious explanations would have been equally valid and perhaps at times preferable. That said, *pace* Nongbri, I still find it difficult to understand why historians of ancient societies should refrain from using a category like 'religion' on such simple grounds that this category took on a significantly new – and henceforth normative and highly influential – meaning from the 16th century onwards.

How different is BCE from CE? Ancient and late ancient religion in a material and visual culture perspective

To conclude, let me reiterate the title question of this chapter and try to extrapolate from our research on 2nd- and 1st-millennium BCE southern Levantine religion (and non-religion) to the main topic of this volume. My far too limited knowledge of late antique religion\s does not allow me to address and construe the comparison of BCE and CE religion materially. But I may be allowed to ask whether a somewhat similar approach, based on material and visual culture, with special attention to so-called minor arts, could not equally well be taken in the study of 1st-millennium CE religious history. We should ask what differences might or might not be expected – and whether the study of material and visual culture would support or rather question the clear-cut distinction between 'ancient' and 'post-ancient', or T1 and T2 religion\s. In this last section of an already longish chapter, I shall proceed by way of suggestion rather than demonstration, from 'rather different' through 'somehow different' to 'not so different, after all'; and I shall conclude by asking *who*, after all, construes and evaluates the degree of difference between BCE and CE religion, and on what grounds.

As the discussion above has shown, historians of religion have suggested a great number of criteria to distinguish 'T2' from 'T1', or CE religions from BCE religion. Many of the criteria and concepts lying behind them concern core features of religion such as the presence or absence of canonical scriptures, notions of absolute truth, strong transcendence/immanence distinctions, belief in post-mortal salvation, imperial institutionalisation vs sectarianism, the practice or rejection of animal sacrifice and so forth. From a macro-historical perspective, there can be no doubt that, as networks of transregional trade and communication extended over the centuries, religious traditions differentiated and adapted their organisational networks, their agents (prophets, healers, traders, monks and other religious entrepreneurs) crossing ever-increasing distances and engaging in competition with each other within and between ever larger imperial frameworks. As a result, the religious field as a whole was deeply transformed

and reconfigured. This core insight from a macro-historical perspective cannot reasonably be doubted.[60]

Yet to acknowledge such historical processes of socio-cultural and religious transformation (an important facet of early globalisation, as it were), processes that would have followed different paths depending on local contexts, power structures and resources, should not lead us to buy in to overly gross and dichotomous distinctions between 'ancient religion' and 'post-ancient religions'. In the framework of this volume, crucial questions are whether and how the material and communicative infrastructure would have significantly changed and adapted to entirely new religious concerns, and whether the transformation would have affected the material and visual culture of specific communities of producers and consumers. Previous research on 'new religions' in the Roman empire may have exaggerated aspects of discontinuity and innovation ('New Testament studies' provide the prime example, but they are not alone).[61] Taking into account the fact that the religious discourse of many ancient or late antique 'new' religions presented itself as innovative and discontinuous, could historians of religion perhaps have followed the rhetoric of their source material when construing late antique, 'post-ancient' religions as essentially different from earlier, 'ancient' religion? Could it be that there is more continuity between 'ancient' and putatively 'post-ancient' religion than we usually think?

The reality of historical processes and transformations which affected religion from BCE to CE cannot be denied. That said, we should demonstrate that reality from data rather than from religious elite discourse authored by stakeholders, experts and virtuosi. When studying matters of diversity vs hegemony, the reality of both needs to be checked against the evidence of contextualised material and visual culture. Both diversity and hegemony, the traditional and the new, may well appear entangled in different sets of material data. One interesting question to ask, when studying localised material and visual data, would be how wide the cultural horizon of any given local community would reach, and whether it would be more affected by local concerns, cooperations and rivalries than by regional or transregional sectarian ones. Taking into account how late antique imperial formations were organised in rather different 'styles' east and west, allowing different religious groups and sects more or less latitude in practising their difference or distinctiveness, we may ask whether and how this difference in diversity is reflected in the material, visual and epigraphic record. The religious policy of the late Roman/Byzantine empire is generally viewed as more hegemonous than that of the Parthian or Sasanian empires. It should be possible to test through the study of material, visual and epigraphic data to what extent that general characterisation (which I take from the secondary literature) is an appropriate representation of historical reality. I assume, however, that, if the different styles can be substantiated through the study of material data, they will hardly coincide with the T1/T2 distinction discussed on pages 156–7.

To point out that the new (or 'secondary') religious formations did not always nor completely replace all facets of earlier ('primary') traditions and practices is to state a truism. Moreover, not all CE religions adopted (one might say, converted to) 'T2' features in the same way. Even if they appealed to non-obvious entities that were increasingly conceived as otherworldly and transcendent (one aspect important to axial age theory), much of CE religious practice remained essentially 'locative': that is, centring on the local social fabric and the immediate everyday concerns for the prosperity of a local urban society or a village community, and the good life of its members.[62]

Historians of religion have always been aware of such aspects of continuity of local traditions within 'new' religions (think of the transformation of the goddess Isis into the Christian Mother of God, to mention but the most visual and iconic example). But there has also been a strong tendency to relegate matters of continuity, or 'persistent paganism', to low-level popular, non-official religion, if not 'magic' *tout court*. I need not go into an elaborate argument to state that, from a material and visual culture perspective on ancient and late antique religion, and despite persistent attempts to taxonomically treat ancient magic as a discrete field,[63] the latter is an integral part of the overall religious field at any given time in any given location. What should interest us as historians of religion is how practices classified by some as 'magic', and the material and visual data that are attributed to it, relate to and complement other aspects of local religion in any given society and community.

A material and visual approach to ancient and late antique religion will probably relativise both the BCE/CE distinction (which, being modelled on BC/AD, is a crypto-confessional convention) and the dichotomy of 'ancient religion' and 'post-ancient religion\s'. Whether these distinctions will continue to mark and structure the history of religion\s will not so much depend on the data, but on scholars who study them and the discursive communities in which they discuss their research. As long as not only BCE and CE scholars, but also archaeologists, philologists or iconographers, experts in theology and specialists of 'ancient magic' operate in largely self-contained and putatively self-sufficient (sub-)disciplinary environments, I see little chance for a thorough reconfiguration of the field and its basic assumptions. If we wish the BCE/CE distinction to fall and a material-cum-visual-culture approach to gain prominence in the study of ancient religion, we need to develop a much more inter- and trans-disciplinary conversation and parallel research environments. The ultimate aim of a material-cum-visual-religion approach should thus not be to develop yet another province of exclusive special expertise; rather, it should invite scholars from as many different disciplines as necessary, studying as many different aspects of ancient culture and society as possible, to engage in mutually challenging cooperation rather than disciplinary boundary-working. Our conversation will be facilitated if we focus on clearly defined questions, combine macro- and micro-perspectives, and appeal to critical theory at large to base the discussion on appropriate etic, non-religious terminology.

The *Empires of Faith* project that initiated this volume has been an excellent instantiation of just such a trans-disciplinary conversation. Perspectives might seem even

brighter if historians of religion engaging in material and visual culture studies are ready to extend their theoretical concerns beyond their own, somewhat traditional questions of representation and meaning, to move towards such much broader horizons as propounded by actor-network-theory (Latour 2005), cognition and material engagement theory (Malafouris 2013) and other theoretical work on practice and materiality. Much remains to be improved in future critical research, which promises to be even more trans-disciplinary, collaborative and mind-opening than our past endeavours.

Notes

1 Readers will note occasional switches between (or combinations of) singular and plural in my use of the term 'religion'. The backslash in 'religion\s' is intended to emphasise that using one or the other really makes a difference in the way we consider the concept. When using the singular, I address a social field identified by a particular concern for non-obvious agents and structured ways to act by involving them in the lives of individuals, groups and societies; the singular should not mask the highly diverse and often segmented, at times fragmented, character of the field. In contrast, the plural is meant to stress diversity and at times optional varieties within the field; if the singular embraces a social field, the plural points to particular social formations, including institutions and organisations. Historians need to resist both homogenisation (as suggested by a singular) and reification of this or that 'tradition' (as often implied by the plural or reference to one particular 'religion'). That said, the difference between singular and plural may be crucial for our understanding of differences (if not *the* difference) between BCE (religion) and CE (religions) – if difference there is.

2 On the millennium as a meaningful period, with Muḥammad as a major caesura, see Fowden 2014; for a critical reflection on periodisation, see Le Goff 2014.

3 Keel and Uehlinger 1992 and 1998.

4 I shall take a very broad view on the concept of 'late antiquity' here, considering one of the characteristics of the period to be the rise of social formations ('religions') which explicitly put their origins and development in relation to earlier antiquity, whether as a model to be followed or as a framework to be superseded. When precisely the period fringes out into what is commonly designated as Middle Ages is irrelevant to my present argument. Emphasis is on the scholarly concept as much as on datable social facts, as with 'BCE' and 'CE'. 'Late antiquity' can in such a perspective be understood as a particular *Denkraum* (or 'intellectual space': see Schmidt, Schmid and Neuwirth 2016) as much as a distinct period in time.

5 That the concept of 'paganism' is unhelpful as a critical category in several respects has long been demonstrated (Remus 2004; Jürgasch 2016; Stenger 2018). It is baffling to observe how difficult it seems to be for scholars studying ancient religion to put it to rest once and for all – proof, if needed, that Christian premises and terminology continue to hinder the development of critical third-order vocabulary.

6 Morphological variations among various modern European languages (e.g. Christianity, *christianisme*, *Christentum*) result from particular semantic differentiations, but the concepts share common assumptions.

7 A good alternative candidate for a historical precedent would be early Zoroastrian religion: ethnically defined and transmitted, 'Zoroastrianism' resists easy classification in similar ways to 'Judaism'.

8 Assmann 1996 and 2009. The contrast of traditional T1 religion and Christianity as the model of a T2 religion appears rather nicely in Part I of Spaeth 2013, where no fewer than eight chapter titles refer to geographical regions (Egypt, Mesopotamia, Syria-Canaan, Israel, Anatolia, Iran, Greece, Rome), followed by 'Early Christianity' as the single non-locative entity. Johnston 2004 has a similar organisation in its section on 'Histories'.

9 I am aware that critical scholarship does not always rely on this typology, and that specialised studies on local histories of religion need not refer to it. Moreover, as one reviewer has rightly remarked, there are richer conceptual frameworks than the one discussed here in both history and sociology of religion (e.g. Bellah 1964 on 'religious evolution', where five stages in 'religious evolution' labelled 'primitive', 'archaic', 'historical', 'early modern' and 'modern' are distinguished). Yet such more sophisticated typologies seem to have been relatively uneffective in overcoming the BCE/CE divide and putting to rest comparable dichotomic models (see below on 'axial age' theories).

10 Sundermeier's observations were first published in 1980 and the distinction repeated, occasionally with slight modifications, in a number of his later publications. Note that, according to Sundermeier, 'primary religious experience' continued to guide African believers long after their conversion to Christianity or Islam, never completely to be replaced by 'secondary religious experience'. See Diesel 2006: 25–31 for a convenient summary.

11 That 'monotheism' correctly qualifies the Hebrew Bible's religious stance is questioned by many; for recent discussions, see Lynch 2014 and Römer 2017.

12 Assmann's theory can be followed through numerous publications since 1990 and found programmatic expression in Assmann 1996. See again Diesel 2006: 31–5. Diesel rightly observes that, whereas the distinction of 'primary' vs 'secondary' served Sundermeier to stress the *integration* of different types of religion within the experience of believers and their communities, Assmann used it to construe a dichotomy between two *mutually exclusive* types of religion.

13 See, e.g., the collected essays in Pongratz-Leisten 2011.

14 See especially the collected essays in Wagner 2006.

15 This is not the place to discuss the genealogy of axial age theory. The theorem as such was established by the philosopher Karl Jaspers in *The Origin and Goal of History* (1953; German original 1949), which was inspired by both Alfred and Max Weber. It was elevated to the status of a paradigm by historically minded sociologists pursuing the Weberian path, among whom Shmuel N. Eisenstadt and Robert N. Bellah have been most influential. Recent adaptations to the history of religion\s include Torpey 2017; Sanderson 2018. For a recent assessment of the paradigm, see Mullins *et al.* 2018; regarding its intellectual genealogy and subsidiary function for theories on modernity, see now Assmann 2018.

16 Smith 1987 and 1990. For a retrospective view on the distinction, see Smith 2004: 14–19.

17 For important studies on the emergence and transformations of an inner self, see Assmann and Stroumsa 1999.

18 See Stroumsa 2016 and 2018.

19 On the question of faith in (Greek) religion, see Veyne 1988.

20 Lincoln 2004: 665. Emphasis added in order to do justice to an otherwise very suggestive essay, republished in 2012 as 'Ancient and post-ancient religions' in a volume of collected articles. Note Lincoln's observation that 'the transition from ancient to post-ancient might better be studied with reference to these four

variables, rather than the one which is their sum and product, "religion" *tout court*' (2004: 660).

21 Lincoln 2004: 659.

22 Lincoln is critically aware of this risk when he states as a provocative conclusion: 'The transition yields Christianity. Or, to put it a bit more cautiously, the ancient ends and the post-ancient begins with Christianity(ies), Judaism(s), and Islam(s), with the westernmost form of Christianity as the extreme case' (Lincoln 2004: 665).

23 Take, for instance, Lincoln's succinct but much more nuanced discussion of the transformative process which started from inspired oral poetry as the main source of expressing divine will and developed through written poetry or prose collected and edited in sacred books; once codified as canonical scripture, the written word replaced inspired speech, and displaced the divinatory process towards hermeneutics – a 'historic shift from a prophetic ethos associated with orality to the scholarly ethos of the text' (Lincoln 2004: 660–1).

24 See Leppin 2007. A similar case could be made for the history of Buddhism until its suppression on the Indian subcontinent, or for all missionising and expanding religions acculturating to newly encountered territories and societies.

25 See Frankfurter 2017; Leppin 2018; Brand 2019, among others.

26 To name but one compelling example, this has been amply demonstrated for Late Antique Egypt in Frankfurter 2017. Earlier scholarship may have considered the relevant materials in terms of 'survivals', which is definitely the wrong concept to make sense of what remained actual practices, both meaningful and habitual.

27 Lincoln 2004: 663 (emphasis added).

28 On material religion and mediation, see Meyer 2012, who may overstress (on Christian premises?) the aspect of 'generating presence' through material artefacts – a sometimes important but often quite irrelevant function of material artefacts in religious practice.

29 The latter argument had been most forcefully made in Knauf 1991; it has since become commonplace in critical historical scholarship.

30 A change from a biblical studies to a study of religion\s environment, which has had some epistemological consequences in my scholarly practice (see Uehlinger2015a and 2019).

31 See Keel 1993 (introductory volume) and 2017 (latest instalment, sites I–K). The project remains unfinished. Thanks to an SNSF Sinergia grant, which allows cooperation of scholars working at the universities of Bern, Tel Aviv and Zurich, we hope to bring it to completion (sites L–Z) and to transform it into an expandable, collaborative, open-access database by the end of 2023.

32 It is all the more surprising that the German version made it to a seventh printing as late as 2014, and the English translation of 1998 continues to be quoted as a standard reference. Alas, this also signals that no alternative account has been produced in the meantime by someone else, however necessary and welcome that would be. Note, however, the important work produced by Silvia Schroer (Schroer and Keel 2005; Schroer 2008, 2011, 2018), which has a much wider scope than *GGIG* both chronologically and geographically.

33 Contrast Uehlinger 1997 with Keel 2001 and 2012.

34 Uehlinger 2015b.

35 In line with ancient primary sources and a growing tendency in recent scholarship, I distinguish between the neighbouring populations and territories of ancient Israel and ancient Judah. Such a distinction also reflects in the Hebrew Bible, whose historiography, however, favours a pan-Israelite perspective largely governed by Judahite, even Jerusalemite, concerns. On the fundamental difference between 'ancient Israel', a modern scholarly construct (Davies 2015), 'Biblical Israel' (Davies 2015) and historical Israel and Judah, see Kratz 2015.

36 The problem is somewhat ill-defined in a recent contribution to this debate by Daniel Pioske (2019), who artificially opposes 'archaeology' and 'texts', an opposition he then wants to dissolve on very general hermeneutical grounds. Pioske's 'texts' include datable inscriptions and historiographic literature (or other genres of biblical literature) indiscriminately, without further differentiating their status as (primary, secondary, tertiary …) sources for the historian.

37 See especially Na'aman 2010, and the reply in Finkelstein 2010. On the latter's position at the time, see also Finkelstein 2011, whose subtitle provocatively paralleled 'archaeology and text' with 'reality and myth'. A few years later, the eminent archaeologist moved towards a kind of *via media* (see Finkelstein 2015). Today he has turned to resolutely engage with biblical literature (see n. 37).

38 See Finkelstein 2017a, 2017b and 2018 for recent examples.

39 See Grabbe 2018.

40 I still consider Knauf 1991 one of the clearest methodological expositions to that end.

41 See Römer 2018.

42 For instance Panofsky 1955: 26–41; and the recent translations (Panofsky 2008 and 2012) by Jaś Elsner and Katharina Lorenz of Panofsky's foundational 1925 and 1932 essays. Although Panofsky has been severely criticised and seems to have somewhat run out of steam in art history narrowly speaking, a glance through introductions and handbooks in visual culture studies demonstrates that wider and neighbouring fields continue to refer to his three-level methodological suggestions as an easy-to-handle orientation, if not an all-encompassing method (which Panofsky did not pretend it should be). That arguments developed in the 1920s and 1930s must be adapted and complemented a century later does not invalidate that foundation. See Uehlinger 2015a for further comments on this issue.

43 For an overview, both handy and suggestive, see Knappett 2005.

44 See Schmitt 2020 for the latest instalment, in an otherwise remarkable synthesis, of this framework.

45 Porzia 2018 criticises the model's pitfalls and weaknesses with special concern for Phoenicia, but his observations apply *mutatis mutandis* to the framework as such.

46 E.g. Holladay 1987 or Dever 2005.

47 The 'field' metaphor is indebted to the sociology of Pierre Bourdieu.

48 Zevit 2001.

49 Zevit 2001: 15.

50 Hess 2007.

51 One should notice the emphasis on 'Israel' as an overarching classifier, in contrast to 'Israel and Judah' preferred in more recent scholarship.

52 Stavrakopoulou and Barton 2010. It is interesting to observe that, in this very useful edited volume, conventional ethno-'national' distinctions according to the various polities of the 1st-millennium southern Levant are conspicuously kept at the back and can only be scouted via the subject index.

53 Albertz and Schmitt 2012, ch. 4.

54 In his recent synthesis, Schmitt 2020 concentrates effectively on three levels (the family or household, the local, and the 'official', i.e. 'national' state), to which he occasionally adds practices related to work (production, profession), and sanctuaries of regional significance.

55 To which one may add self-critical reflection on the scholar's location, conceptual apparatus, etc. (see above).

56 Keel and Uehlinger 1992/1998, chap. VII.

57 E.g. Suter 2011.

58 See Nongbri 2008 and 2013. Nongbri's book has received mixed reactions in the religious studies community. Substantial reviews include Roubekas 2014 and Segal 2016; and see now Roubekas 2018 for different attempts at theorising ancient religion.

59 See also Barton and Boyarin 2017.

60 See Super and Turley 2006; Pitts and Versluys 2014; Humphries 2017; Woolf 2017.

61 For cautious remarks on 'religious mutations', see Pirenne-Delforge and Scheid 2013.

62 To give a single example for the contiguity of traditional village life, including religion, and new features related to relatively recent sectarian developments, I refer to the Leiden PhD thesis of Mattias Brand (2019) on the religious situation in 4th- to 5th-century CE Kellis; see Bagnall *et al.* 2015 and the extended review in Brand 2017.

63 As once more in Frankfurter 2019.

Bibliography

Albertz, R. and Schmitt, R. 2012. *Family and Household Religion in Ancient Israel and the Levant*, Winona Lake, IN.

Assmann, J. 1996. 'The Mosaic distinction: Israel, Egypt, and the invention of paganism', *Representations* 56, 48–67.

— 2009. *The Price of Monotheism*, Redwood City, CA.

— 2018. *Achsenzeit. Eine Archäologie der Moderne*, Munich.

Assmann, J. and Stroumsa, G.G. (eds), 1999. *Transformations of the Inner Self in Ancient Religions*, Leiden.

Bagnall, R.S. *et al.* 2015. *An Oasis City*, New York.

Barton, C.A. and Boyarin, D. 2016. *Imagine No Religion: How Modern Abstractions Hide Ancient Realities*, New York.

Bellah, R.N. 1964. 'Religious evolution', *American Sociological Review* 29, 358–74.

— 2011. *Religion in Human Evolution: From the Paleolithic to the Axial Age*, Cambridge, MA and London.

Brand, M. 2017. 'Religious diversity in the Egyptian desert: new findings from the Dakhleh Oasis', *Entangled Religions* 4, 17–39.

— 2019. 'The Manichaeans of Kellis: religion, community, and everyday life', PhD dissertation, Leiden University.

Davies, P.R. 2007. *The Origins of Biblical Israel*, London.

— 2015. *In Search of 'Ancient Israel': A Study in Biblical Origins*, 3rd ed., London.

Dever, W.G. 2005. *Did God Have a Wife? Archaeology and Folk Religion in Ancient Israel*, Grand Rapids and Cambridge.

Diesel, A.A. 2006. 'Primäre und sekundäre Religion(serfahrung): das Konzept von Th. Sundermeier und J. Assmann', in A. Wagner (ed.), *Primäre und sekundäre Religion als Kategorien der Religionsgeschichte des Alten Testaments*, Berlin and New York, 23–41.

Elsner, J. and Lorenz, K. 2012. 'The genesis of iconology', *Critical Inquiry* 38(3), 483–512.

Finkelstein, I. 2010. 'Archaeology as a high court in ancient Israelite history: a reply to Nadav Na'aman', *Journal of Hebrew Scriptures* 10, article no. 19.

— 2011. 'Jerusalem in the Iron Age: archaeology and text; reality and myth', in K. Galor and G. Avni (eds), *The Jerusalem Perspective: 150 Years of Archaeological Research in the Holy City*, Winona Lake, IN, 189–201.

— 2015. 'History of ancient Israel: archaeology and the biblical record – the view from 2015', *Rivista Biblica* 53, 371–92.

— 2017a. 'A corpus of north Israelite texts in the days of Jeroboam II?', *Hebrew Bible and Ancient Israel* 6(3), 262–89.

— 2017b. 'What the biblical authors knew about Canaan before and in the early days of the Hebrew kingdoms', *Ugarit-Forschungen* 48, 173–98.

— 2018. *Hasmonean Realities behind Ezra, Nehemiah, and Chronicles: Archaeological and Historical Perspectives*, Atlanta.

Fowden, G. 2014. *Before and after Muhammad: The First Millennium Refocused*, Princeton.

Frankfurter, D. 2017. *Christianizing Egypt: Syncretism and Local Worlds in Late Antiquity*, Princeton.

— (ed.) 2019. *Guide to the Study of Ancient Magic*, Leiden and Boston.

Grabbe, L.L. 2018. *The Hebrew Bible and History: Critical Readings*, London.

Hess, R.S. 2007. *Israelite Religions: An Archaeological and Biblical Study*, Grand Rapids and Nottingham.

Holladay, J.S. 1987. 'Religion in Israel and Judah under the monarchy: an explicitly archaeological approach', in P.D. Miller, P.D. Hanson and S.D. McBride (eds), *Ancient Israelite Religion*, Philadelphia, 249–99.

Humphries, M. 2017. 'Late antiquity and world history: challenging conventional narratives and analyses', *Studies in Late Antiquity* 1(1), 8–37.

Johnston, S.I. (ed.) 2004. *Religions of the Ancient World: A Guide*, Cambridge, MA.

Jürgasch, T. 2016. 'Christians and the invention of paganism in the late Roman empire', M.R. Salzmann, M. Sághy and R.L. Testa (eds), *Pagans and Christians in Late Antique Rome: Conflict, Competition, and Coexistence in the Fourth Century*, Cambridge and New York, 115–38.

Keel, O. 1995. *Corpus der Stempelsiegel-Amulette aus Palästina/Israel. Von den Anfängen bis zur Perserzeit. Einleitung*, Fribourg and Göttingen.

— 2001. 'Warum im Jerusalemer Tempel kein anthropomorphes Kultbild gestanden haben dürfte', in G. Boehm and S.H.G. Hauser (ed.), *Homo pictor*, Munich and Leipzig, 244–82.

— 2012. 'Paraphernalia of Jerusalem sanctuaries and their relation to deities worshiped therein during the Iron Age IIA–C', in J. Kamlah (ed.), *Temple Building and Temple Cult: Architecture and Cultic Paraphernalia of Temples in the Levant (2.–1. Mill. B.C.E.)*, Wiesbaden, 317–42.

— 2017. *Corpus der Stempelsiegel-Amulette aus Palästina/Israel. Von den Anfängen bis zur Perserzeit. Katalog Bd. V: Von Tel 'Idham bis Tel Kitan*, Fribourg and Göttingen.

Keel, O. and Uehlinger, C. 1992. *Göttinnen, Götter und Gottessymbole. Neue Erkenntnisse zur Religionsgeschichte Kanaans und Israels aufgrund bislang unerschlossener ikonographischer Quellen*, Freiburg im Breisgau (7th ed. Fribourg, 2014).

— 1998. *Gods, Goddesses, and Images of God in Ancient Israel*, trans. T.T. Trapp, Minneapolis and Edinburgh.

Knappett, C. 2005. *Thinking Through Material Culture: An Interdisciplinary Perspective*, Philadelphia.

Knauf, E.A. 1991. 'From history to interpretation', in D.V. Edelman (ed.), *The Fabric of History: Text, Artifact and Israel's Past*, Sheffield, 26–64.

Kratz, R.G. 2015. *Historical and Biblical Israel: The History, Tradition, and Archives of Israel and Judah*, Oxford.

Latour, B. 2005. *Reassembling the Social: An Introduction to Actor-Network-Theory*, Oxford.

Le Goff, J. 2014. *Faut-il vraiment découper l'histoire en tranches?*, Paris.

Leppin, H. 2007. 'Old religions transformed: religions and religious policy from Decius to Constantine', in J. Rüpke (ed.), *A Companion to Roman Religion*, Oxford and Malden, 96–108.

— 2018. *Die frühen Christen. Von den Anfängen bis Konstantin*, Munich.

Lincoln, B. 2004. 'Epilogue', in Johnston 2004: 657–67.

— 2012. *Gods and Demons, Priests and Scholars: Critical Explorations in the History of Religions*, Chicago.

Lynch, M.J. 2014. 'Mapping monotheism: modes of monotheistic rhetoric in the Hebrew Bible', *Vetus Testamentum* 64(1), 47–68.

Malafouris, L. 2013. *How Things Shape the Mind: A Theory of Material Engagement*, Cambridge, MA.

Meyer, B. 2012. *Mediation and the Genesis of Presence: Towards a Material Approach to Religion*, Utrecht.

Mullins, D.A. et al. 2018. 'A systematic assessment of "axial age" proposals using global comparative historical evidence', *American Sociological Review* 83(3), 596–626.

Na'aman, N. 2010. 'Does archaeology really deserve the status of a "high court" in biblical and historical research?', in B. Becking and L.L. Grabbe (eds), *Between Evidence and Ideology*, Leiden, 165–83.

Nongbri, B. 2008. 'Dislodging "embedded" religion: a brief note on a scholarly trope', *Numen* 55(4), 440–60.

— 2013. *Before Religion: A History of a Modern Concept*, New Haven.

Panofsky, E. 1955. 'Iconography and iconology: an introduction to the study of Renaissance art', in *Meaning in the Visual Arts*, Chicago, 26–41.

— 2008. 'On the relationship of art history and art theory: towards the possibility of a fundamental system of concepts for a science of art', trans. Jaś Elsner and Katharina Lorenz, *Critical Inquiry* 35(1), 43–71 (with critical introduction by the translators 33–42) (German orig. 1925).

— 2012. 'On the problem of describing and interpreting works of visual arts', trans. Jaś Elsner and Katharina Lorenz, *Critical Inquiry* 38(3), 467–82 (German orig. 1932).

Pioske, D. 2019. 'The "high court" of Ancient Israel's past: archaeology, texts, and the question of priority', *Journal of Hebrew Scriptures* 19, http://www.jhsonline.org/Articles/article_247.pdf (accessed 6 July 2020).

Pirenne-Delforge, V. and Scheid, J. 2013. 'Qu'est-ce qu'une "mutation religieuse"?', in L. Bricault and C. Bonnet (eds), *Panthée. Religious Transformations in the Graeco-Roman Empire*, Leiden, 309–13.

Pitts, M. and Versluys, J.M. (eds) 2014. *Globalisation and the Roman World: World History, Connectivity and Material Culture*, Cambridge.

Pongratz-Leisten, B. 2011. *Reconsidering the Concept of Revolutionary Monotheism*, Winona Lake, IN.

Porzia, F. 2018. '"Imagine there's no peoples". A claim against the identity approach in Phoenician studies through comparison with the Israelite field', *Rivista di Studi Fenici* 46, 11–27.

Remus, H. 2004. 'The end of "paganism"?', *Studies in Religion/Sciences religieuses* 33(2), 191–208.

Römer, T.C. 2017. 'Le problème du monothéisme biblique', *Revue biblique* 124(1), 12–25.

— 2018. 'The concepts of "counter-history" and menomohistory applied to biblical studies', in J. Keady (ed.), *Scripture as Social Discourse: Social-Scientific Perspectives on Early Jewish and Christian Writings*, London and New York, 37–50.

Roubekas, N.P. 2014. Review of Nongbri 2013, *Relegere* 4, 261–4.

— (ed.) 2018. *Theorizing 'Religion' in Antiquity*, Sheffield.

Sanderson, S.K. 2018. *Religious Evolution and the Axial Age: From Shamans to Priests to Prophets*, London.

Segal, R.A. 2016. Review of Nongbri 2013, *Religion & Theology* 23, 423–7.

Schmidt, N., Schmid, N.K. and Neuwirth, A. (eds) 2016. *Denkraum Spätantike. Reflexionen von Antiken im Umfeld des Koran*, Wiesbaden.

Schmitt, R. 2020. *Die Religionen Israels/Palästinas in der Eisenzeit: 12.–6. Jahrhundert v. Chr.*, Münster.

Schroer, S. 2008, 2011, 2018. *Die Ikonographie Palästinas/Israels und der Alte Orient. Eine Religionsgeschichte in Bildern*. Vols 2–3, Fribourg; Vol. 4, Basel.

Schroer, S. and Keel, O. 2005. *Die Ikonographie Palästinas/Israels und der Alte Orient. Eine Religionsgeschichte in Bildern*. Vol. 1, Fribourg.

Smith, J.Z. 1987. *To Take Place: Toward Theory in Ritual*, Chicago.

— 1990. *Drudgery Divine: On the Comparison of Early Christianities and the Religions of Late Antiquity*, Chicago and London.

— 2004. *Relating Religion: Essays in the Study of Religion*, Chicago.

Spaeth, B.S. (ed.) 2013. *The Cambridge Companion to Ancient Mediterranean Religions*, Cambridge.

Stavrakopoulou, F. and Barton, J. (eds) 2010. *Religious Diversity in Ancient Israel and Judah*, London.

Stenger, J. 2018. 'The "pagans" of late antiquity', in J. Lössl and N.J. Baker-Brian (eds), *A Companion to Religion in Late Antiquity*, Chichester, 391–410.

Stroumsa, G.G. 2012. 'Robert Bellah on the origins of religion: a critical review', *Revue d'histoire des religions* 229, 467–77.

— 2016. *The Scriptural Universe of Ancient Christianity*, Cambridge, MA.

— 2018. 'The scriptural galaxy of late antiquity', in J. Lössl and N.J. Baker-Brian (eds), *A Companion to Religion in Late Antiquity*, Chichester, 553–70.

Sundermeier, T. 1980. 'Die "Stammesreligionen" als Thema der Religionsgeschichte: Thesen zu einer "Theologie der Religionsgeschichte"', in T. Sundermeier (ed.), *Fides pro mundi vita. Missionstheologie heute*, Gütersloh, 159–67.

— 1999. *Was ist Religion? Religionswissenschaft im theologischen Kontext. Ein Studienbuch*, Gütersloh.

Super, J.C. and Turley, B.K. (eds) 2006. *Religion in World History: The Persistence of Imperial Communion*, London.

Suter, C.E. 2011. 'Images, tradition, and meaning: the Samaria and other Levantine ivories of the Iron Age', in G. Frame *et al.*, *A Common Cultural Heritage: Studies on Mesopotamia and the Biblical World in Honor of Barry L. Eichler*, Bethesda, MD, 219–41.

Torpey, J. 2017. *The Three Axial Ages: Moral, Material, Mental*, New Brunswick, NJ.

Uehlinger, C. 1997. 'Anthropomorphic cult statuary in Iron Age Palestine and the search for Yahweh's cult images', in K. van der Toorn (ed.), *The Image and the Book: Iconic Cults, Aniconism, and the Veneration of the Holy Book in Israel and the Ancient Near East*, Leuven, 97–156.

— 2015a. 'Approaches to visual culture and religion: disciplinary trajectories, interdisciplinary connections, and some conditions for further progress', *Method and Theory in the Study of Religion* 27(4–5), 384–422.

— 2015b. 'Distinctive or diverse? Conceptualizing ancient Israelite religion in its southern Levantine setting', *Hebrew Bible and Ancient Israel* 4(1), 1–24.

— 2019. 'Beyond "image ban" and "aniconism": reconfiguring ancient Israelite and early Jewish religion\s in a visual and material religion perspective', in B. Meyer and T. Stordalen (eds), *Figuration and Sensation of the Unseen in Judaism, Christianity and Islam: Contested Desires*, 99–123, 286–87, 304–7.

Veyne, P. 1988. *Did the Greeks Believe in Their Myths?*, Chicago.

Wagner, A. (ed.) 2006. *Primäre und sekundäre Religion als Kategorien der Religionsgeschichte des Alten Testaments*, Berlin and New York.

Woolf, G. 2017. 'Empires, diasporas and the emergence of religions', in J. Lieu and J.C. Paget (eds), *Christianity in the Second Century: Themes and Developments*, Cambridge, 25–38.

Zevit, Z. 2001. *The Religions of Ancient Israel: A Synthesis of Parallactic Approaches*, London and New York.

Response to C. Uehlinger, 'Material Religion in Comparative Perspective: How Different Is BCE from CE?'

Stefanie Lenk

In asking 'How different is BCE from CE?', Christoph Uehlinger problematises the validity of a distinction that scholars of religion commonly make between two ideal types of religion. Uehlinger's compilation of oppositionals, extracted from 20th- and 21st-century writing on ancient religions, demonstrates the prevalence of this typological divide in our fields. Emphases differ (for example, 'traditional' versus 'revealed' or 'locative' versus 'utopian'), yet core characteristics of Type 1 religions (T1) and Type 2 religions (T2) are consistent. Uehlinger summarises T1 'as fully coextensive with social convention, if not "locally common-sense" altogether; as such it is transmitted and inherited from one generation to the next without too much questioning', and T2 'as fundamentally optional and oppositional, based on conviction and conversion, a choice to become a member in an elective community and to adopt belief in the truth of this group's particular myth and its superior potential for salvation' (p. 156).

While Uehlinger is not against using the T1-T2-typology as a heuristic device, he is sceptical of its value as a descriptive category in historical scholarship, for which he has ample justification. The idea that the T1-T2-typology can be projected onto a temporal frame is (as Uehlinger demonstrates) deeply engrained in current scholarship. T2 religions are commonly assumed to have supplanted T1 religions; oppositional pairs like 'primary' and 'secondary' religions, or 'ancient' and 'post-ancient', give vivid testimony of the typology's use as a template for historical development. The breaking point is most often located between BCE and CE – to put it bluntly, before and after the rise of Christianity. A text by Bruce Lincoln which seems to have nourished Uehlinger's concern, is particularly explicit about timing. Lincoln writes:

> Within such multistranded formations, one's neighbors were one's fellow citizens and also one's coreligionists, who spoke the same language, shared the same norms, celebrated the same festivals, and worshipped at the same altars, seeking favor of the same gods for the group of which they were all a part. The post-ancient, by contrast, saw the emergence of communities based primarily – also most explicitly and emphatically – in religious considerations, integrating persons which might well be divided by geography, language, culture, and/or citizenship. … Inclusion or exclusion in such amorphous communities was not ascribed by birth in a given place, lineage, or social stratum but had an elective quality.[1]

And a bit later: 'the transition yields Christianity. Or, to put things a bit more cautiously, the ancient ends and the post-ancient begins with Christianity(ies), Judaism(s), and Islam(s), with the westernmost form of Christianity as the extreme case.'[2]

Lincoln places much emphasis on the role of locality when he distinguishes T1 from T2. In contrast to T1, T2 is more concerned with integrating the likeminded, potentially from afar, than with making the religion work in its local context. He endorses a popular variety of the T1-T2-typology here, authored by Jonathan Z. Smith, which differentiates 'locative' T1 religions, dependent on and supportive of the given local customs, from 'utopian' T2 religions like Christianity which transcend local concerns or are even in opposition to them.[3] This is where Uehlinger objects, and

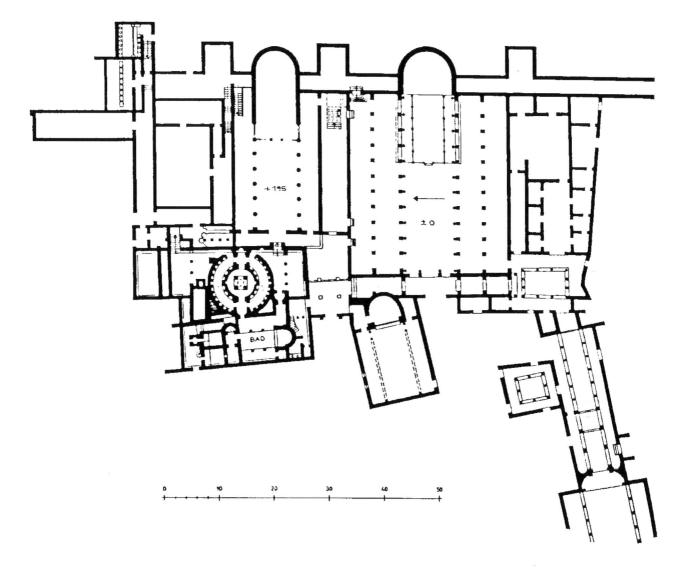

Plate 9.1 Ground plan of the church complex at Cuicul. Image: after Christern 1976: 138, fig. 27a

rightly so: 'much of CE religious practice remained essentially "locative": that is, centring on the local social fabric and the immediate everyday concerns for the prosperity of a local urban society or a village community, and the good life of its members' (p. 165). According to him, the central quality of T1 religions, their local horizon, remains more often than not central to T2 religions. Uehlinger's is a project to deconstruct the T1-T2 dichotomy, and respectively the BCE–CE dichotomy. In order to grasp 'locative' religious practice where religious discourse strives towards global uniformity, however, due consideration is needed for the lived reality of religious practitioners. Uehlinger touches here on a prime concern of the *Empires of Faith* project, as this is what makes the study of material culture such a crucial concern for historians of religion.

I would like to support Uehlinger's call for a more nuanced take on the impact of local customs on T2 religious formations by offering an example of religious material culture from a late antique Christian community in North Africa. The community resided in the city of Cuicul, modern Djémila (Algeria), in the first half of the 5th century. Located in the space and time of St Augustine, it surely epitomises what Lincoln called the 'westernmost form of Christianity'. Cuicul lay in the mountains of the Tell Atlas, a north-western area of ancient Numidia, on the route between Sitifis (Sétif) and Cirta (Costantine), and experienced a vivid phase of construction and restoration of public and private buildings in the 4th and 5th centuries. At this time, a substantial Christian complex in the southern district of the city was also developed.[4] The carefully planned complex consisted of two churches set parallel to each other, a chapel and a baptistery, as well as an entrance hall, alley, courtyards and living quarters (**Pl. 9.1**).

At first glance, the Christian complex fully qualifies as T2. When the Donatist controversy split the North African church in the 4th and 5th centuries, with so-called Donatists denying the efficacy of sacraments administered by priests who had collaborated with the Roman authorities under Diocletian's persecutions of Christians (303–5), Cuicul's Christian community took sides. The so-called Cresconius inscription, found in the choir of the south church, attests that the place was elevated to a memorial site for the rightful predecessors of the Catholic (that is anti-Donatist) Bishop Cresconius.[5] The inscription states further that the bishops' memorial was supposed to attract believers from afar: 'And from everywhere the Christians come together fulfilled by the wish to see themselves united in the praise of God ….'[6] Likely, a spectacular 90-metre-long subterranean

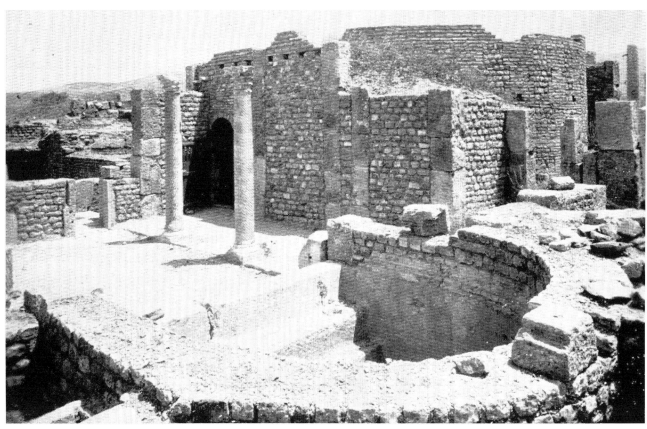

Plate 9.2 The baptistery at Cuicul, view from the adjacent bath complex. Image: Leschi 1953: 51

passageway connecting the two churches became the new location of the remains of the Catholic bishops.[7] The passageway also provided space for exclusion: the Donatist bishop attested in Cuicul was most likely not the target of commemoration.[8] We are in the middle of a T2 scenario in which taking sides in religious matters can be right and wrong, and religious leaders seek to gather the right sort of believers from far and wide.

A quintessential expression of a T2 ritual act is the rite of baptism. Baptism is the once-in-a-lifetime transition from the old, perilous life into the new Christian one; it is the 'death' and spiritual rebirth of the baptisand as a member of the body of Christ.[9] The baptisand is, so to speak, at a watershed moment. Baptism transforms the commitment to and ownership of Christ. In Augustine's time, the baptismal ceremony marked the transition from the catechumenate, the state of adhering to Christ, to the state of *fidelis*, the faithful.[10] According to the missionary logic of conversion, the sacrament of baptism is meant for everyone. In Cuicul's baptistery, we have one of the most elaborate and best-preserved baptisteries of North Africa (**Pl. 9.2**). It has received little scholarly attention since its excavation in 1922 owing to lack of archaeological investment in the site since Algerian independence. The circular, free-standing baptismal building consists of a baptismal chamber (**Pl. 9.3**) with a font covered by a canopy in its centre, and an ambulatory. The latter possibly served as waiting space for a maximum of 36 people, since semicircular niches fit for sitting are carved into its walls. The baptistery, monumental for North African standards, makes an apt component of a Christian district with pretensions to supra-regional importance.

Looking closer at the baptismal furnishings, however, the picture gets more complex. With respect to the ambitions behind the baptistery, we should expect the Christian mission to become manifest visually, the promise of a new Christian life to take shape. The opposite is the case. It seems that neither the walls nor the cupola of the baptistery were adorned.[11] The mosaic decoration of the baptismal floor, on the other hand, is bare of distinctly Christian symbols.[12] Rich aquatic scenery covers the floor of the central rotunda and the font within (**Pl. 9.4**). Besides many kinds of fish, one of them flying, the mosaic features a starfish, a winged insect, a seashell and a crustacean; the mosaicists evoked the entirety of aquatic life. A Christian interpretation as 'living water' is certainly possible, but was not made explicit by any means. Instead, the mosaicists employed visual expressions of plenty and prosperity that were totally habitual in late Roman North Africa, where scenes of marine life had commonly embellished Roman villas, fountains and baths for centuries.[13] Cuicul's preserved mosaics of profane spaces are a good example of this: aquatic subject matter outnumbers all other figurative themes depicted in private households.[14] The visual message was one of continuity, not of rupture. A reluctance to depict unequivocally Christian symbolism, let alone narrative, is, in fact, typical for the early church decorations of North Africa. Cuicul's baptistery shares this feature with the mosaics of the adjacent double church, but also with some of the largest episcopal churches, such as those at Hippo Regius, Dermech in Carthage, Timgad and Tebessa.[15]

Christians in Cuicul were assured of their unbroken connection with local custom and practice not only visually, but also ritually. The cleansing from all sins in the baptismal

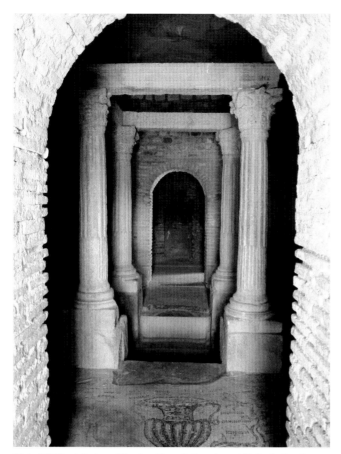

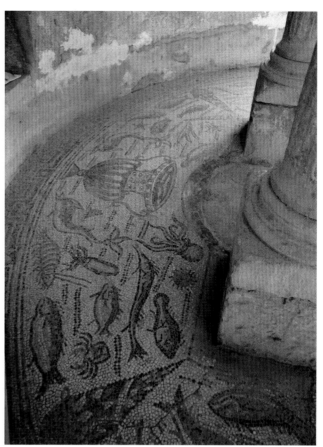

Plate 9.3 The interior of the baptismal chamber at Cuicul, view from the adjacent bath complex. Image: photograph by the author

Plate 9.4 Detail of the mosaic floor south of the font. Image: photograph by the author

font was followed by anointing with oil and the imposition of hands by the celebrant. With this last rite, the Holy Spirit was conferred.[16] In Cuicul, a fitting place for this would have been the apsidiole at the font's exit (**Pl. 9.3**).[17] Important to us is what lay behind the baptisands at this point in the ceremony. At the opposite end to the font, a prominent

portal leads into a small but fully furnished bath complex (**Pls 9.2, 9.5**).[18] The Great Bath of Cuicul is only a few minutes away, which begs the question why a separate Christian bath was needed here. Reasons of piety and practicality come to mind, yet the one occasion safely attested by a contemporary, on which the bath most likely

Plate 9.5 3D-model of the baptistery and the adjacent bath at Cuicul. Image provided by Zamani, Cultural Heritage Documentation Project, University of Cape Town

would have been used, relates to baptism itself. Augustine writes to Januarius (*c.* 400 CE) on the regional practice of bathing on Maundy Thursday:

> many or almost all persons in many places were in the habit of bathing on that day. … If you ask how the custom of bathing arose, no more reasonable explanation occurs to me than that the bodies of those to be baptized had become foul during the observance of Lent, and they would be offensive if they came to the font without bathing on some previous day. This day was especially chosen for it, on which the Lord's Supper is annually commemorated, and, because it was permitted for those about to be baptized, many others wished to join with them in bathing and relaxing the fast.[19]

Augustine reports that the bathing praxis was firmly integrated in the Lenten period, in which neophytes prepared for baptism. During Lent, they abstained from eating meat, drinking wine, engaging in sexual relations, attending the theatre and visiting the public baths, as well as going through a series of purifications such as exorcisms and catechetical lessons.[20] Although the Church's Lenten calendar did not prescribe the pre-baptismal bathing on Maundy Thursday, neophytes commonly practised it and were joined by friends and family. The significant number of baptismal bath annexes excavated in North Africa can only be read as confirmatory evidence.[21]

Was pre-baptismal bathing for Augustine's contemporaries actually purely practical, as he makes it sound? Let us think back to the prominent portal leading from the baptismal rotunda directly into the bath complex in Cuicul (**Pl. 9.3**). What was this entrance for? Two direct entrances led into the baptistery opposite the smaller of the two churches, and two different entrances gave access to the bath complex (**Pl. 9.1**). Why would the architects have wanted to provide direct access between bath and baptismal chamber? Why would they have sought to create a visual link between the bathing fonts and the 'well of life', if it had not been to factor pre-baptismal purification into the preparatory rites towards baptism? The spatial solution indicates that Cuicul's Christian community saw a need for purification before the performance of the sacrament – even if it was the ultimate rite of purification. Pre-baptismal purification is thus difficult to bring in line with Christian theology. The observance of local convention and tradition, however, explains the close link between baptistery and bath. Preliminary purification by washing belonged to the standard practices of much of Roman religious worship – be it in civic temples or in healing or oracular sanctuaries, whether in mystery religions like Mithras worship or in magical practices.[22] The pre-baptismal bathing custom thus indicates the community's indebtedness to local ritual practice and the wish to maintain elements of this tradition in their religious life as Christians.

The lived religious practice of Cuicul's Christian community can neither be described 'as fundamentally optional and oppositional' (T2) nor 'as fully coextensive with social convention' (T1). As Uehlinger has lucidly argued, religious reality is much more likely to consist, to a varying degree, of opposites, but to see this we are required to closely observe local material culture.

Notes

1. Lincoln 2012: 79–80.
2. Lincoln 2012: 82.
3. Smith 1978.
4. Blanchard-Lemée 1975; Février 1996; Blas de Robleès and Sintès 2003: 89–124; Sears 2007. For the minority opinion that part or all of the Christian complex is Justinianic, see Février 1996 and Strube 1996.
5. Christern 1976: 253–4. See also Grabar 1946: 448–50.
6. Pflaum and Dupuis 2003: 873, no. 8299.
7. For a discussion of the Cresconius inscription and the crypts located in the passageway, see Christern 1976: 140–4. The previous location of the bishops' tombs is unclear.
8. For the Donatist bishop of Djémila, see Lancel 1974: 12.1.
9. Romans 6:1–14.
10. Aasgaard 2011; Burns and Jensen 2014: 203.
11. The walls were covered only with plaster. See Monceaux 1922: 404. The excavators left no record about any fragments of a potential mosaic or painted decoration of the cupola. See also Ballu 1921 and 1923; Monceaux 1923.
12. A small swastika on the mosaic floor of the baptismal font is a 20th-century addition. For the original state at the time of the excavation, see Monceaux 1923: 107, no. 21.
13. Dunbabin 1978: 125–30; Smati 2000.
14. Blanchard-Lemée 1975.
15. Dunbabin 1978: 188.
16. Burns and Jensen 2014: 202.
17. The reading direction of an inscription on the floor of the baptismal font prescribes the likely directions of entering and leaving the font. For the inscription, see Monceaux 1923: 107, no. 21.
18. Thébert 2003: 203; Ballu 1923: 22–3.
19. Augustine, *Epistles*, 54.7.9–10 (Augustine 2008: 259).
20. Burns and Jensen 2014: 205–6.
21. Annexed baths are also documented in Tipasa and in the Donatist church of Timgad. Similar complexes have been suggested for Hippo, Rusguniae, Bulla Regia and Sbeitla II. See Thébert 2003: 226–7 and 252–3; and, further, Leglay 1957: 706; Lassus 1965: 597-8 and 1970: 251; Duval 1989: 389.
22. Hellholm 2011, 41–154.

Bibliography

Aasgaard, R. 2011. 'Ambrose and Augustine: two bishops on baptism and Christian identity', in D. Hellholm (ed.), *Ablution, Initiation, and Baptism: Late Antiquity, Early Judaism, and Early Christianity*, Berlin, 1253–82.

Augustine 2008. *Letters. Volume 1 (1–82)*, trans. W. Parsons, Washington, DC.

Ballu, A. 1921. 'Les ruines de Djemila (antique Cuicul)', *Revue Africaine* 62, 204–74.

— 1923. *Rapport sur les travaux de fouilles et de consolidations effectués en 1922 aux monuments historiques de l'Algérie*, Algiers.

Blanchard-Lemée, M. 1975. *Maisons à mosaïques du quartier central de Djemila, Cuicul*, Paris.

Blas de Roblès, J-M. and Sintès, C. 2003. *Sites et monuments antiques de l'Algérie*, Aix-en-Provence.

Burns, J.P., Jr and Jensen, R.M. 2014. *Christianity in Roman Africa: The Development of Its Practices and Beliefs*, Grand Rapids.

Christern, J. 1976. *Das frühchristliche Pilgerheiligtum von Tebessa*, Wiesbaden.

Dunbabin, K. 1978. *The Mosaics of Roman North Africa: Studies in Iconography and Patronage*, Oxford.

Duval, N. 1989. 'L'évêque et la cathédrale en Afrique du Nord', *Actes du XIe Congrès international d'archéologie chrétienne* 11, 345–99.

Février, P-A. 1966. 'Remarques sur les mosaïques de basse époque à Djemila (Algérie)', *Bulletin de la Société nationale des antiquaires de France*, 85–92.

— 1996. 'Notes sur le développement urbain en Afrique du Nord: les exemples comparés de Djemila et Sétif (1964)', in Ecole française de Rome, *La Méditerrannée de Paul-Albert Février*, Rome, 651–97.

Grabar, A. 1946. *Martyrium. Récherches sur le culte des reliques et l'art chrétien antique*, Paris.

Hellholm, D. (ed.) 2011. *Ablution, Initiation, and Baptism: Late Antiquity, Early Judaism, and Early Christianity = Waschungen, Initiation und Taufe. Spätantike, frühes Judentum und frühes Christentum*, Berlin.

Lancel, S. (ed.) 1974. *Gesta conlationis Carthaginiensis, anno 411. Accedit Sancti Augustini breviculus conlationis cum Donatistis*, Turnhout.

Lassus, J. 1965. 'Les edifices du culte autour de la basilique', in *Atti del VI Congresso internazionale di archeologia cristiana*, Vatican City, 581–610.

— 1970. 'Les baptistères africains', *Corsi di Cultura sull'Arte ravennate e bizantina* 17, 235–52.

Leglay, M. 1957. 'Note sur quelques baptistères d'Algérie', in *Actes du Ve congrès international d'archéologie chrétienne*, Vatican City, 401–6.

Leschi, L. 1953. *Djemila: Antique Cuicul*, Algiers.

Lincoln, B. 2012. 'Ancient and post-ancient religions (2004)' in *Gods and Demons, Priests and Scholars: Critical Explorations in the History of Religions*, Chicago, 73–82.

Monceaux, P. 1922. 'Découverte d'un groupe d'édifices chrétiens à Djemila', *Comptes rendus des séances de l'Academie des inscriptions et belles-lettres* 66, 380–707.

— 1923. 'Cuicul chrétien (Numidie), Miscellanea Giovanni Battista de Rossi', *Atti della Pontificia accademia romana di archeologia* 3(1), 89–112.

Pflaum, H-G. and Dupuis, X. 2003. *Inscriptions latines de l'Algérie*, Paris.

Sears, G. 2007. *Late Roman African Urbanism: Continuity and Transformation in the City*, Oxford.

Smati, N. 2000. 'Les mosaïques figurées à thème marin en Afrique du Nord (Tunisie-Algérie-Maroc): étude descriptive et analytique (Tunisie, Algérie, Maroc)', PhD dissertation, Paris.

Smith, J.Z. 1978. *Map Is Not Territory: Studies in the History of Religions*, Leiden.

Strube, C. 1996, 'Zur Datierung der Baudekoration von Tebessa', in B. Brenk (ed.), *Innovation in der Spätantike*, Wiesbaden, 423–55.

Thébert, Y. 2003. *Thermes romains d'Afrique du Nord et leur context méditerranéen*, Rome.

Contributors

Jaś Elsner is Professor of Late Antique Art at Oxford and was Principal Investigator of the *Empires of Faith* project between the British Museum and Wolfson College Oxford (2013–18). He serves also as Visiting Professor of art and religion at the University of Chicago and as External Member of the Kunsthistorisches Institut in Florenz. His expertise is in all areas of art and religion in the late antique world, especially in the Mediterranean.

Rachel Wood is Departmental Lecturer in Classical Archaeology at the University of Oxford, a fellow of Lincoln College, specialising in the art of ancient Iran from the end of the Achaemenid empire to the Sasanian period. She was a postdoctoral researcher at the British Museum on the *Empires of Faith* project.

Nadia Ali is a historian of Islamic art, focusing on early Islamic images. From 2018 to 2020, she was a faculty fellow at Silsila: Center for Material Histories at New York University. Before that, she was a postdoctoral researcher on the *Empires of Faith* project (2013–18). She is currently completing a monograph entitled *Qusayr 'Amra: The Pandora's Box of Early Islamic Aesthetics*.

Umberto Bongianino is Departmental Lecturer in Islamic Art and Architecture at the Khalili Research Centre, University of Oxford. His research and publications revolve around the visual and material culture of the medieval Islamic Mediterranean, with a focus on Maghribī calligraphy, the aesthetics of inscribed artefacts and the arts of the book.

Alice Casalini is a PhD student in Art History at the University of Chicago. Her research focuses on the Buddhist art and architecture of Gandhāra, and she has previously worked on the rock monasteries of Xinjiang. Prior to moving to Chicago, she studied at Ca' Foscari University of Venice and Peking University, where she specialised in Buddhist archaeology.

Katherine Cross is a historian of early medieval northern Europe and the author of *Heirs of the Vikings: History and Identity in Normandy and England, c. 950–1015*. She is currently Lecturer in Medieval History at the University of York and was a postdoctoral researcher at the British Museum on the *Empires of Faith* project.

Dominic Dalglish is currently a Departmental Lecturer in Roman History and Tutor in Ancient History and Classical Archaeology at Worcester College, Oxford. He undertook his doctorate as part of the *Empires of Faith* project, working on the construction of gods through material culture in the Greek and Roman Near East, and was a co-curator of the *Imagining the Divine* exhibition.

Ivan Foletti is full professor at Masaryk University. He specialises in investigating the history of art history and the art of late antiquity and the early Middle Ages around the Mediterranean. He uses social and anthropological approaches to explore the impact of human migrations on visual cultures of the Italian peninsula and the pilgrimage art in medieval Europe.

Martin Goodman has been Reader in Jewish Studies (from 1996, Professor of Jewish Studies) and a Fellow of Wolfson College in the University of Oxford since 1991 and a Fellow of the Oxford Centre for Hebrew and Jewish Studies since 1986. From 1977 to 1986 he taught ancient history in the University of Birmingham. He has written widely on both Jewish and Roman history.

Richard Hobbs is the Weston Curator of Roman Britain at the British Museum. His previous publications include *The Mildenhall Treasure: Late Roman Silver Plate from East Anglia* (2016), and *Roman Britain: Life at the Edge of Empire* (2010; with Ralph Jackson). His primary interest is the material culture of the late Roman period, especially metalwork and hoards. During 2018, he was a British Museum Research Fellow with the *Empires of Faith* project.

Catherine Karkov is Chair of Art History in the School of Fine Art, History of Art and Cultural Studies at the University of Leeds. She has published extensively on early medieval English Art, including *The Art of Anglo-Saxon England* and *Imagining Anglo-Saxon: Utopia, Heterotopia, Dystopia*. She is currently completing a book on *Form and Image in Early Medieval England*.

Stefanie Lenk is a researcher at the Institute of Art History at the University of Göttingen. During her time on the *Empires of Faith* research project, she was the lead curator of the exhibition *Imagining the Divine. Art and the Rise of World Religions* (Ashmolean Museum, Oxford, October 2017– February 2018).

Maria Lidova has studied at Moscow State University, in Italy and France. She is an art historian working on Byzantine and Western Medieval art. Her research is primarily dedicated to the icons of the Mother of God, their presentation in liturgical space, the origin of Marian cult as well as questions of cultural and historical interaction between Italy and Byzantium in early Middle Ages. She was a postdoctoral researcher at the British Museum on the *Empires of Faith* project.

Katharina Meinecke is a classical archaeologist associated with the University of Vienna. A specialist in Roman funerary culture, she is the author of *Sarcophagum posuit*, a study on Roman sarcophagi in their original context. In recent years, she has focused on late antique visual culture from a global

perspective. She is currently preparing a monograph on the appropriation and transfer processes that led to the integration of pre-Islamic motifs into Umayyad art.

Hindy Najman is the Oriel and Laing Professor of the Interpretation of Holy Scripture at the University of Oxford. She is also the director and founder of the Oriel College Centre for the Study of the Bible. Her publications include *Losing the Temple and Recovering the Future: An Analysis of 4 Ezra*; *Past Renewals: Interpretive Authority, Renewed Revelation and the Quest for Perfection* and *Seconding Sinai: The Development of Mosaic Discourse in Second Temple Judaism*.

Verity Platt is Chair of Classics and Professor of Classics and History of Art at Cornell University, where she also co-curates the cast collection. She is the author of *Facing the Gods: Epiphany and Representation in Graeco-Roman Art, Literature and Religion* (2011) and co-editor (with Michael Squire) of *The Frame in Classical Art: A Cultural History*, as well as numerous articles on art and religion in classical antiquity.

Salvatore Settis was Director of the Getty Research Institute, Los Angeles (1994–9) and of the Scuola Normale Superiore, Pisa (1999–2010). His research interests include ancient and Renaissance art history. Among his books are: G*iorgione's Tempest. Interpreting the Hidden Subject* (Cambridge 1990); *La Colonna Traiana* (Turin 1988); *The Future of the Classical* (Oxford 2006), *The Classical Tradition*, Cambridge, MA, 2010 (co-edited with A. Grafton and G. W. Most); *If Venice Dies* (London 2018).

Benjamin C. Tilghman is Assistant Professor of Art History at Washington College (Maryland, USA) and a member of the Material Collective, a collaborative working group of medieval art historians that explores innovative and more humane modes of scholarship. He has written extensively on the visual nature of writing in medieval and early modern art.

Christoph Uehlinger studied (Roman Catholic) theology and biblical studies, with electives in Egyptian and Near Eastern languages and cultures in Fribourg, Bern, Jerusalem and London. From 1991–2003 he was senior lecturer in Hebrew Bible/Old Testament studies at the University of Fribourg, Switzerland. Since 2003, he has been Professor in History of Religions/Comparative Religion at the University of Zurich.

Index

healing power of frescoes 135
Heart Sutra 7, 7, 42
Helios 66, *67*, *70*, 71, *72*, *75*, 76, *76*, 78, *78*, 79
 see also sun god
Heraclius (Byzantine emperor) 121–2, *121*
Hesiod 27, 33n.78
heterotopias 87, 93
hetoimasia 9–11, *10*
Hinduism 113
Hinton St Mary mosaic *20–1*, 21, 22, 72
Hishām (caliph) 120
Historia Augusta 140–1
historical study of religion\s 155–65, 166n.1, 170–4
 BCE and CE in material and visual culture 164–6
 Cuicul, Algeria, church at 171–4, *171–3*
 methodology and theory 155–6, 159–64
 types of religion 156–9, **157**, 163, 170–1
hoards 143, 148n.69
Hodegetria (the Virgin holding the Child Jesus) 5, *6*
Hölscher, Tonio, *The Language of Images in Roman Art*
 134
Horace, *Ars poetica* 5
hunter-king imagery 139–40, *139–40*, 141, 142, 143, 147n.34,
 148n.47
hunting *144–5*, 145
Huqoq, Israel, synagogue mosaics 72, 76

Ibn Abī Shayba, *Muṣannaf* 60
Ibn Ishāq 120–1
Ibn Sallām 60
Ibn Zafar al-Siqillī, *Sulwān al-Muṭā* 150
iconoclasm 11–14, *12–13*, 16–17
iconography
 Buddhist 96, *96–8*, 97–100, 103
 Christian 5, 55–6, *56*, 71–2, 106
 classical 19, 20, 21, 24, 38
 indirect representations 9–11, *10–11*
 Jewish 66, 71
 of Sasanian silver plate 151–2
 Umayyad 55, 119–25, *120–5*
icons
 Buddhapada as 98, 100, *100–2*, 103, 105
 of Christ 5, *6*
 Christian and Buddhapada compared 106–7
illuminated manuscripts *see* manuscripts, Christian and
 Quranic
image/word antithesis 5–7, *6–7*
imagines agentes 8
Imagining the Divine (exhibition) 1, 3, 19, 20, 21, 22, 38, 40, 44
imperial gifts 139–40, *139–41*, 147n.23, 147n.37, 150–1
India 17
 see also Buddhapada (footprints of Buddha)
inscriptions
 aniconism of 9
 on Buddhapada 100
 of manuscripts 41, 50
 runic 85, *85*, 86
 sun god 71
Isidore of Seville 58, 89
Islam
 iconoclasm of 11–12

scripture of 54–5, 63n.36
 see also manuscripts, Christian and Quranic
Israel 161
Israelite religions 157, 160, 161, 162–3
Istanbul, Turkey, footprints of Muḥammad 11, *11*
ivory 88

Japan 13–14
Jerome (saint) 61, 118
Jerusalem, Israel
 Dome of the Rock 120, 134
 empty throne in the Temple 10
 footprints of Jesus 11
 Temple, imagery of 78, *78–9*, 79
 Temple, sack of 82, *84*, 86
John Lydus 71
Jonah 87, 89
Josephus 68, 69, 71
Judaism
 biblical texts and other imagery in mosaics 75–80, *76–9*
 characteristics of 157, 159
 god, image of in mosaics 2, 66–9, *67–8*, *70*, 71–2, *76*
 see also Israelite religions
Julian (Roman emperor) 71
Justin Martyr, *Dialogue with Trypho* 69
Justinian I (Byzantine emperor) 118–19, *119*
Justinian II (Byzantine emperor) 8, 119, *120*
Juvenal 71

Kaaba, Mecca, Christ, images of 121
Kaiseraugst treasure 143, *143*, 144
Karnataka, India, footprints of Gautama 112
Kauśāmbī, India, Buddhapada 99
Kerch, Ukraine 139, 140, *140*
al-Khalīl b. Aḥmad al-Farāhīdī 61
'king of kings' 119, 120, 141, 150, 151–2
Klimova, Russia 141–2, *142*
Komarovo, Russia, silver plate 141
Kufic script 50, 55, 59, *60*, 61
Kumluca, Turkey, silver plate 143

Lakkhana Sutta 105
largitio (imperial gifts) 139–40, *139–41*, 147n.23, 147n.37, 150–1
Lenormant Statuette *23*, 25
Leonardo da Vinci, *On Painting* 5, 14n.2, 16
Lichfield (St Chad) Gospels 41, 46–7, *46*, 47–9, *48–9*
lidded cups 141
Life of Brendan 88
Lindau Gospels 57
Lindisfarne Gospels 41, 50
literacy 6
Lucian 27, 32n.49, 32n.69

Madrid *missorium* 139, *139*, 142
magic 165
magnificentia in parvis (magnificence in small things) 23–4
Mahābodhi Temple, Bodh Gaya, Buddhapada *114*, 115
Mahāmūd of Ghazna 11, *12*
Mahāyāna Buddhism 106
al-Mahdī (Abbasid caliph) 42, 51
Majjhima nikaya 105